Gabriele Fahr-Becker

□WIENER□ WERKSTÆTTE

1903–1932

TASCHEN

KÖLN LISBOA LONDON NEW YORK PARIS TOKYO

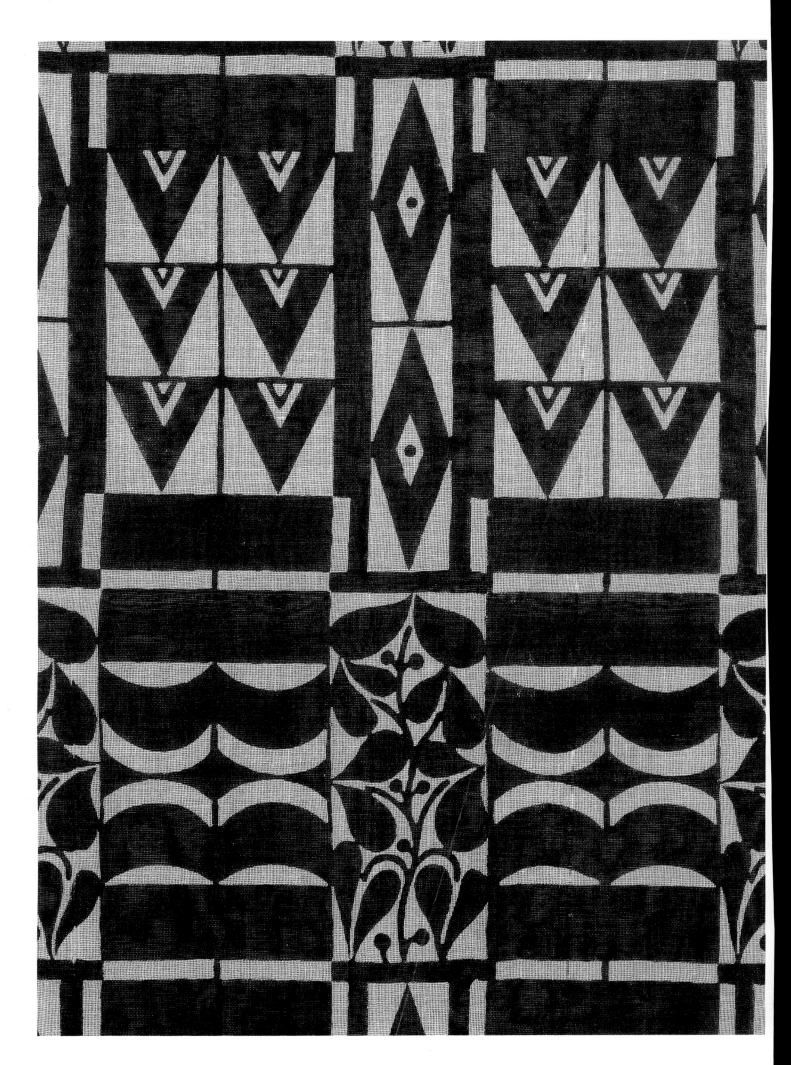

Page 1:
Logo of the Wiener Werkstätte's New York branch, 1922

Pages 4 and 5:
Wiener Werkstätte monogram and trademark
from the 1905 Work Programme

This book was printed on 100 % chlorine-free bleached paper
in accordance with the TCF standard.

© 1995 Benedikt Taschen Verlag GmbH
Hohenzollernring 53, D-56072 Köln
Edited and designed by Angelika Muthesius, Cologne
English translation by Karen Williams, High Warden

Printed in Germany
ISBN 3-8228-8571-1

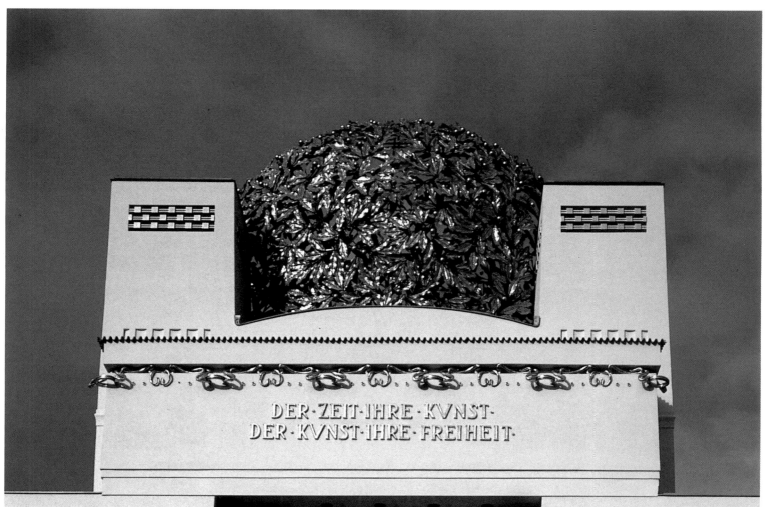

DER·ZEIT·IHRE·KVNST·
DER·KVNST·IHRE·FREIHEIT·

ER·SACRVM·

MALEREI·ARCHITECTVR·PLASTIK

Introduction

Vienna around 1900 – Secession – Wagner

What is art? Life! What is life? Art! Such was the mood in Vienna at the turn of the century – one of lightness, sociability, good-humoured self-irony, cheerfulness, love of festivity, and refinement. Nowhere in Europe was aesthetic culture so intensely associated with personal stand ng as in Viennese middle-class society. Art offered the members of the Vienna bourgeoisie the opportunity to place themselves on a par with the politically all-powerful aristocracy, whose exclusive circles they were otherwise unable to penetrate. The magnificent buildings lining the Ringstrasse were a statement by the upper middle classes which profoundly changed the face of the city. Patrons from the bourgeoisie supported every field of the arts and thereby took over the role traditionally played by the nobility.

At the Vienna Congress Exhibition of 1896, the Austrian metropolis basked in the revival of a glorious era. Portraits of beautiful women and items of costly jewellery were exhibited before an enthusiastic public as a testament to the elegant lifestyle of the day. The flamboyant stylistic flourishes of the departing 19th century continued to find an appreciative audience in Vienna. Here the history painter Hans Makart, whose studio resembled a cabinet of curiosities, was still revered like a god. As official "state artist" with the emperor as his patron, he became the idolized arbiter of artistic taste. The fascination exerted by Makart's painting – he placed his creative talents in the service of an almost cult-like veneration of the female – was felt even by younger artists, and influenced the early work of Gustav Klimt in particular. Thus the old was not abruptly overturned, but the new founded on purely aesthetic, less ethical grounds. It was a question of finding the form, with Vienna as the material.

When Auguste Rodin visited the city in 1902 and voiced his delight at what he found, Gustav Klimt replied with just one word: "Aut-riche!". Klimt's pun on the "great riches" hidden in the French name for his country was typical of the sparkling repartee found in the coffee-house, an institution of a very special kind. In the period around 1900, the Viennese coffee-house was not just the hub of social life, but the undisputed centre of cultural activity. When a group of avant-garde artists decided to form themselves into an association in 1876, they called themselves the Hagenbund after the owner of the "Zum blauen Freihaus" restaurant. Not long afterwards, another group of artists formed the Siebener Club in the Sperl coffee-house. On 3 April 1897, the anti-establishment Austrian Association of Artists (Verein Bildender Künstler Österreichs) – better known as the Vienna Secession – came into being

Otto Wagner: Majolika House, Vienna, 1888–1900, roof figure. The "call" of the new style had grown too loud to ignore.

Joseph Maria Olbrich: Vienna Secession exh bition building, 1897–1898. The cubic forcefulness of the windowless façade, crowned by a cupola in the form of a huge, stylized laurel, represented a memorable contribution to the history of Viennese architecture. "Children have already learned by heart the inscription above the door, 'To the Age its Art, to Ar: its Freedom'... and then there is the cupola... the crown of a colossal laurel tree, in real gold leaf... the impression is magical... for there is nothing else like it anywhere in the world."[1]

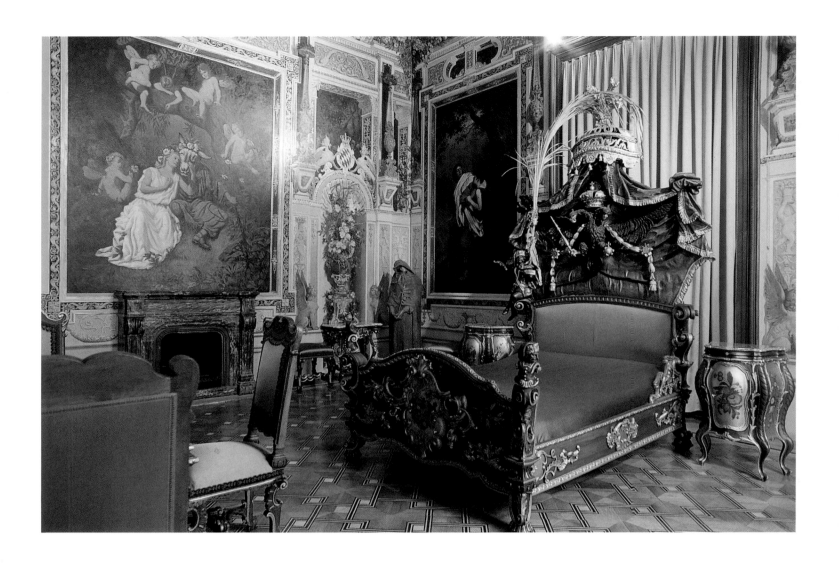

Bedchamber of Empress Elisabeth of Austria, 2nd half of the 19th century. In a room designed for its aesthetic rather than practical value, the bombastic decoration of the furnishings fulfils its purpose perfectly. It is the complete opposite of the functionalist ethic, which sought to marry the shape of things with their function in daily life.

in the Griensteidl coffee-house. Six years later, in 1903, the Wiener Werkstätte was born around another such coffee-house table.

The Vienna Secession comprised 50 founding members, with Gustav Klimt as president. Virtually within a year, in 1898, it opened its own exhibition building, designed by Joseph Maria Olbrich (p. 8). Written large on the façade was the inscription: "Der Zeit ihre Kunst, der Kunst ihre Freiheit" (To the Age its Art, to Art its Freedom). Olbrich's dazzling building continues to house exhibitions even today. The cubic forcefulness of the main body of the building finds its opposite pole in a golden cupola in the form of a stylized laurel, prompting Ludwig Hevesi to describe the overall impression as "magical"[1]. The "call" of the new art had grown too loud to ignore and had materialized in an unmistakable, clearly visible form. But although the soft, flowing Secession style met with rapid and great success, by 1902 – the year of the triumphant Art Nouveau exhibition in Turin – the death knell had sounded for the pleasing line of Secession ornament.

Artistic paths in Vienna had already begun to diverge a few years earlier. While some embraced Jugendstil (the Austrian and German form of Art Nouveau) with its polished vocabulary of vegetal, scrolling forms, others championed a thoroughly rational and practical aesthetic. It was this latter that appealed to the members of the Wiener Werkstätte. The truly revolutionary character of the "simple, practical" style to which Otto Wagner, the father of modern Austrian architecture, aspired is revealed most strikingly in a comparison of his Austrian Post Office Savings Bank

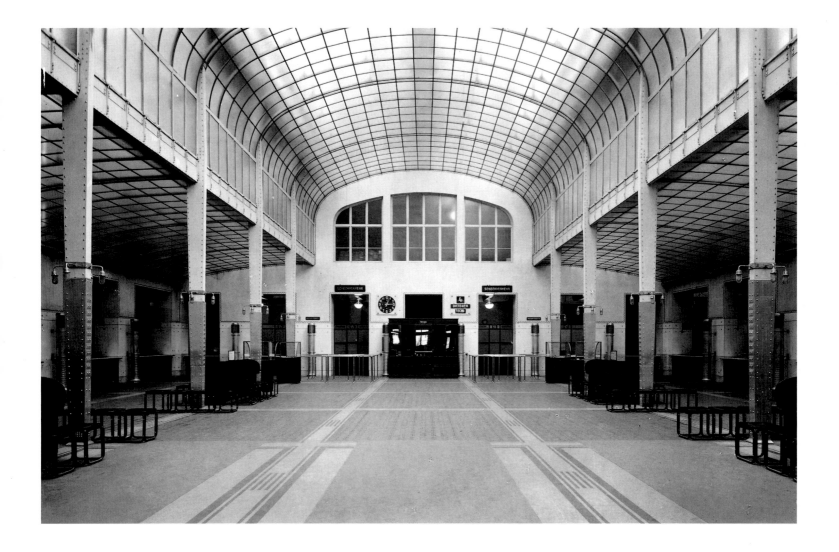

(p. 11) with the bedroom of Empress Elisabeth (p. 10), who at that time was rushing restlessly around Europe full of similarly revolutionary ideas. As a counterpoint to the bombastic decoration of the bedchamber, pompously camouflaging the room's true purpose, Otto Wagner's functionalist principles sought to marry the shape of things with their meaning and measure them against their function in life. "What is happening is not a renaissance of the Renaissance, but a 'Naissance'," he noted.[2] The many "renaissances" that took place in rapid succession from the 1870s onwards, and which all amalgamated into an almost unbearable pomp, prepared the ground for a rebellion by the younger generation of artists, who wanted to tear off the stylistic masks held up by historicism. Imitated style was spurned in all its variations – but not style as such, and not the creation of a style.

Otto Wagner built his Austrian Post Office Savings Bank in 1905 – the year in which, like Gustav Klimt and Koloman Moser, he left the Secession – as an elegant space whose formal details are simplified to an absolute minimum: factual, functional, but nevertheless artistic. The banking hall is still an architectural sensation today.

Otto Wagner: Post Office Savings Bank, Vienna, 1905. The calm and spacious architecture of Wagner's Post Office Savings Bank, its formal details simplified to an absolute minimum, is the very opposite of the restlessly ornate bedchamber of Empress Elisabeth. The network of small, geometricizing decorative elements overlying the structural members is a typical feature of the Vienna school of architecture. "The means that are available and the purpose of the building under construction will always give rise to a vacillation between the extremities of pure utility and artistic execution…"[2]

The Foundation of the Wiener Werkstätte (1903)

Elegance, functionality and appropriateness were also the aims underlying the foundation of the Wiener Werkstätte (Vienna Workshops). An architect, a painter

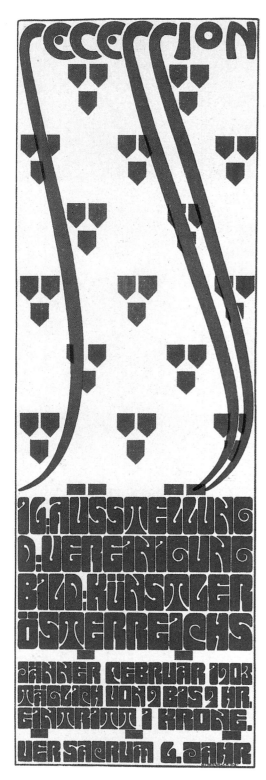

Alfred Roller: Poster for the 16th Vienna Secession exhibition, 1903, lithograph

and a patron thereby helped elevate Viennese architecture and applied arts to a position of international prominence and renown. The approaching end of the Secession and the demise of its journal, *Ver Sacrum*, simultaneously heralded the birth – or "Naissance", as Wagner had termed it – of a new movement in art. Lasting almost 30 years, from 1903 to 1932, it would represent a culmination of the concept of the *Gesamtkunstwerk*, the "total work of art". But the waters would not always run smooth, especially not in Vienna: "The Vienna artist spends his life hitting his head against a big grey wall, on which is stuck a heart of blotting paper; the wall is Viennese indolence and the blotting paper heart is the Viennese heart of gold", as Rudolf von Alt figuratively described it in 1900.[3]

Indifference, and the Viennese tendency to honour "heroes" only after their death, were just one aspect of the difficulties facing the newly-formed Wiener Werkstätte. Another problematical area was maintaining the "purity of the ideal", as intimated even in its name. In early studies of this turn-of-the-century period in art, for so long reviled, we frequently encounter the term "Wiener Werkstätten"; but although the plural "n" ending may be grammatically correct and more natural in speech, there was properly speaking only *one* workshop, which incorporated many others within itself – a work of art as the product of all the arts.

"The trimmings of life were so rich, so varied, so overladen, that there was almost no room left for living itself," wrote that critical observer of his age, Thomas Mann, in his novella *Wälsungenblut* (Blood of the Volsungs) of 1905. Overladen, in the sense of an excess of objects, was not a word that could be applied to the interiors designed by the Wiener Werkstätte, although they certainly overflowed with the desire to raise everything to the status of a work of art. There was no more room for incidentals, be it in life or furnishings. But although the public, craving for beauty, wanted to escape the monotony of standardization, it did not wish to become enslaved to a "designer concept". Thus it was not lack of business acumen which caused the Wiener Werkstätte to struggle financially throughout its existence; it was simply unable to sell its products to the wider public.

The original capital for the Wiener Werkstätte was put up by "arts manager" Fritz Waerndorfer. By 1906 the enterprise was already running into financial trouble, and Waerndorfer approached Koloman Moser's wife Ditha, née Mautner-Markhof, for a loan. (The upset this caused led amongst other things to Moser's resignation from the group.) With cash flow a constant problem, in 1912 a series of restructuring measures was implemented. The Wiener Werkstätte became a limited company in England that same year. In 1914 Fritz Waerndorfer succumbed to pressure from his family, who were presumably unable to watch him ruining himself for any longer, and emigrated to America.

The original Wiener Werkstätte went into liquidation, and a new operating company with limited liability was founded. The shareholders were company employees, sponsors and clients, including Robert Primavesi, who had commissioned the Villa Skywa-Primavesi. In 1915, following further financial crises, Robert's cousin Otto Primavesi took over as managing director. Philipp Häusler, a graduate from the School of Arts and Crafts in Vienna and a colleague of Josef Hoffmann, was made head of general operations in 1920, with the task of injecting new life into the company. He sought to establish a firm hand over what he perceived as sloppiness and extravagances. Equipped with a pragmatic business sense, Häusler wanted to

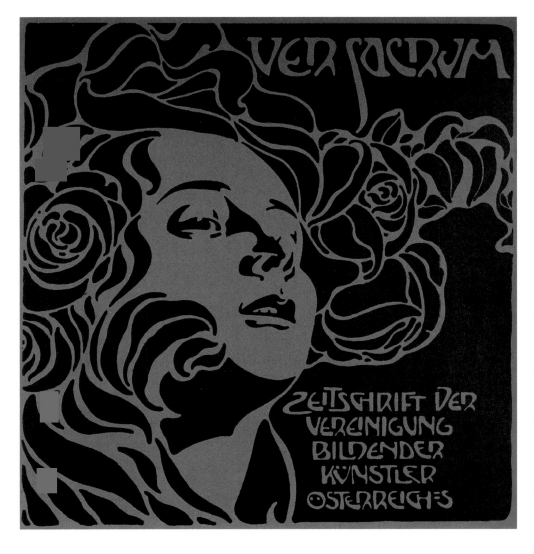

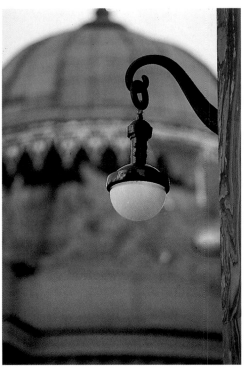

boost sales on a broader basis, whereas the artists of the Wiener Werkstätte wanted exclusivity. In 1925 he left the Wiener Werkstätte after profound differences with the Primavesis. Otto Primavesi himself, tired of the fight, gave his shares to his wife Eugenie. Soon afterwards the Wiener Werkstätte went bankrupt. A settlement was reached in August 1926, and Kuno Grohmann, owner of a textiles empire and a relation of Eugenie Primavesi, put together a substantial new aid package with the help of two other industrialists. Although an attempt to float the Wiener Werkstätte as a public limited company in 1927 failed, Grohmann nevertheless succeeded in stabilizing the firm in the short term. At the start of 1930, however, after much effort and sacrifice, he decided to pull out. For the Wiener Werkstätte, the writing was on the wall. The next few years were more or less a "closing-down sale", and the company was finally removed from the Trade Register in 1939. A sorrowful tale of art and commerce which ended, in true Viennese fashion, with a "beautiful death".

The closure of the Wiener Werkstätte marked the beginning of the "banishment of man from art" against which the philosopher and writer José Ortega y Gasset polemicized, and by which he meant the advent of abstract art. This development – simply the other side of the coin to the incorporation of man into the realm of art – had first been introduced by Art Nouveau.

Left: *Koloman Moser:* Front cover of *Ver Sacrum*, *Ver Sacrum II*, 1899, vol. 4. *Ver Sacrum* was the "organ of the Austrian Association of Artists", the voice of the Secessionists and of contemporary literary Vienna. The magazine soon found itself the object of satire and parody: following the appearance of the first issue, a group of young artists – including Bertold Löffler, a later member of the Wiener Werkstätte – brought out *Quer Sacrum*, the "organ of the Madland Association of Artists".

Forerunners in England and Scotland

The movement that desired to embrace and transform everthing had its cradle in Britain. John Ruskin, William Morris, Charles Robert Ashbee and Charles Rennie Mackintosh were the major forerunners of the Wiener Werkstätte, which based its programme upon Ruskin, took over the workshop practices of Morris and Ashbee, and adapted its design principles from Mackintosh. Whereas Morris was still seeking his aesthetic forebears in the Middle Ages and the Gothic era, Ashbee and Mackintosh had put the past behind them. Morris wanted a return to handicraft, castigating machine production and the "swinish luxury of the rich", whereby his Morris & Co. workshops nevertheless produced predominantly standardized furniture in order to secure him an income.

One day, so the story goes, a friend was visiting Morris in his workshop and saw him hard at work at the bench. "What beautiful thing are you making there, William?" the visitor asked. "By the sweat of my brow," replied Morris, "I'm making simple furniture that is so expensive that only the wealthiest capitalists will be able to buy it."[4] An illuminating answer and one which implies the failure of Morris's theories and points to the problems which the Wiener Werkstätte would also have to face. In contrast to the "manufacturing co-operative" (Proouktivgenossenschaft) which the Wiener Werkstätte announced itself to be, however, Morris and Ashbee had created a sort of sect, the Arts and Crafts movement. Ashbee was unable to stand living in London and moved to the countryside with his "disciples". Even he had to ask a number of very wealthy people for help in order to save his small community in Chipping Campden.

The artists in Glasgow were less socialist and missionary in their ambitions. Here, Mackintosh joined forces with the architect Herbert MacNair and the sisters Margaret and Frances McDonald to form "The Four". In 1897 their design won the

Fritz Waerndorfer, c. 1903, photograph. Fritz Waerndorfer was the "arts manager" who put up the original capital for the Wiener Werkstätte.

Charles Rennie Mackintosh: Waerndorfer music room (with the piano not yet installed); view of the fireplace, Vienna 1902. In a letter of December 1902, Waerndorfer praised Mackintosh's design for his apartment and wrote: "The Macksh salon with a few provisional pieces and complete but for the piano."

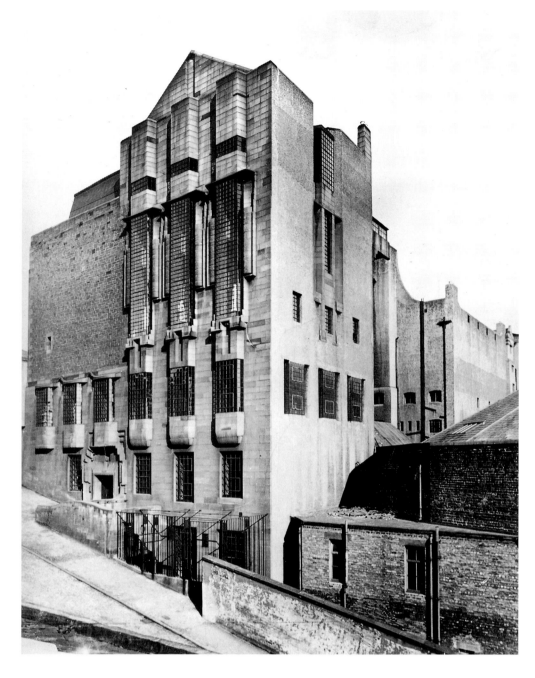

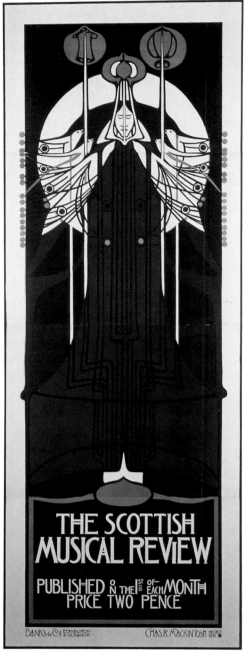

competition for the new Glasgow School of Art (p. 15 left). The building's attraction lies in the contrast between its closed, block-like construction and its broken surface, which fuses into an eye-catching pattern of geometrical severity.

Like his architecture, Mackintosh's furniture designs are also dominated by squares and cubes. A Hoffmanesque passion for geometry is suffused in Mackintosh's case with the poetic ornament introduced by his wife, Margaret McDonald Mackintosh. "Tall, incorporeal figures dissolved or woven into delicate webs of stems and threads, with only their heads human or saint-like, slightly inclined, each like the next, with closed eyes and dark, cascading hair – [such are the] figures in a frieze, pale green and pink, for Cranston's Tea Room in Glasgow… All forms and objects, whether for use or for ornamentation, are slender, thin-boned, fragile, without flesh, dreamily spiritual – a singular ghostly but not unsensual sphere, abstracted, it would appear, and filtered from the angelic figures of Pre-Raphaelite forebears: this is the physiognomy of the Scottish School."[5] (Dolf Sternberger)

Left: *Charles Rennie Mackintosh:* Glasgow School of Art, 1897. Mackintosh's building was to exert an enduring influence upon European architecture as a whole. Its appeal lies in the contrast between its closed, block-like construction and its broken surface, which together fuse into an eye-catching pattern of geometric severity.

Right: *Charles Rennie Mackintosh:* Poster, 1896

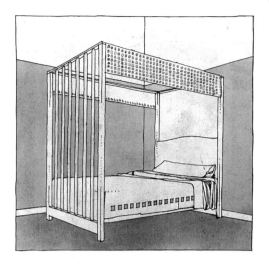

Charles Rennie Mackintosh: Design for a four-poster bed, 1900, pencil, watercolour and ink

Fireman's coat, Japan, 19th century, buckskin, with the stencilled arms of a firefighting company. In Japan, decorative patterns and stencils have been in use for over a thousand years and are still employed today.

Josef Hoffmann: Design for a four-poster bed, c. 1901, ink on squared paper

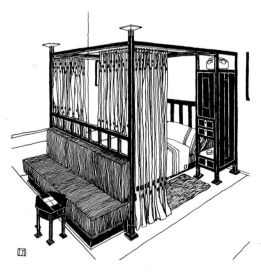

Japonism: Influences from Japan

It can be said without exaggeration that Japanese art and the Japanese aesthetic made an impact upon virtually every turn-of-the-century artist, even if a direct link with specific Japanese originals cannot always be identified. The Japanese approach to interior design, decoration and the applied arts shaped the attitudes of European artist craftsmen towards their work. European painters and graphic designers were similarly influenced by Japanese prints, adopting the luminosity of their bright colours, the pulsating rhythm of their lines and dots, the heightened expressiveness of their simplified outlines and their juxtaposition of decorative areas on the pictorial plane. Both Vincent van Gogh and William Morris were great admirers of Japanese prints. Liberty began importing large consignments of goods from the Far East from 1875 onwards. Charles Rennie Mackintosh was another who appreciated Japanese art. It is clear, too, that Vienna also came into close contact with Japan.

At the risk of over-simplification, there were three main reasons why Japanese art

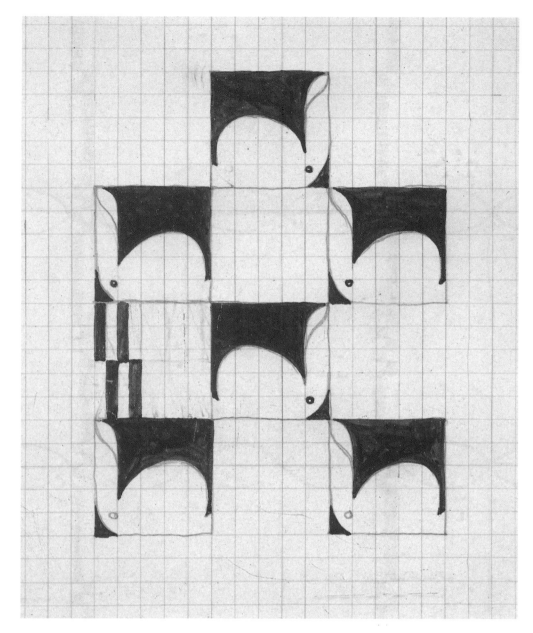

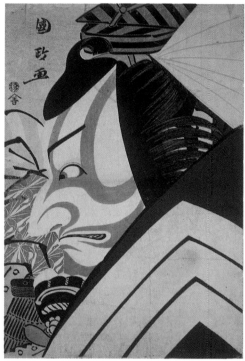

Utagawa Kunimasa: The actor Ichikawa Ebizō, Japan, 1796, woodblock colour print, *nishiki-e*. The ornamental, linear, two-dimensional style of Japanese prints made a decisive impact upon European art in the 1890s.

Koloman Moser: Decorative design with "rabbit motif", c. 1900–1905, tempera and pencil on squared paper

met with such an enthusiastic response in Europe around 1900. Firstly, industrial expansion in the 1870s had created new consumer wealth and given rise to a demand for exotic luxury items. Secondly, artists, craftsmen, designers and architects were hungry for fresh forms and motifs with which to replace the exhausted vocabulary of naturalism and history painting. Thirdly, the threat to the quality of life posed by an increasingly industrialized society was giving rise to a new spirituality, one which sought to counteract humankind's alienation both from inner and outer nature. Viennese artists were able to admire the Oriental collection in the Austrian Museum of Art and Industry. As part of the new trend in art around 1900, the work of Koloman Moser and Josef Hoffmann is characterized by the seemingly contradictory components of floral arabesques and squares. These characteristics are also found in Japanese design, however, where organic and geometric motifs are harmoniously combined.

Furthermore, the Japanese artist craftsman was a figure for whom the "lower" applied arts and "higher" fine arts enjoyed the same status – an equality which the Wiener Werkstätte also championed. The formal expression of Zen made a rapid

Josef Hoffmann: Table, c. 1903–1904, oak, stained black and rubbed with chalk, inlay of maple and white metal. The legs, which widen towards the feet, are connected by sections of latticework.

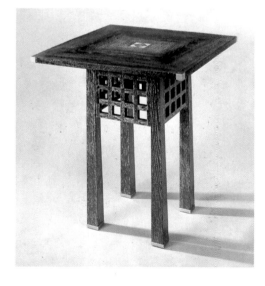

Japonism: Influences from Japan **17**

DIE SCHUTZMARKE UND
DIE MONOGRAMME DER
WIENER WERKSTÄTTE
DIE REGISTRIERTE SCHUTZMARKE

DAS MONOGRAMM DER WIENER
WERKSTÄTTE

DIE MONOGRAMME D. ENTWERFER

PROFESSOR JOSEF HOFFMANN

PROFESSOR KOLOMAN MOSER

Registered trademark and monogram of the Wiener Werkstätte, and the monograms of its designers Josef Hoffmann and Koloman Moser. From the Work Programme of 1905.

Page 19: *Josef Hoffmann:* Room at the International Art Exhibition in the Mannheim Kunsthalle, 1907; sculptures by George Minne; painting *Portrait of Adele Bloch-Bauer* by Gustav Klimt.

and direct impression on Viennese architecture: interior and exterior were allowed to flow smoothly one into the other by means of simple design and thoughtful use of materials. Objects made up of simplified forms translated emptiness into the round, whereby the specific character of the material remained visible. "While telling us about his travels, a gentleman who knows Japan well described a tea ceremony at the end of which the empty teapot was passed from hand to hand and the delicacy of its work admired by the guests. This appreciation of artistic beauty formed the high point of the ceremony. Apparently there is nothing unusual about this; it is an everyday habit to pay special attention to the quality of an object and the artistic work which is an inseparable part of it. To the European of today, such things sound like pure fiction."[6] (Josef August Lux)

Alongside Frank Lloyd Wright in America, the artists grouped around Josef Hoffmann succeeded — albeit not always comprehensibly to the western-trained eye — in transferring into their own work the vision of beauty in Japanese art: the realistic prompts the absolute perfection of the decorative, and the self-contained consummateness of the decorative becomes the supreme revelation of the spiritual. This "cultural exchange" was not all one-sided, however: in 1900, Austrian ski teachers opened a ski school in Japan.

Both for Art Nouveau and the Wiener Werkstätte, the ultimate total work of art was the home. It was in the design of every aspect of this private realm of the individual that artistic synthesis found its most mature expression — in the harmony of interior and exterior, of decoration, furnishings, lighting, and in every hand-crafted detail. Thus a discussion of Wiener Werkstätte "style" means a discussion of the Werkstätte's main architectural commissions.

The Wiener Werkstätte's entire œuvre is documented in the journal *Deutsche Kunst und Dekoration* (German Art and Decoration). Thanks to the personal interest of the publisher, Alexander Koch, a comprehensive visual record of Wiener Werkstätte activity survives in the form of over 1000 reproductions. Both these illustrations and contemporary interviews and articles from the journal have provided vital source material for the present book.

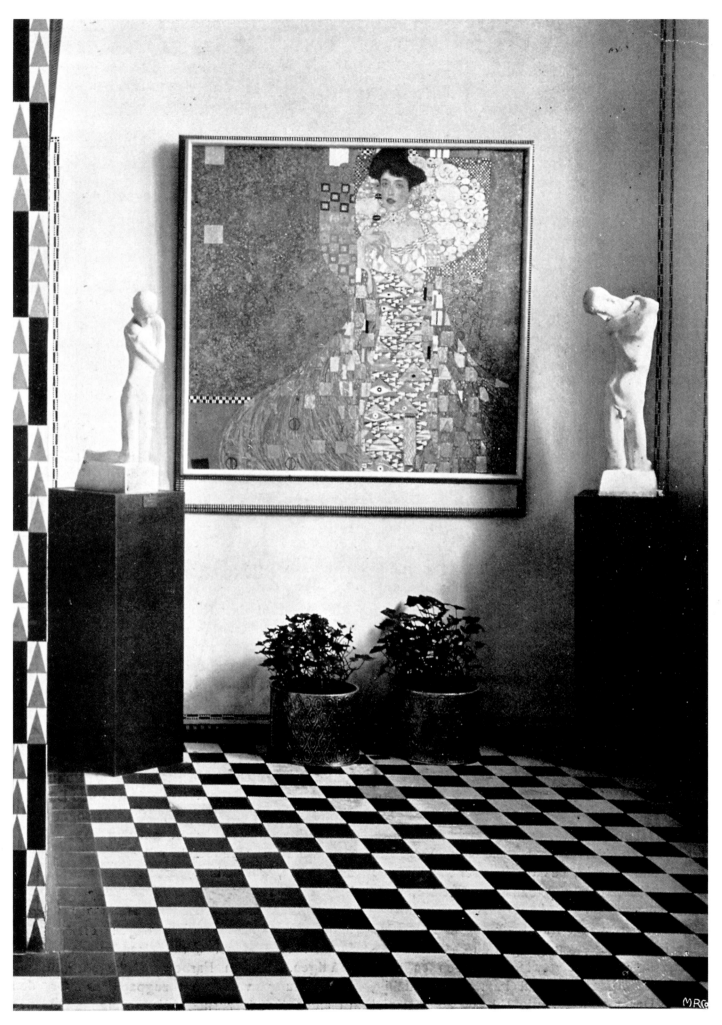

20 Purkersdorf Sanatorium (1904–1906)

Purkersdorf Sanatorium (1904–1906)

The aim of avant-garde artists at the turn of the century was to restore the unity of art and life. This desire to create an integral work of art found its most powerful expression in the realm of interior decoration, which offered artists the opportunity to cloak every aspect of indoor living in a unifying style.

"The outer cover of all constructed things (by which I mean everything from a house to an item of clothing) has long since lost all integrity and organic expression; it lives its own life entirely unrelated to its environment. People treat the various organic components of a piece of furniture or a house just like a confectioner handles his sweets: he puts them into the bags or tins that [his customers] have chosen, but these may range from a simple paper bag, which reveals what its contents are because its form is related to its function, to a golden cardboard tube."[7] Such criticism, formulated here by Henry van de Velde in 1902, gave rise to the birth of modern handicraft and the opening up of a whole new world of creative activity. It now became a question of achieving a harmony of aesthetic design, functionality, and *Zeitgeist*. The search for an optimum solution to this challenge led to the development of a new style.

The Purkersdorf Sanatorium is a particularly illuminating example of this. The task here was to create not the villa of a wealthy patron of the arts or the showcase residence of a prince, but an institution which combined sophistication with a specific medical purpose. Functional buildings are determined for the most part by practical and logistical considerations. Should an architect, interior designer or craftsman wish to create a whole which is both functional and aesthetically harmonious, he is obliged to develop a new language of form. In the Purkersdorf Sanatorium, Josef Hoffmann and Koloman Moser succeeded in achieving just such a synthesis of form and function, of aesthetics and economy, of the outer form and organization of the building and the activities pursued within it.

The vision of modern architecture offered by the contemporary American architect Frank Lloyd Wright is most apt in this context: "In most of the interiors there will be found a quiet, a simple dignity that we imagine is only to be found in the 'old' and it is due to the underlying organic harmony, to the each in all and the all in each throughout. This is the modern opportunity – to make of a building, together with its equipment, appurtenances and environment, an entity which shall constitute a complete work of art, and a work of art more valuable to society as a whole than has before existed because discordant conditions endured for years are smoothed away; everyday life here finds an expression germane to its daily existence; an

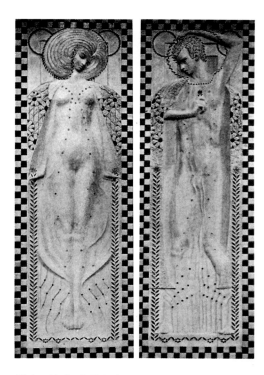

Richard Luksch: Reliefs positioned on either side of the main entrance from the garden, 1904, glazed mortar, narrow decorative bands of blue and white tiles

Page 20: *Josef Hoffmann:* Purkersdorf Sanatorium, west façade, main entrance from the garden, 1904–1906. The strict geometry of the entrance is offset by pedestals for plants and the reliefs by Richard Luksch.

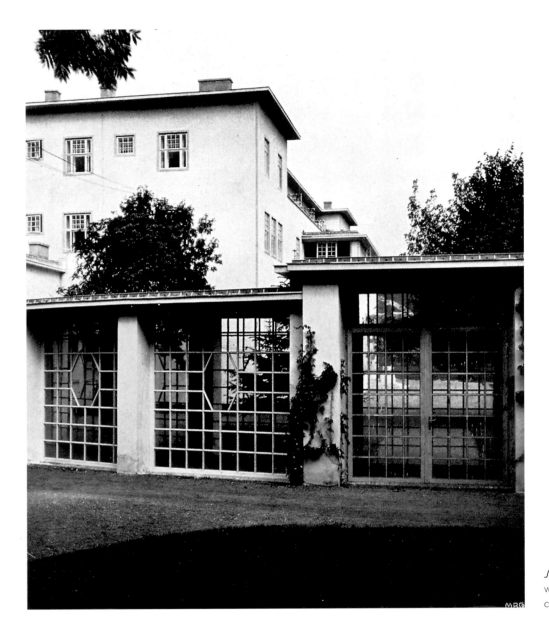

Josef Hoffmann: Purkersdorf Sanatorium, covered walkway, 1904–1906. View of the glazed walkway connecting the two already existing pavilions.

idealization of the common need sure to be uplifting and helpful in the same sense that pure air to breathe is better than air poisoned with noxious gases."[8] These principles, formulated by Wright in 1908, can be seen at work in the Purkersdorf Sanatorium. Indeed, the Sanatorium represented an architectural achievement which was no less pioneering than Wright's own Larkin Building in Buffalo, New York, of 1903–1905.

The commission for the Sanatorium came from Viktor Zuckerkandl, whose sister-in-law, Berta Zuckerkandl, was an enthusiastic fan of the Wiener Werkstätte. In 1904, at Berta's recommendation, Viktor invited Josef Hoffmann and his colleagues to design a new building for his Westend Sanatorium in Purkersdorf, near Vienna. With the intention of maximizing the return on investment offered by a modern functional building, Hoffmann employed what was then the latest in building technology – reinforced concrete. It seems that he had originally intended to employ new construction methods even more extensively than was ultimately the case: his design drawings reveal that, in addition to reinforced concrete ceilings and supports, he had planned a line of windows running along the entire ground floor. Brick masonry and reinforced concrete determine not only the structure but also

the outer appearance of the building, which may be seen as programmatic for Wiener Werkstätte style between 1900 and 1906. Ornamentation is reduced to bands of blue and white tiles whose chequered pattern takes up and emphasizes the interplay between the smooth, unbroken areas of façade and the concentrations of windows (pp. 20, 21, 37 right). Thanks to the balanced arrangement of the axes, the dynamism of the individual façade elements and the edges of the intersecting slab sections successfully combine to create an elegant exterior. A close relationship is established between exterior and interior through the recurrent use of line, cube and plane as an aesthetic statement both within and without. This relationship is reinforced by a generous use of glass and transparent partitions, a second theme running consistently through both the inside and outside of the Sanatorium.

The result is a building "without the lies told by dishonest ornament, by pillars and gables; no dazzling display of colours disturbs the simple harmony".[9] The architects' brief was to design a plainly-styled sanatorium offering medicinal baths and physical therapy, a large dining hall, lounges and guest rooms. As Karl Marilaun regretfully observed: "It seems rather a pity that, in order to enjoy one of the wonderful white Purkersdorf cubicles, you have to be of somewhat unsound mind."[10] The cubicles were not simply equipped in line with the latest medical thinking, but were also designed with great elegance by Josef Hoffmann and Koloman Moser. Indeed, the word "cubicle" is something of a misnomer in view of the generously-sized rooms it describes. Expansiveness, precision and clarity dominate, but without being subjugated to proportional doctrine. Hoffmann's predilection for interconnecting rooms of different proportions – 2:3 in the hall, for example, as opposed to 1:3 in the dining hall – results in a varying experience of space. The interior decoration is also based largely on contrast rather than on the introduction of decorative elements. Tension is created by the alternation of primary forms. The inclusion of the

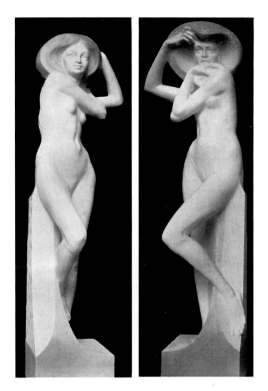

Richard Luksch: Two faience figures for the east façade of the Purkersdorf Sanatorium, 1904–1906, faience, glazed in blue and white. Later placed in the garden of the Palais Stoclet.

Josef Hoffmann: Purkersdorf Sanatorium, east façade, 1904, perspectival drawing, ink with graphite. Two blue and white faience figures by Richard Luksch are included above the entrance.

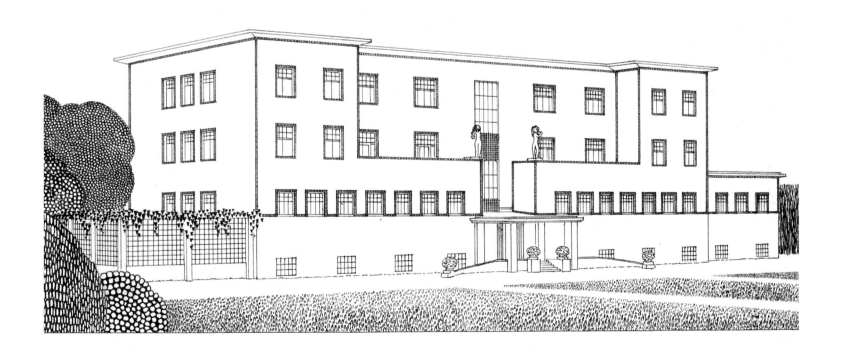

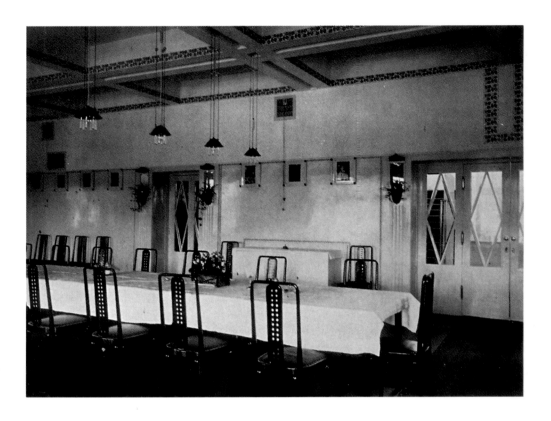

Josef Hoffmann: Purkersdorf Sanatorium, main dining hall, 1st floor, 1904–1906

Koloman Moser: Design for the cover of the Wiener Werkstätte brochure "Simple Furniture for a Sanatorium", c. 1903, ink on card

clearly visible reinforced concrete ceiling as a design element in rooms used by "ladies in full dress"[11] is truly revolutionary.

Hoffmann employs none of the ornamental stucco which traditionally served to veil architecture and disguise angles and corners. Instead, the presence of the structural fabric is incorporated into the interior decoration. The surface of the material and its function are made clear. This is not then left to stand as the posturing gesture of an architect who wishes to make his intentions public, but is integrated seamlessly and harmoniously into the overall décor. The sunken panels of the coffered ceiling are echoed in the patterning of the floor. The lead-glass windows in the doors refract the light and lend rhythm to the suite of rooms on the upper floor. The upper floor thus becomes one open space, divided solely by thin partition walls and doors.

The lightweight bentwood furniture in the dining hall offers a charming contrast to the surrounding architecture. Hoffmann's now legendary Purkersdorf chair (p. 25 left) is made up of the simplest elements: straight front legs of beech; a U-shaped back of tapering bentwood; and, as part of the back, a vertical brace composed of a plywood board perforated by a double row of round holes and set in a bentwood surround. A special feature of the chair's construction are the wooden balls screwed into every corner, which serve to stabilize the whole. These wooden balls, which are used instead of semicircular supports or permanent glueing, are a typical feature of series furniture from Vienna. "Architectural furniture" was thus not merely a theoretical concept; many types of furniture were named after the building project for which they were originally designed.

To complement the Sanatorium's rigorously cubist exterior, Koloman Moser designed furniture for the entrance hall whose matt-varnished lathwork, in its geometric and down-to-earth austerity, reflects the structure of the whole house. The early phase of Hoffmann's œuvre might be called a "homage to the square";

the square dominated the first years of his career and earned him the nickname of "Quadratl-Hoffmann" (Little Square Hoffmann). His Purkersdorf chair and metalwork designs (pp. 30, 31) from around 1905 still read as the incunabula of the Wiener Werkstätte even today. And the same may be said of all the designs from the Purkersdorf phase. Although the original Purkersdorf chairs have long since vanished from the building, they are still available on the market in modern-day re-editions.

As a decorative principle, the cube turns our conventions of seeing upside down. In place of fanciful ornamental creations, decoration now consists of simple lines drawn with a ruler. This linear structure cannot be summarized (and thereby simplified) as plain linearism, however. What we read as a single plane suddenly tranforms itself into a representation of several planes. Our system of vision starts from whole forms. Objects composed of straight lines initially present themselves to the viewer as homogeneous. The conflict between two-dimensional plane and three-dimensional space dramatically activates the viewer's attention. We undergo an experience which runs counter to our desire to fix a form. Here Hoffmann is concerned not with geometry alone, but with the artistic tension created by formal means reduced to their absolute essentials.

Page 26, above: *Josef Hoffmann:* Purkersdorf Sanatorium, 3rd project, ground plan of the 1st floor, 1904, drawing

Pages 26–27: *Josef Hoffmann:* Purkersdorf Sanatorium, main dining hall, 1st floor, 1904. The impression of spaciousness is enhanced by means of mirrors and views through to adjoining rooms. The sides of the concrete ceiling joists are decorated with a stencilled frieze of leaves.

Left: *Josef Hoffmann:* Purkersdorf chair from the main dining hall, c. 1905, polished beech and leather, wooden balls on the front legs as stabilizers; made by J. & J. Kohn, Vienna

Right: *Josef Hoffmann:* Chair, c. 1905, mahogany-stained and polished beech, seat of moulded plywood; made by J. & J. Kohn, Vienna

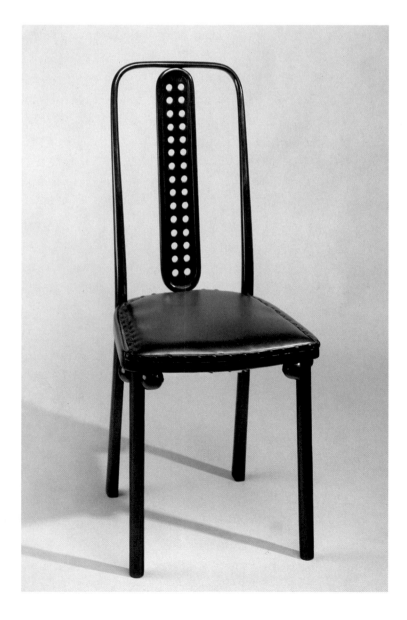

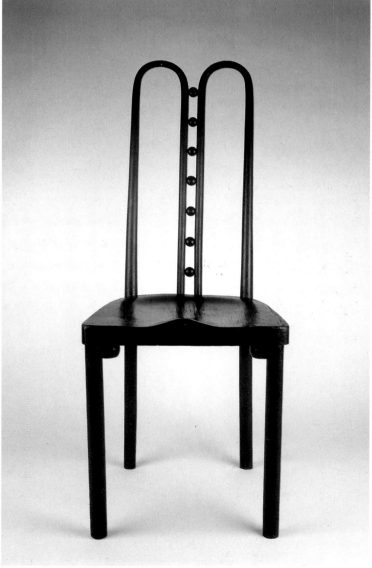

Purkersdorf Sanatorium (1904–1906) **25**

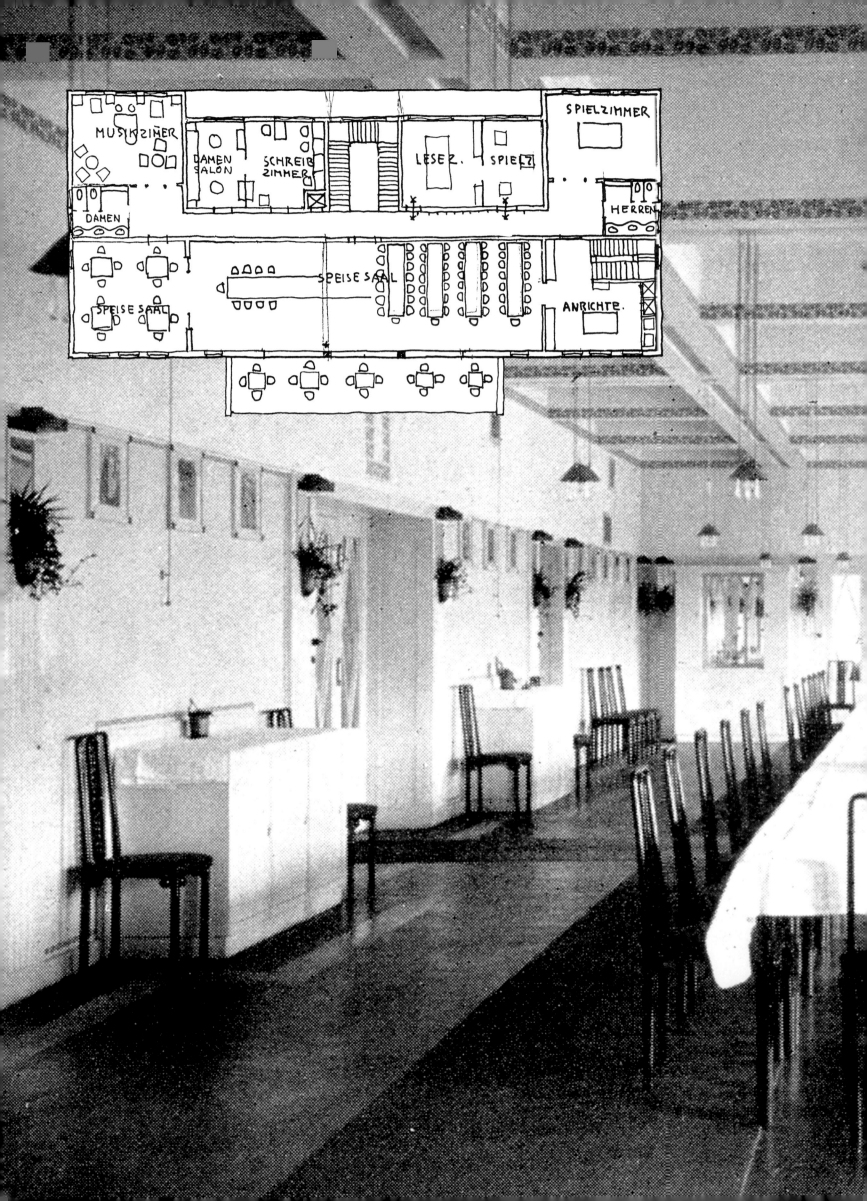

MUSIKZIMMER

DAMEN SALON

SCHREIB ZIMMER

LESEZ.

SPIEL Z.

SPIELZIMMER

DAMEN

HERREN

SPEISE SAAL

SPEISE SAAL

SPEISE SAAL

ANRICHTE.

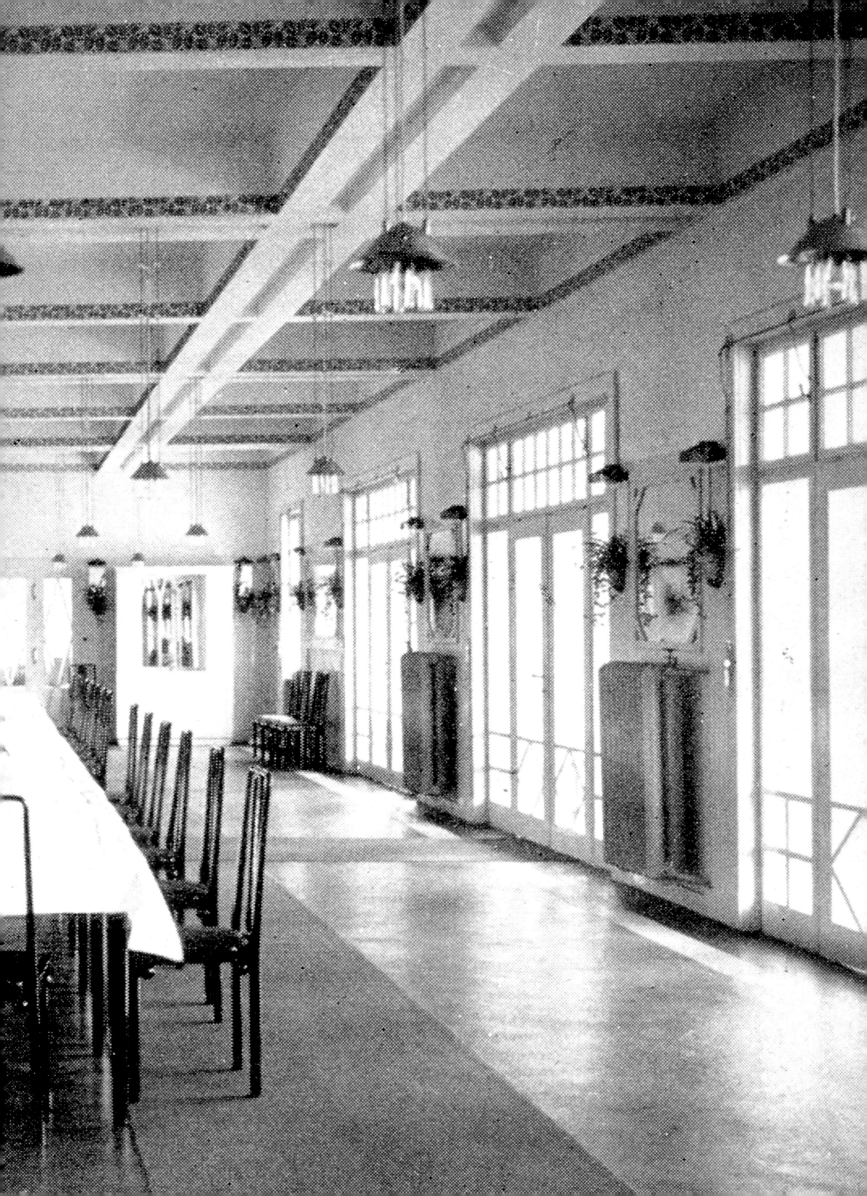

The designs of the Purkersdorf years offer an exemplary illustration of the Wiener Werkstätte ideal, namely the "permeation of all expressions of existence" by means of design. The elongated grid structure of the Sanatorium with its flat roof – most avant-garde for its day – is taken up in smaller-scale designs for household objects and furnishings. Thus architecture is approached not from a tectonic angle alone, but is consciously "designed"; by the same token, the hand-crafted item becomes the vehicle of an overall artistic vision. It is often the case that a building is made to resemble a casket or jewel box, while a handicraft object is monumentalized to the status of architecture. In the Purkersdorf Sanatorium, on the other hand, in an architectural stroke of genius, the design principle at work is one not far removed from the world of mathematics: a reduction to elementary forms which is then enlivened with a planar, cubist cloak of ornament. This cloak of ornament is applied to a very wide variety of practical objects and utensils, regardless of inherent contradictions.

Thus the grid of the windows in the Sanatorium façade is taken up in planters, tables and étagères. In one example, Koloman Moser effectively develops a plant stand out of the façade (p. 33 right): in its composition of sheet-iron boxes with black-and-white chequered sides, held by vertical beech supports rising from the cross-struts and frame of the square base, Moser's plant stand duplicates the chequered pattern of the tiling found on the outside of the building. Meanwhile, balls – sta-

Josef Hoffmann: Part of the "Flat Model" cutlery set, silver, c. 1903–1904. The cutlery was designed for Fritz Waerndorfer in 1903 and shown in the exhibition "The Laid Table" in 1906.

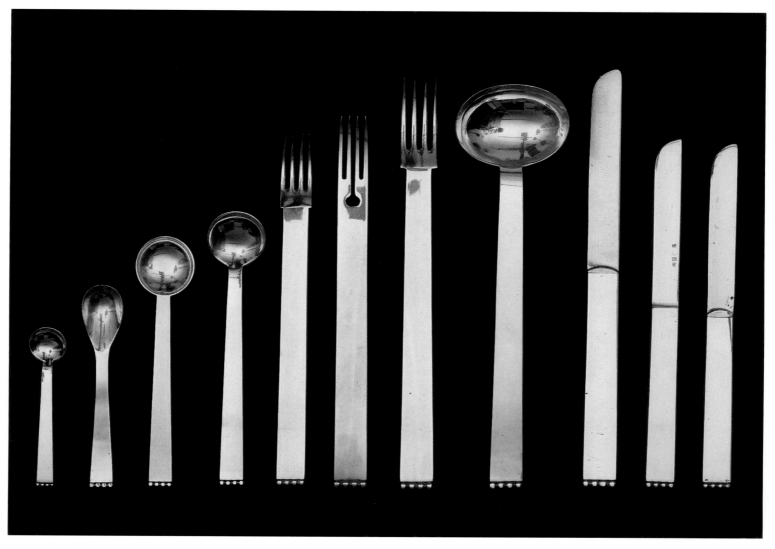

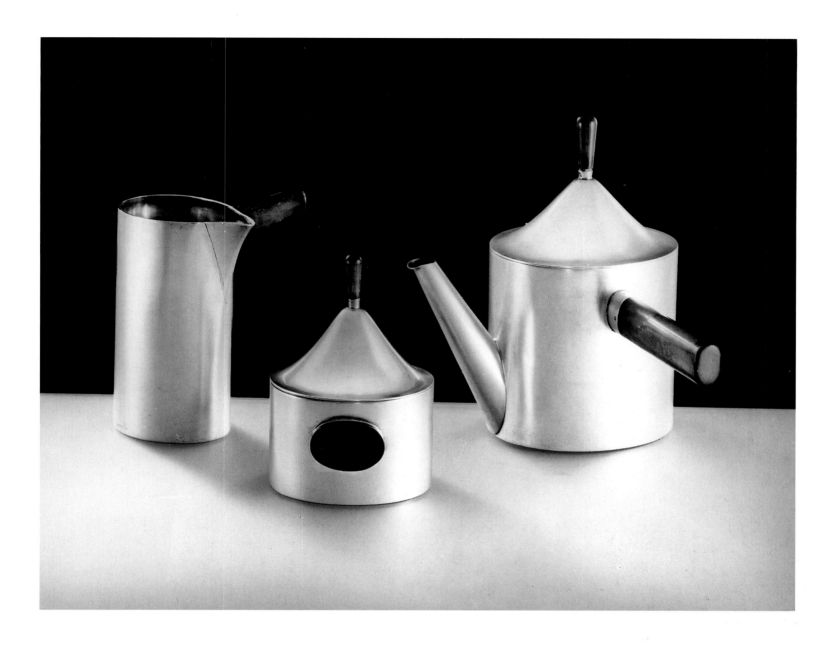

bilizers on the dining-hall chairs – reappear in a set of cutlery (p. 28) as purely decorative elements.

Tableware received the same detailed attention as the architecture itself. In summer 1906, the Wiener Werkstätte opened a new showroom with an exhibition entitled "The Laid Table" (Der gedeckte Tisch) – a clear indication of the importance which they attached to this area of life. Indeed, Koloman Moser took the subject so seriously that he even designed new shapes of pastry suitable for a table laid *à la* Wiener Werkstätte, although it was with some difficulty that he found a baker who could actually produce biscuits and buns to his formal specifications. Such dedication also brought ridicule. In one satirical article of 1906, Armin Friedmann wrote: "The geometric element guides both of our artistic table-layers in their creations, and the new grace at mealtimes will surely have to be: 'Bless these lines which we are about to receive'... Two parallel strands of macaroni can only be bisected in infinite space... for which a theoretical grounding and practical tutorials are first necessary... To carve the beef with stylistic correctness, you need a ruler and dividers; the dumplings are hand-turned by a craftsman, and the only stylistically pure black-and-white desserts are the poppy-seed puddings improved by Koloman Moser... here madness marries geometry."[12]

Josef Hoffmann: Tea and coffee service, 1904, silver with ebony handles and stone inlay. All the components display the smooth forms which are typical of early Wiener Werkstätte design.

Josef Hoffmann: Fruit basket, 1904, silver

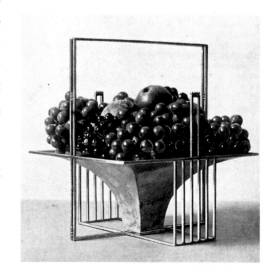

Josef Hoffmann and *Antoinette Krasnik:* Cake slice and tongs, c. 1905, silver, decorative design of perforated squares

Koloman Moser: Jardinière, chased silver, 1904. In the works of the Wiener Werkstätte, the conflicts within Art Nouveau – floral ornament on the one hand versus line and constructivism on the other – are resolved by dialogue. In architectonic plant holders, stands, étagères, vases and pots, flora and geometry combine into a single unity. Absolute extremes of material are drawn harmoniously together; metal and plants form one design.

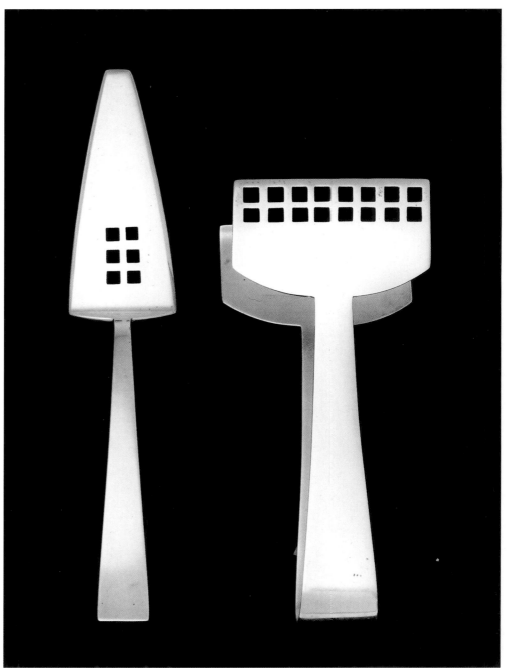

Page 31: *Josef Hoffmann:* Basket vase, silver, c. 1905

This stylization of the pleasures of the table stands in strange contrast to the "new simplicity" otherwise propounded by the Wiener Werkstätte, and is more reminiscent of baroque banquets. This apparently excessive artistic zeal was fuelled, however, by the same missionary ambition which lay at the heart of all Wiener Werkstätte activity: namely, the desire to stamp every aspect of our domestic world, and indeed every expression of life itself, with a single "designer style".

Moser's pretzels were not the only things to be submitted to strict stylistic controls with regard to overall effect; arrangements of flowers and fruit came under the same scrutiny. Fresh flowers – their colour and type determined by the "artistic directions" issued by the Wiener Werkstätte – were delivered to the Purkersdorf Sanatorium every day from a carefully chosen florist's in the centre of Vienna. The combination of flowers and plants with grille-like surrounds of perforated silver or white-painted sheet metal was both astonishing and inspiring (pp. 30 left, 33 left). In this way, the "organic" was fused with the "geometric" into one unity.

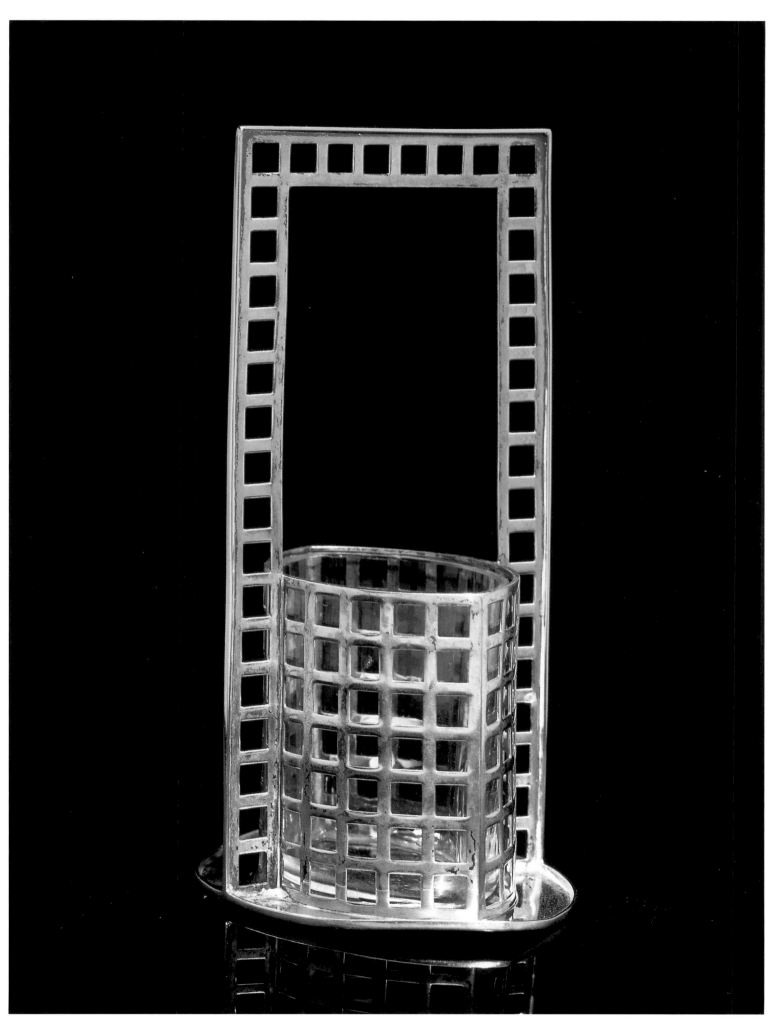

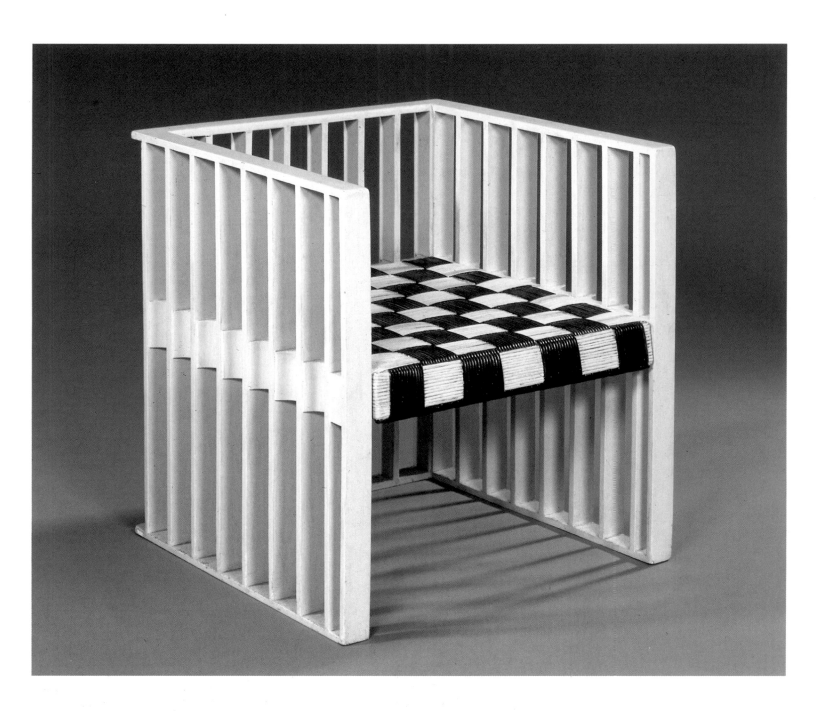

Koloman Moser: Armchair, 1903, painted beech, painted cane seat; made by Prag Rudniker. "The most dramatic piece in the Purkersdorf Sanatorium." Although the original Purkersdorf chairs have long since vanished from the building, they are still available on the market in modern-day re-editions.

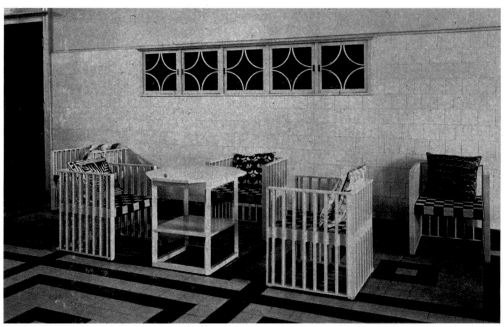

Josef Hoffmann: Purkersdorf Sanatorium, hallway, 1904–1906.

Josef Hoffmann: Plant stand, 1904–1905, sheet iron, painted white

This unity formulated itself in another of the Wiener Werkstätte's fundamental principles: the workshops, where all materials enjoyed equal status. Workshops for gold and silver, metalwork, bookbinding, leather, cabinetmaking and varnishing, together with an architecture office, were all founded in October 1903. The leather was specially purchased in Paris, where William Morris also obtained his materials. While the decision to import leather may at first sight seem somewhat extravagant, it was nevertheless logical: the simpler the design, the more important the quality of the material employed. A leather perfume box (p. 36 above), its decorative design of broad vertical stripes lending it a monumental air, derives its vitality from the emphasis upon its surface in much the same way as a "small" wooden casket (p. 36 below). This emphasis upon surface draws the viewer's attention to the material. This, again, is a principle derived from the Purkersdorf Sanatorium. Emphatically vertical sides cast heavy shadows which themselves form a precise design element.

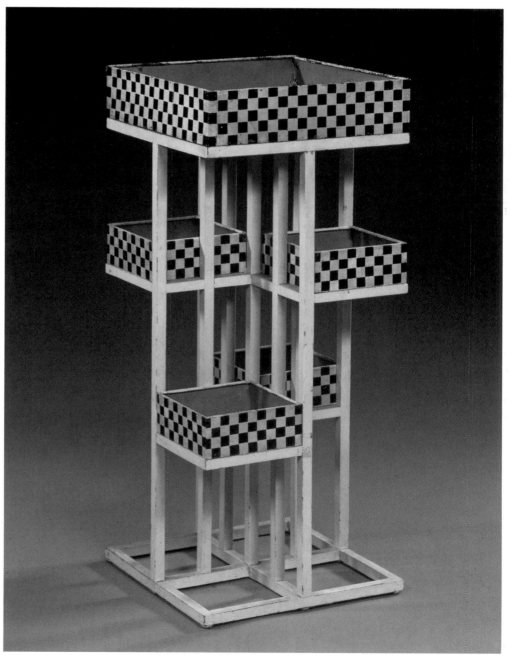

Koloman Moser (attributed): Plant stand, 1903, painted beech, sheet iron painted black and white on the outside and green inside

Purkersdorf Sanatorium (1904–1906) 33

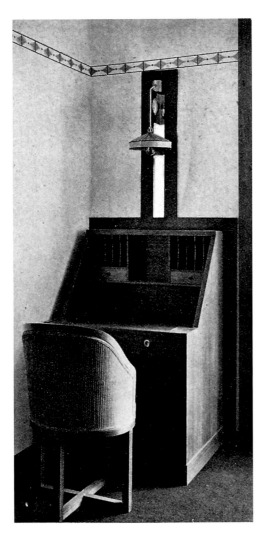

Josef Hoffmann: Purkersdorf Sanatorium, study, 1st floor, 1904

Josef Hoffmann: Chair from one of the offices in the Purkersdorf Sanatorium, 1904, oak, upholstery woven after the original design

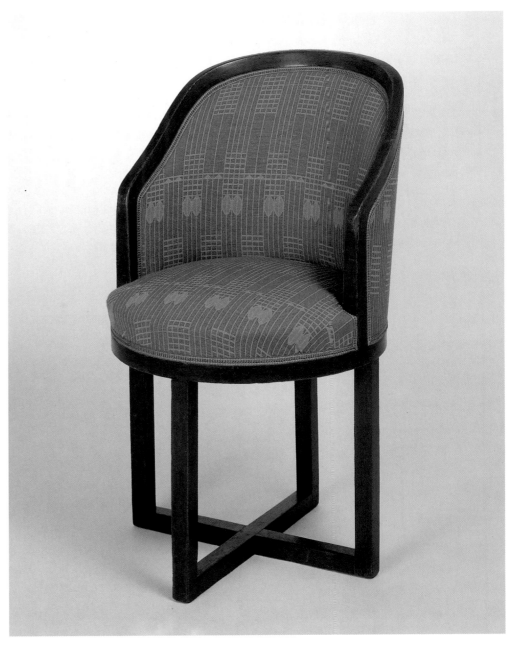

In the 19th century – as frequently even today – the fine arts and the applied arts were by no means always held in equal esteem. Julian Marchlewski recounts the following, quite illuminating tale: "One day in 1897, in the Glass Palace in Munich, my attention was caught by an unusually cultured couple who were discussing painting and sculpture in a highly knowledgeable manner, but without attempting to show off. When they entered the room containing the pictorial cycle of the Legend of St George by Burne-Jones, I grew a little uneasy; it might be that these exquisite works, not being easily accessible, would elicit rather banal comments from them. But no, both before the picture by Burne-Jones and the watercolours by my other favourite, Toorop, my couple passed the test; they attempted to understand them, and that in itself is worth a great deal. I was thus able to convince myself that these were people who were not visiting the exhibition pro forma, for fashion's sake, but because they had developed a certain eye for beauty. Now, however, they turned their steps towards the galleries in the left wing. I followed them; they passed through one room after another, until the beautiful lady wrinkled up her nose and

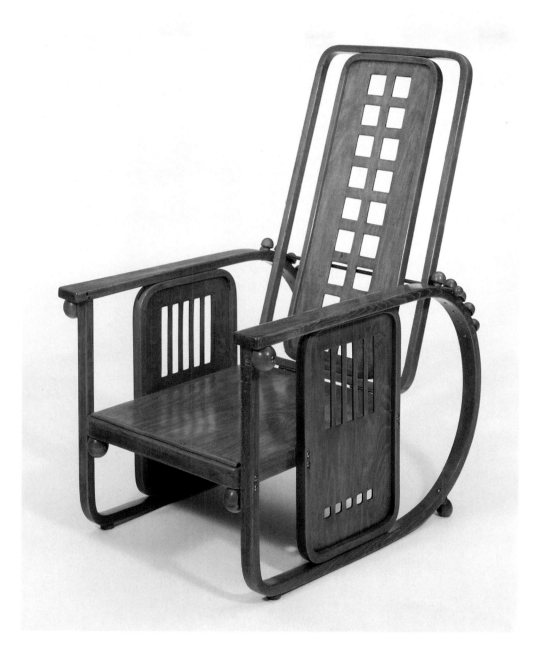

Josef Hoffmann: "Sitzmaschine" (Sitting mach ne), c. 1905, mahogany-stained beech; made by J. & J. Kohn, Vienna

uttered the words: 'junk room!', whereupon they quickly vanished. This junk room contained neither paintings nor sculpture, but tables, cupboards, vases, lamps, fabrics etc. This 'junk', however, was art in the truest sense of the word, and included magnificent furniture by Berlepsch, wonderful glass by Emile Gallé, carpets and wall-hangings by Obrist, bronzes by Henri Nocq, Danish ceramics and much besides. This was a typical instance."[13]

However great the care which the artists of the Wiener Werkstätte bestowed upon their materials, and however great their appreciation of their qualities, it was not the "preciousness" of the object which counted, but its design. The idea was not to create primarily "collector's items" which would be expensive and therefore "beautiful", but to lend value to everyday utensils by ensuring their formal beauty. Alongside economy of ornament and form, financial economy was also a top priority. The introduction of new technology encouraged a greater awareness of economic factors. Standardization, serial repetition of individual elements, and clear, smooth geometry all increased cost-efficiency. Manufacturing quality became an aesthetic

Josef Hoffmann: "Sitzmaschine" (Sitting machine), c. 1905, beech, painted blue and white; made by J. & J. Kohn, Vienna

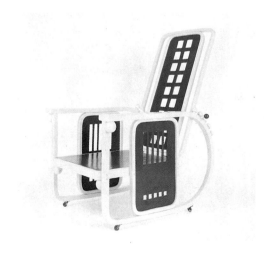

Purkersdorf Sanatorium (1904–1906) **35**

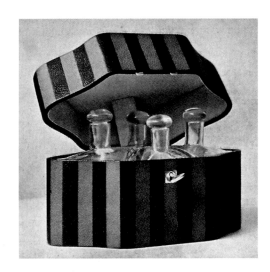

Koloman Moser: Perfume box, 1905, leather intarsia

category; ease of upkeep and hygiene – as required in the Purkersdorf Sanatorium – smoothed the way to clarity and brightness.

In its choice of artistic means, the Wiener Werkstätte carried "economy" to its furthermost point in the Purkersdorf Sanatorium project. From a purely financial point of view, however, the artistic conclusions at which it arrived so logically went beyond what could be realized in practice. When it came to the matter of the final bill, serious differences arose with the Sanatorium's owner, Viktor Zuckerkandl; these subsequently gave rise to a series of lawsuits and later, for legal reasons, to the architecture studio being hived off from the Wiener Werkstätte. A report by Christian Nebehay[14] sheds interesting light on the commercial strategy adopted by the Wiener Werkstätte. Nebehay's father commissioned Josef Hoffmann to refurbish his business premises. Hoffmann's initial estimate of the costs that would be involved appeared remarkably low. Gustav Nebehay undertook to pay up to twice the estimated figure, but not a penny more. The final bill came to four times the original quoted price.

In as early as 1901, Josef Hoffmann had written in an essay that "...we should avoid love of show in everything and constantly strive for better material and more perfect execution, since our own life, inasmuch as it is to be taken seriously, acquires its dignity through simplicity, honesty and uprightness... I believe that a house should present itself as an integrated whole and that its exterior should also contain clues to its interior."[15]

With his "Purkersdorf style", Josef Hoffmann fully met his own criteria. He would subsequently become a model for generations of architects and craftsmen.

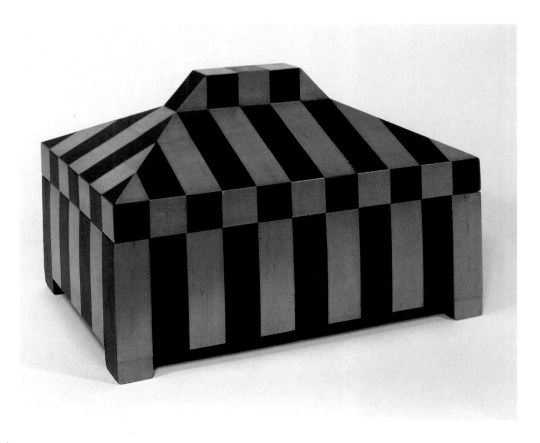

Koloman Moser: Casket, c. 1905, wood verneer, stripes of ebony and maple, inside black

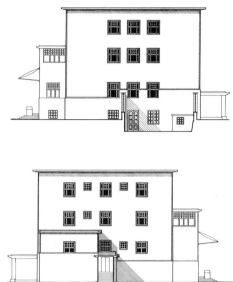

Josef Hoffmann: Purkersdorf Sanatorium, 1904–1906, reconstructions of the north elevation (above) and south elevation (below), drawn by G. Breckner, 1984

Josef Hoffmann: Geometric design, c. 1930, pencil and ink

Wittgenstein – Interiors – Flöge Fashion Salon

In 1906 the English magazine *The Studio* published a special issue dedicated to *The Art-Revival in Austria*. From its launch in 1893 onwards, *The Studio* – still in circulation today under the name of *Studio International* – proved influential upon the entire Art Nouveau movement. Its critical, in-depth discussions of individual aspects of art inspired and encouraged the international exchange of ideas between artists.

The Wiener Werkstätte, whose foundation was originally inspired by the guilds of craftsmen in Britain, was by now celebrating real triumphs in its own country. The preface to the special issue of *The Studio* reads: "Revivals in art spring from a sense of disquietude concerning the existing order of things; they are the strivings after

truer and nobler ideals." At the start of the chapter on Austrian architecture, it continues: "In the fact that it has taken its rise from the domain of architecture lies the strongest proof of the organic character of the modern art movement in Austria. For whenever a new style makes its appearance, it is in architecture that its first indications are to be seen."

This is undoubtedly true of the stylistic development of the Wiener Werkstätte: here, too, architecture is chosen as the vehicle through which to introduce a new style. The special issue of *The Studio* pays lengthy tribute to the Purkersdorf Sanatorium. It also features, amongst other illustrations, the Vienna apartment of Dr. Hermann Wittgenstein. The interior of the Wittgenstein apartment effectively represents a microcosm of Wiener Werkstätte style around 1905. Here we find the strict black-and-white aesthetic, the cubist ornament, and the "planks-of-wood" style of furniture – characteristics which look back to Mackintosh. These are counterpointed by white, elegant bentwood furniture in the best Viennese tradition. It is interesting to note that the first furniture of this type was produced not by Thonet, the classic Viennese bentwood company, but by its competitors J. & J. Kohn, for whom Josef Hoffmann also produced designs. The Wittgenstein family were the perfect clients.

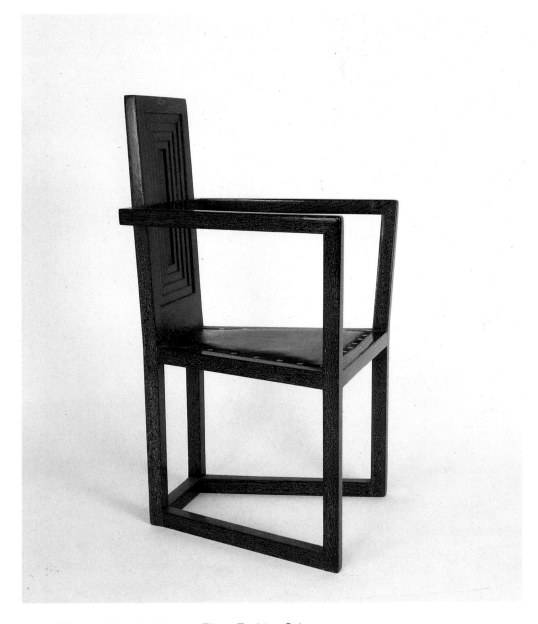

Josef Hoffmann: Armchair, c. 1905, oak, stained black, rubbed with chalk and polished. The armchair originally furnished the apartment of Dr. Hermann Wittgenstein in Vienna.

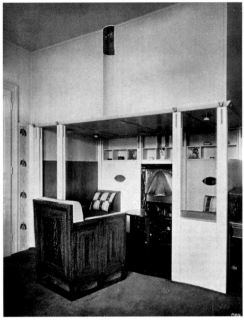

Josef Hoffmann: The apartment of Dr. Hermann Wittgenstein, Vienna, 1906. View of the seating area around the fireplace.

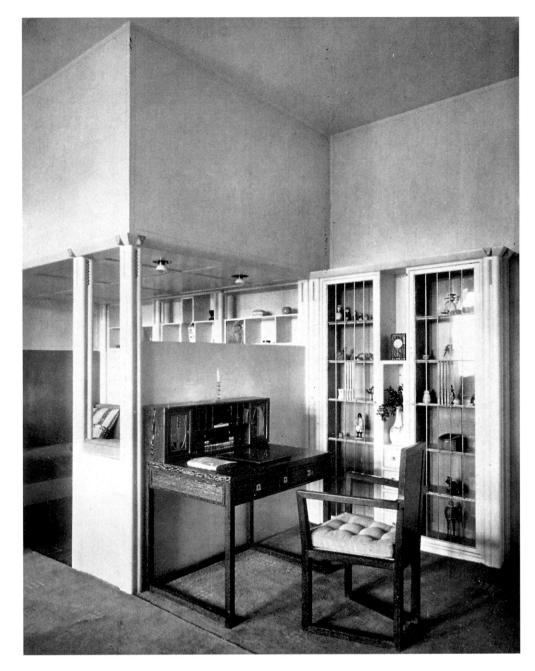

Josef Hoffmann: The apartment of Dr. Hermann Wittgenstein, Vienna, 1906. View of the writing desk in the living-room backing onto the fireside seating area.

The commissions from Karl Wittgenstein – a prominent figure in Imperial Royal industry – and from members of his whole family also reveal the close relationship between customer and Wiener Werkstätte. The managing director of a company of which Wittgenstein was principal shareholder also became a regular client. Karl Wittgenstein's daughter, Margarethe Stonborough, is known to us from a painting by Gustav Klimt; her Berlin apartment was also furnished by the Wiener Werkstätte, and part of her wardrobe came from the Wiener Werkstätte fashion department. The Wiener Werkstätte had indeed achieved the "permeation of all expressions of existence".

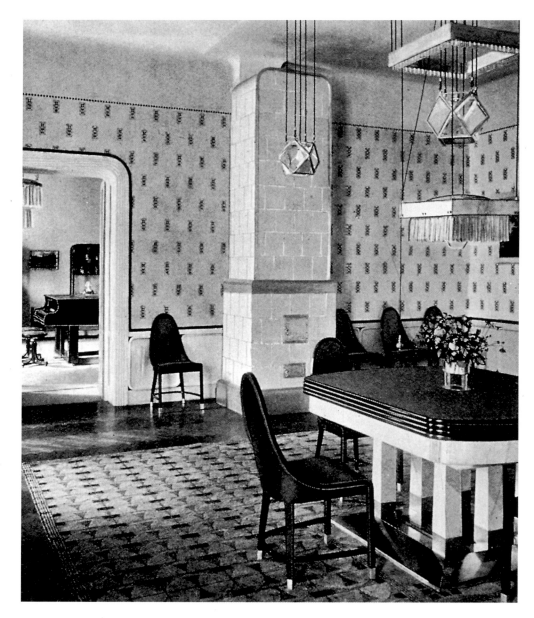

Josef Hoffmann: Dining-room interior, c. 1901. As a consultant to the firm of Jacob and Josef Kohn, Hoffmann designed an extensive range of bentwood furniture. This dining-room formed part of the Christmas 1901 exhibition at the Austrian Museum of Art and Industry in Vienna. The furnishings illustrate the great versatility of bentwood. The exhibition also included a bedroom and a living-room, which can here be glimpsed in the background. Together, the rooms represented "three complete interiors in the modern style".

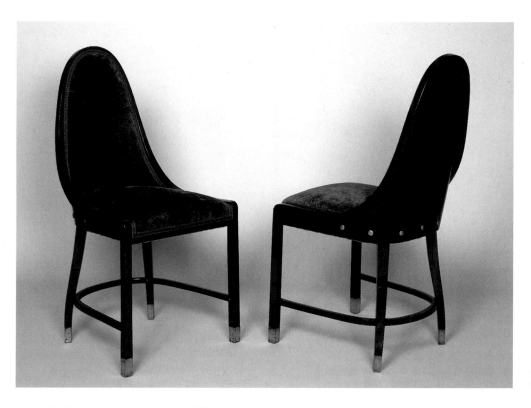

Josef Hoffmann: Two chairs, 1901, beech, brass sleeves, brass tacks; made by J. & J. Kohn, Vienna

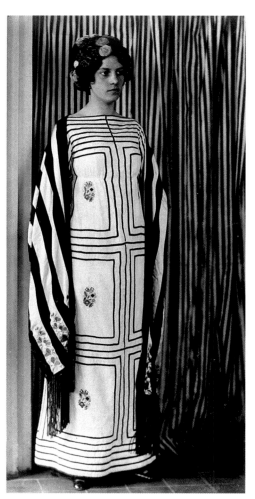

Josef Hoffmann: Summer dress from *Mode*, a book of fashion photographs from the Wiener Werkstätte archives, 1911, photograph

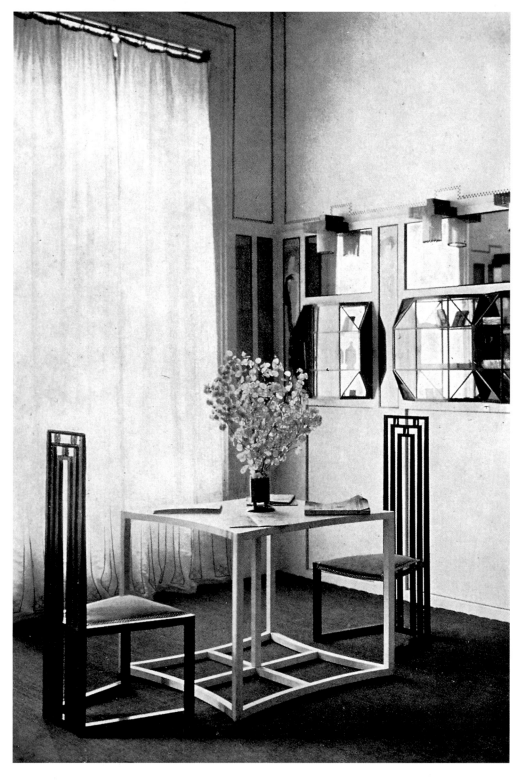

Koloman Moser and *Josef Hoffmann:* Reception of the fashion salon run by the Flöge sisters, Mariahilferstrasse, Vienna, c. 1903

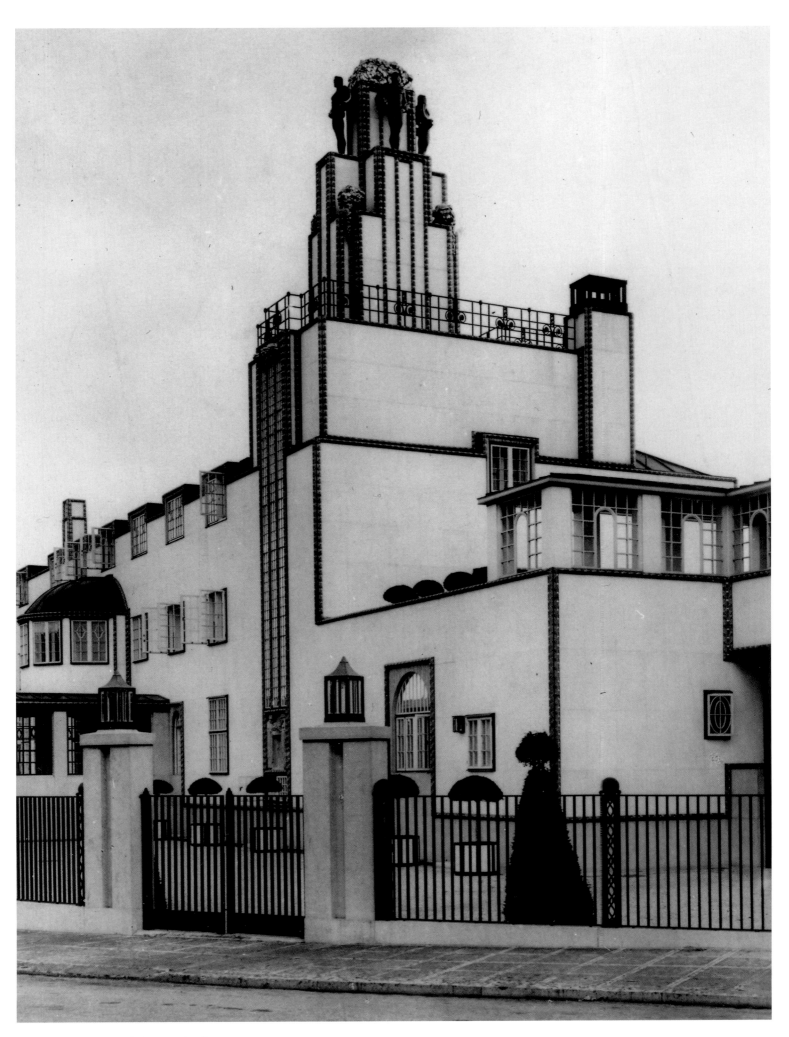

42 Palais Stoclet (1905–1911)

Palais Stoclet (1905–1911)

The Palais Stoclet in Brussels is a masterpiece in the history of architecture. Whether it may be called *the* masterpiece of Art Nouveau, however, or whether it signals a departure in a quite new direction, remains the subject of debate. From a stylistic point of view, the Palais Stoclet retains little of Art Nouveau. It marks the start of an "elementary" classicism, i.e. one which seeks to establish a vocabulary of basic geometric architectural forms.

By 1902 Henry van de Velde was already convinced that ornamentation employing tendrils, flowers and women had had its day, and that the art of the future would be abstract: "I maintain that, with such principles, it will be possible to create entirely new forms of architectural ornament which will match step for step the intentions of the building and the various means of construction and methods of organization; thus they will change depending on the material employed..."[16] In this respect, the Palais Stoclet may be called "post-Art Nouveau". At the same time, however, the spirit of Art Nouveau is not simply alive and well in the Palais Stoclet, but once again reaches its most sublime expression. The Palais Stoclet is thus both the climax and the epilogue of an epoque.

"Pathetic Objectivity"[17], seemingly a contradiction in terms, is nevertheless the most accurate description of this integral work of art. The buildings signalling radical stylistic change have always been the greatest of their day.

Art Nouveau's vision of the total work of art was fulfilled by Austrian artists in Brussels. Here Art Nouveau raised its most beautiful monument, as a bricks-and-mortar illustration of the ideas about which so many Art Nouveau artists had been theorizing. Mass society was simply not in a position to enjoy what Peter Behrens called the "feast of life"[18]. The dream of the total work of art turned, in the shape of the household utensil, into a nightmare. It was realized instead at the "superman" level – in line with Nietzsche's idea of a "Zarathustra style" – in the form of the private residence as an edifice of art and ritual.

In the Palais Stoclet, built between 1905 and 1911, Josef Hoffmann translated into reality the turn of the century's design ideal: a composition demonstrating coordination and harmony in all its parts – from the shape of its cutlery to the landscaping of its gardens. More still: within his overall scheme for the interior décor, he succeeded in orchestrating a host of individual artists – painters, sculptors and craftsmen – into a symphonic whole.

The building itself is stunningly beautiful in its clear, orthogonal order. Its block-like components are placed above, below and in front of each other, and its overall

Josef Hoffmann: Design for a tumbler, "Var. A" broncit decoration, c. 1910

Page 42: *Josef Hoffmann:* Palais Stoclet, Brussels, view from the street, 1905–1911. The tall, three-columned window of the stairwell runs the full height of the tower. It is separated from the window below by a relief panel by Emilie Simandl-Schleiss.

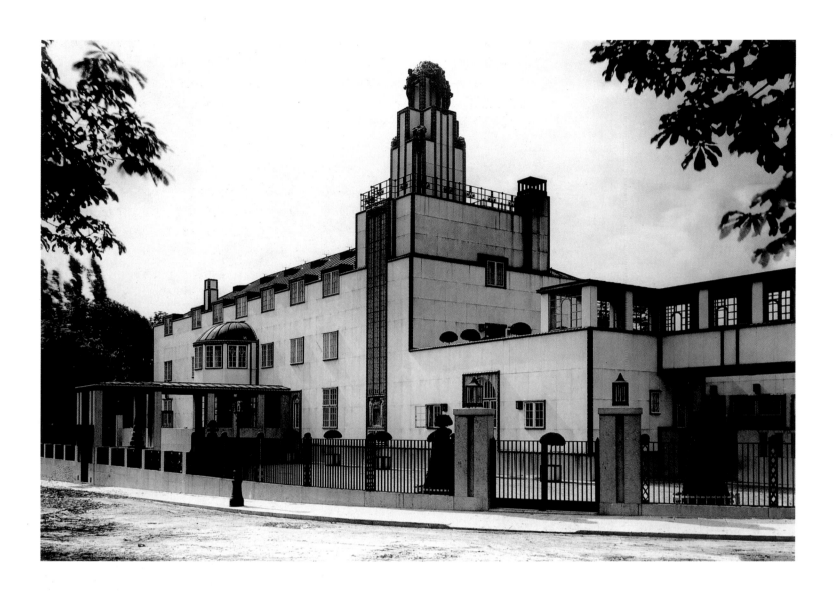

Josef Hoffmann: Palais Stoclet, Brussels, view of the street façade from the northwest, 1905–1911

appearance is dominated by horizontals and verticals. This impression of a construction of cubes is softened, however, by the calming flatness of the white marble slabs with which the walls are faced. Seams are picked out by metal bands of bronze gilt which simultaneously restore the unity of the whole. Despite the preciousness of the materials, the building does not appear pompous, but serene and light; even the somewhat emotionally-charged tower (p. 42), which recalls Joseph Maria Olbrich's Wedding Tower in Darmstadt, fails to detract from its flowing grace. The proportional assurance demonstrated in the exterior continues in the spacious rooms inside. The glistening white main hall, two-storeyed and columned, is flooded with light (p. 48). As on the exterior, the point at which one plane meets the next is identified by means of decorative bands. The black-and-white striped armchairs similarly obey the cubic principle of the architecture in their simplicity and statics.

For all its sumptuousness, the "palatial" character of the Palais Stoclet is toned down. The building is open and extends out into the geometrical gardens surrounding it. The rear façade and trees trimmed into spherical shapes are mirrored in the waters of the artificial pond (p. 45 below right) – reflections of rectilinear beauty. A "feast of life", a "feast of homogeneity", a celebration of harmony of detail, furnishings and surroundings; the triumph of a love of decorative element, two-dimensional design and noble linearity.

The linearity expressed in the axes of the building is continued not only in the highly formal design of the garden, but also in the floor plan. Like the elements of the exterior façade, the rooms inside the Palais Stoclet represent a sequence of contrasting but homogeneous compositions. The "hub" is the main hall; to the left lies the music room and theatre (p. 55), to the right the dining-room (pp. 52–53). The different character of the various rooms clearly emerges from the ground plan (p. 46), and is taken up in the décor. The longitudinal axis of the music room, which ends in an apse, runs at right angles to the longitudinal axis of the main hall; that of the dining-room, which ends in a bay window, runs parallel to the main hall. Both the top floor and the first floor – the private rooms – reflect the same attention to architectural and design detail as the public rooms. Proportioning and rhythm, skilful deployment of natural and artifical light, colour and surface treatment, even iconographic characterization are the consistent hallmarks of the overall design.

Behind this "monument" of interior decoration, which had been built on an unrestricted budget, there was a corresponding patron. In this regard, the Palais Stoclet

Right: *Josef Hoffmann:* Palais Stoclet, Brussels, view of the garden façade from the pond, 1905–1911

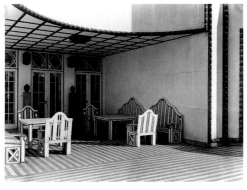

Josef Hoffmann: Palais Stoclet, Brussels, loggia seating area, garden façade, 1905–1911. The section of the first floor bridging the loggia sweeps inwards in a crescent shape from the outer corners.

Josef Hoffmann: Palais Stoclet, Brussels, view of the garden from the loggia, 1905–1911. A stone border surrounds the rectangular pond, which lies parallel to the house. Rising from its centre is a tall columnar shaft, on top of which rests a fountain basin.

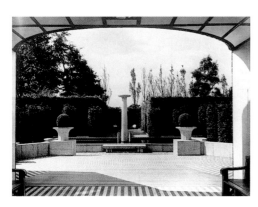

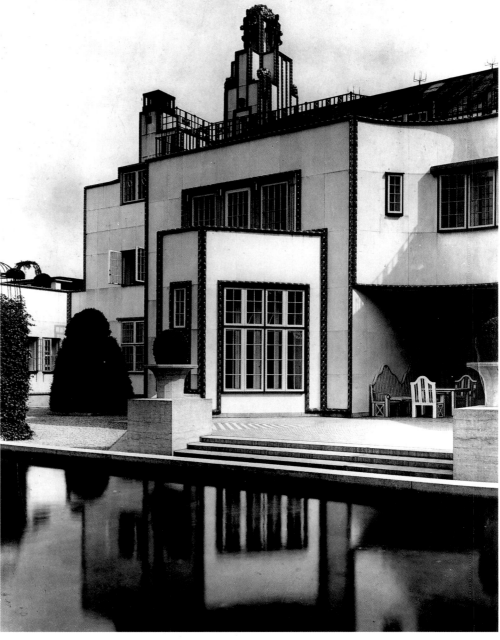

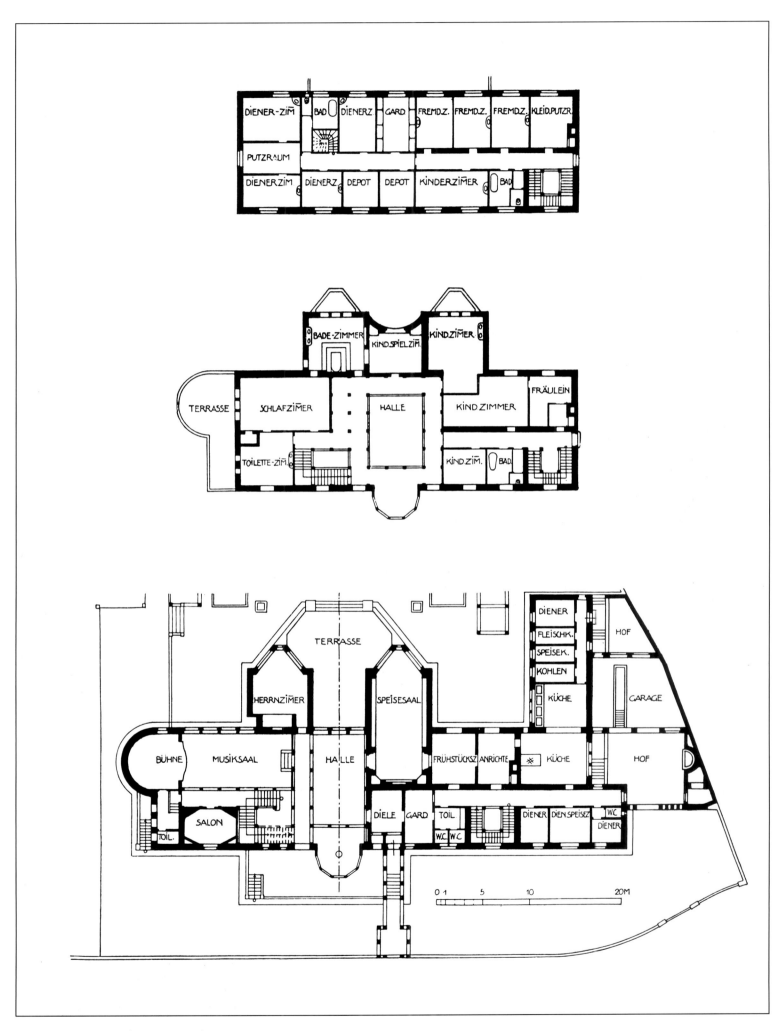

DIENER-ZIM · **BAD** · **DIENERZ** · **GARD** · **FREMDZ.** · **FREMDZ.** · **FREMDZ.** · **KLEID.PUTZR.**

PUTZRAUM

DIENERZIM · **DIENERZ** · **DEPOT** · **DEPOT** · **KINDERZIMER** · **BAD**

BADE-ZIMMER · **KIND.SPIELZIM.** · **KIND.ZIMER**

TERRASSE · **SCHLAFZIMER** · **HALLE** · **KIND ZIMMER** · **FRÄULEIN**

TOILETTE-ZIM. · **KIND.ZIM.** · **BAD.**

TERRASSE

DIENER · **FLEISCHK.** · **SPEISEK.** · **KOHLEN** · **HOF**

HERRNZIMER · **SPEISESAAL** · **KÜCHE** · **GARAGE**

BÜHNE · **MUSIKSAAL** · **HALLE** · **FRÜHSTÜCKSZ** · **ANRICHTE** · **KÜCHE** · **HOF**

SALON · **DIELE** · **GARD** · **TOIL** · **DIENER** · **DIEN.SPEISEZ** · **WC**

TOIL. · **W.C.** · **W.C.** · **DIENER**

0 1 5 10 20M

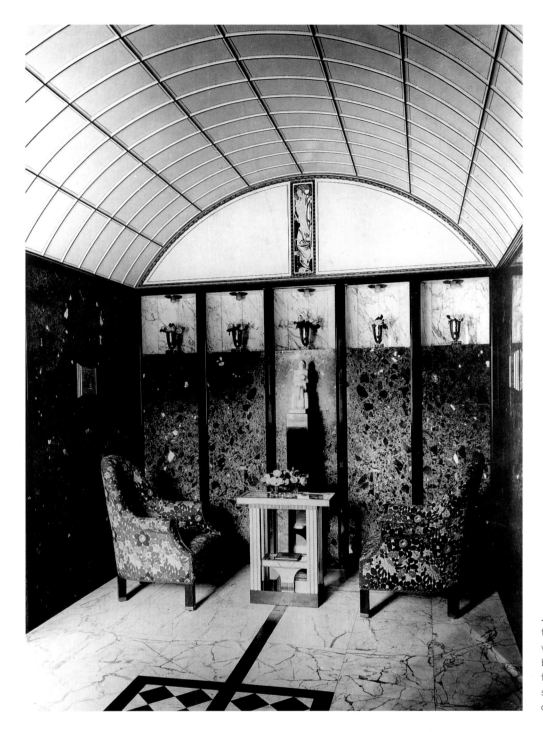

Josef Hoffmann: Palais Stoclet, Brussels, view into the vestibule from the entrance, 1905–1911. The walls are clad in verde-antico marble, with gilt vases by Josef Hoffmann in the niches. The veined marble floor incorporates mosaics by Leopold Forstner. The sculpture, which stands on a fitted plinth, is by Michael Powolny.

was a typical Art Nouveau commission. The mistake of the years prior to the First World War was to attempt to bring down salvation from above, that is to cure social ills through an emphatically individual art. The category of commission more or less dominating the field rapidly became the villa of the wealthy businessman who was interested in the arts. What William Morris had many years earlier called the "swinish luxury of the rich" now provided artists who shared his ideals with fertile soil in which to realize their talents. "The dominance of the villa and country house on the one hand, and industrial buildings on the other, reflected the interests of the ruling élite. They cultivated the arts in their own homes and mollified their social consciences with the thought that luxury simultaneously encouraged progress… Housing for the masses or for the less wealthy middle classes was given almost no consideration."[19]

Page 46: *Josef Hoffmann:* Palais Stoclet, Brussels, ground plans of the ground floor (below), 1st floor (middle) and top floor (above), 1905–1911. These plan drawings show the final layout of the rooms.

Palais Stoclet (1905–1911) 47

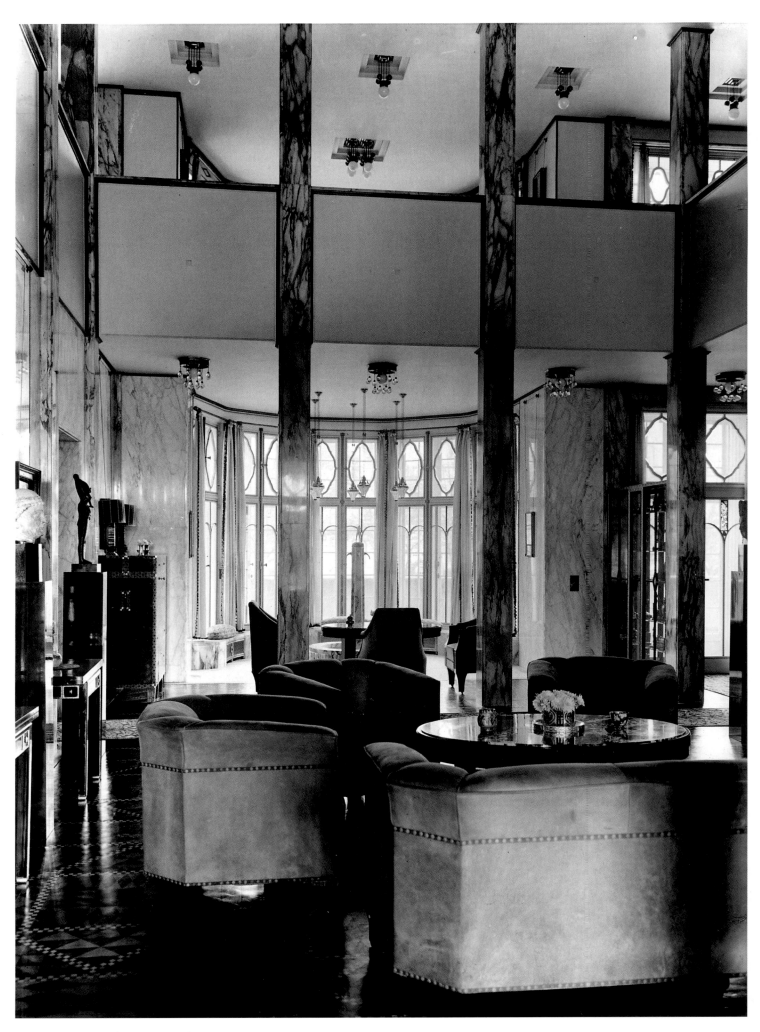

48 Palais Stoclet (1905–1911)

Adolphe Stoclet was the archetypal art lover of the turn of the century. He believed in the transfiguring power of art, but at the same time he was a realist, capable of running a large bank and turning his dreams of a sophisticated lifestyle into reality. The Stoclets proved to be ideal clients for the Wiener Werkstätte. Suzanne Stoclet was the daughter of Arthur Stevens, an art critic and dealer who played a prominent role in the Paris art scene. Adolphe Stoclet, who came from the Belgian financial world, married the fashionable Parisienne against the wishes of his family, and the couple lived in Milan before settling in Vienna. Stoclet's cosmopolitan lifestyle also explains his decision to have his personal environment designed by Viennese rather than by leading Belgian artists.

It was during their time in Vienna that the Stoclets started up their remarkable art collection, specializing in old and exotic works. Inspired by a Secession exhibition, they visited Hohe Warte, a garden suburb of newly designed villas on the outskirts of Vienna. There they made the acquaintaince of Carl Moll, whom they met in the garden of his house. Stoclet spontaneously commissioned the architect responsible for Moll's villa, Josef Hoffmann, to build him a house in Hohe Warte, on the site of the later Villa Ast. In 1904, however, Stoclet was recalled to Brussels following the death of his father, and thus the building site was effectively shifted to Belgium.

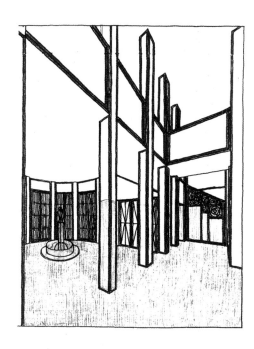

Josef Hoffmann: Palais Stoclet, Brussels, design for the main hall, c. 1905, ink and paper on graph paper

Koloman Moser: Writing desk (open position) from the main hall of the Palais Stoclet, 1909, ebony with marquetry

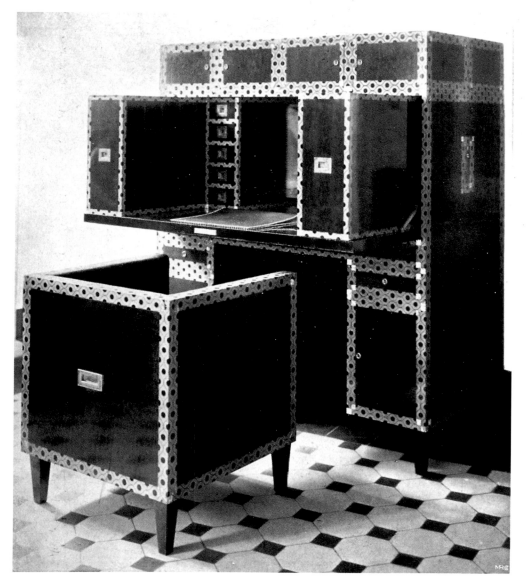

Page 48: *Josef Hoffmann:* Palais Stoclet, Brussels, main hall with view of the fountain alcove, 1905–1911. As on the exterior façade, every plane is framed by means of narrow bands. In the centre of the alcove, which faces onto the street, stands a marble fountain crowned with a sculpture by George Minne. The walls and pillars are clad in paonazzo and Belgian marble. Sculptures from Adolphe Stoclet's collection are mounted on black marble pedestals. The furniture is made of calamander. The chairs were originally upholstered in chamois leather. The writing desk by Koloman Moser can be seen in the left-hand background.

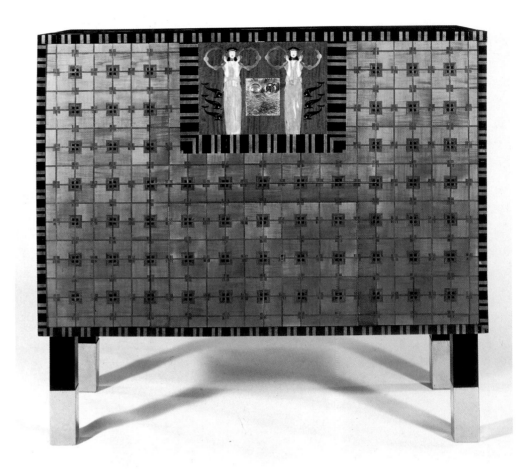

Above and below: *Koloman Moser:* Writing desk from Charlottenlund Palace, near Stockholm, 1902, various wood verneers, with elm, rosewood, ebony, mother-of-pearl and ivory marquetry, and silver-plated fittings.

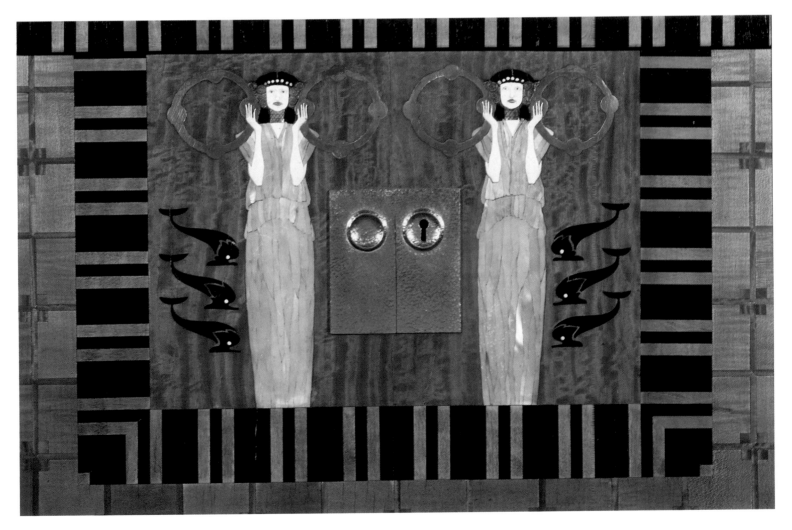

The congenial collaboration between patron and artist could now begin. Congenial, because according to G.S. Salles in the preface to his *Adolphe Stoclet Collection*, even Stoclet's exterior matched his Palais: "His black beard shot with silver, his manner – charming, with just a hint of pomposity – and his distinguished appearance lent him a remarkable affinity in style with the objects in his collection, with which he seemed to have an almost natural rapport. Indeed, the polished marble surfaces in the large entrance hall suited him just as well as they suited his carvings… He was completely at home in such monumental company."[20] It was no surprise, therefore, that Adolphe Stoclet should decree that he was to be buried sporting a breast-pocket handkerchief designed by Hoffmann. The secret of the final cost of the Palais Stoclet was similarly something that he took with him to the grave.

While Josef Hoffmann may have earned something of a reputation for his lack of control over the financial side of his building projects, his organizational skills on the practical side were all the more prodigious. The execution and coordination of a project as ambitious as the Palais Stoclet demanded very special talents. Hoffmann's singleness of purpose, and his vision of the unity of all the individual parts, meant that he encouraged the many artists engaged on the project to work in harmony, both at the artistic and the personal level. Between the design and the final execution in the Wiener Werkstätte workshops lay a wealth of finer details to be resolved: "…for quite apart from the fact that he [Adolphe Stoclet] was able to

Josef Hoffmann: Two armchairs, c. 1905–1910. Upholstered in silk, with silver-plated, hammered feet, these two armchairs are similar in shape to those in the main hall of the Palais Stoclet.

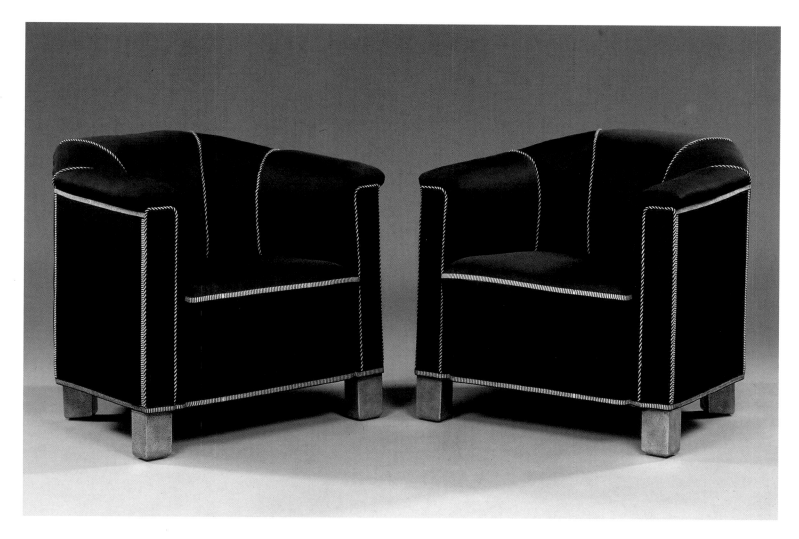

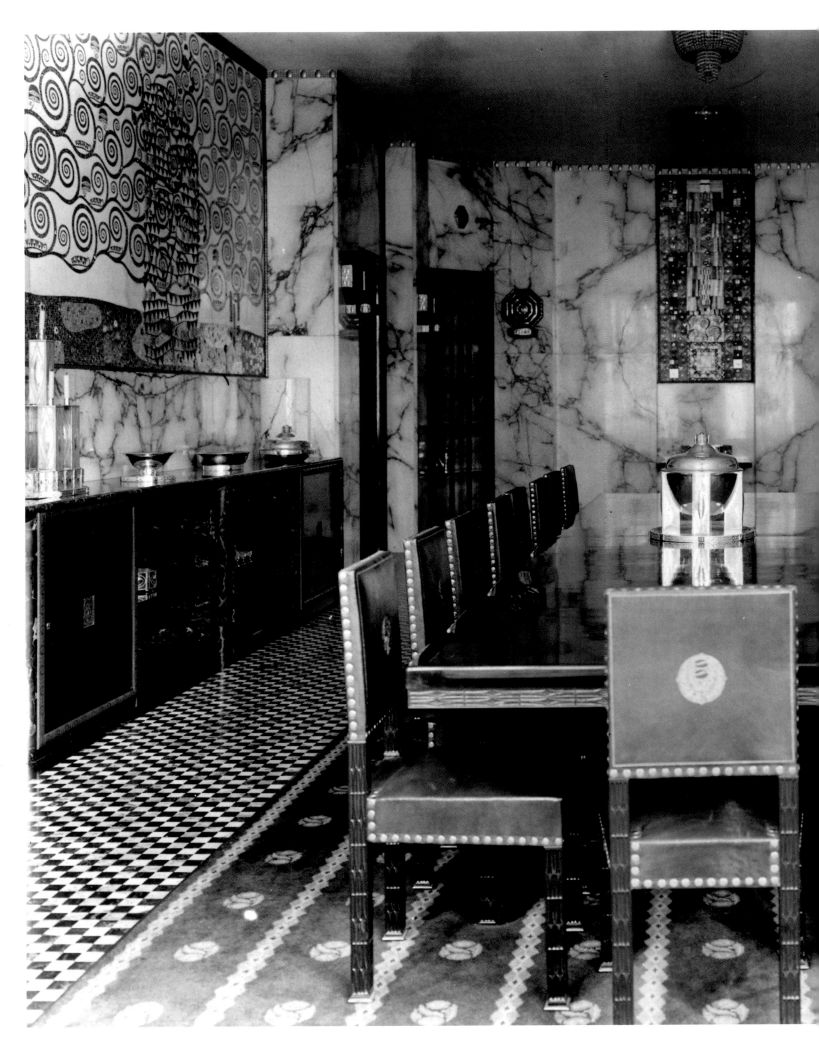

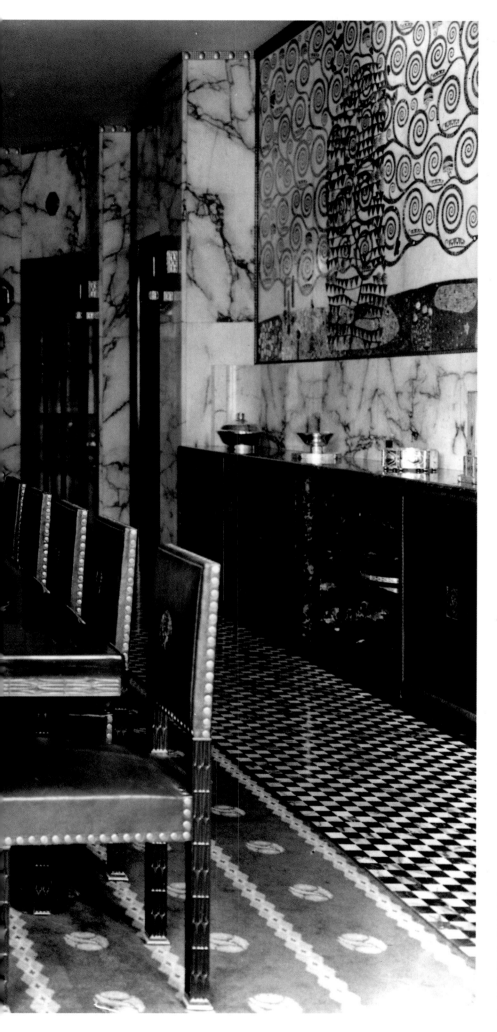

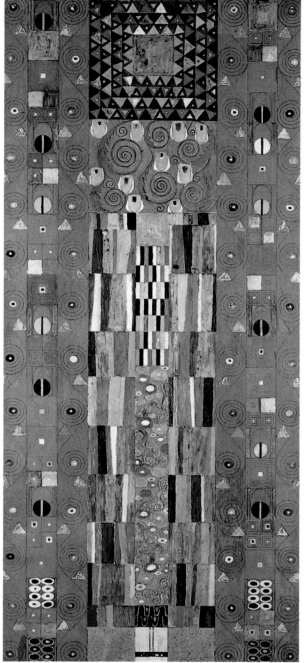

Gustav Klimt: Cartoon for the Stoclet Frieze in the dining-room of the Palais Stoclet, Brussels, c. 1905–1909, tempera, watercolour, gold paint, silver bronze, chalk, pencil and opaque white on paper. This cartoon provided the basis for the execution of the abstract decorative mosaic on the narrow end wall of the dining-room.

Josef Hoffmann: Palais Stoclet, Brussels, view of the dining-room, 1905–1911. The walls are faced in paonazzo marble, with mosaics by Gustav Klimt. The floor is composed of marble in a chequerboard pattern. The sideboards are portovenere marble and calamander. The furniture is also calamander, upholstered in black leather and with gold embossing. The corner cabinets contain silverware by Josef Hoffmann.

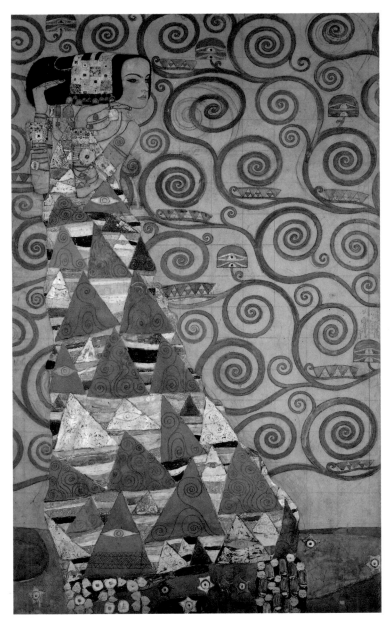 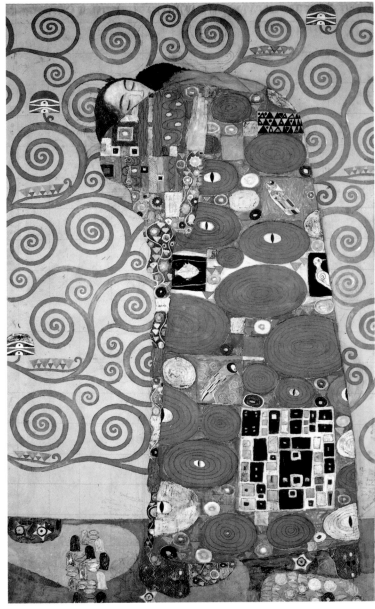

Gustav Klimt: Cartoons for the Stoclet Frieze in the dining-room of the Palais Stoclet, Brussels; left: *Expectation*; right: *Fulfilment*, c. 1905–1909, tempera, watercolour, gold paint, silver bronze, chalk, pencil and opaque white on paper.

The two long walls of the dining-room each bear mosaics measuring seven metres in length. The main motifs within these mosaics are the figures of *Expectation* and *Fulfilment*, which are located opposite each other on the left and right wall respectively. The materials employed in the mosaics include marble, copper, gold, semiprecious stones, faience and coral. The cartoons for the Stoclet Frieze were not shown in public until June 1920, when they were exhibited for the first time in Gustav Nebehay's gallery in Vienna.

draw upon unlimited financial resources, he was also of one mind with his architect in wishing to create a total work of art in the new house, in which only the best and most exquisite materials were to be used, and only the most skilled craftsmen and imaginative artists were to be employed."[21] Carl Otto Czeschka, Leopold Forstner, Ludwig Heinrich Jungnickel, Gustav Klimt, Bertold Löffler, Richard Luksch, Elena Luksch-Makowsky, Franz Metzner, Koloman Moser, Michael Powolny and Emilie Simandl-Schleiss all worked on the Palais Stoclet under the umbrella of the Wiener Werkstätte.

Josef Hoffmann, always eager to promote young talent, also showed Stoclet designs by Oskar Kokoschka and Egon Schiele. Although Stoclet did not accept them, both artists remained closely linked with the Wiener Werkstätte over the following years.

Koloman Moser, alongside Hoffmann the leading figure in the Wiener Werkstätte until his resignation in 1908, developed a special "Stoclet style" for his furniture designs for the Palais, based on the streamlined, functional Hoffmann-Moser style which prevailed up until about 1910. Moser carries the fundamental design prin-

ciple of the right angle through into his ornament, which – exquisite, but never forced – offsets the austerity of the basic form and lends it elegance.

But it was first and foremost the collaboration between Josef Hoffmann and Gustav Klimt, who designed the mosaic frieze in the dining-room, which transformed the Palais Stoclet into a three-dimensional artistic experience. Hoffmann, as always, gave careful consideration to the suggestions of his admired friend, while Klimt integrated his mosaics with equal thoughtfulness into the architecture. Each was undoubtedly influenced by the other. In the course of his work with Hoffmann, Klimt, who had quit the Secession in 1905, now developed an uncompromising two-dimensional style tending towards abstraction. He was subsequently vigorous in his refusal to allow the Stoclet Frieze to be exhibited in Vienna: "No! I can do without seeing my work – probably the ultimate conclusion of my ornamental development and the product of so many years of exploration and struggle, and a work into which artist craftsmen have steadfastly put their best in such a quiet and selfless manner – ridiculed and put down by Beckmesser and company."[22]

The two long walls of the Palais Stoclet dining-room are decorated with mosaics measuring seven metres in length (pp. 52–53). They were assembled in Brussels in 1911. Klimt's full-scale cartoons were not exhibited until 1920, when they were shown in the Nebehay gallery in Vienna. The central motif on both walls is the tree of life, its branches spiralling outwards across the surface of the mosaic and enlivened with blossoms, perching falcons and butterflies. A frieze of flowers runs along the bottom. In line with the axial layout of the building as a whole, the single standing figure of *Expectation* (p. 54 left) on the left wall corresponds to *Fulfilment*, (p. 54 right) a couple embracing, on the right. Since both figural compositions are located to the left of the central trunk of the tree of life, they are counterbalanced on the

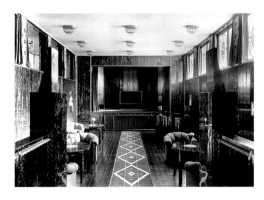

Josef Hoffmann: Palais Stoclet, Brussels, view of the music room and theatre, looking towards the stage and organ, 1905–1911. The walls are clad in porto-venere marble, with gilt copper strips. The parquet floor is made of teak and coralwood. The pillars in the gallery and windows feature glass and enamel inlay. The windows were designed by Carl Otto Czeschka. The furniture is carved and gilded.

Josef Hoffmann: Palais Stoclet, Brussels, design for the music room and theatre, interior view, c. 1905, pencil, ink, coloured crayon, watercolour and gold

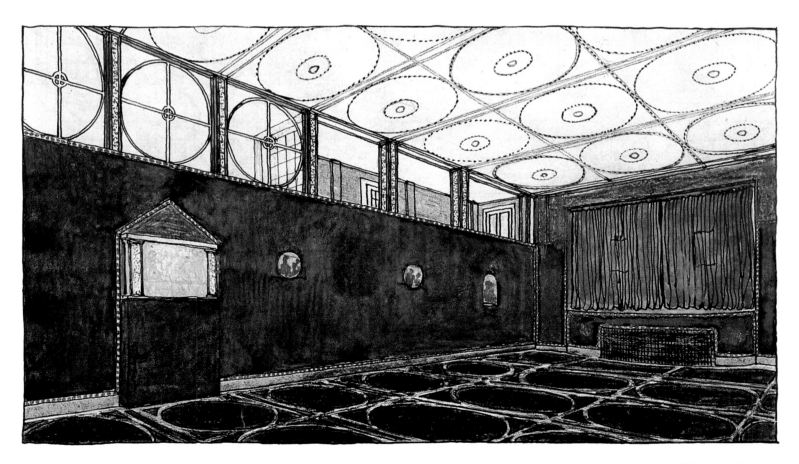

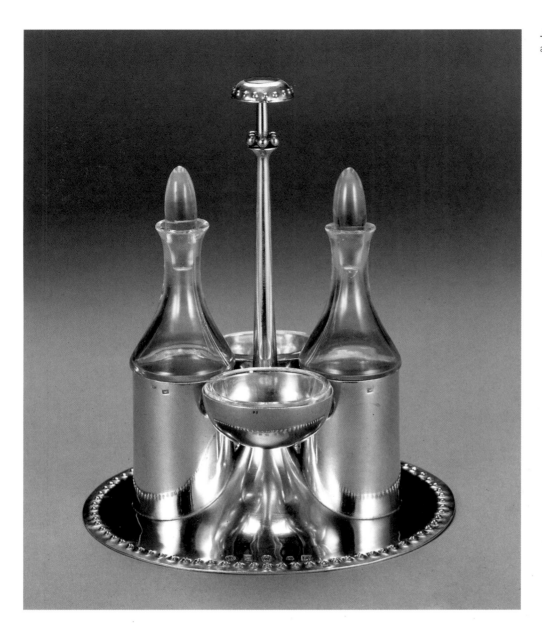

Josef Hoffmann: Cruet stand, c. 1905, silver, coral and glass; made by Josef Czech

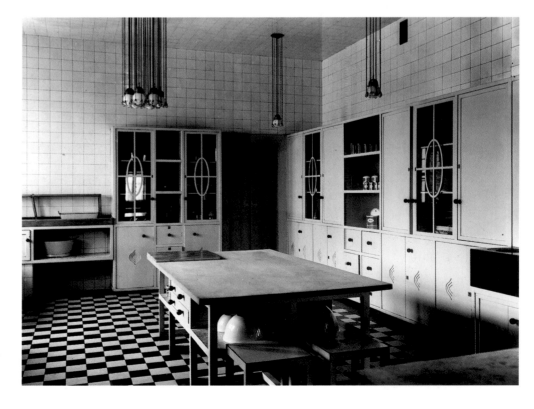

Josef Hoffmann: Palais Stoclet, Brussels, kitchen, 1905–1911, with lights designed by Koloman Moser. All the silverware, porcelain and glass was executed to designs by Josef Hoffmann.

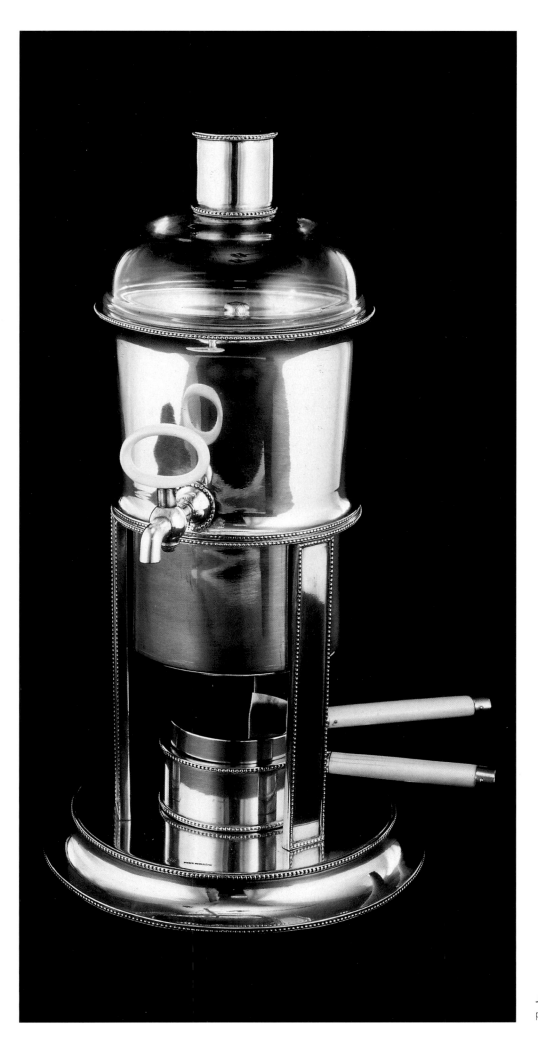

Josef Hoffmann: Coffee machine, c. 1905, silver-plated white metal, ivory and glass

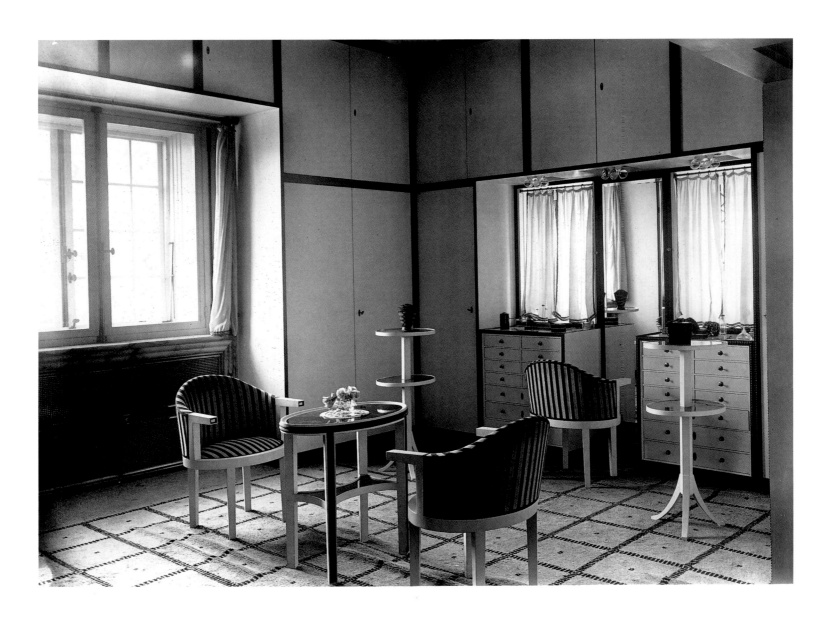

Josef Hoffmann: Palais Stoclet, Brussels, lady's dressing-room, 1905–1911. The wall cupboards, fittings, carpet and upholstery are restricted to black, white and light grey, in order to provide a subtle foil for the clothes donned by the lady of the house.

right by a tall, blossoming shrub. A third mosaic by Klimt is located on the narrower, less conspicuous end wall of the dining-room. It is a purely abstract, decorative composition which, unlike the other works, is not traced in colour against a white marble background, but fills the entire surface. This abstract picture faces the windows and seems to offer a reflection of the geometrically tamed garden outside: a union of art and life.

The combination of a dining-room and a music room is found in many Art Nouveau villas, including examples by Mackintosh, Olbrich and Peter Behrens, and was dictated less by architectural considerations than by the intellectual and aesthetic tastes of the patrons concerned. From the point of view of synaesthetic pleasure and the celebration of sensual enjoyment, banqueting, music and theatre enjoyed equal status. All were celebrated in almost solemn splendour. It was only logical, then, that the furnishing and décor of the Palais Stoclet should reach its most sublime heights in the music room and dining-room. In the words of Ludwig Hevesi: "In an attractive view from a gallery, one looks down into a lower-lying marble music room, which ends in a semicircular stage upon which complete musical works can be performed. An electric organ can be played in all sorts of acoustical combinations, allowing music of louder or softer volume to travel to different rooms. As in the children's playground at the Villa Brauner [Josef Hoffmann, 1905–1906], the

architect here becomes the poet.... Hoffmann has planned for the staging of festive events with true sophistication."[23] The architect as poet – of all the works of architecture built around 1900, there was probably none so "poetically composed" as the Palais Stoclet.

A description by Hermann Muthesius of his impressions of a Mackintosh interior, which appeared in his three-volume work *Das Englische Haus* (The English House) of 1904, might equally well be applied to the Palais Stoclet: "Once the interior attains the status of a work of art, that is, when it is intended to embody aesthetic values, the artistic effect must obviously be heightened to the utmost. The Mackintosh group does this and no one will reproach them on this particular point. Whether such enhancement is appropriate to our everyday rooms is another question. Mackintosh's rooms are refined to a degree which the lives of even the artistically educated are still a long way from matching. The delicacy and austerity of their artistic atmosphere would tolerate no admixture of the ordinariness which fills our lives. Even a book in an unsuitable binding would disturb the atmosphere simply by lying on the table, indeed even the man or woman of today – especially the man in his unadorned working attire – treads like a stranger in this fairy-tale world. There is for the time being no possibility of our aesthetic cultivation playing so large a part in our lives that rooms like this could become general. But they are milestones placed by a genius far ahead of us to mark the way to excellence for mankind in the future."[24]

The influence which Mackintosh exerted on Hoffmann is well-known, whereby the admiration appears to have been thoroughly mutual. But it was Hoffmann who conjured the magic and mystery of the architecture and interiors of the Palais Stoclet. Interior design was the ultimate consequence of the aesthetic protest launched by the entire Art Nouveau generation. The gross tastelessness which had

Josef Hoffmann: Design for a tumbler, "Var. A", broncit decoration, c. 1910

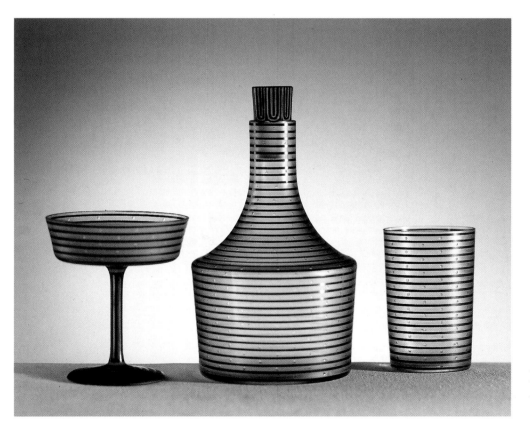

Josef Hoffmann: Champagne glass, decanter and tumbler from the "Var. A" set of glasses, c. 1910, frosted glass with transparent globules and black broncit decoration; made by J. & L. Lobmeyr, Vienna

Palais Stoclet (1905–1911) 59

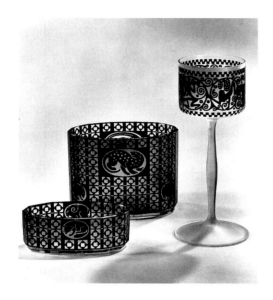

characterized furnishings and décor since the middle of the 19th century now prompted architects to design for themselves the entire interior in which daily life was to unfold. Le Corbusier would react in a similar fashion a few years later. (Only recently have we returned to the opinion that a tasteless room is preferable to one furnished by an architect.) In the hands of Hoffmann, interior design is carried to perfection. Muthesius ultimately came down in favour of the artistic interior, despite some reservations that it might impose restrictions on the daily life of the individual. From this point of view, the interior as a work of art indeed enslaves its occupants. A fundamental feature of interior design is that the shape of the room, its measurements and proportions, its materials, colours and patterns, its fitted and free-standing furniture and its domestic requisites are all mutually coordinated. Where this is the case, people will frequently be the only elements that trouble the overall effect. Hence their slavery to the overall design. Adolf Loos captured the essence of this

Ludwig Heinrich Jungnickel and *Urban Janke:* Jardinière for violets, pot and wine glass, c. 1911, frosted glass with black broncit, oval; made by J. & L. Lobmeyr, Vienna. The two oval-shaped flower holders depict birds and animals, including foxes, rams, and hares, in circular and oval medallions.

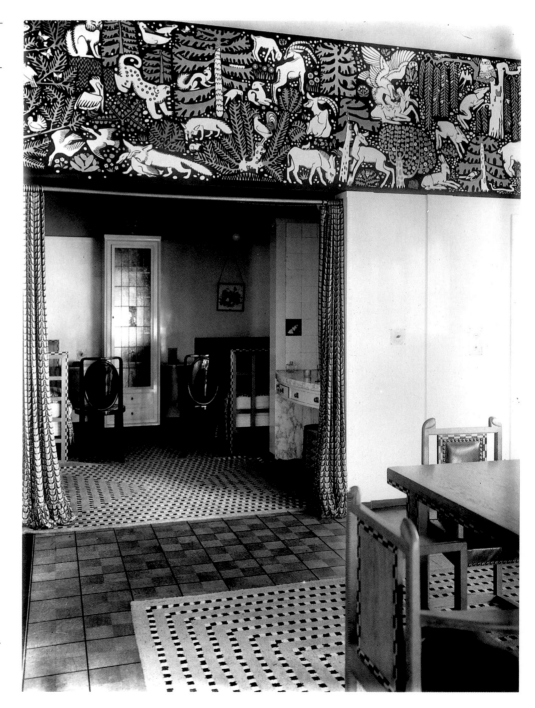

Josef Hoffmann: Palais Stoclet, Brussels, children's room, 1905–1911. The children's room, with its "playful" chequerboard patterning, contains an animal frieze in predominantly black and green by Ludwig Heinrich Jungnickel.

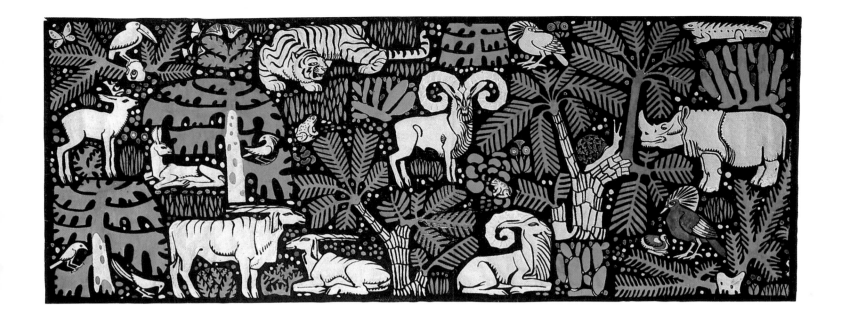

Ludwig Heinrich Jungnickel: Design for the animal frieze in the children's bedroom in the Palais Stoclet, c. 1908–1909

dilemma in his tale *Von einem armen reichen Mann* (The Poor Rich Man) of 1900. The architect in the story is explaining to his client, the poor rich man who has hung a birdcage in the exquisitely designed interior of his living-room, that he may not do so. "You are already complete!"[25] he pronounces. Loos is hereby protesting against the "artifying" of life – although his own interiors are themselves pure interior design. From this point of view, the Palais Stoclet was fortunate to be built outside Austria and thus beyond the scope of the destructive "Loos vs. Hoffmann" controversy.

The *Gesamtkunstwerk* of the Palais Stoclet thus fluctuates between two poles: realism and idealism. It was not solely the final, glittering manifestation of an Art Nouveau whose spirit and forms of expression would never be regained, it simultaneously contained components of a modern way of life. The utensils designed by the Wiener Werkstätte during this period and for the Palais Stoclet were, in their elegance and costliness, indeed part of the "total work of art", yet in their sober austerity they offer textbook examples of modern design. However noble their appearance may seem, their simple form and economic use of colour meant that they could also be industrially reproduced. The works of the Wiener Werkstätte during the Palais Stoclet years are distinguished by decorative discipline. Such decorative discipline, careful handling of the material, and free artistic design of the surface are also fundamental characteristics of Japanese art. Hoffmann saw his ideal of utility married to elegance realized not only by his British colleagues, but also in the domestic articles traditionally employed in Japan through the centuries. He was similarly impressed by the Japanese treatment of space. When contemplating the façade of the Palais Stoclet, one is immediately struck by the balanced relationship between blank surface and interlinking element; there is a seeming mobility, too, to the individual components of the architecture, so that one is tempted to slide them one behind the other, like a Japanese door, in order to demonstrate their harmonious proportionality.

The Palais Stoclet is proof that, whatever our reservations, a "unity of art and life" is still possible even today. It continues to be maintained and cared for by its owners. Its interiors have been preserved and are lived in. The rooms, which can be visited

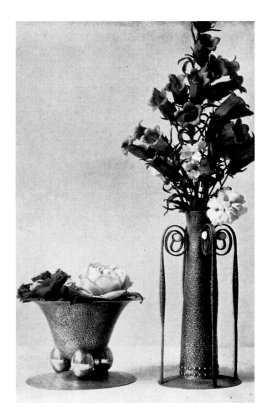

Josef Hoffmann: Vases, 1904, metalwork

by prior appointment, clearly reveal that the artists of the Wiener Werkstätte, designing almost ninety years ago, pioneered much of what we today understand under *Neues Bauen* (new architecture) and "contemporary living".

The interior of the children's room (p. 60 below) was designed by Ludwig Heinrich Jungnickel. Its deployment of black, green and white harmonizes with the monochromatic palette of the building as a whole. The artist nevertheless creates the room for a child: the walls are decorated with a continuous frieze of animals (p. 61), fairy-tale in atmosphere but incorporated into a clear composition. The furniture, too, is designed with children in mind, and the chequerboard ornamentation is cheerful and bright. The bathroom (p. 63 above) is also very light. Lavish marble fittings aside, it seems to look forward to the modern personal fitness room: a spacious balcony was provided for gymnastic exercises in the fresh air, while other facilities included a massage table and a day bed. These contemporary statements on personal grooming were complemented by valuable toilet articles of silver and precious stones.

Also carefully conceived is the dressing-room of the lady of the house (p. 58), in which whites, greys and blacks set off the clothes to their full effect. The bedroom – panelled in rosewood – exudes an atmosphere of security and repose. The Palais Stoclet was interior design carried to a high art, yet Josef Hoffmann was still anxious to note: "Of course this is just a beginning…"[26]

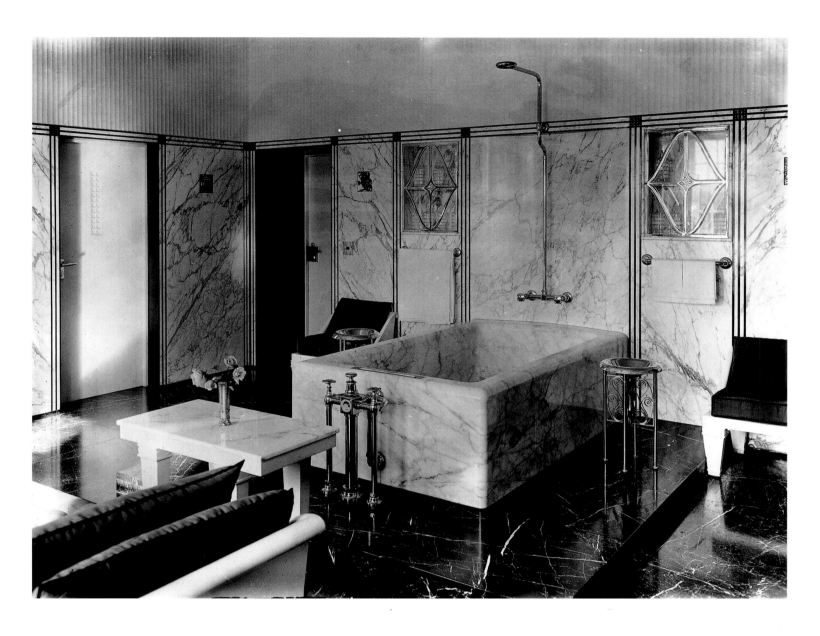

Josef Hoffmann: Palais Stoclet, Brussels, main bathroom, 1905–1911. The walls are faced in statuario marble with mosaics and encrustments of black marble and malachite. The floor is bleu-belge marble.

Josef Hoffmann: Palais Stoclet, Brussels, elevation (above) and perspectival drawing (below) of the rear (garden) façade, pencil on paper

Palais Stoclet (1905–1911) 63

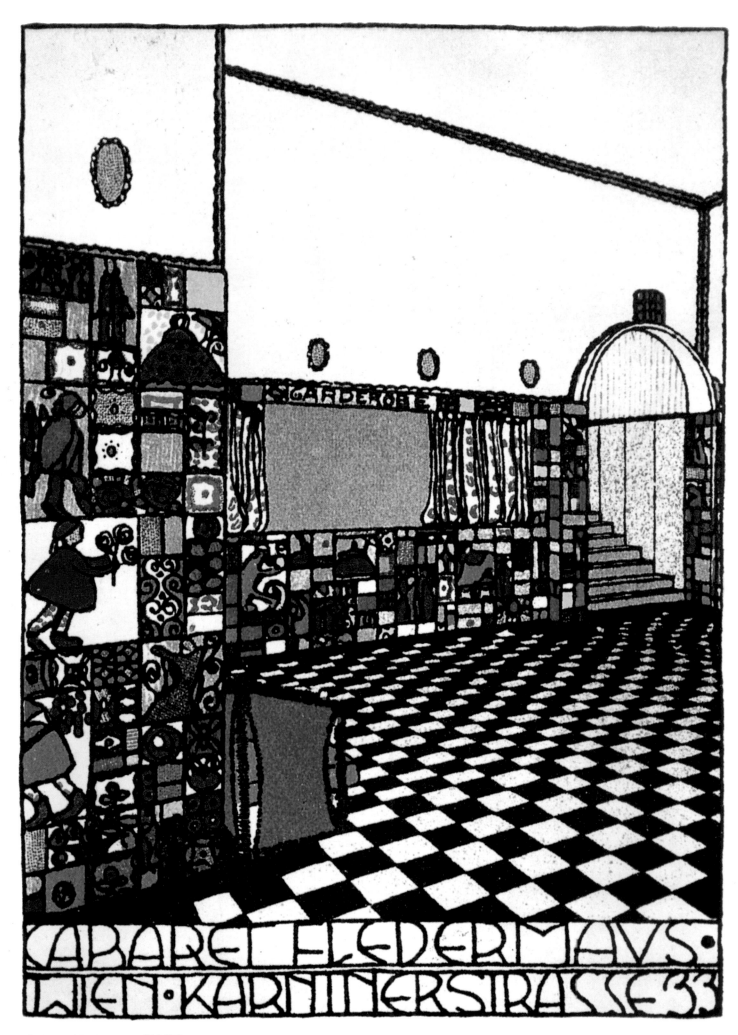

64 Cabaret Fledermaus (1907)

Cabaret Fledermaus (1907)

In the album published to celebrate the Wiener Werkstätte's 25th anniversary, Egon Friedell recalled the story of what was probably the Werkstätte's most popular creation: "In 1907 Fritz Waerndorfer, a sophisticated gentleman with a great deal of money and taste — two things which, as everyone knows, almost never go together — decided to commission the Wiener Werkstätte to build a cabaret. Both the colourfully tiled bar and the black-and-white auditorium were jewels of intimacy and noblesse."[27] The idea of creating a sophisticated place of entertainment fell fully in line with Art Nouveau thinking, whereby all areas and forms of life were to be infused with art and linked together via style. Thus not only was the term "Art Nouveau" extended to dance, theatre, song and literature, but these came to display formal Art Nouveau traits.

Caricature — cabaret turned into standard abbreviation — had already established itself as a specific artistic genre of the turn of the century. The virtuoso linear acrobatics performed by Art Nouveau graphic designers carried caricature to new heights. One of the most celebrated artists in this medium was Thomas Theodor Heine, a man of enormous talent who excelled in a number of different fields — a characteristic of many Art Nouveau artists. Heine not only designed magnificent posters for the Munich cabaret "Die Elf Scharfrichter" (The Eleven Executioners), of which he was a co-founder, but trod the boards himself. His example was emulated by Oskar Kokoschka, who as well as being involved in the design of the Cabaret Fledermaus also staged his own pieces there.

A theatre, even more so than a villa or country house, gave artists the opportunity to pursue a theme through a highly diverse range of media. The auditorium in the Cabaret Fledermaus was wider than it was deep, reducing the gap between audience and actors and ensuring that every seat was an ideal distance from the stage. Visitors entered the snow-white theatre (p. 104 above) through a bar (p. 67), whose arrangement Ludwig Hevesi describes as an imaginative stroke of decorative originality: "… as colourful as colourful can be, as fantastic as fantasy itself. An irregular mosaic, in fact, seemingly composed at random, made up of large and small rectangular majolica tiles each differently coloured."[28] This total work of art was executed "unimpeded by the interferings of a patron".[29]

The Cabaret Fledermaus drew upon the skills of furniture designers, ceramic artists, silversmiths, and designers for its lighting, tableware and table decorations. For graphic designers in particular, however, it offered a wide field of activities: posters, tickets, menus, programmes, postcards and much more besides. Even the name-

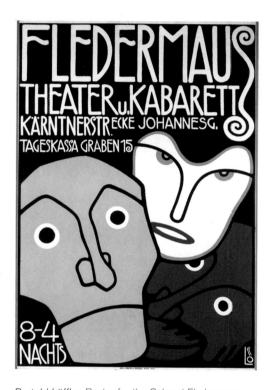

Bertold Löffler: Poster for the Cabaret Fledermaus, 1907, lithograph

Page 64: *Josef Hoffmann:* Cabaret Fledermaus, Vienna, 1907, partial view of the foyer with the bar, Wiener Werkstätte Postcard No. 74. In addition to the floor of black-and-white chequered tiles, the walls of the foyer and bar were also faced with ceramics up to over head height. These were executed by Bertold Löffler and Michael Powolny, co-founders of the Wiener Keramik ceramics workshop. Over 7000 majolica tiles make up a frieze of caricatures, portraits, ornamental designs, fabulous creatures, etc.

Michael Powolny: "Autumn" putto, c. 1907, porcelain, moulded white body, coloured underglaze painting. Displayed on the plinth by the entrance to the foyer of the Cabaret Fledermaus.

badges for the hostesses were specially created. The cabaret's architecture was closely related to that of the Palais Stoclet: simple square and rectangular forms, contrasting effects of black and white, and bands of chased metal decorated with garland-like reliefs.

In hindsight, however, the interior of the Cabaret Fledermaus may be seen as the ultimate Wiener Werkstätte showroom. The artists employed on the project were: Carl Otto Czeschka, Franz Karl Delavilla, Fritz Dietl, Josef Hoffmann, Carl Leopold Hollitzer, Gustav Klimt, Anton Kling, Oskar Kokoschka, Bertold Löffler, Emil Orlik, Michael Powolny, Eduard Josef Wimmer-Wisgrill (who stepped in to replace Koloman Moser) and Fritz Zeymer. Many of the objects which originally furnished the Cabaret Fledermaus are today synonymous with the art of the Wiener Werkstätte: the chair by Josef Hoffmann with the rounded stabilizers at its critical points, in the original version in black with white balls or white with black balls and familiar in many variations (cf. p. 105), has gone down as a classic of furniture history as the "Fledermaus chair". The same is true of Michael Powolny's putto, which in both its colour and black-and-white versions has become *the* small Wiener Keramik sculpture (pp. 66, 138 above, 139). Not to mention the famous Wiener Werkstätte vases, centrepieces and waste-paper baskets made out of perforated sheet metal. Not everything was Viennese, however – the Cabaret Fledermaus also laid claim to internationality with an American barman and a French cook.

Wiener Werkstätte "groupie" Berta Zuckerkandl wrote a glowing article on the new cabaret in the *Wiener Allgemeine Zeitung*: "From these rooms, imbued with an artistic sophistication of the highest degree, one can see how much is now possible in Vienna… [Here is] a confident, dignified, honest, almost chaste unfolding of splendour, the harmony and power of the chromatic idiom, melodious design crystallized out of the purpose in hand."[30] The satirist Karl Kraus responded rather differently: "There was a long debate about whether [the hygienic needs of the audience] would be better served by using the paper on which the art reviews of Ms Zuckerkandl were printed, or by a special dress for the lavatory lady which Professor Hoffmann was to design. In the end, however, it was agreed that the cistern was to be painted white and the beloved chequerboard pattern imprinted upon it."[31] The retort from Oskar Kokoschka: "Kraus has bitten the Fledermaus lavatory attendant in the leg because she's not wearing clothes from the Hoffmann collection."[32] But even this age was not ready for the *Gesamtkunstwerk*, it seemed; in 1913 the Fledermaus was taken over. Under its new name of "Femina", it became a variety theatre with hostesses.

Josef Hoffmann: Cabaret Fledermaus, view of the foyer and bar, 1907. The table and chairs include the now legendary "Fledermaus chair".

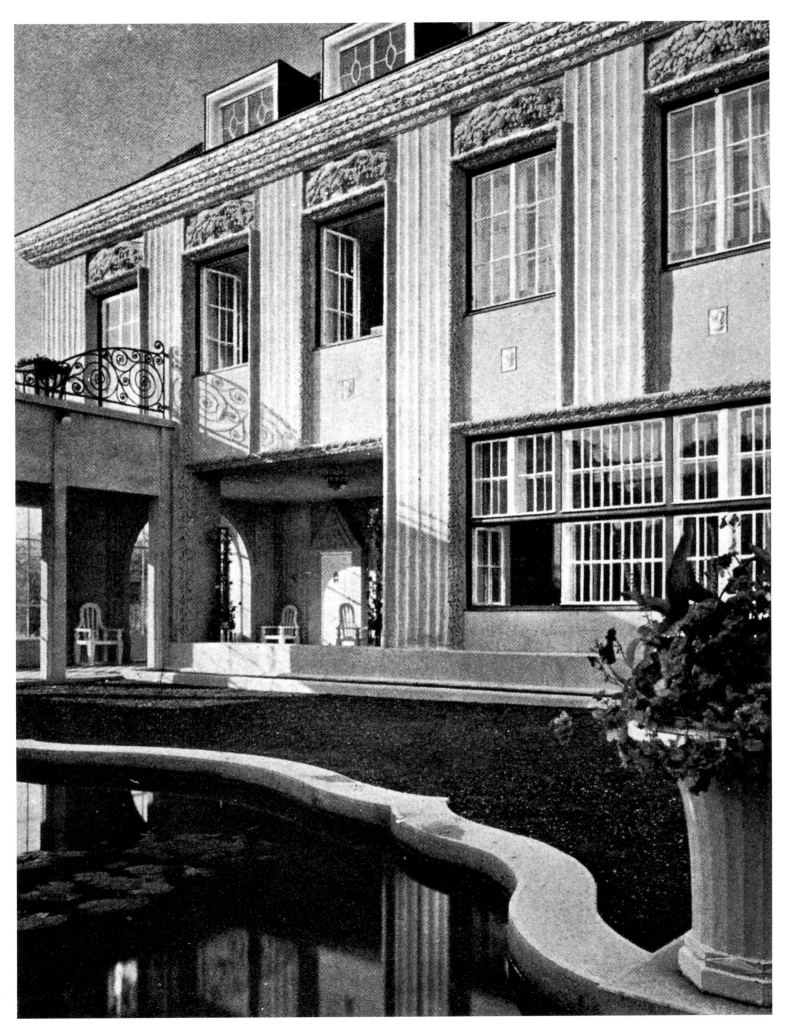

68 Villa Ast (1909–1911)

Villa Ast (1909–1911)

The architectural projects executed by Josef Hoffmann and the Wiener Werkstätte between 1905 and 1910 – i.e. from the embarkment upon the Palais Stoclet to the start of work on the Villa Ast – clearly draw upon a number of different stylistic points of reference. Thus the influence of the British country-house style and of Charles Rennie Mackintosh is evident in a number of private residences (e.g. the Hochreith hunting lodge for Karl Wittgenstein, 1906, and the Villa Carl Moll II, 1906–1907), while other interiors and exteriors reveal an interest in folk art (e.g. the villa built for Dr. Otto Böhler, 1910–1911, and the Primavesi country house in Winkelsdorf, 1913–1914). The Villa Ast, on the other hand, takes its cue from the Palais Stoclet – only here the classicist tendencies of the earlier building evolve into a purer classicism. The English country-house style might have been made for the homes in Hohe Warte, the new villa colony on the outskirts of Vienna. The fact that, in Britain, the houses in question actually lay in the countryside, and not in urban suburbs, meant that the imported style now mutated into a suburban architecture with a country-house character.

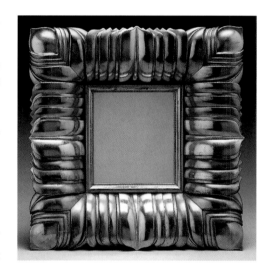

Dagobert Peche: Mirror, c. 1925, gilded rosewood, mirror glass

The elements of vernacular art employed in Wiener Werkstätte architecture reflected an interest in the protection of historical monuments, a desire to tie in with local building styles, a growing awareness of tradition, and the discovery of Primitive art. As with other stylistic means, Hoffmann employed folk art, too, in a consistent manner. For dinner in the Primavesi country house, for example, the residents wore not only evening dress but also specially designed robes made of hand-printed Wiener Werkstätte fabric. "Pork feasts" were held, featuring local Moravian culinary specialities. The lady of the house frequently fled her private chamber, with its folklorist decoration, for the woodshed in order to find some peace and quiet. Hoffmann himself, so it is reported, preferred to occupy the guest room with the black-and-white interior on the ground floor.

Although the first designs for the Villa Ast similarly contain echoes of a vernacular style, the final building is dominated by classicist principles of composition. The word "classical" is a description not simply of architectural style, but also – and above all – of architectural value. The term may be applied to any age and style in which certain factors of "classicalness" come together: maturity, i.e. a historic moment which is a culmination of the past; unique self-fulfilment in the historical sense; consciousness of this maturity and uniqueness; and a consequent perfection. From this point of view, "classical" is synonymous with "classic"; it becomes the description not of a style but of an achievement of the highest order – complete self-realization.

Page 68: *Josef Hoffmann:* Villa Ast, Hohe Warte, Vienna, view of the garden façade from the pond, 1909–1911. The pond in the centre of the garden courtyard has a decoratively curved border and is flanked by concrete vases.

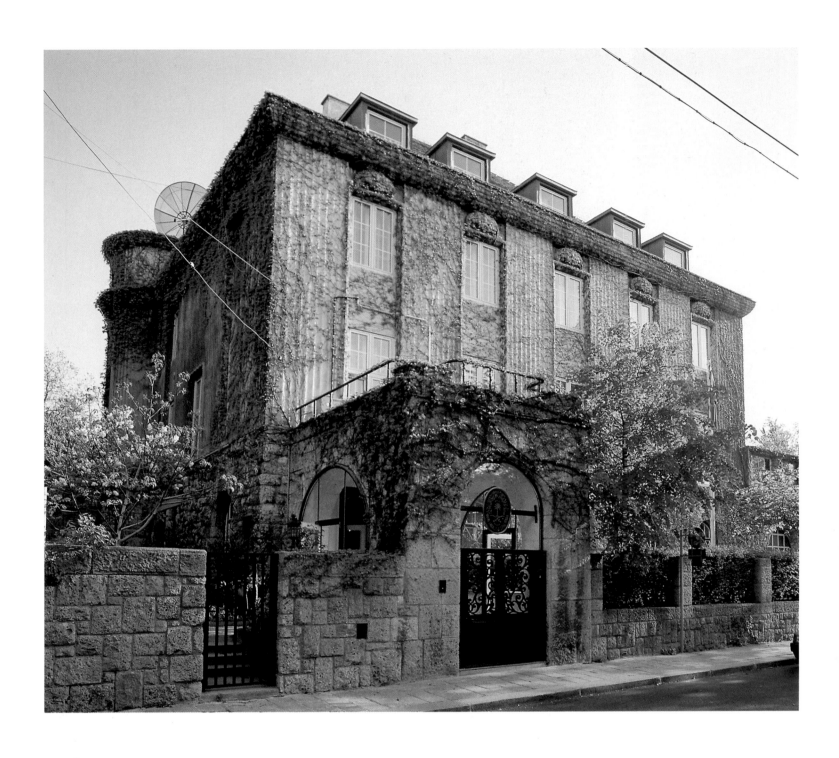

Josef Hoffmann: Villa Ast, Hohe Warte, Vienna, view of the front façade, 1909–1911 (photograph: 1994). The decorative motifs on the façade of the Villa Ast – cordated foliage combined with all sorts of floral and umbellate forms – demonstrate the encrustment technique perfected by the villa's owner, Eduard Ast.

The Villa Ast was commissioned by Eduard Ast, a structural steel engineer with whom Hoffmann had already worked on several occasions. The villa's design was undoubtedly influenced by Ast's wish to show off, on the façade, the encrustment technique which he had perfected. The garland-like reliefs running around the windows are directly related to the Palais Stoclet, as is the emphasis upon the vertical in contrast to horizontal ornamentation. Here, however, the transparent, smooth-flowing quality of the Brussels building has given way to a tectonic approach in the classicist spirit. The pronounced fluting of the masonry, the solid, projecting main cornice, the use of pilaster strips and capitals, and the triangular fields above the doorways are demonstration of Hoffmann's aim to arrive, by re-creating a historical classicism, at an independent, mature style of his own based on an "elementary" geometry. The interior décor and furnishings in the Villa Ast obey the same principle.

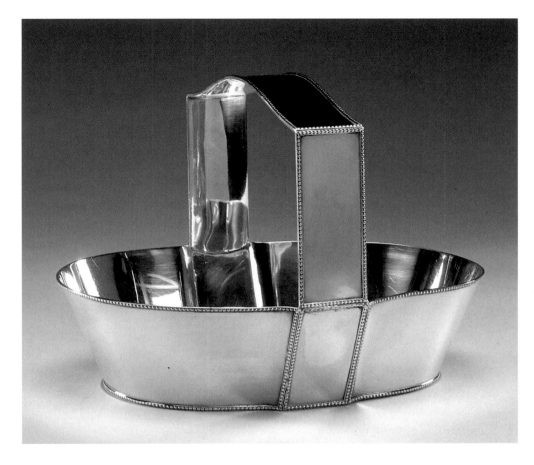

Josef Hoffmann: Fruit basket, 1909, silver-plated brass; made by Anton Pribil

Josef Hoffmann: Villa Ast, Hohe Warte, Vienna. dining-room, 1909–1911. The walls are partially faced in brownish-black portovenere marble mottled with orange and white. Fluting and leaf motifs characterize the decorative stuccowork.

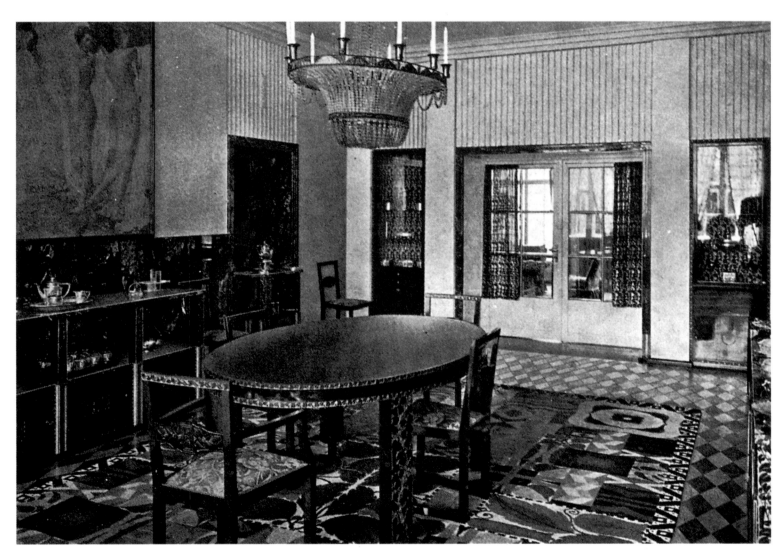

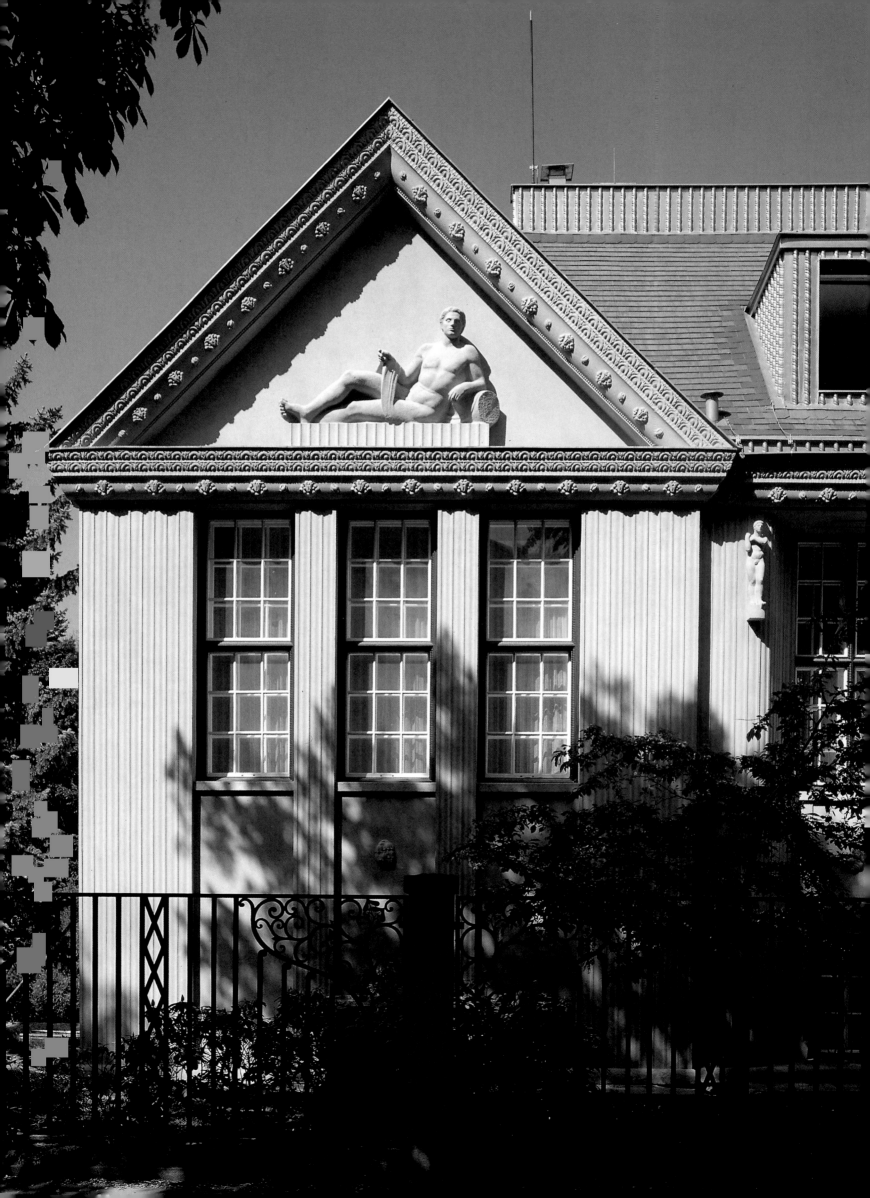

Villa Skywa-Primavesi (1913–1915)

During the years 1910 to 1914, a period rich in commissions for the Wiener Werkstätte, Josef Hoffmann and his colleagues developed an increasing tendency towards monumentality and the decorative, albeit without forgetting the discipline of their early purist phase. In retrospect, the style thus created may be seen to anticipate Art Déco. Whereas at the Exposition Internationale des Arts Décoratifs et Industriels Modernes (International Exhibition of Decorative and Industrial Modern Arts) held in Paris in 1925 – *the* Art Déco exhibition, and indeed the one that gave the style its name – the work displayed by the Wiener Werkstätte presented a Viennese art which was already moving on to something new.

The interiors and objects designed by Dagobert Peche were typically decorated with subtle lanceolate leaves and flowering tendrils far removed from the more weighty ornament of French Art Déco, and even further removed from the "little squares" of Hoffmann's Purkersdorf Sanatorium. While the Wiener Werkstätte is today frequently accused of "retrogressing" from 1905 onwards, this is not correct. Judged in terms of our current understanding of what constitutes modern, namely simplicity and clear lines, the Purkersdorf style may indeed appear the most contemporary and "modern" in the history of Wiener Werkstätte architecture. But if we consider the art of the 20th century as a whole, Josef Hoffmann and the Wiener Werkstätte were permanently one step ahead of the rest.

While Art Nouveau artists shortly after the turn of the century were indulging in lavish linear ornament, Vienna embraced purism. Whereas industrial design had been widely discovered before the First World War, it was the Wiener Werkstätte who anticipated the costliness of post-war art. Peche's ornamental style of the twenties in turn seems to prefigure the "playfulness" of the fifties. To put it emphatically, the Wiener Werkstätte was not simply *one* of the many associations of artists formed this century, but – seen in context – *the* designer group of the twentieth century. In the words of Julius Posener, speaking in a lecture: "Austrian *Jugendstil* has always possessed a geometric tendency. Its grand master is Josef Hoffmann; although there are designs by the very same Hoffmann which seem to anticipate sketches by Mendelsohn."[33]

"Grand master" Josef Hoffmann remained the point around which the Wiener Werkstätte crystallized. His artist associates do not appear to have changed arbitrarily or by chance, and all exerted equal influence upon his own stylistic development. What mattered was not whether they adapted themselves to Hoffmann's intentions or impressed their own forms of expression upon him, but that they were

Josef Hoffmann: Design for a tumbler, "Var. F", broncit decoration, c. 1910

Page 72: *Josef Hoffmann:* Villa Skywa-Primavesi, Vienna, view of the left-hand lateral projection in the street façade, 1913–1915 (photograph: 1994). The south façade, which overlooks the street, is organized into eleven axes. The reclining figures adorning the gables and the six smaller figural sculptures beneath the cornice were carved by Anton Hanak. The Villa Skywa-Primavesi represents a high point in Josef Hoffmann's "classicist period".

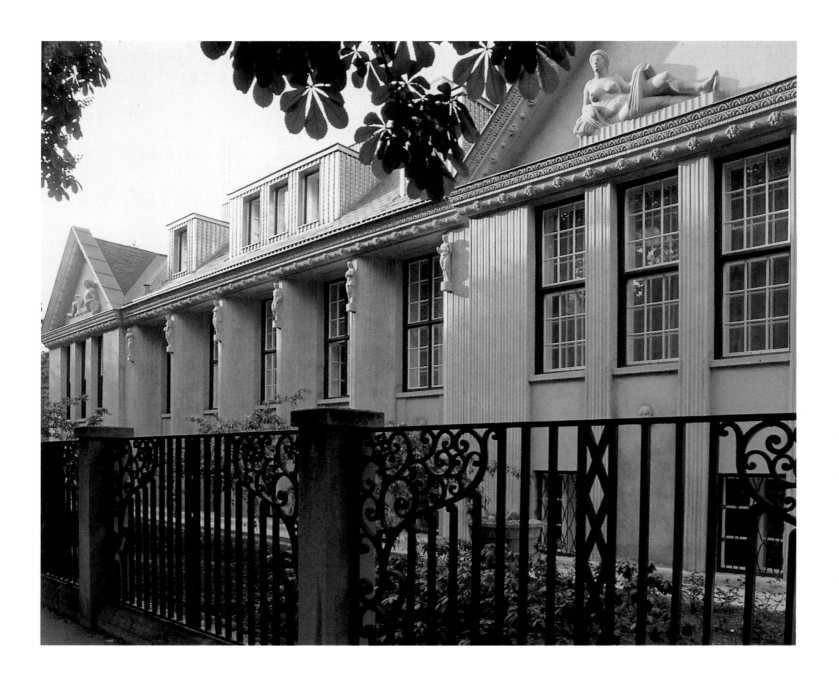

Josef Hoffmann: Villa Skywa-Primavesi, Vienna, view of the street façade, 1913–1915 (photograph: 1994)

kindred spirits working towards the same goal. If Koloman Moser was Hoffmann's companion in the early "geometric" years, he was succeeded in later years by Eduard Josef Wimmer-Wisgrill, the Wiener Werkstätte's "fashion designer". Wimmer-Wisgrill's highly personal vocabulary of forms left its decisive mark on the Villa Skywa-Primavesi. The constantly recurring motif of the "bell-flower" – calyces on fragile stalks incorporated into a geometrizing frame – extends not simply to architecture, metalwork and wall decoration, but also to silverwork, glass, fabrics, and indeed to practically all the products of the era, and was "borrowed" by Hoffmann just as much as by other Wiener Werkstätte artists. The architect Oskar Strnad was another new colleague who exerted an influence upon the Skywa-Primavesi project. Strnad's plain, classicist designs for the Lobmeyr glassworks anticipate Art Déco glass. Hoffmann's collaboration with sculptor Anton Hanak would also prove significant.

In 1913–1914, at a time when Europe's social problems were becoming increasingly urgent and the concept of "publicly-assisted housing" was gaining in significance, there arose in the shape of the Villa Skywa-Primavesi a building which offered

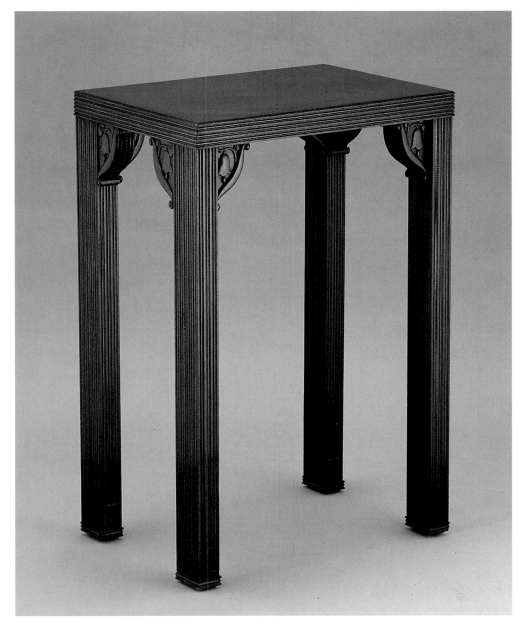

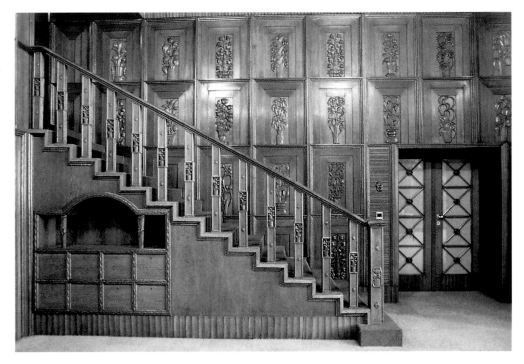

Josef Hoffmann: Side table designed for the Villa Skywa-Primavesi, c. 1915

Josef Hoffmann: Villa Skywa-Primavesi, Vienna, detail of the panelling in the hall, 1913–1915

Josef Hoffmann: Villa Skywa-Primavesi, Vienna, view of the main hall with staircase, 1913–1915 (photograph: 1990). The walls and ceiling are clad in dark oak with a natural wood finish. The upright panels, with their three different levels of relief, feature carved floral motifs at their centre; executed by J. Solek, Vienna

Villa Skywa-Primavesi (1913–1915) 75

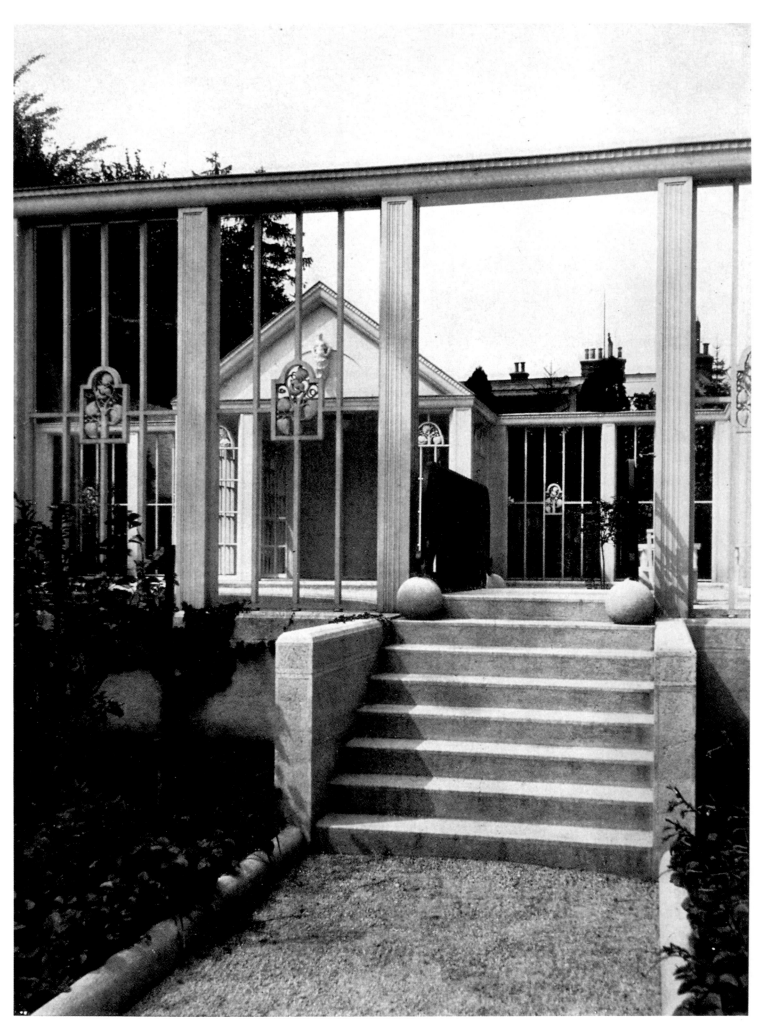

76 Villa Skywa-Primavesi (1913–1915)

a perfect statement of the pretentions to grandeur of a social class whose days were already numbered. It was as if the cultivation of beauty was to heal the gaping wounds torn open by politics. Love of life was to be defended against a deadly threat. A diary entry of 1897 by Stefan Zweig – "We even talked about politics" – might equally well be applied to pre-First World War Vienna. And as Hugo von Hofmannsthal commented: "We must bid farewell to a world before it collapses. Many people have realised this already, and an inexpressible feeling is turning them all into poets."

The Villa Skywa-Primavesi was commissioned by Robert Primavesi, the cousin and brother-in-law of Otto Primavesi, who himself commissioned the Primavesi country house in Winkelsdorf and who played a central role in the financial affairs of the Wiener Werkstätte. In 1912 the Wiener Werkstätte was made into a limited company under English law. Fritz Waerndorfer, under the pressure of financial circumstance, was dispatched to America by his family. The largest shareholders now became Otto and Eugenie Primavesi, who owned 30%. They had been introduced to the Wiener Werkstätte by Anton Hanak, who was a friend of the family. Eugenie Primavesi (p. 79 right) and her daughter Mäda are both known to us from the

Josef Hoffmann: Brooch, c. 1910–1913, fire-gilt silver and mother-of-pearl, openwork

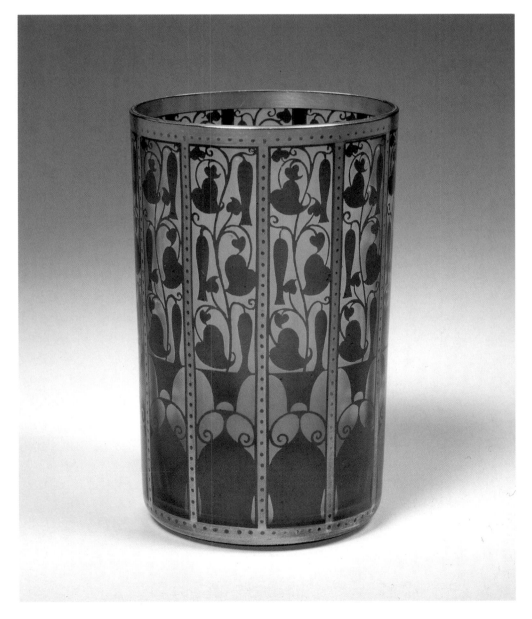

Josef Hoffmann: Tumbler, c. 1912, colourless frosted glass, stylized bell-flower and cordated leaf pattern in brown broncit (Var. E), gold paint; made by J. & L. Lobmeyr, Vienna

Opposite page: *Josef Hoffmann:* Villa Skywa-Primavesi, Vienna, the small tea house or "Tea Temple", view through the pergola, 1913–1915, sculpture by Ferdinand Andri

Josef Hoffmann: Villa Skywa-Primavesi, Vienna, the master's study, 1913–1915. The room is furnished with oriental carpets and features a chandelier specially designed by Josef Hoffmann.

Eduard Klablena: Parrot, c. 1911–1912, stoneware, white body, coloured underglaze painting, details painted on top of the glaze; made by Langenzersdorfer Keramik. Wiener Werkstätte ornament exerted an influence on virtually all the leading Vienna ceramic manufacturers of the day.

paintings of Gustav Klimt. The constant state of emergency governing Wiener Werkstätte finances eventually served to cause a rift between husband and wife, with the result that in 1922 Otto transferred his shares to Eugenie. For him, too, the Wiener Werkstätte had brought nothing but misfortune. His cousin Robert was a member of the house of representatives and, as a large-scale landowner, led a lavish social life on his estate in Moravia. After the death of his young wife, he resolved never to marry again. Instead, he lived together with his new companion Josefine Skywa, with whom he moved into their new villa in Vienna. Robert Primavesi must truly have been as self-possessed and impressive a man as descriptions would have him, since even the planning applications bear the name of Josefine Skywa alongside his own.

The actual task of construction lay in the hands of Eduard Ast, whose own recently completed "Hoffmann house", like the Villa Skywa-Primavesi, was directly de-

Gustav Klimt: Portrait of Eugenie Primavesi, c. 1913–1914, oil on canvas, 140 x 84 cm. In 1914 the industrialist Otto Primavesi, his wife Eugenie and cousin Robert Primavesi acquired a 30% stake in the Wiener Werkstätte.

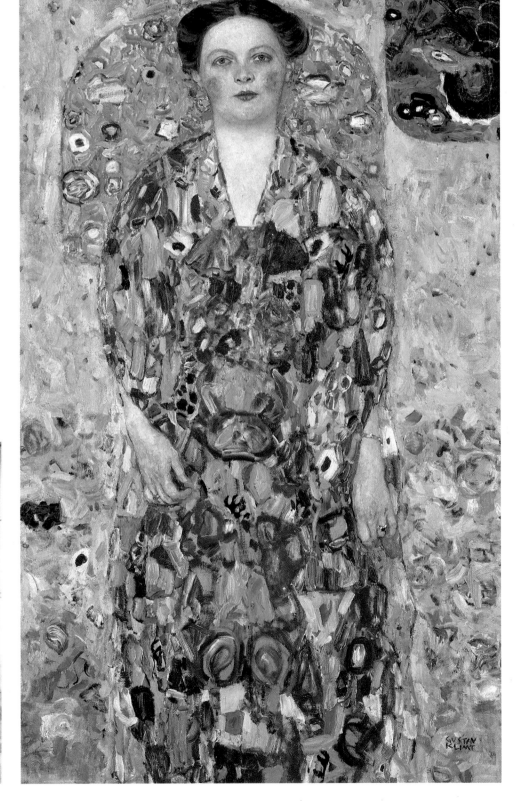

Gustav Klimt in the garden in front of his studio in Josefstädterstrasse, Vienna, c. 1912, photograph

Josef Hoffmann: "Kohleule" fabric design, c. 1910–1915, from the pattern book of silks issued by the Wiener Werkstätte around 1912

KOHLEULE
1 S1
ENTWURF VON
PROF.
J. HOFFMANN
BREITE 90 cm
PREIS: 9.90

Page 81: *Josef Hoffmann* and *Eduard Josef Wimmer-Wisgrill:* "Tazza", c. 1905, chased silver. While Koloman Moser was Hoffmann's companion in the early "geometric" years, he was later succeeded by Eduard Josef Wimmer-Wisgrill, who started the Wiener Werkstätte fashion department. Wimmer-Wisgrill's highly personal vocabulary of forms left a decisive mark upon the Villa Skywa-Primavesi. Alongside rosebuds and rose-leaves, the motif of the "bell-flower" – calyces on fragile stalks – is one that recurs constantly, incorporated into a geometrizing frame. This bell-flower motif surfaces not just in architecture, latticework and wall decoration, but also in silverwork and jewellery, on glass and fabrics, and indeed in practically all the products of the era, and was "borrowed" by Hoffmann just as much as by other artists of the Wiener Werkstätte.

scended from the Palais Stoclet. The Villa Ast, however, did not possess the palatial character that the new project shared with the Palais Stoclet.

The south-facing front of the Villa Skywa-Primavesi runs for a length of 30 metres, and the site extends backwards to a depth of 27 metres. This front façade, which faces onto the street and thus the public, is organized into eleven vertical axes in strict bilateral symmetry (p. 74). As in the case of the Villa Ast, the façade is conceived in classicist terms, employing fluted pillars and lateral projections. Ornament is provided by pearl, egg-and-dart and leaf mouldings, interspersed with numerous festoons of fruit and flowers beneath the cornice. "Classical monumentality"

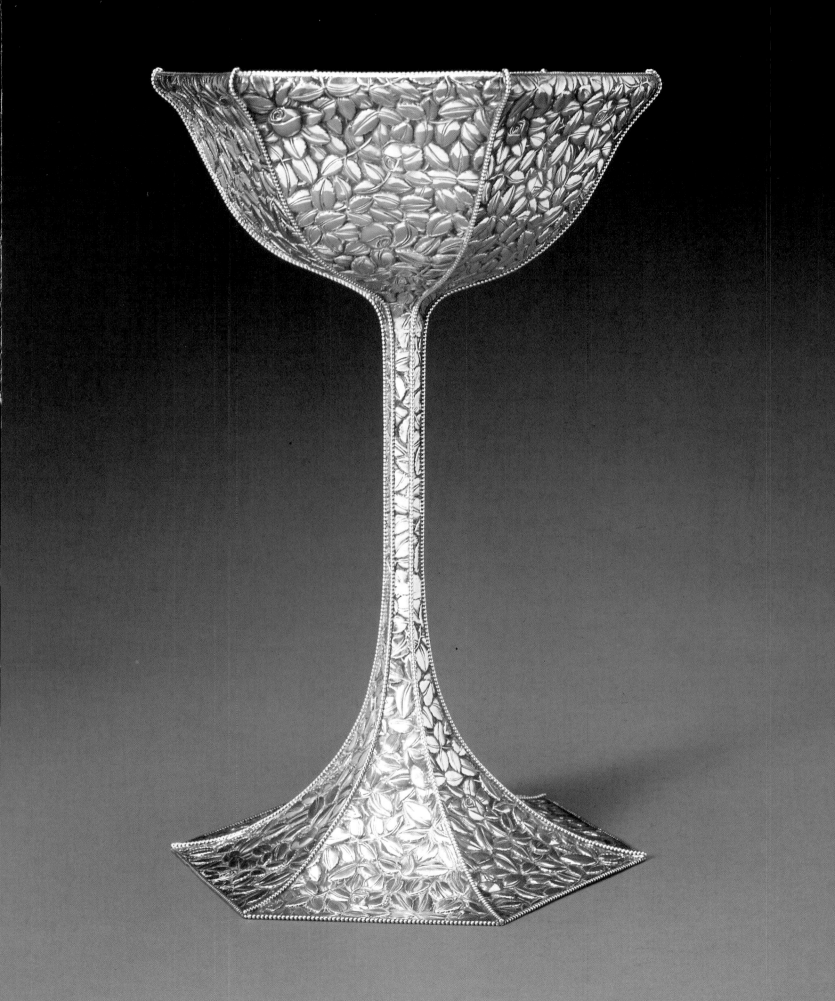

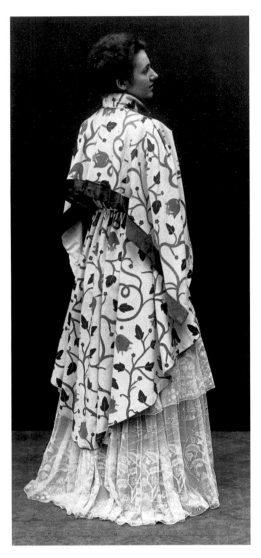

Arthur Berger: Jacket, "Mekka" fabric design, 1915, photograph

reaches its peak in the massive gable, adorned with a sculpture by Anton Hanak (p. 72). The severity of the whole is softened by the rich modulations of light and shade which arise from the careful shaping of the individual forms. Hoffmann avoids monotony by continuing to cultivate his "free style". The organization of the west-facing garden façade is more relaxed, and a "Tea Temple" with a pond and a pergola recalls memories of the rococo (p. 76).

The pavilion also bears a steep gable with a wood sculpture by Stefan Andri. The pergola, on the other hand, employs latticework with decorative floral fields – a clear illustration that, even during his classicist phase, Josef Hoffmann never relinquished the formal canon of his early years. His assimilation of Japanese influences is also evident. With its combination of strict verticals with floral cartouches, the latticework of the pergola unites two seemingly contradictory positions; just as in Japanese art, organic and geometric motifs are here found side by side as equals. This is true of all the designs from the Skywa-Primavesi years: whether furniture, fabric, glass or porcelain, every hand-crafted item bears a floral décor, inserted into or in conjunction with geometric grid patterns. Characteristic features of this period include flowers in squares or between bands of straight lines, clear fields, lozenge patterns, muted colouring in black, white and gold, or alternatively strong contrasts of complementary colours with white and black.

The design of the garden, too, was an important aspect of the "living environment" to be created in the Villa Skywa-Primavesi. The differences in ground level within the site gave rise to a succession of terraces, the largest of which bears the glazed, semi-cylindrical conservatory. It is bordered by an arcade crowned with putti by Anton Hanak.

The interiors of the Villa Skywa-Primavesi are designed in what appears to be the

Josef Hoffmann: Jardinière, 1914–1915, colourless frosted glass, broncit decoration of stylized leaves on four of the eight sides; made by J. & L. Lobmeyr, Vienna

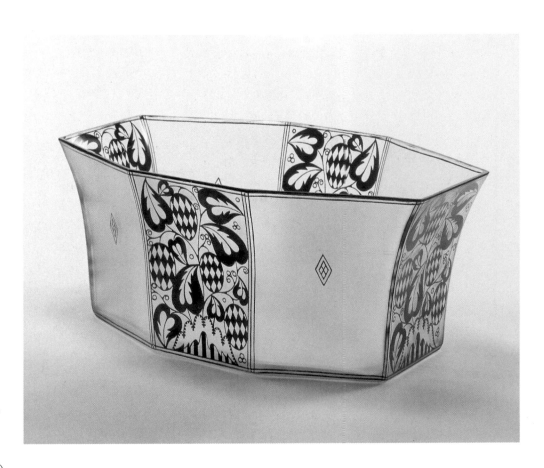

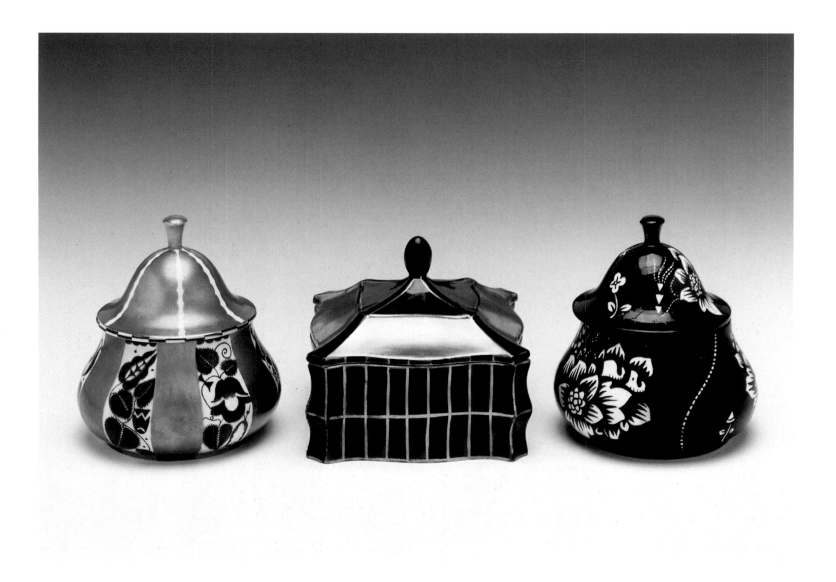

Dagobert Peche: Two lidded jars (left and right), c. 1920, glazed and painted stoneware; made by Vereinigte Wiener und Gmundner Keramik
Ernst Wahliss: Bonbonnière (centre), c. 1911–1912, glazed Serapis faience

purest Art Déco. Yet this was a style which was only given a name ten years later, after the Paris exhibition of 1925. But if we interpret Art Déco as the culmination of a wealth of inventive imagination, a flair for materials and an elegant mix of forms, then the interior of the Villa Skywa-Primavesi is most certainly Art Déco. The impressively high and light stairwell, with its free-standing marble columns and marble cladding, is very "Palais Stoclet" in the rhythmic, planar organization of its walls, and resembles the décor of later luxury ocean-going liners in its massive, rectilinear splendour. Stepping into the vestibule, the style changes – not abruptly, but smoothly. In comparison to the stairwell, it appears almost rustic, panelled in wood with decorative glasswork. The salon creates an overall impression of lightness and rococo-type ornament, although again employing marble in the skirting and door-frames. Its citronwood floor with black marquetry in a geometric pattern is pure Art Déco. Robert Primavesi's penchant for things oriental is reflected in his study (p. 78 right): the walls are hung with oriental carpets, and the chandelier was specially designed by Hoffmann in an oriental style.

At the German Werkbund exhibition of 1914, the attic of the Austrian pavilion bore an inscription from Franz Grillparzer, chosen by Hoffmann: "Science persuades with reasons; art must persuade with its existence… It is not the thought that makes the work of art, but the representation of the thought." It is the "represented thoughts" of Josef Hoffmann which fuse the diversity of his art into unity.

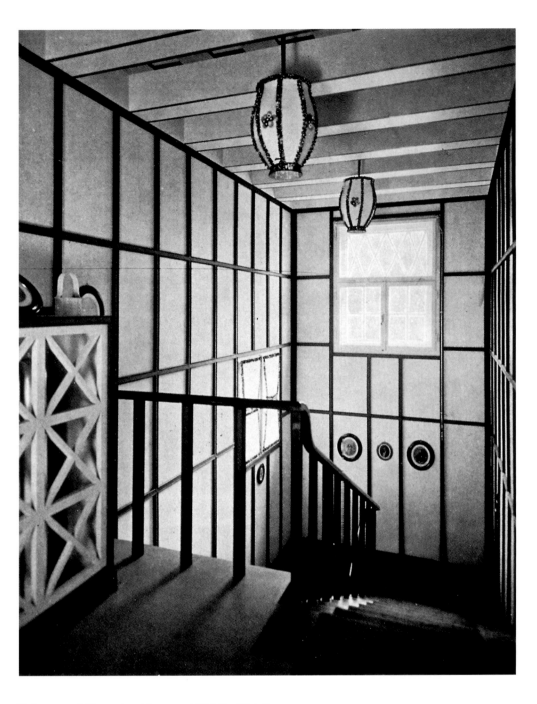

Josef Hoffmann: Primavesi country house, Winkelsdorf, view of the stairwell, 1913–1914

Primavesi Country House (1913–1914)

The Primavesi country house in Winkelsdorf, in northern Moravia, was a persuasive example of the thoughtful manner in which Josef Hoffmann and the Wiener Werkstätte integrated outside stylistic stimuli into their work. "Folk art" in this case was not translated into a cosy pine-clad parlour; instead, its elements were made subordinate to Wiener Werkstätte artistic discipline and placed in the service of a rural lifestyle. Berta Zuckerkandl aptly described this in her review of the house: "It is a home blessed with children, where interior design is matched to the youthful vitality, expression, purpose and meaning of the whole. The colourful living-room [p. 86 left], with its tile oven baroquely modelled by Professor Hanak dominating one corner, presents a cheerful sight. Next to it, as an extension of the same room, lies the dining-room, separated only by wooden pillars decorated with coloured battens. Colourful print curtains divide the rooms. Attached to the dining-room are the pantry and the kitchen, beyond which lie the servants' stairs leading to the rear courtyard.

Right: *Josef Hoffmann:* Primavesi country house, Winkelsdorf, the room of the Primavesi's daughter, Mäda, 1913–1914

Lotte Frömmel-Fochler: "Mauerblümchen" fabric design, c. 1910–1912, from the pattern book of silks issued by the Wiener Werkstätte around 1912. This design was employed for the walls and the light-shade in one of the children's rooms in the Primavesi country house.

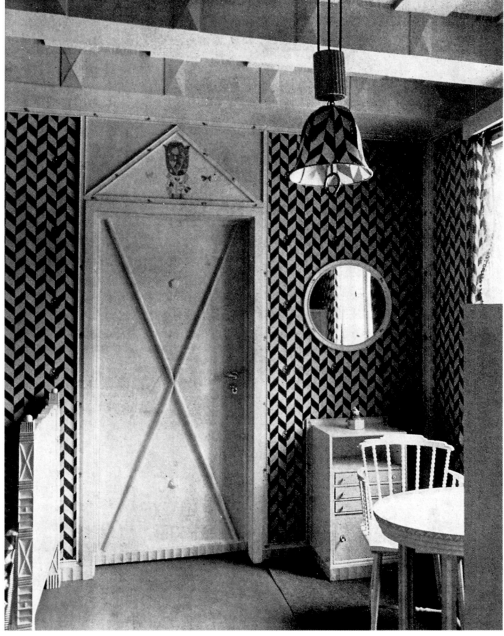

Page 86: *Josef Hoffmann:* Primavesi country house, Winkelsdorf, view of the hall, 1913–1914. The col-ourful tile oven by Anton Hanak, decorated with statues, forms the focal point of the room.

Pages 86–87: *Josef Hoffmann:* Primavesi country house, Winkelsdorf, 1913–1914, design for a bed-room, hand-coloured drawing by *Carl Bräuer* Each of the imaginatively designed rooms was given its own distinct colour scheme. The master's bedroom was decorated in light yellow and red, for example, and the lady's bedroom in blue and light blue

On the first floor, the layout of smaller rooms grouped around a large central room is repeated for the third time. This is the domain of the children, whose bedrooms are separated from those of their parents by a large playroom, whose doors open onto a children's loggia.

How differentiated the shape of each room, each colour scheme and each piece of furniture, in every case the most perfect expression of its respective purpose; and yet how absolute the unity into which these so very individual rooms neverthe-less fuse, and indeed become the most perfect expression of a type! This is some-thing granted only to high art. In this rhapsodic house, resplendently coloured and showered with ornamental decoration, such all-embracing harmony is only achieved through an intuitive sense of ideal proportions – perhaps the absolute value of the Hoffmann style. Traditional Moravian popular culture is rooted in colour... And it is thus that the fundamental aim of the artistic design is to be understood: to be a conscious continuation of surrounding nature... One would like to call this most recent and rare work by Josef Hoffmann his pantheistic confession of faith."[34]

Primavesi Country House (1913–1914) **85**

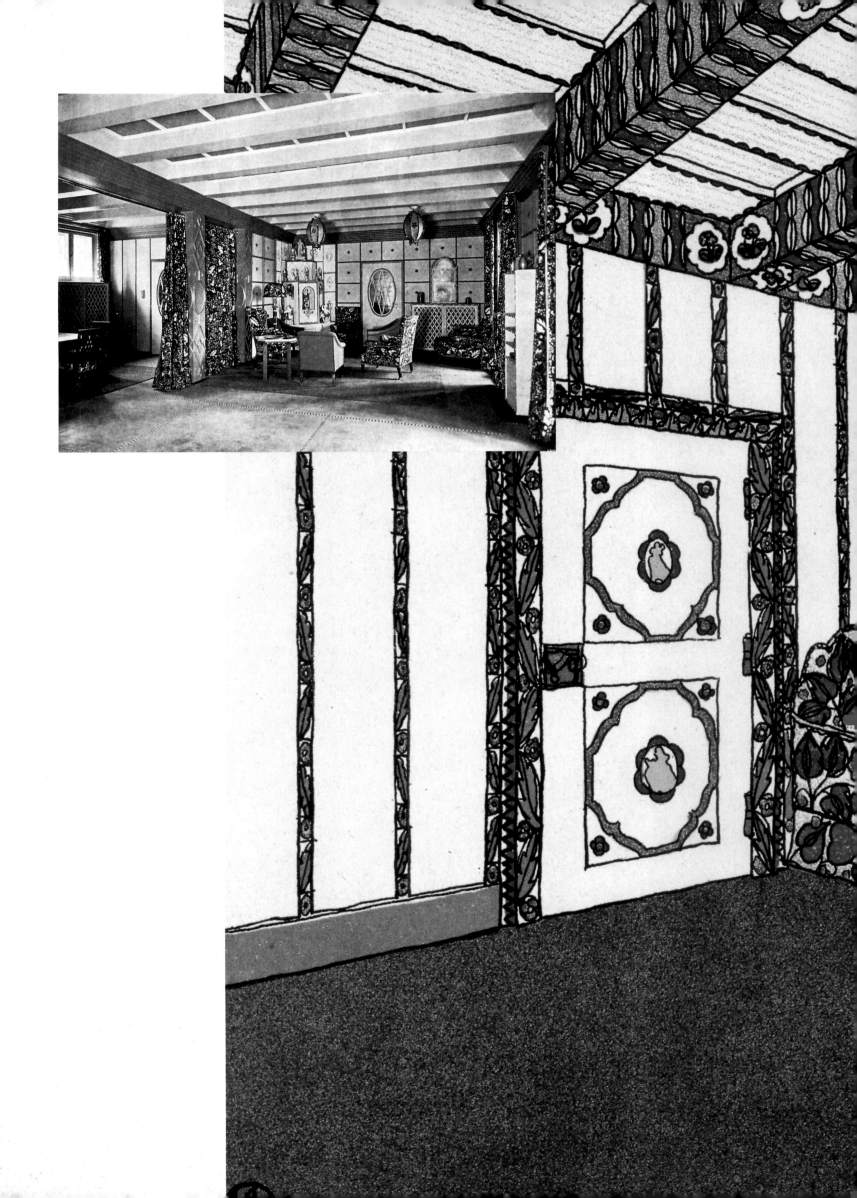

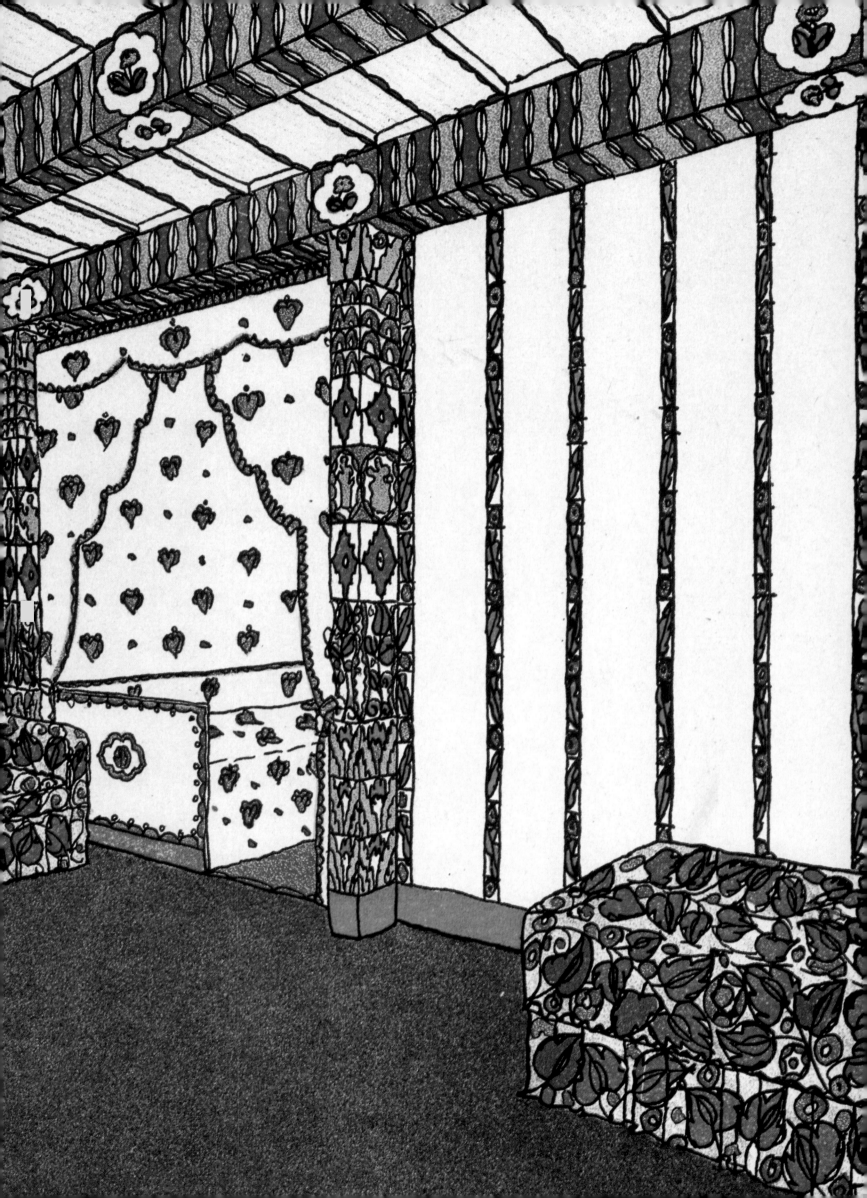

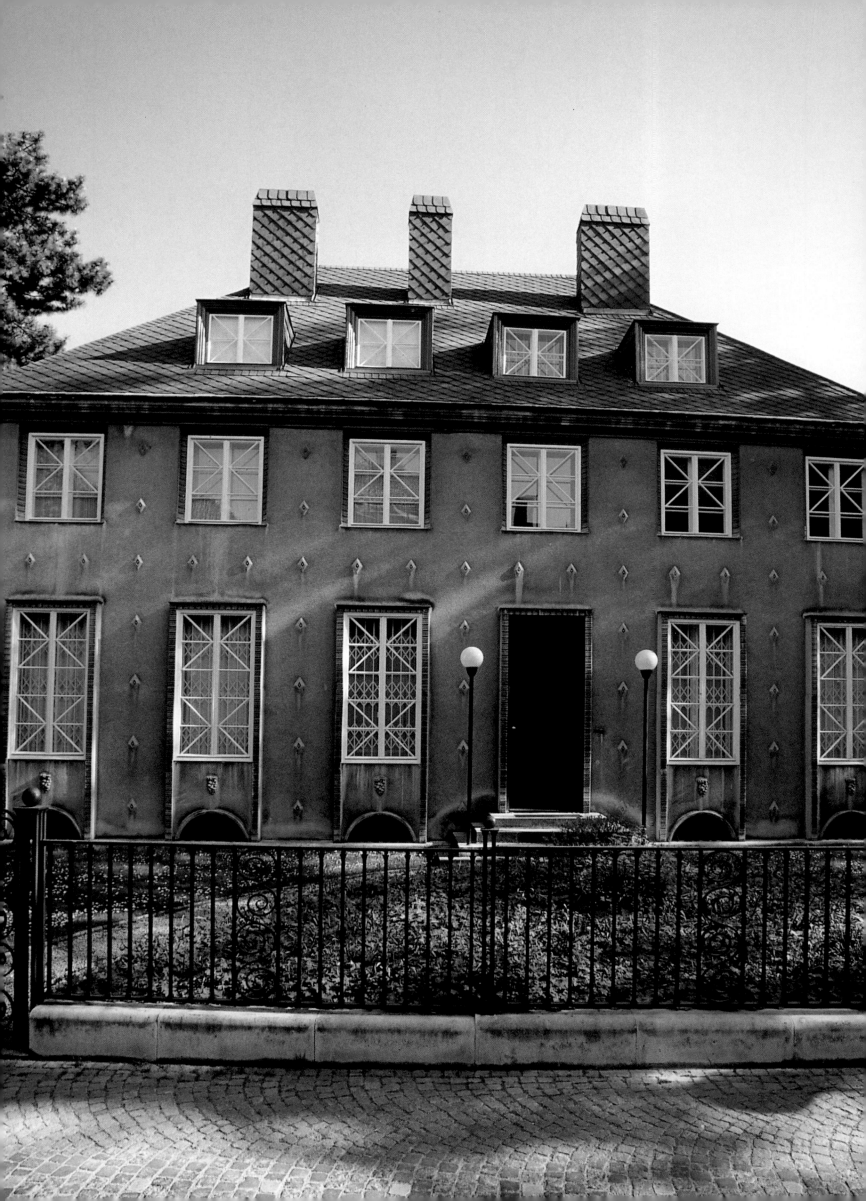

Sonja Knips House (1924–1925)

In the last of the urban villas which Josef Hoffmann designed in Vienna, the house for Sonja Knips which arose between 1924 and 1925, he drew once again upon the English country-house style. The simple, generous ground plan and the clear layout of the rooms are in the best tradition of the Arts and Crafts movement. The building features many traditional elements, including a compact main body and a hipped roof, with a low wing extending to the right. Such echoes of Biedermeier architecture were by no means coincidental: the Sonja Knips House is located in Döbling, which was an old Biedermeier district of Vienna, and Josef Hoffmann's design is an expression of his respect for the setting in which the new house was to be built.

In contrast to the Villa Skywa-Primavesi, the Sonja Knips House has a front lawn, which sets it back from the street and permits a clear view of the façade. The otherwise symmetrical front façade is studded with rows of small, diamond-shaped elements and, between the windows of the ground floor and the cellar, bunches of grapes. The tall hipped roof, dormer windows and chimneys are finished in slate. The only asymmetrical feature is the front door, which is positioned slightly off-centre. Amidst the architectural rigour of this composition, the row of ground-floor windows offers a presentiment of the large, clear rooms inside, whose blank walls were hung with the paintings of Gustav Klimt. Sonja Knips had sat for the artist in 1898, and the resultant painting was Klimt's first important female portrait and the work in which he found his own personal style.

Josef Hoffmann was again fortunate in finding an ideal patron in Sonja Knips. The immense significance of this fact is described by Leo Adler: "Whereas, everywhere else, the 'work of art to order' is the exception, in architecture it is the rule. This means, however, that every building expresses, alongside the creative impulse of the architect, another component which has its origins in another individual... Its realization requires the assent of *essentially foreign* factors."[35]

Sonja Knips, née Baroness Poitier des Echelles, was *essentially akin* to Josef Hoffmann. In her style and philosophy of life, she belonged to the Art Nouveau era; she was a firm believer in the *Gesamtkunstwerk*, something she demonstrated many times in her loyalty to the Wiener Werkstätte over the years. Josef Hoffmann had already designed a country house of astonishing simplicity for the Knips family in 1903; in the same year he designed Sonja Knips' Vienna apartment. This was followed by commissions for a dining-room in 1909 and in 1919 the Knips family tomb. Incidentally, the piece of land which this "ideal customer" found as the site

Gustav Klimt: Portrait of Sonja Knips, 1898, oil on canvas, 145 x 145 cm. This painting of the young Sonja Knips was Klimt's first important female portrait.

Page 88: *Josef Hoffmann:* Sonja Knips House, Vienna, façade without the side wing, 1924–1925 (photograph: 1994)

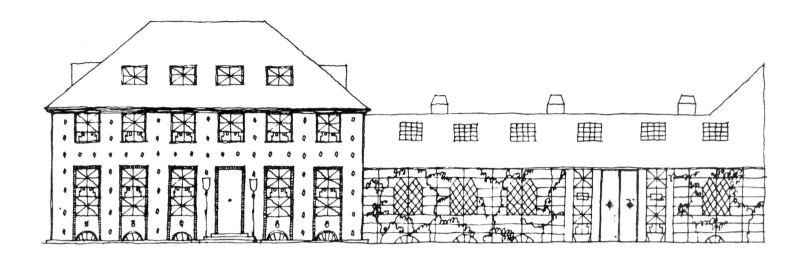

Josef Hoffmann: Sonja Knips House, Vienna, design for the façade with side wing, 1924

Josef Hoffmann: Sonja Knips House, Vienna, 1924–1925, view of the main building from the garden

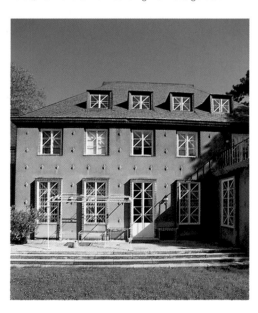

for her new house belonged to that other female Wiener Werkstätte enthusiast, Berta Zuckerkandl.

For Josef Hoffmann in the mid-twenties, a house was – in his own words – "simply four walls which define a ground".[36] The decoration of the interior by the Wiener Werkstätte, however, unmistakably reveals the influential hand of Hoffmann's colleague Dagobert Peche, "the greatest genius of ornament that Austria has possessed since the Baroque".[37]

Writing in 1923, Josef Frank viewed the collaboration between Hoffmann and Peche thus: "Dagobert Peche, the draughtsman, took the place of Josef Hoffmann, the giver of form. A draughtsman of unusual skill, of splendid imagination, who for many years has exerted a tremendous influence both at home and abroad…"[38] It is interesting at this point to compare Hoffmann's first design for the Sonja Knips House, drawn up in 1919, with the version finally executed in 1925. The original projection for the façade features a considerably larger number of "Pechean" elements. Its showcase front façade, ornamented in a less sober, more maneristic fashion with fragile decorative elements, lies directly on the street. Slender cast-iron columns, a cast-iron main cornice decorated with foliage, together with pointed-arch windows lend the building a sense of lightness and give the façade a certain expressive dynamism. Hoffmann here clearly demonstrates his identification with the applied arts in which the Wiener Werkstätte was engaged.

At the opposite remove to Neue Sachlichkeit (New Objectivity), ornamental line once again played a favoured and leading role. Grace and ease dominate the works of the leading Wiener Werkstätte artists of this period, such as Emanuel Josef Margold, Maria Strauss-Likarz and of course Dagobert Peche. Josef Hoffmann also made increasing use of the arabesque; his purism had metamorphosed into lighter, more curvacious structures, not only in his designs for hand-crafted items, but also in his architecture. This is apparent, for example, in his interiors for Sigmund Berl's house in Freudenthal (1919–1922) and for Eduard Ast's country house on Lake Wörth (1923–1924). Even the Sonja Knips House still has aspects in common with

this decorative phase, albeit tempered by a reserve which already looks forward to a very different future. The verticals framing the windows in the final version are composed of horizontal elements stacked one above the other, as in the Sigmund Berl House. The pointed double windows from the first design are retained in the wing of the finished building. The garden façade (pp. 90, 91) is a perfect mixture of decorative elements and clear grid patterns. The same is true of the interior: generously sized rooms and spacious areas of blank wall are framed by bands of decorative reliefs. The motifs, part abstract and part florally arabesque, derive from the formal vocabulary of Dagobert Peche. Although Peche was no longer involved in the project – he had died prematurely in 1923 – many of the design features stem from his hand, in particular the upholstery fabrics which match the interior décor.

Christine Ehrlich, a pupil of Josef Hoffmann and Michael Powolny, carried out the stucco decoration. In masterly fashion, she succeeded in combining the two aspects of Wiener Werkstätte style: expressive ornament and pertinence. Particular attention was naturally paid to the private rooms of the lady of the house. The boudoir

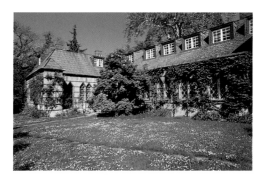

Josef Hoffmann: Sonja Knips House, Vienna, view of the garden façade from the swimming-pool, 1924–1925 (photograph: 1994). The side wing turns a corner at the boundary of the plot.

Josef Hoffmann: Sonja Knips House, Vienna, view of the garden façade, 1924–1925 (photograph: 1994)

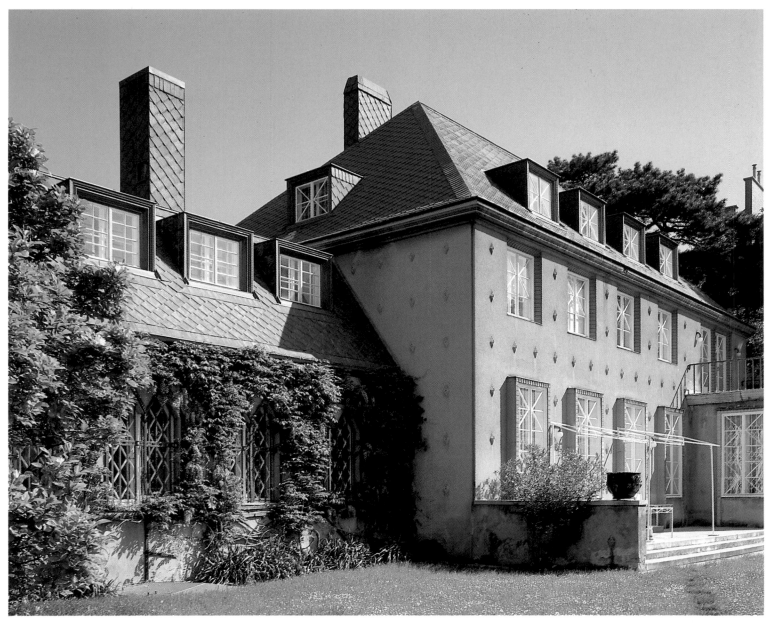

Sonja Knips House (1924–1925) 91

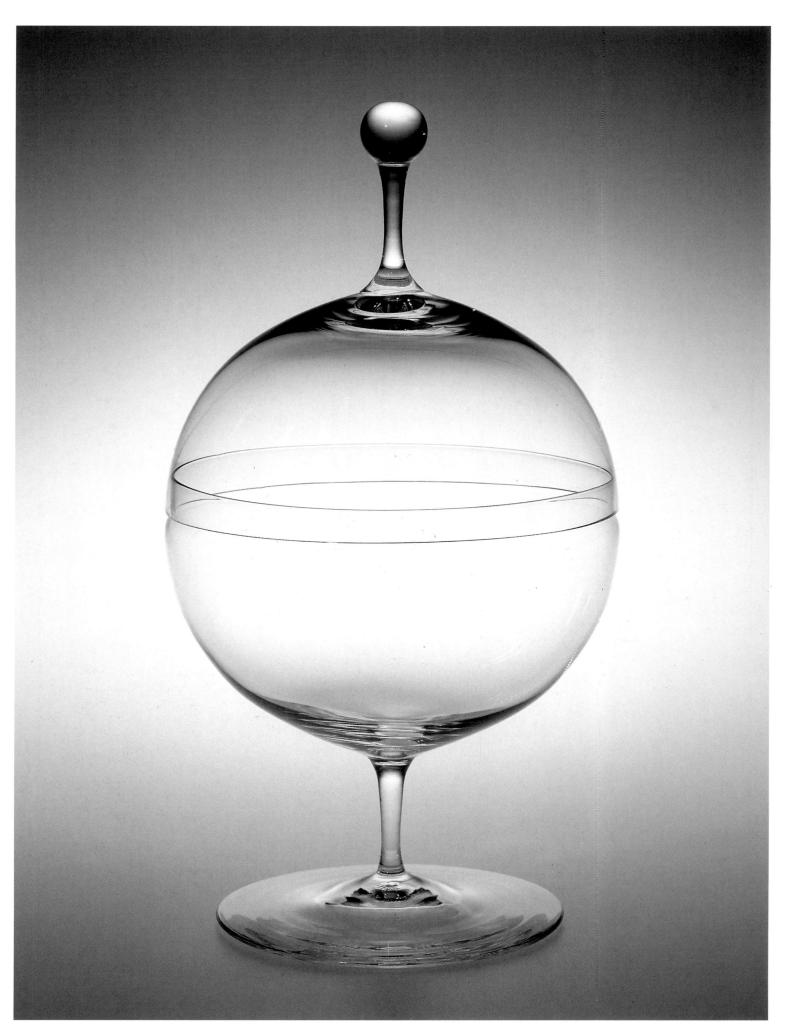

Josef Hoffmann: Sonja Knips House, Vienna, view of the glazed cupboards in the kitchen, 1924–1925. The kitchen, decorated and furnished entirely in white, is "transparently" connected to the dining-room and living-room by a wall cupboard glazed on both sides.

was originally conceived for an exhibition in the Austrian Museum in 1923; in 1925 it was shown at the Exposition International des Arts Décoratifs et Industriels Modernes in Paris and was subsequently constructed again that same year in Macy's department store in New York. The room, a cross between an oriental divan and a French boudoir, reflects the tastes of the "roaring twenties".

A French critic observed sarcastically: "The room lacks only the scent of opium, and one might easily assume that it was intended for a certain purpose, were it not for a small basket of balls of wool standing by the door, conjuring up the shade of the chaste and faithful Penelope."[30] The "certain purpose" no doubt sprang to the gentleman's mind in view of the room's erotic décor. The central panel depicts scenes from the life of a lady who is receiving her admirers. A "special niche for

Page 92: *Oswald Haerdtl:* Bonbonnière, c. 1925, muslin glass; made by J. & L. Lobmeyr, Vienna

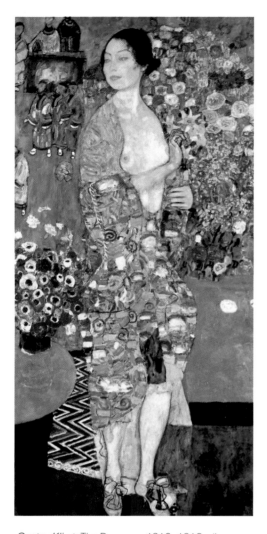

Gustav Klimt: The Dancer, c. 1916–1918, oil on canvas, 180 x 90 cm. This painting was the focal point of the entrance rotunda in the Wiener Werkstätte's New York branch.

keepsakes" contains a sensual Venus by Susi Singer and intarsia-like paintings by Maria Strauss-Likarz. A sleeping or resting area is built into a decorative niche, beside which are located a small bar, smoking accessories and confectionery. Scattered pillows and wood-carvings reminiscent of Chinese motifs complete the impression of exoticism. A further ceramic female nude by Susi Singer stands in front of the window.

Turning to the other rooms in the Sonja Knips House, the rich diversity of twenties' style quickly becomes apparent. Each of these rooms employs different stylistic means to create its own atmosphere. Thus the bedroom is characterized by "warm" cherry-wood cupboards and panels, while the adjoining dressing-room is restricted to "cool" shades, as in the Palais Stoclet. In the "make-up room", with its simple dressing-table, the upholstery is almost "jazzy". The high point of these rooms is the elegant salon containing Klimt's portrait of the young Sonja Knips.

The transparency and lightness arrived at in the early years, and so significant for the *Neues Bauen* of the 1920s and 1930s, is reiterated in the linking of the living-room, dining-room, kitchen and study. A wall cupboard glazed on both sides (p. 93) provides the connection between the rooms. The contents of the cupboard are thus visible from both directions. The kitchen, which is decorated and furnished entirely in white, is thoroughly modern, as is the crockery in the wall cupboards. A simple, functional design. The influence of Oswald Haerdtl is evident here. Haerdtl trained under Moser and in 1922 became Josef Hoffmann's assistant. It was he who implemented the new, objective style which would be profoundly influential upon the future of design. Some of his glassware (cf. p. 92) and applied-art designs are still being produced today.

Josef Urban: Seating ensemble comprising two armchairs and a table, c. 1921, varnished wood, mother-of-pearl, natural linen and silk. The upholstery is based on a 1917 design by *Dagobert Peche*, which Josef Hoffmann had already used in the Ast country house and would later employ in the Sonja Knips House. The ensemble was on show in the entrance rotunda of the Wiener Werkstätte's New York branch.

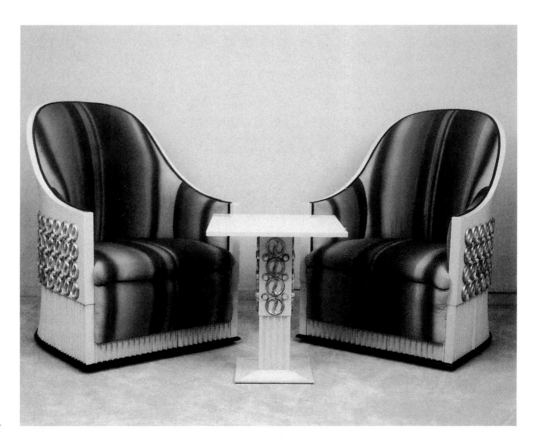

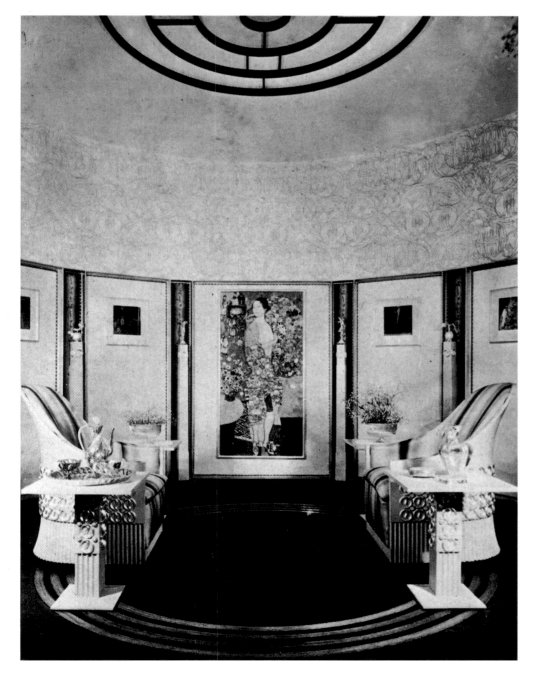

Josef Urban: Entrance rotunda of the Wiener Werk-stätte's New York branch, c. 1922. The Wiener Werk-staette of America, Inc. opened its showroom on the 2nd floor of 581, Fifth Avenue in autumn 1922. The initial response was excellent, and a large proportion of the goods on display were sold within the first two days.

Josef Urban

It was the talented and imaginative architect Josef Urban who took the Wiener Werkstätte to America. He had already made a name for himself with Otto Wagner and Josef Hoffmann in the pre-war years and, like Carl Witzmann, had earned acclaim as an exhibition designer. The clear affinity between Wiener Werkstätte style and American design is surely nowhere clearer than in high-rise architecture, that fundamentally American type of building.

The primary influences acting upon American architecture and design did not derive from Art Déco, as so often assumed, but rather from Scandinavia, Germany and Austria. Josef Urban went to America in 1911. There he ran his own "Decorative and Scenic Studio" and worked as a designer for the Metropolitan Opera and for Ziegfeld, for whom he also built a theatre. He designed over twenty films for William Randolph Hearst.

FACADE·OF·THE·PROPOSED·MAX·REINHARDT·THEATRE·IN·NEW·YORK·CITY·

After visiting Vienna in 1921, he founded an Artists' Fund to help the impoverished artists of the Wiener Werkstätte. Urban also put up the capital for the foundation of the Wiener Werkstaette of America, Inc., and in 1922 designed the branch's showroom on Fifth Avenue. Urban thereby manifested the quintessential Wiener Werkstätte style of the twenties. The interior design is both "classically decorative" and "decorative class". The influence of Dagobert Peche is evident in the ornamental principle underlying the design, while Josef Hoffmann is present in its classicism. Urban's own furniture designs, white high-gloss armchairs, are upholstered in the famous modulated-stripe fabric which Peche had designed in 1917 (pp. 94 below, 95), and which was also employed in the Ast country house and later in the Sonja Knips House. The gleaming mother-of-pearl inlay and the gold decoration are like an American version of the more light-footedly ornate originals by Dagobert Peche. In the entrance rotunda of the New York branch (p. 95), the focal point was provided by the portrait of a dancer by Gustav Klimt (p. 94 above). One of his late pictures, in which his portraiture, typified by "ephebic nobility and strongly Old-Testament *hautgoût*"[40], fuses seamlessly with his love of the decorative.

The opening exhibition met with a tremendous reception; people paid homage to Josef Hoffmann, who was already famous in America, and enthused over the almost "shrill" pieces by Peche. Klimt, too, found a growing number of collectors. William Randolph Hearst became a loyal supporter, but even his financial bestowals could not prevent the failure of the ambitious venture. Eduard Josef Wimmer-Wisgrill – who had taken up a teaching post in Chicago – attempted a restructuring, but in 1924, after just two years, Josef Urban closed the business, angered by exorbitant bills from the parent company. While the "American dream" may have been short-lived, the artistic repercussions cannot be estimated too highly.

Josef Hoffmann: Vase, c. 1904, silver, decorative design of perforated squares

Carl Witzmann

One of the keys to the magnificent works executed by the Wiener Werkstätte lay in the ability of its protagonists to nurture the talents of all concerned, to allow everyone sufficient artistic freedom, and to act not in a doctrinaire but in a motivating fashion. They thereby put into practice the English notion of the Guild and School of Handicraft. Alongside many other "pupils", Carl Witzmann stands out in particular for the creative freedom which he brought to Wiener Werkstätte "decorative purism". "…Just because they are concentrating primarily upon the typical characteristics of contemporary style, however, does not mean to say that the younger generation of artists now succeeding the leaders lack their own personality… Witzmann and Prutscher may be numbered amongst these… What is at work here is a mind which understands interior design as a unifying factor, which models furniture which is not simply there to fill the room, but which serves its organization."[41] (Berta Zuckerkandl)

"In each of his works, Witzmann concentrates upon the artistic element without losing sight of function. As a true pupil of Hoffmann, he knows how to bring out the beauty of the material, which he does with deliberation and dignity."[42]

Carl Witzmann was the Wiener Werkstätte's most gifted exhibition designer. His talents as an architect and his no less imaginative flair as a designer enabled him

Page 96: *Josef Urban:* Design for the façade of the Max Reinhardt Theatre between 50th and 51st Street, New York, 1929, ink and watercolour on paper. Linearity, latticework, grid and "little squares" – all elements of the early vocabulary of form employed by the Wiener Werkstätte in New York.

Page 98, above: *Koloman Moser:* Three square-bottomed rectangular vases with right-angled handles, c. 1905, sheet iron painted white, decorative design of perforated squares

Pages 98–99: *Carl Witzmann:* Foyer of the Wallpaper Exhibition, Vienna, 1913.
"…wallpapers are capable of so many and varied effects! Some fill the room with large and splendid forms, toned down solely through their rhythmic repetition, and providing a background against which furniture, sculpture and people cut a lively clash and hence stand out as favourably as possible. Other wallpapers reduce the wall to a simple, strict pattern of stripes, offering a flattering foil to any curves standing in front…"[43]

Carl Witzmann: Design for an interior, c. 1905–1910, coloured chalk, pencil and ink on paper. The inscription (translated) reads: "Anteroom. Apartment. J. Müller. Brünn Architect. C. Witzmann"

to translate the concept of the "total work of art" into exhibition format, and furthermore to make it plausible. According to a review of the 1913 Wallpaper Exhibition in the Austrian Museum of Art and Industry (pp. 98–99): "The preparations for the exhibition were carried out by a committee which included Josef Hoffmann, Alfred Roller, Schmidt, purveyor of wallpaper to the imperial household, and the director of the museum. The architect Carl Witzmann has done a sterling job on the design. From a technical point of view, the exhibition is a perfect success, perhaps even setting the example for all future events of this kind… wallpapers are capable of so many and varied effects! Some fill the room with large and splendid forms, toned down solely by their rhythmic repetition, and providing a background against which furniture, sculpture and people cut a lively clash and hence stand out as favourably as possible. Other wallpapers reduce the wall to a simple, strict pattern of stripes, offering a flattering foil to any curves standing in front; others are strewn with small, regularly repeated motifs; others again transform the surface into a colourful chaos of fabulous vegetal forms, evoking a particularly powerful sense of enclosure. Some patterns are designed to allow sections of wall to be emphatically demarcated, a measure which divides the surface into smaller, clearly assimilable compartments and thereby serves as a very appreciable 'visual aid' when taking in a room… Thus wallpaper is even used to practise architecture…"[43]

Carl Witzmann, a "first-rate master of stagecraft", had already played a substantial role in designing the Kunstschau (Art Show) exhibition held in Vienna in 1908. He also showed a room at the Werkbund exhibition in Cologne in 1914, featuring furniture made by J. & J. Kohn (p. 101). In harmonious contrast to the strict linear ornament of the walls, glass cabinets and floor, the furniture was ornamented with sweeping arabesques and almost Biedermeier curves.

Carl Witzmann: Cupboard, c. 1904, wood painted white and black, brass mountings

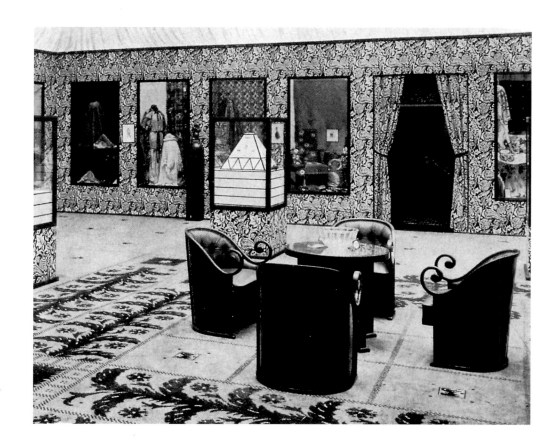

Carl Witzmann: Decorative arts display in the Austrian Pavilion at the German Werkbund exhibition, Cologne, 1914

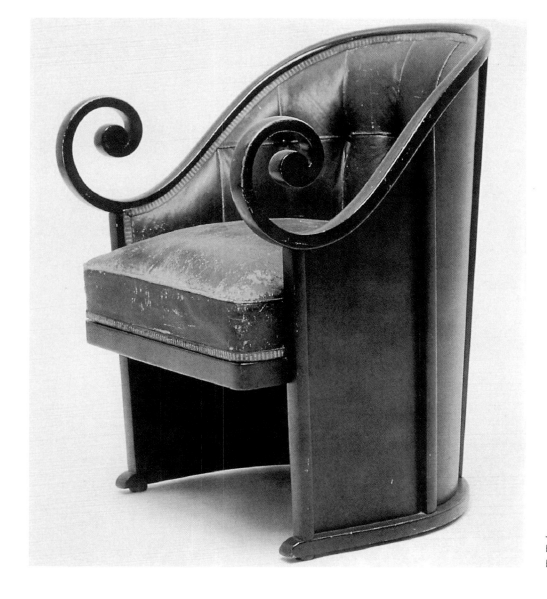

Jacob & Josef Kohn, Vienna: Armchair, 1914, beech and plywood, bent, stained black, blue leather

M1:10.

19☐04

Furniture

"The furniture of Art Nouveau cannot be considered independently of the designed interiors in which it stood. It was a period in which furniture once again became a component part of an integral décor. The comprehensive vision overlying every aspect of the furnishings frequently meant that individual pieces took second place to a cohesive overall effect. A room might be entirely dominated by certain stylistic trends, or its walls, carpets and furniture might be infused throughout with constantly recurring formulae of line and ornament. These instantly gave the room an unmistakably homogeneous appearance and made everything seem to belong together. Any consideration of individual chairs, cupboards or other items of furniture in isolation can therefore serve only to shed light on their finer details and the artistic intentions of their designers."[44]

The "philosophy of the right angle" which characterized the early furniture of Josef Hoffmann and Koloman Moser undoubtedly had its origins in Scotland. The elective affinity with Charles Rennie Mackintosh was striking not only at the stylistic level, but also in the fact that in Vienna as previously on a more modest scale in Glasgow, such furniture was conceived chiefly within the framework of a complete interior ensemble. The large part of Mackintosh's furniture arose as part of an overall design scheme and not as individual commissions. "Architectural furniture" thus became a concept not confined simply to theory, but one given concrete expression in the many furniture types named after the building for which they were designed. Mackintosh's Willow Tea Room chair, for example, had already preceded Hoffmann's Coffee-house chair. The formal principles informing Mackintosh's chair are developed entirely out of the interior to which it belongs. Taken by itself, the chair is highly individual, almost meaningless; within its surroundings, it is not first and foremost functional, but is perfectly integrated into an intellectual pretention – the total work of art. "Here was indeed the oddest mixture of puritanically severe forms designed for use with a truly lyrical evaporation of all interest in usefulness. Here was mysticism and asceticism, though by no means in the Christian sense, but with much of a scent of heliotrope, with manicured hands and a delicate sensuousness".[45]

The Wiener Werkstätte, by its very nature as an association of artist craftsmen and women, was able to rectify a problem which Mackintosh was never able to overcome. From a technical point of view, the furniture issuing from Glasgow had numerous defects; it was made as simply as possible and did not always represent the best statical solution. One of the chief problems was that Mackintosh worked not with trained cabinetmakers, but with ordinary craftsmen who came from the ship-building

Josef Hoffmann: Bed, 1903, oak with ebony verneer, rubbed with chalk. The bed was made for the Wittgenstein/Stonborough apartment and the country home of the Knips family.

Page 102: *Josef Hoffmann:* Design for three chairs, 1904, pencil, black ink and coloured crayon on squared paper; probably for the reception of the fashion salon run by the Flöge sisters (cf. p. 41). The design clearly testifies to Hoffmann's "confrontation" with the Glasgow designer Charles Rennie Mackintosh, whose elongated chair backs came to represent a "Mackintosh trademark".

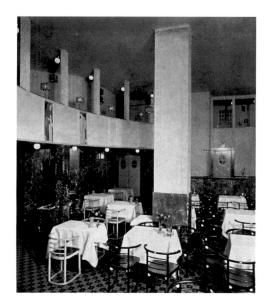

Josef Hoffmann: Cabaret Fledermaus, auditorium, 1907

industry. The sloppiness in the construction of his furniture was markedly at odds with the sophistication of his designs. It was the declared aim of the Wiener Werkstätte to vanquish the evils of machine manufacturing and the mass production to which it had given rise. It also wished to re-establish direct contact between consumer and producer. In its furniture workshop, architect-designers were able to have their designs executed by the best and most skilled cabinetmakers, something which Mackintosh's circumstances did not allow. Thus the furniture built by the Wiener Werkstätte was not only beautiful in terms of exterior form, but its construction was conceived and executed in the best possible manner, in line with the Wiener Werkstätte *Arbeitsprogramm* (Work Programme) of 1905: "The immeasurable harm caused in the realm of arts and crafts by shoddy mass production on the one hand, and mindless imitation of old styles on the other, has swept through the entire world like a huge flood. We have lost touch with the culture of our forebears and are tossed about by a thousand contradictory whims and considerations. In most cases the machine has replaced the hand, and the businessman has taken the craftsman's place. It would be madness to swim against this current.

All this notwithstanding, we have founded our workshop. It exists to provide on native soil a point of repose amid the cheerful noise of craftsmanship at work, and to give comfort to all who accept the message of Ruskin and Morris. We make our appeal to all those who value culture in this sense, and we hope that even our inevitable mistakes will not deter our friends from promoting our ideas.

We wish to establish intimate contact between public, designer and craftsman, and to produce good, simple domestic requisites. We start from the purpose in hand,

Josef Hoffmann (attributed): Table (left), c. 1905, oak, brass mountings, balls between the struts. *Josef Hoffmann:* Table (right), c. 1908, oak, rubbed with chalk, hammered brass top and base mount; made by J. & J. Kohn, Vienna (attributed)

Page 105: *Josef Hoffmann:* Coffee-house chair, c. 1906, painted bentwood, red leather upholstery; made by J. & J. Kohn, Vienna. Original design for the Cabaret Fledermaus.

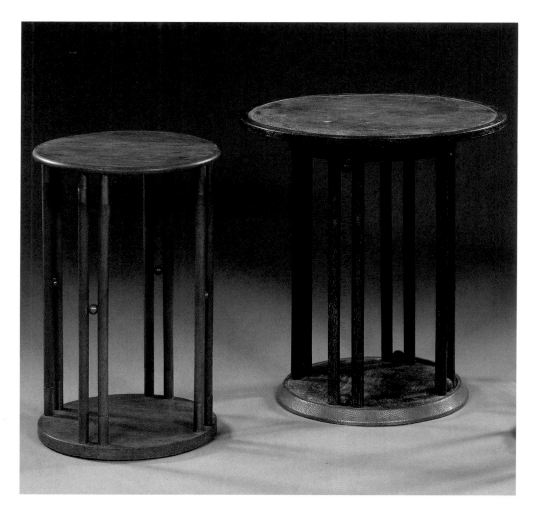

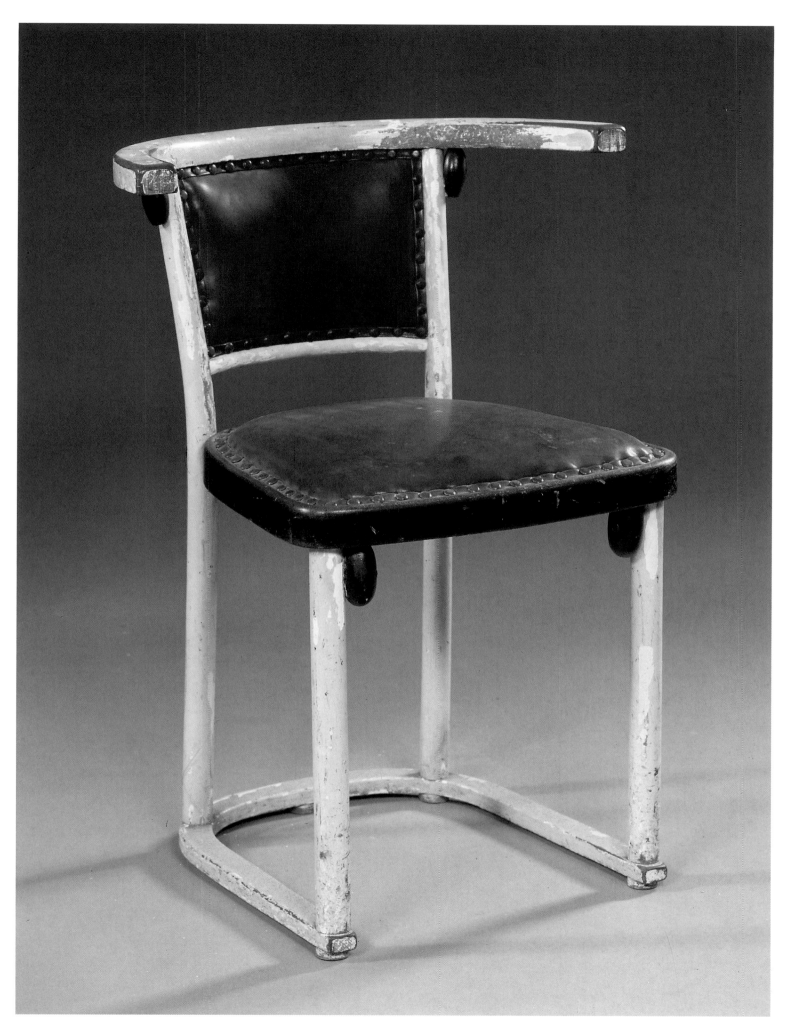

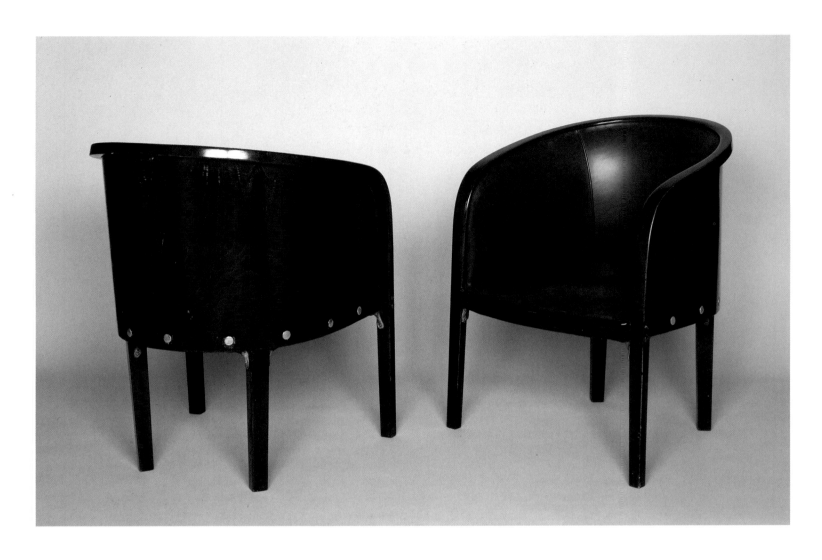

Josef Hoffmann: Two easy chairs, c. 1902, half-barrel-shaped, mahogany-stained red beech, polished brass rivets on the back

usefulness is our first requirement, and our strength has to lie in good proportions and materials well handled. We will seek to decorate, but without any compulsion to do so, and certainly not at any cost. We use many semi-precious stones, especially in jewellery − they make up in beauty of colour and infinite variety what they lack in intrinsic value by comparison with diamonds. We love silver for its sheen and gold for its glitter. In artistic terms, copper is just as valuable as precious metals, as far as we are concerned. We feel bound to admit that a silver ornament can be just as valuable as an object made of gold and precious stones. The worth of artistic work and of inspiration must be recognized and prized once again. The work of the artist craftsman is to be measured by the same yardstck as that of the painter and the sculptor.

We neither can nor will compete for the lowest prices − that is chiefly done at the worker's expense. We, on the contrary, regard it as our highest duty to return him to a position in which he can take pleasure in his labour and lead a life in keeping with human dignity. All this can only gradually be achieved.

We aim to use materials of quality and ensure a technically impeccable execution in our leatherwork and bookbinding, just as we do in all our other activities. It goes without saying that we apply decoration only where the nature of the material does not militate against it. We make use of all the leather inlay techniques in turn, of blind blocking and good tooling by hand, leather braicing and marbling.

Good bookbinding has completely died out. Hollow backs, wire stitching, ugly trimming, poorly secured pages and bad leather have become ineradicable. The

so-called individual binding, i.e. a factory-made wrapper generously covered with stereotypes, is all we have got. The machine works away diligently and fills our bookcases with ill-printed volumes; its criterion is cheapness. Yet every cultured individual should feel ashamed of such material abundance: for on the one hand ease of production leads to a diminished sense of responsibility, while, on the other, abundance leads to perfunctoriness. How many books do we genuinely make our own? And should one not possess these in the best paper, bound in splendid leather? Have we perhaps forgotten that the love with which a book has been printed, decorated and bound creates a completely different relationship between it and us, and that intercourse with beautiful things makes us beautiful? A book must be a work of art in itself, and its value must be assessed as such.

In our cabinetmaking workshops, execution of the most accurate and solid kind is the basic rule. We have unfortunately become accustomed nowadays to such shoddy goods that even a moderately carefully made piece of furniture seems beyond our means. It must be remembered that we are driven to erect a fair-sized house and furnish it with all that it needs at a cost equivalent to – say – that of constructing a railway sleeping car. This should make it plain how impossible it is to establish a solid foundation. Even a century ago, hundreds of thousands were already being spent on one room in a country mansion; and now modern workmanship is blamed for its lack of elegance and paucity of imagination, though it might prove effective beyond belief if only the necessary commissions were to hand. The

Below left: *Koloman Moser:* Armchair, c. 1901 mahogany-stained and polished bentwood, supporting disks and rivets of brass; made by J. & J. Kohn, Vienna

Below right: *Josef Hoffmann:* Wing chair, 1903, mahogany-stained bentwood, original upholstery; made by J. & J. Kohn, Vienna

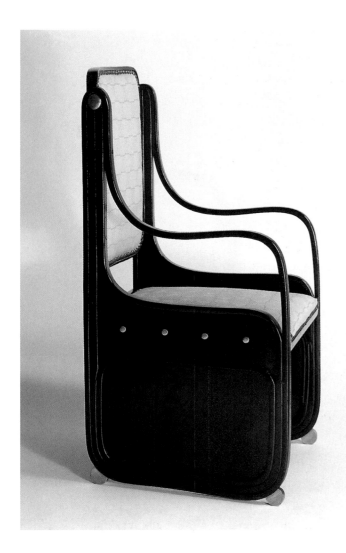

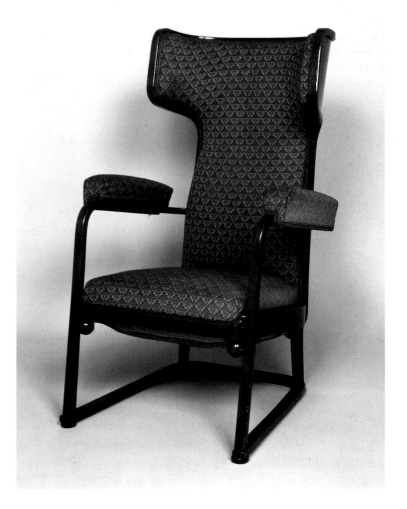

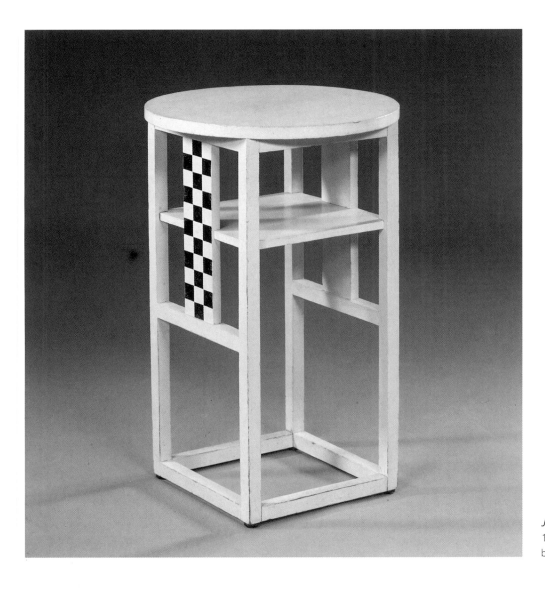

Josef Hoffmar n (attributed): Side table, c. 1903–1905, beech, painted white and decorated with a black-and-white chequerboard pattern

substitutes provided by period reproductions are strictly for *parvenus*. Today's bourgeois, and today's worker, must have enough pride to achieve a clear sense of their own worth; they must not try to compete with other classes that have accomplished their cultural tasks and rightly look back upon a splendid past in terms of art. Our middle class is as yet very far from having fulfilled its cultural task. Its turn has come to do full and wholesale justice to its own evolution. It is certainly not enough merely to buy pictures, however splendid they may be. So long as our cities, our houses, our rooms, our furniture, our effects, our clothes and our jewellery, so long as our language and our feelings fail to reflect the spirit of our times in a plain, simple and beautiful way, we shall lag infinitely far behind our ancestors; no lie can conceal these weaknesses.

May we also point out that even we are aware that a mass-produced object of a tolerable kind can be provided by means of the machine; it must, however, then bear the imprint of its method of manufacture. We do not regard it as our task to enter upon this area yet. What we are trying to do is what the Japanese have always done: who could imagine an item of Japanese craft art produced by mechanical means? We shall undertake to carry out whatever lies within our power. But even a single step forward requires the cooperation of all our friends. We are in no position to chase after daydreams. We stand with both feet firmly planted in reality and need tasks to carry out."[46]

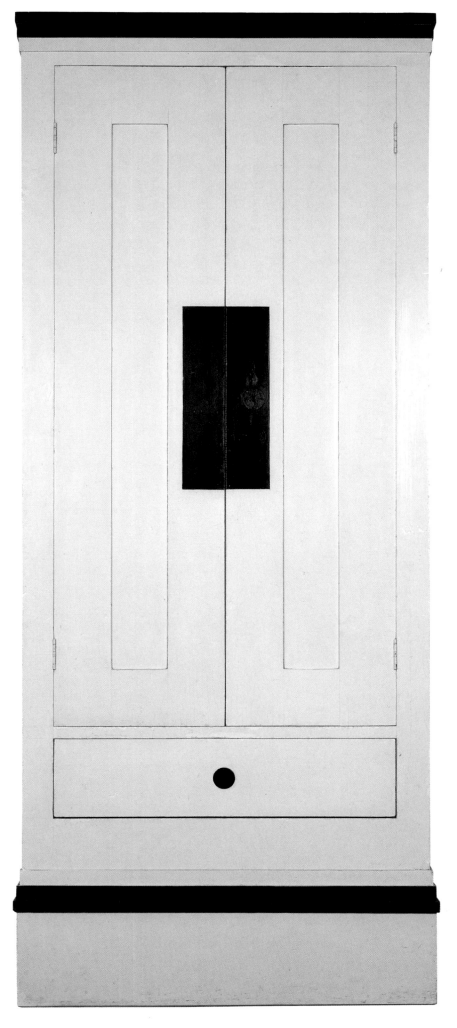

Koloman Moser (attributed): Cupboard, c. 1903–1905, wood, painted white with a decorative upright rectangle in blue

Emilie Flöge in the garden of Klimt's studio in Josef-städterstrasse, Vienna, c. 1905–1906; photograph by Moriz Nähr

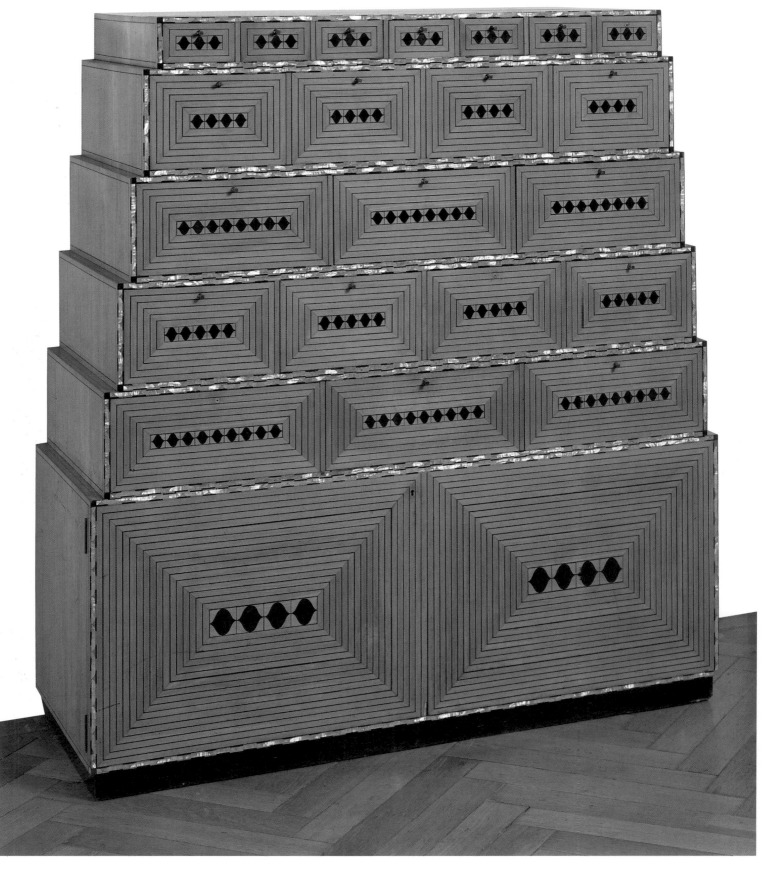

Page 110: *Eduard Josef Wimmer-Wisgrill:* Chest of drawers, c. 1910–1914, softwood, with mother-of-pearl, boxwood and ebony marquetry

Right: *Koloman Moser:* Armchair, 1904, rosewood verneer, decorative design in dark-painted wood, encrusted, stylized bird in maple, feathers and beak in mother-of-pearl

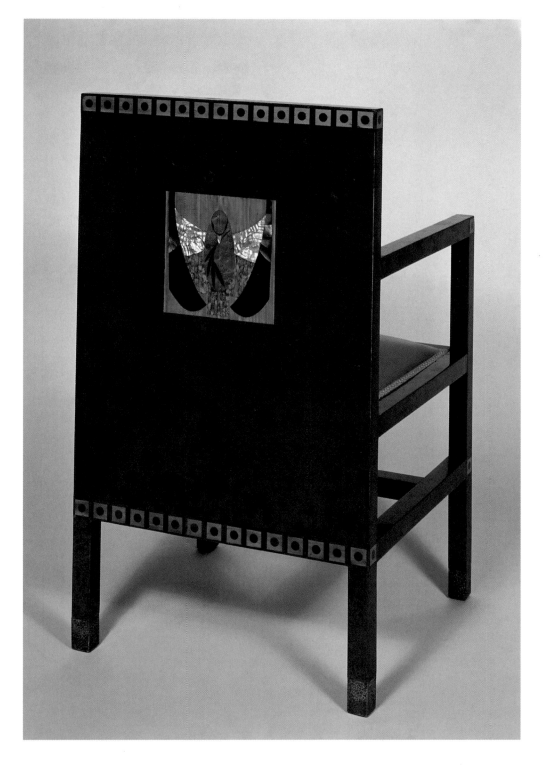

Koloman Moser: Armchair, c. 1905, mahogany-stained bentwood, brass sleeves, original upholstery; made by J. & J. Kohn, Vienna

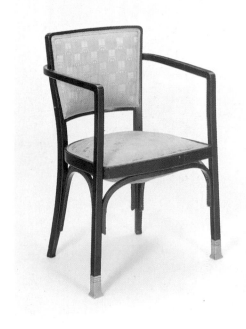

Wiener Werkstätte furniture is discussed in the chapters on the individual building projects, since it evolved primarily, as stated earlier, as a dimension of interior décor rather than as individual designs. The significance of this "holistic" approach to design is clearly underlined in the words of the Wiener Werkstätte Work Programme: "A book must be a work of art in itself, and its value must be assessed as such." The word "book" in this context may be replaced by building, interior, vase, poster and indeed any other work designed by an artist.

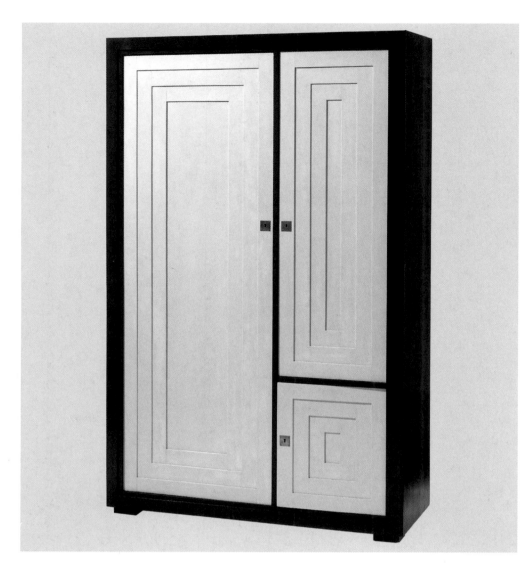

Marcel Breuer: Wardrobe, 1927, Dessau Bauhaus. "This harmony has its basis in the understanding of contrast, of the complex of contrasts, of dissonance etc... This equilibrium made up of tensions is the quintessence of the new constructive unity. Therefore we call for the application or demonstration of this constructive unity in daily practice." Theo van Doesburg and Cornelis Eesteren, The Path to a Collective Architecture, in: *De Stijl*, Leiden 1924

Josef Hoffmann: Cupboard from the servant's room in the Stonborough apartment, Berlin, 1905. The asymmetrical division of the front and the use of a stepped sequence of mouldings as a framing device are typical features of the furniture in the servant's room.

Josef Hoffmann: Easy chair, before 1910, leather

Le Corbusier, Pierre Jeanneret, Charlotte Perriand: "Grand confort" armchair, c. 1929, tubular-steel frame, bent and chrome-plated, loose, leather-upholstered padded cushions; made by Gebrüder Thonet, Vienna and Paris

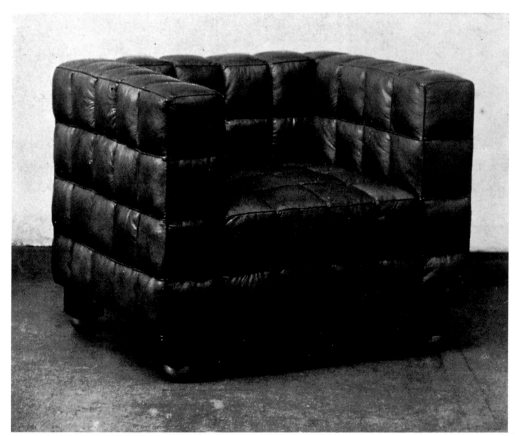

Josef Hoffmann and *Oswald Haerdtl (attributed):* Armchair, 1929, moulded and punched plywood, bentwood arms. Although often attributed to Josef Hoffmann, this chair bears a striking resemblance to a Thonet design, model no. A 811, a variation of the terrace-café chair seen at the 1930 Austrian Werkbund exhibition.

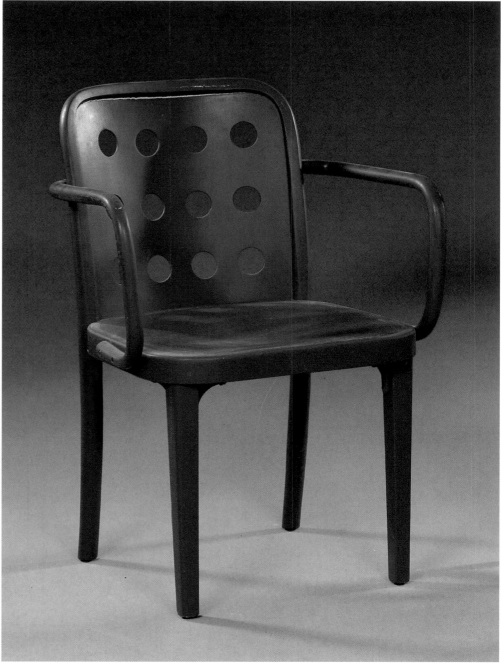

Hans Coray: "Landi" stacking chair, 1939, aluminium, pressed and deformed; made by Blattmann Metall-warenfabrik AG, Wädenswil, Switzerland

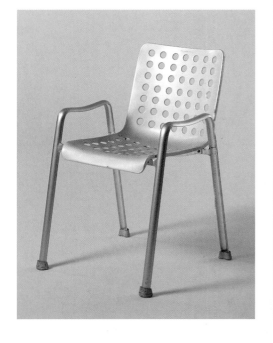

Josef Hoffmann: Austrian Werkbund exhibition, terrace café, 1930

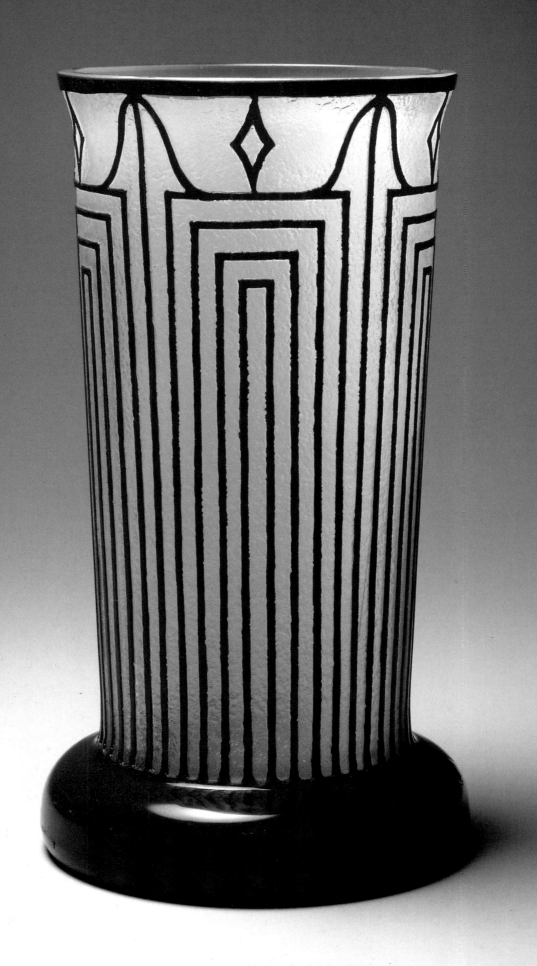

Page 116: *Jutta Sika:* Winged punch bowl with lid, c. 1904, optic blown glass, electro-silverplated metal; made by E. Bakalowits & Söhne, Vienna

Right: *Koloman Moser:* Sherry decanter, c. 1900–1905, optic blown glass with "dimples", electro-silverplated mountings, "1902 1923" engraved on the lid; made by E. Bakalowits & Söhne, Vienna

Bertold Löffler: Design for the Savoy Hotel wine list, c. 1908, tempera and ink on card

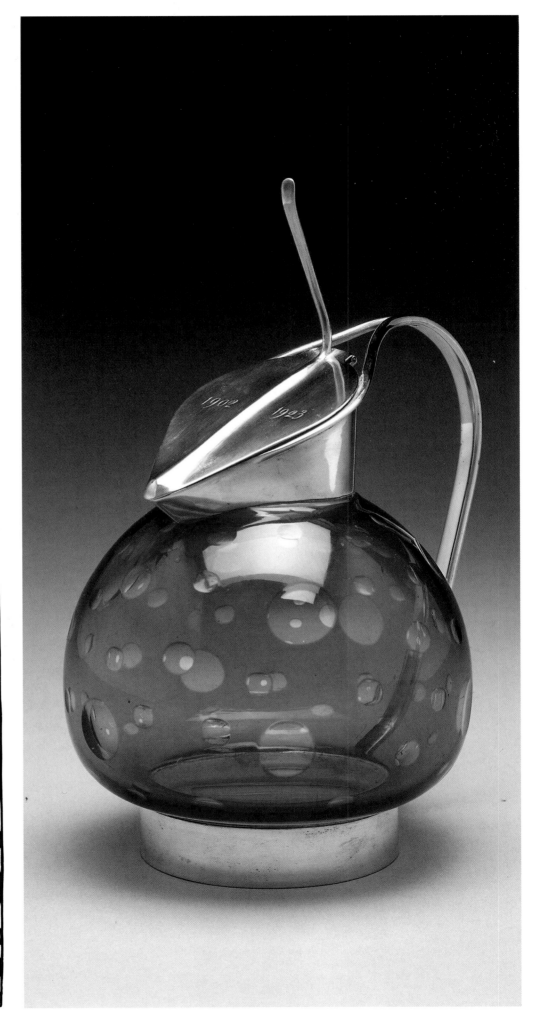

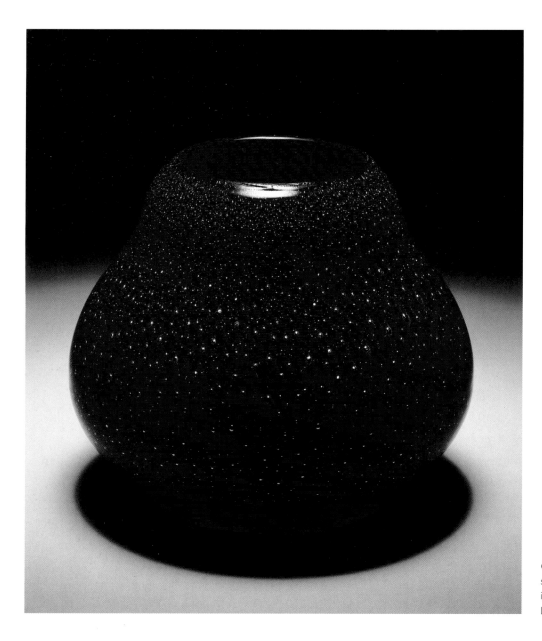

Otto Prutscher: Vase, 1908, imperial red glass and so-called "bead glass", a colourless flashing containing globules of silver, mould-blown; made by Johann Loetz' Witwe, Klostermühle

Christopher Dresser. A number of Moser's students also produced glassware designs for the Wiener Werkstätte, amongst whom Jutta Sika, Therese Trethan and Bertold Löffler deserve particular mention.

Wiener Werkstätte glass found its truest expression, however, in the broncit works produced by Lobmeyr. For the artists of the Wiener Werkstätte, broncit decoration offered a perfect vehicle for their design aesthetic of black-and-white contrast and floral decoration within a geometric grid; toilet sets and vases in this style are today prized collector's items. The broncit technique itself was developed in around 1910 by Steinschönau Technical College – in Bohemia, of course. In this process, the glass was first coated with a layer of bronzite, and the decorative design then painted over it using a protective varnish. Any unvarnished areas were then removed with a caustic acid, leaving a decorative pattern with a metallic sheen. This technique was taken up by Lobmeyr: "The surface of the glass is given a black or brown, faintly metallic coat, evenly applied; the ornament is then covered with varnish, and the uncovered ground removed with hydrofluoric acid, so that the drawing remains in black or brown on the matt ground..."[47]

The designers of broncit glassware were first and foremost Josef Hoffmann, Urban

Janke, Ludwig Heinrich Jungnickel and Arnold Nechansky. In Hoffmann's designs, broncit latticework is on occasions replaced by painted gold lines (p. 77 below). Jungnickel, an animal painter, and Janke designed pieces in which animal motifs are incorporated within ornamental chequerboard grids (pp. 60 above, 120). Michael Powolny contributed a number of designs with a delicate black-and-white decoration. At the same time as producing such etched works, however, Lobmeyr also remained true to the transparency of its specialist medium, manufacturing cut-glass works in tectonic and classical forms by Oskar Strnad, Michael Powolny, Hilda Jesser, Vally Wieselthier, Otto Prutscher, Oswald Haerdtl and Josef Hoffmann. In later years, Hoffmann designed exquisitely elegant services in wafer-thin muslin glass with the rainbow-like display of colours of a soap bubble (p. 119).

The formal canon of this broncit glassware – strict linearity and stylized ornament – is also found in the designs executed by Johann Loetz' Witwe. Famed primarily for its chandelier glass, Loetz also manufactured glass for the Wiener Werkstätte. The black-and-white palette was here transformed into flashed glass of clear, luminous colour in blue, red and yellow, created by Josef Hoffmann, Arnold Nechansky and Jutta Sika. Michael Powolny remained indebted to the stripe in his designs

Josef Hoffmann: Bowl, c. 1915, muslin glass; made by J. & L. Lobmeyr, Vienna

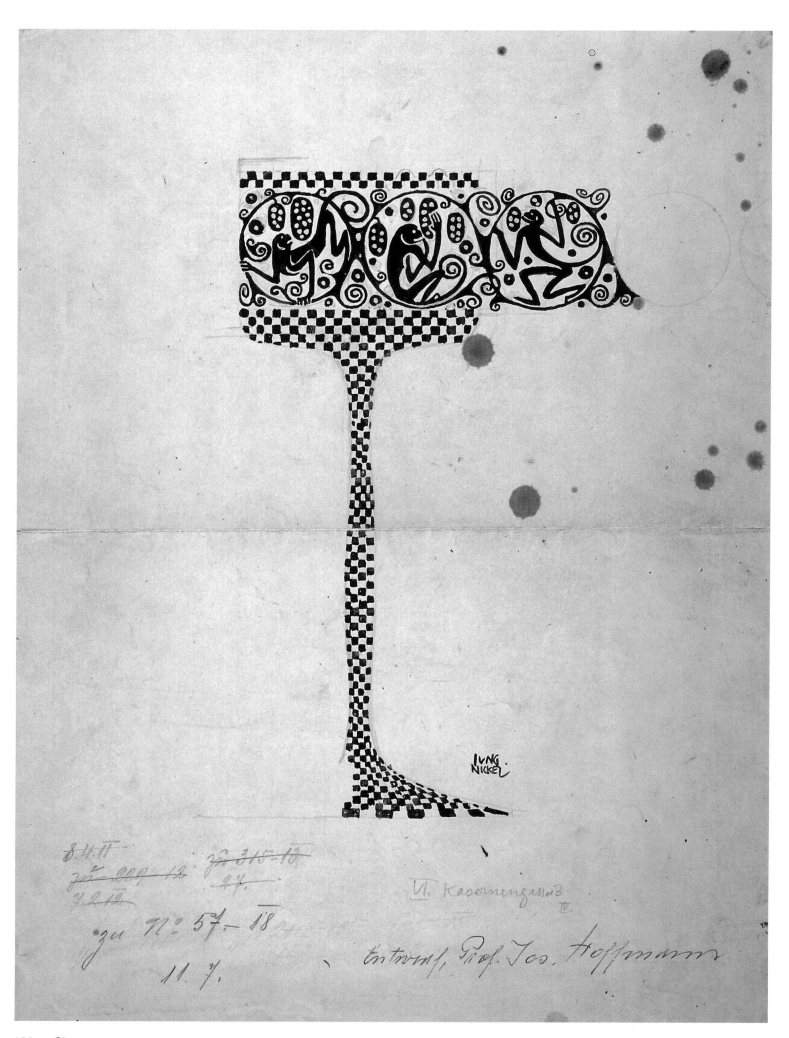

Page 120: *Ludwig Heinrich Jungnickel:* Wine glass, c. 1911, "monkey frieze" pattern within spiralling vine tendrils, working drawing by Josef Hoffmann

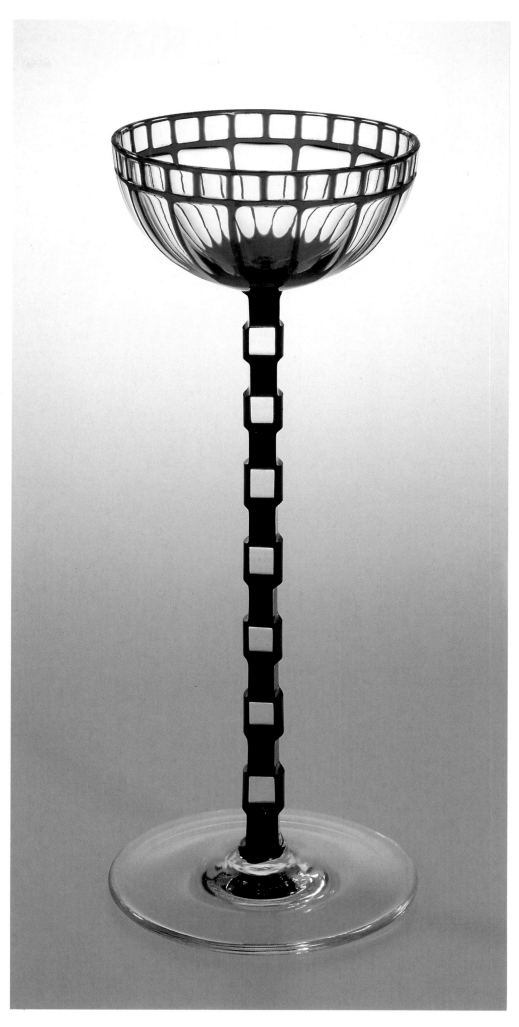

Otto Prutscher: Wine glass, c. 1907, cobalt blue flashed glass, ground and cut, facetted stem; made by Meyr's Neffe, Adolf near Winterberg

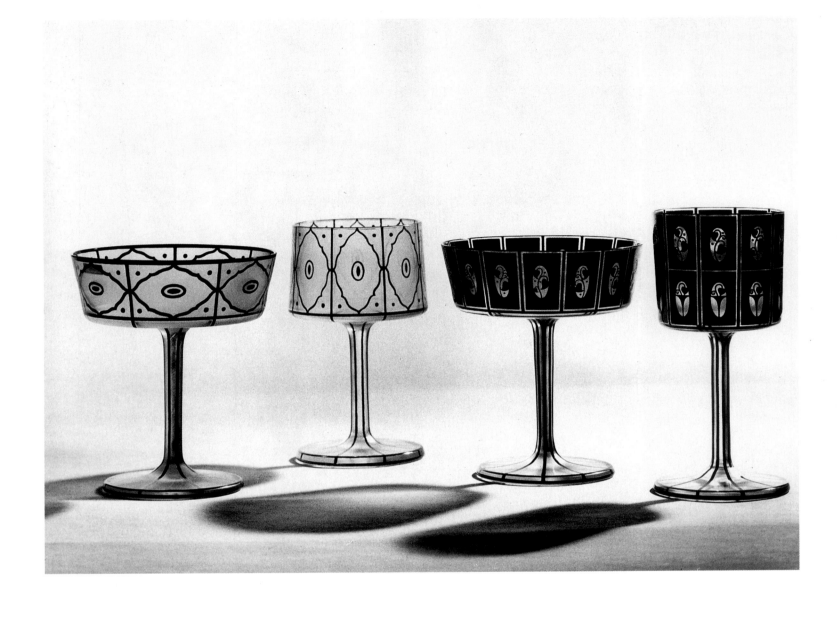

Josef Hoffmann: Champagne and wine glass from the "Var. C" set of glasses (left), c. 1912; champagne and wine glass from the "Var. F" set of glasses (right) c. 1910; frosted glass with black broncit decoration; made by J. & L. Lobmeyr, Vienna. The delicate patterning of "Var. C" gives way in "Var. F" to black fields containing floral motifs in transparent medallions.

for white-flashed glass ornamented in blue and black. Dagobert Peche also decorated Loetz glassware with his typical lanceolate designs.

Amongst the most original and most beautiful glass creations by the Wiener Werkstätte are the slender glasses by Otto Prutscher, with their facetted and windowed stems (pp. 121, 128 left). Mostly wine or champagne glasses with an architectonic construction of straight-sided cup and flat foot, they offer a masterly illustration of the wealth of possibilities offered by geometric ornament. Making bold use of contrast, their sparkling colours embrace the whole spectrum from violet to turquoise. Their stems, dissolved into chequerboard patterns and "little squares", are particularly striking. They were manufactured by Meyr's Neffe in Adolf, near Winterberg, in southern Bohemia. Meyr's Neffe maintained close links with Lobmeyr, Koloman Moser, Joseph Maria Olbrich and – until 1922 – the artists of the Wiener Werkstätte. In addition to Otto Prutscher, it worked in particular with Josef Hoffmann, who designed sets of drinking glasses in glass and crystal, in part employing Biedermeier and classicist forms. Meyr's Neffe was famed for the "sparkling purity of its glass" and supplied crystal glass to numerous firms. In 1922 it merged with Ludwig Moser & Söhne to form the Karlsbader Kristallglasfabriken AG Ludwig Moser & Söhne und Meyr's Neffe.

The Moser company in Karlsbad specialized in glass with a green or purple flashing and in coloured crystal. From 1920 onwards it primarily manufactured glassware after designs by Josef Hoffmann, Hilda Jesser, Dagobert Peche, Eduard Josef Wimmer-Wisgrill and Julius Zimpel. One particular series manufactured by Moser forms its own chapter in the history of Wiener Werkstätte glass: like most of the undecorated Wiener Werkstätte glassware, it was designed by Josef Hoffmann, and consists of heavy pieces of coloured crystal, classicist in shape, resembling cut gems and harking back to the tradition of onyx, agate and jasper glassware (pp. 128, 129). These angular vases and bowls also seem to anticipate French Art Déco; their shapes look forward to the pressed and imitation crystal glassware which became so popular in Paris in the mid-twenties.

Josef Hoffmann also provided cut-glass designs for Karl Schappel in Haida. These demonstrated the Borussian glass technique developed by the Schappel factory – crystal with a double black and white flashing and ornamental edging – and were shown at the Werkbund exhibition in Cologne in 1914.

Alongside the distinctive Hoffmann style, the arrival of Dagobert Peche at the Wiener Werkstätte heralded the emergence of a second, ornamental trend in glassware design. This decorative style gained more and more ground, and it remained a dominant theme of Wiener Werkstätte production even after Peche's untimely death in 1923. This type of decoration, usually executed in enamel paint, is asymmetric and free in its positioning on the surface of the glass. As in Wiener Werkstätte ceramics, there is an emphasis upon the figural, expressed in female heads and animal motifs which appear unexpectedly between pointed leaves and delicate arabesques (p. 130). Glass, painting and colour are all equally light. There is rhythm, and almost a suggestion of Pop Art, in the finished objects; even the zigzig style of Art Déco makes an appearance. Alongside Dagobert Peche, the most important

Josef Hoffmann: Design for a tumbler, "Var. C" broncit decoration, c. 1910, pencil and ink

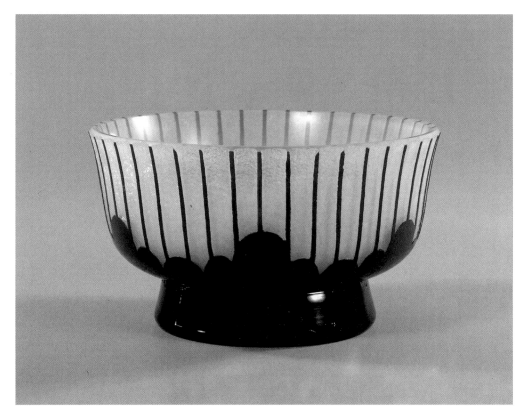

Josef Hoffmann: Bowl, 1913, glass, bluish opalescent inner layer with luminous blue flashing, mould-blown, black foot separately mounted, etched stripe design with remaining surface frosted; made by Johann Loetz' Witwe, Klostermühle

Page 124: *Jutta Sika:* "Coral with squares" vase, 1905, glass, bright red flashing over a colourless ground, mould-blown, chequerboard decoration etched in a single process; made by Johann Loetz' Witwe, Klostermühle

Page 125: *Josef Hoffmann:* Vase, 1911–1912, glass, white interior, black flashing, etched decorative design with remaining surface frosted; made by Johann Loetz' Witwe, Klostermühle

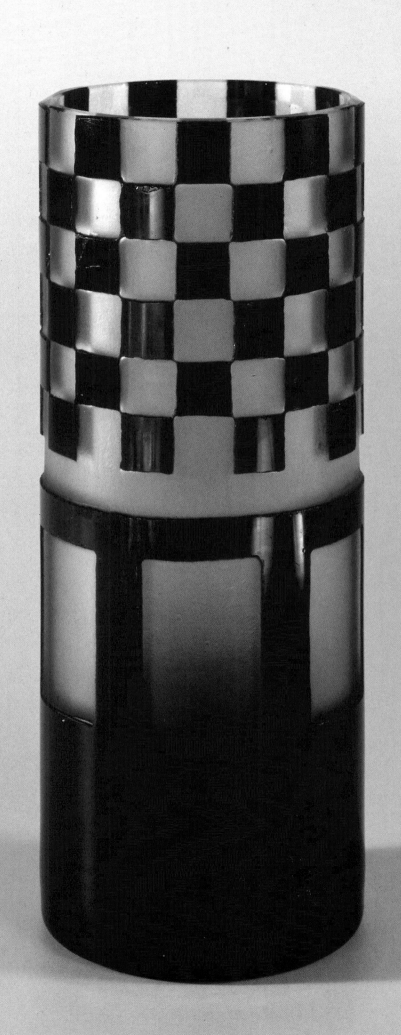

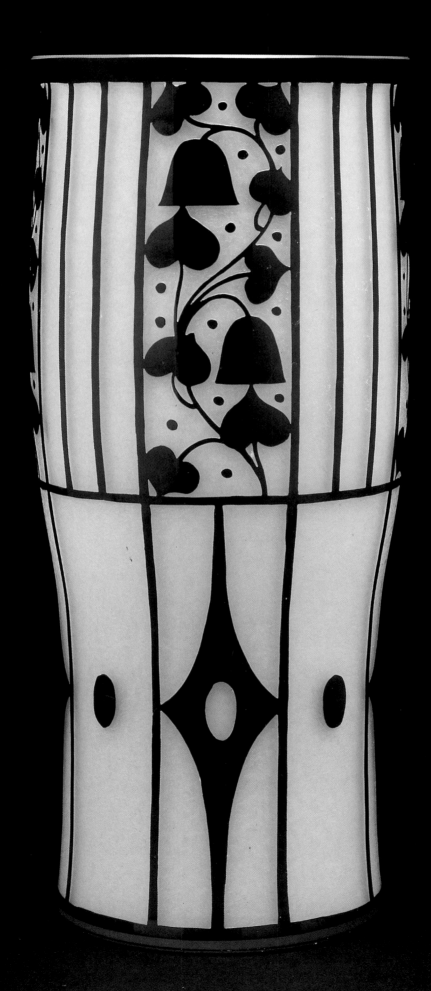

artists working in this area included Maria Vera Brunner, Mathilde Flögl, Hilda Jesser, Leopold Krakauer, Jakob Löw, Felice Rix, Reni Schaschl, Julius Zimpel and Vally Wieselthier.

Enamel painting – the art of painting on glass with a translucent glaze of ground glass dyed with metallic oxide – originated in Persia and was particularly popular in the Biedermeier era. Indeed, there are Empire and Biedermeier echoes in early Wiener Werkstätte enamel glassware. The elegant, thin-walled glasses themselves were supplied by Johann Oertel & Co. in Haida, a company which had previously manufactured elegantly simple sets of glasses to designs by Josef Hoffmann.

It was the secret wish of Emile Gallé, the great French glass artist, "…to embellish the home of every Frenchman with a beautiful piece of glass".[48] The prices of his magnificent creations did not allow this, however, and the designs mass-produced more cheaply after his death in 1904 bordered closely on kitsch.

What sort of people bought artistic glassware in Vienna? The liberal-minded upper middle classes, undoubtedly, as well as artist friends, patrons, and in later years

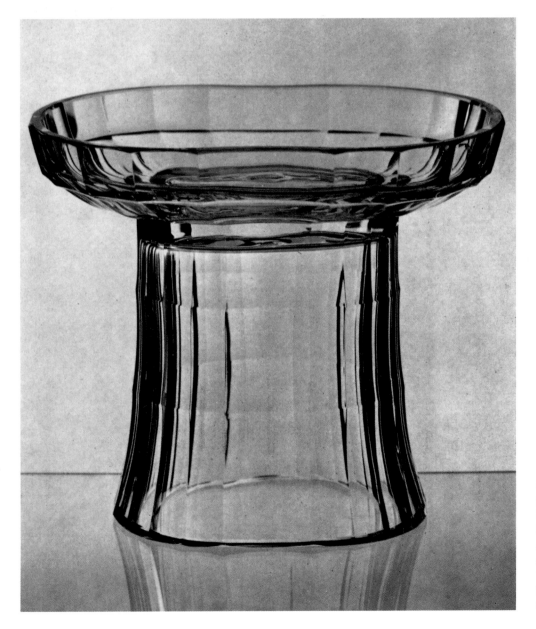

Oskar Strnad: Centrepiece, c. 1910, ground crystal, featuring a tall foot and a shallow, oval, polygonal bowl with slightly undulating sides; made by J. & L. Lobmeyr, Vienna. Oskar Strnad, who worked with Josef Hoffmann on virtually all the Wiener Werkstätte's major architectural commissions from the 1920s onwards, was one of the designers who embraced Neue Sachlichkeit (New Objectivity) from the very beginning.

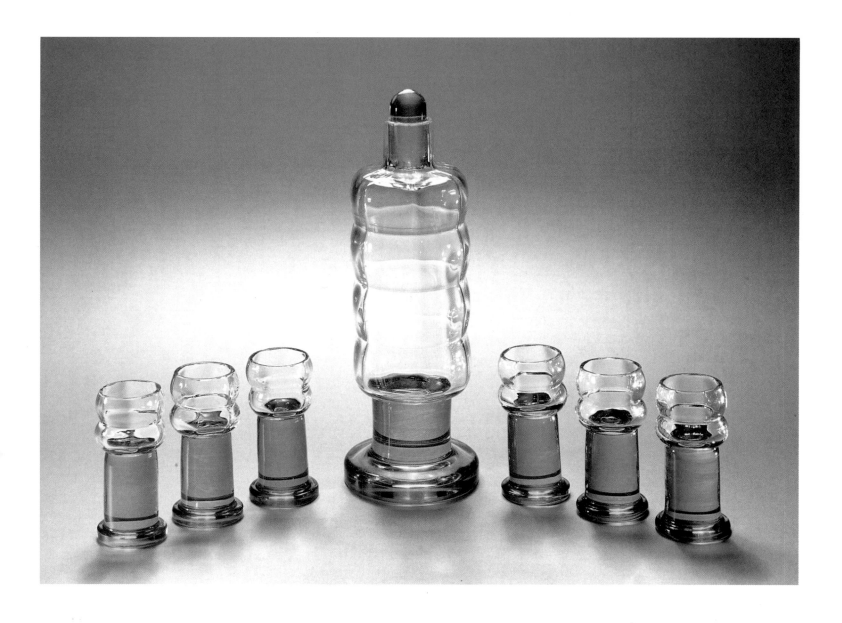

Otto Prutscher: Liqueur service, c. 1910–1911, colourless glass with yellow mordant; made by Meyr's Neffe, Adolf near Winterberg

museums, home furnishing stores and a growing international clientele. A reviewer in an issue of *Deutsche Kunst und Dekoration* of 1926/27 offered the following thoughts on the subject: "It is easy to understand how a person of taste who becomes the fortunate owner of one of these objects will, in time, experience around him a revolution which has been sparked by the object in question. This revolution transforms not only his environment but, ultimately, the owner himself. There will be many a case when someone who starts off by buying a cigarette case or a vase finds no peace until he has the home and all the bits and pieces to go with it. Today he knows where to go to find it all in a beautifully matching style. There are many people, inevitably, who say: that may all be very well, but where in heaven's name are the folk who actually buy such things? The general public no longer understands that there are still people with a genuine need for art, who are prepared to pay prices which, wrongly deemed expensive, are in fact cheap. As regards the order books of the 'Wiener Werkstätte', goodman tailor and goodman glovemaker can sleep in peace. There are large numbers of people in America, Scandinavia and indeed all over the world, who perceive themselves as the champions of modern culture and who call eagerly for products that are contemporary and good. Surely that is not too much to demand?

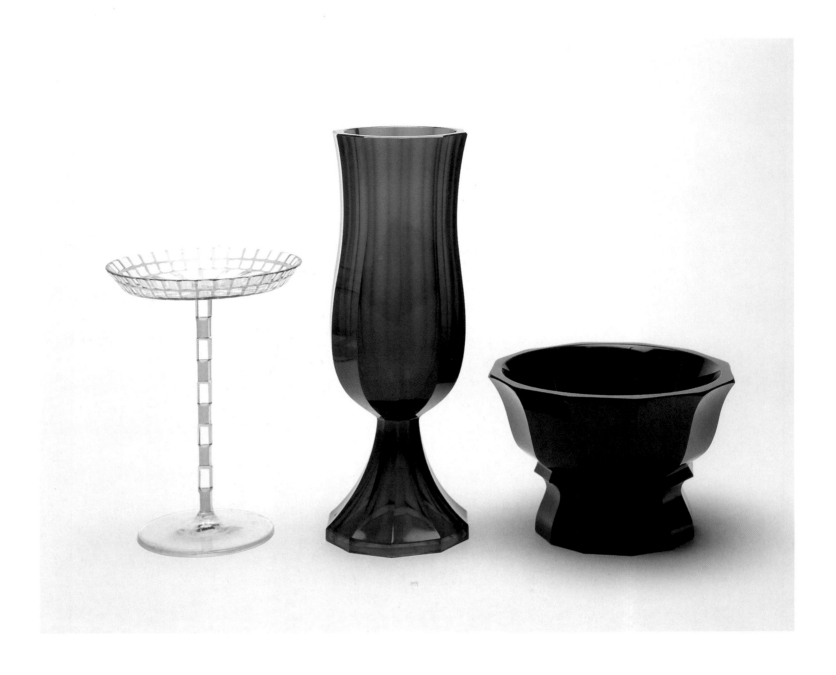

Otto Prutscher: Champagne glass (left), c. 1906–1910, flashed, cut and ground glass; made by Meyr's Neffe, Adolf near Winterberg
Josef Hoffmann: Vase (centre), c. 1920, cut and ground crystal; made by Ludwig Moser & Söhne, Karlsbad
Josef Hoffmann: Bowl (left), c. 1920, cut and ground crystal; made by Ludwig Moser & Söhne, Karlsbad

Page 129: *Josef Hoffmann:* Waisted goblet vase with lid, c. 1920, cut and ground crystal; made by Ludwig Moser & Söhne, Karlsbad

People who take the good where they find it are no longer a rarity. What is rarer are people whose expectations are high from the very start and who fulfil an important cultural function as patrons and connoisseurs. One finds them in Paris and London, but here they are almost unknown. The masses lag far behind the advancing age. For the members of the general public, the sole arbiter of taste is the chattering shop assistant, whose recommendations they almost always follow. Their expectations can best be judged by the way they buy presents. To advise people to 'only give what you would like to own yourself!' would be to invite ridicule. Saint Anthony found a more willing ear when he preached to the fishes. – The masses buy gifts with the words: 'Give me something that is very cheap and looks expensive!' For such people, the 'Wiener Werkstätte' has nothing to offer."[49]

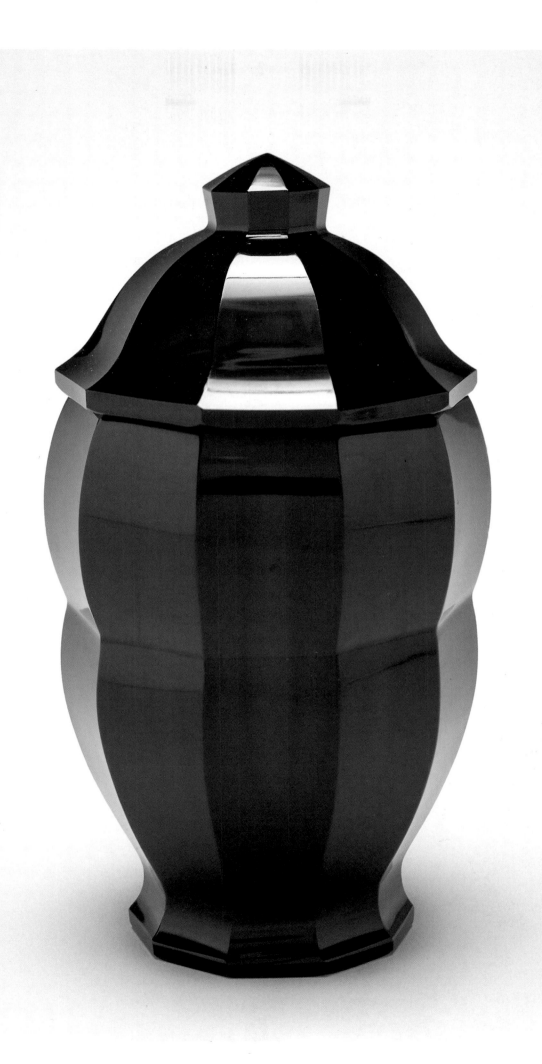

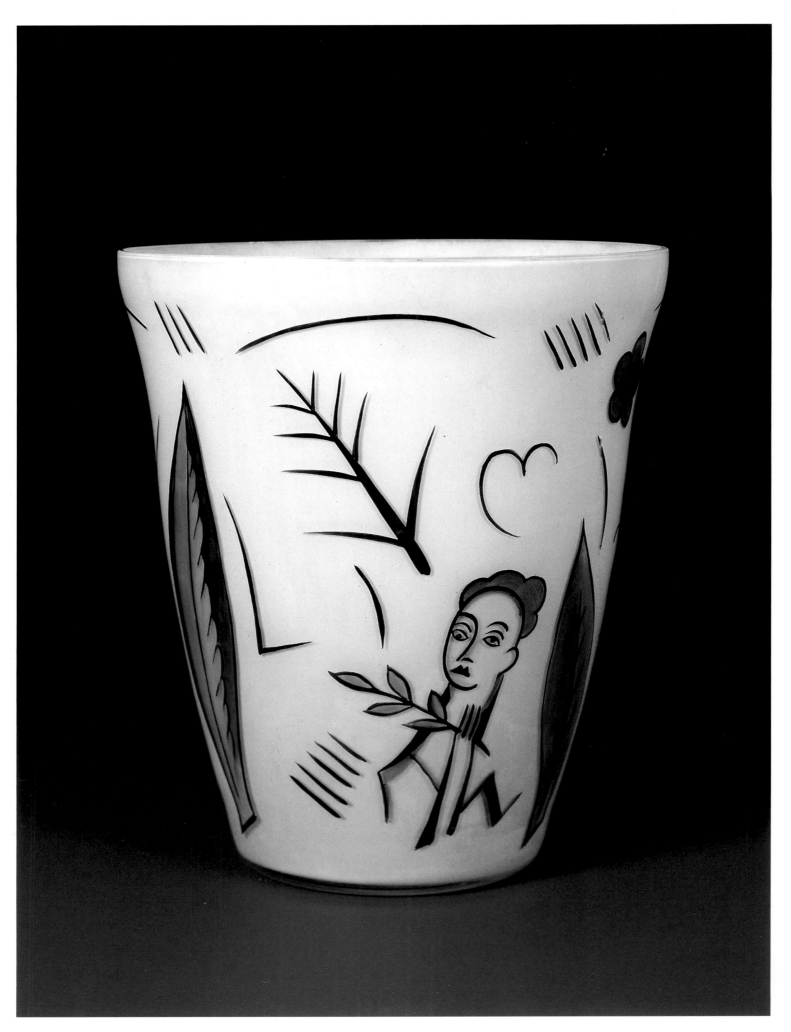

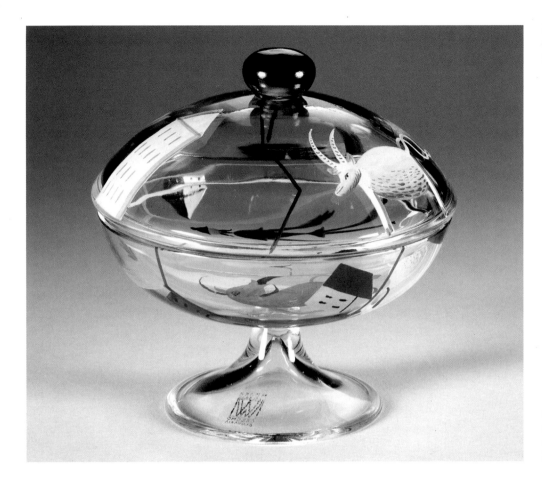

Page 130: *Mathilde Flögl:* Vase, c. 1920, glass, interior painted opaque white, decorative design painted in black, grey and green enamel

Dagobert Peche (decorative design), *Josef Hoffmann* (form): Jar with foot and lid, 1919, clear glass, decorative design painted in transparent enamel and black solder; made by Johann Oertel & Co., Haida

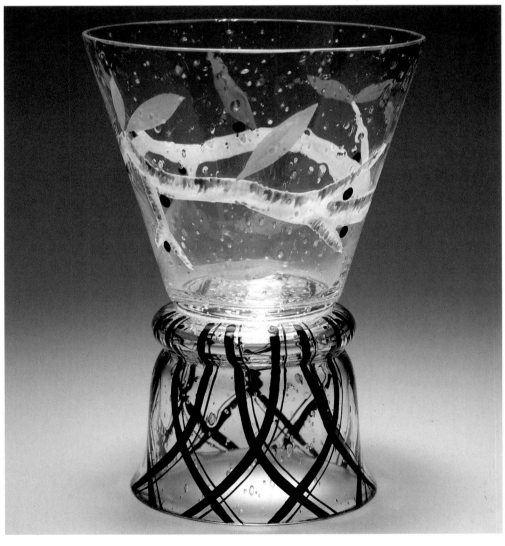

Dagobert Peche (decorative design), *Josef Hoffmann* (form): Goblet, 1917, clear glass with air bubbles, decorative design painted in white opaque enamel, transparent colours and black solder; raw glass made by Ludwig Moser & Söhne, Karlsbad

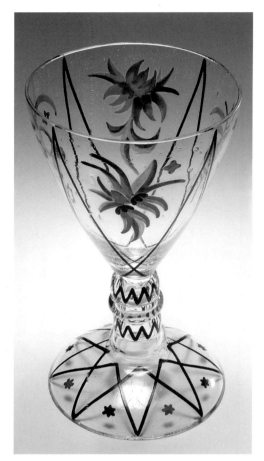

Maria Vera Brunner (decorative design), *Josef Hoffmann* (form): Goblet, c. 1917, clear glass painted in transparent enamel and black solder; raw glass made by Johann Oertel & Co., Haida

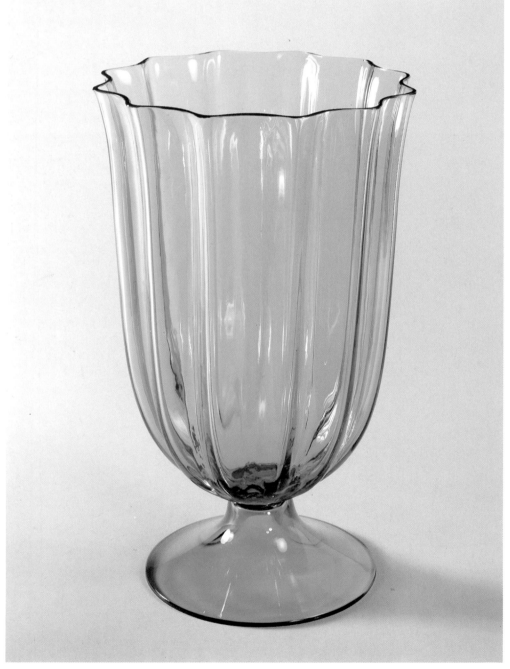

Josef Hoffmann: Vase, c. 1923, light green ribbed glass, mould-blown; made by Johann Oertel & Co., Haida (attributed)

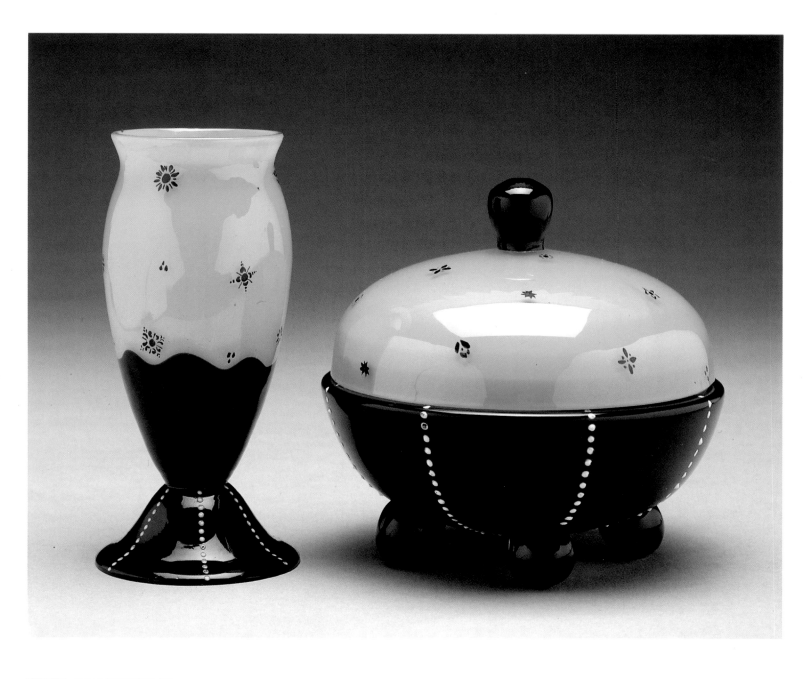

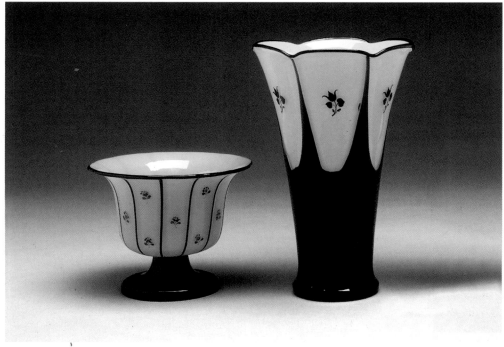

Dagobert Peche: Vase and lidded bowl, c. 1916, enamelled flashed glass; made by Johann Loetz' Witwe, Klostermühle

Dagobert Peche: Two vases, c. 1916, enamelled flashed glass; made by Johann Loetz' Witwe, Klostermühle

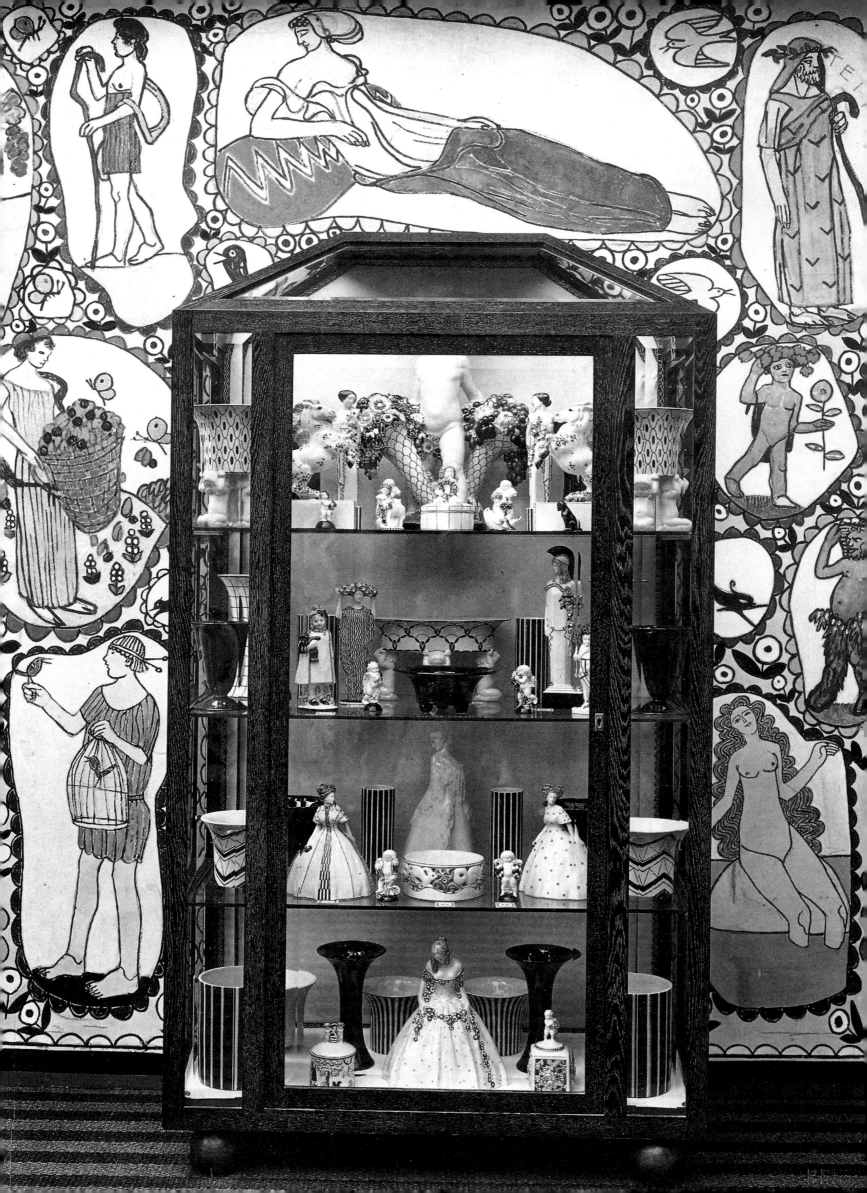

Ceramics

"The works in ceramic once again demonstrate the free, voluptuous handling which is the familiar speciality of the Neu Wiener Keramik. It is no coincidence that they should occasionally echo the rococo vocabulary of form, for they share the same uninhibited, playful, sensuous spirit. One sees a whole world take shape around these objects, a cheerful, light-hearted, friendly world in which life is happy and festive."[50]

These words, written in 1926, may be aptly applied to the work of the Wiener Keramik (Viennese Ceramics) firm – the ceramics arm of the Wiener Werkstätte – in its early as well as its later years. No other area of Wiener Werkstätte activity demonstrated such a broad range of artistic styles at once. This heterogeneity was entirely in line with Hoffmann's belief that everything was valid insofar as it possessed inner vitality and made an artistic statement. The influence of Bertold Löffler and Michael Powolny's putti, clasping their Klimtesque cascades of fruits and flowers, pervaded the entire spectrum of Wiener Keramik production (pp. 138 above, 139, 141). They offered a counterbalance to the stricter, more hieratical figures by Richard Luksch for the Palais Stoclet, and their "cheerful, light-hearted, friendly world" stood at the opposite pole to the designs which Hoffmann executed on squared paper, his regular medium. Even as Hoffmann started to combine his "grid patterns" with carefully placed floral motifs over the following years, the Wiener Werkstätte putti were being transformed, at the hands of Vally Wieselthier, Susi Singer and Gudrun Baudisch, into vivacious bathing beauties.

One of the reasons for the formal and stylistic variety characterizing Wiener Werkstätte ceramics lay in the fact that, up until 1917, they were executed "off the premises" to designs by Wiener Werkstätte artists. Both the actual manufacturer and the individual designer thereby played a more pronounced role than would have been the case inside the Werkstätte itself.

Alongside glass and metalwork, ceramics and porcelain dominated artistic activity both during the Art Nouveau era and later within Art Déco. Following the trend started by the Arts and Crafts revivalists of the 19th century, all the leading Art Nouveau artists rallied to the "rescue" of handicraft with designs for stoneware – Henry van de Velde and Peter Behrens no less than Emile Gallé and Hector Guimard. Parallel with this development, numerous new ceramic workshops sprang up alongside long-established ones.

In Austria, new ceramic workshops were founded by Josef Böck and Hugo F. Kirsch. Unlike the Netherlands, where Rozenborg invented its own new type of

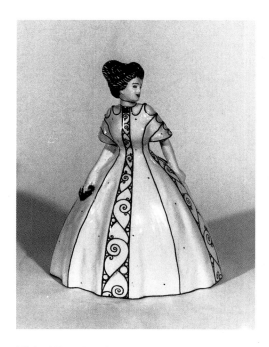

Michael Powolny: "Crinoline", c. 1912, stoneware, white body, white glaze with decorative design painted in black; made by Wiener Keramik

Page 134: *Bertold Löffler:* Interior in the Spring Exhibition at the Austrian Museum for Art and Industry, Vienna, 1912. The glass cabinet contains works by Wiener Keramik.

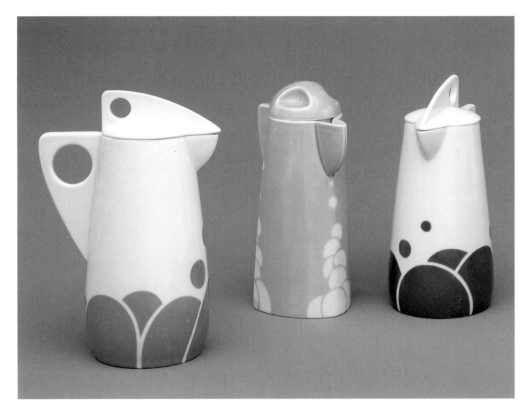

Page 136: *Koloman Moser:* "Blumenerwachen" fabric design, 1899–1900

Left: *Jutta Sika:* Pots (right and left), c. 1901–1902, porcelain with stencilled design; made by Wiener Porzellan-Manufaktur Jos. Böck
Schule Prof. Koloman Moser: Pot (centre), c. 1901–1902, white body with a pale blue glaze; made by Wächtersbacher Steingutfabrik via Jos. Böck, Vienna. "… the services by Koloman Moser, Jutta Sika and Therese Trethan, produced around 1900, were thereafter to be seen in *Das Interieur, The Studio* and other specialist magazines. With their highly original forms and decorative designs, they became 'classic' examples of their kind, inimitable in their simplicity and clarity." (Waltraud Neuwirth, Österreichische Keramik des Jugendstils, Vienna, 1974)

Below: *Jutta Sika:* Tea and coffee service, c. 1901–1902, porcelain with stencilled design; made by Wiener Porzellan-Manufaktur Jos. Böck

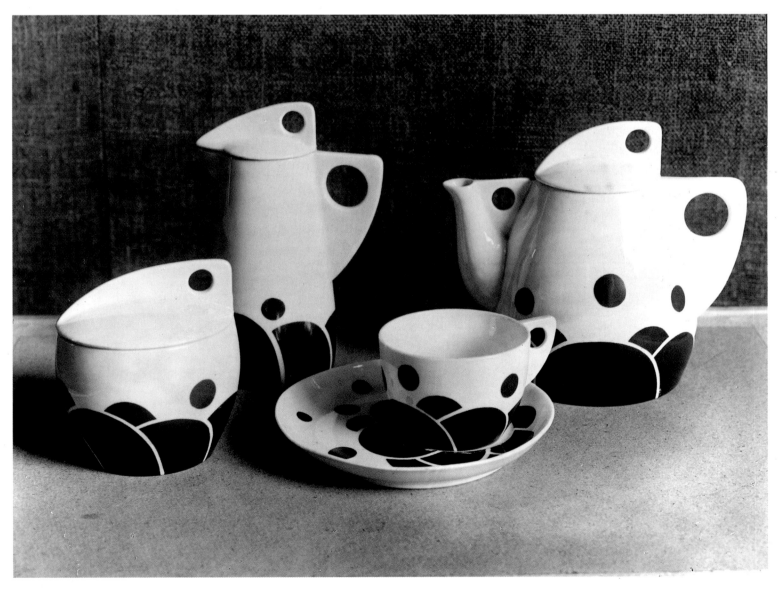

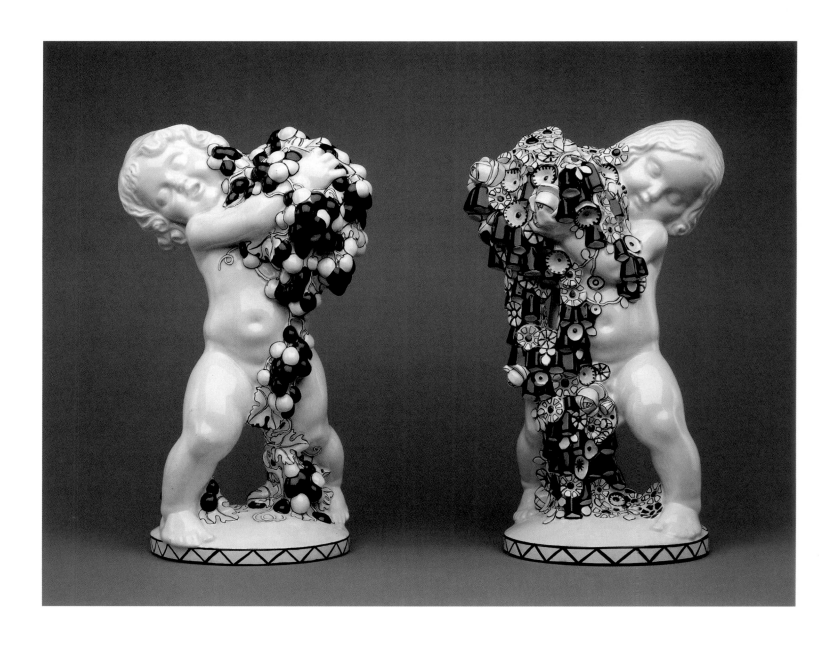

Michael Powolny: "Autumn" and "Spring" putti,
c. 1910, stoneware, modelled white body, white
glaze, painted in black; made by Wiener Keramik

Michael Powolny: Grape goat, c. 1910–1911,
glazed ceramic; made by Wiener Keramik

porcelain, innovations in Vienna came from outside. Stimulus was provided by the technical classes run by Hoffmann and Moser at the Vienna School of Arts and Crafts. It was in Koloman Moser's class, in particular, that the seeds of the future Wiener Werkstätte ceramics production were sown in around 1900. A number of Moser's students were directed to his classes by Josef Böck, and were thus able to have their designs executed in German and Bohemian factories. Their works bear the stamp "Schule Prof. Kolo Moser" (Prof. Kolo Moser's Class). Gisela von Falke, Jutta Sika, Therese Trethan, Antoinette Krasni< and Bruno Emmel were amongst those who designed new "vessels" for the ideas of Moser and Hoffmann. Alongside household utensils denied all decoration and pared down to their essential form, they produced tea and coffee services, vases, and lamps featuring only sparing geometric ornament – works that one is tempted to date later than the more "flowery" designs of Powolny. While the individual students were highly inventive, Moser's influence can nevertheless be detected in their use of soft, semicircular, stencilled decoration. Close collaboration with the school's laboratories, and with its ceramics experts Emil Adam, Friedrich Linke and Hans Macht, ensured that, in terms of their finished quality, the designs lived up to high standards set by the Wiener Werkstätte. Ceramics manufactured in the laboratories attracted consider-

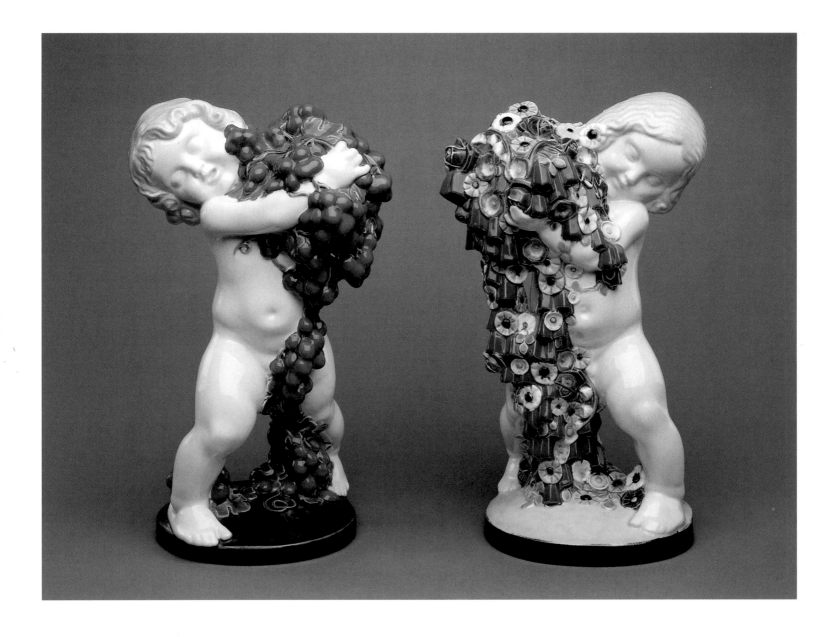

able attention at the Paris World Fair of 1900. In 1901 Hoffmann and Moser were instrumental in the foundation of the Wiener Kunst im Hause (Viennese Art in the Home), an artists' exhibiting society which offered ceramic artists another forum within which to present their work.

In 1905 Michael Powolny and Bertold Löffler founded Wiener Keramik, which now became the protagonist of figural ceramic art. Up until its merger with Gmundner Keramik in 1912, Wiener Keramik was involved in all the major architectural projects undertaken by the Wiener Werkstätte, including the Cabaret Fledermaus and the Palais Stoclet. The partnership between "potter" Michael Powolny and "graphic designer" Bertold Löffler was an ideal one. In the true spirit of the Wiener Werkstätte, they produced vases whose black grid patterns on a white glaze were closely allied to the perforated metal vases of Moser and Hoffmann, and which only reached their fullest expression when filled with flowers. Even the famous Wiener Keramik baroque putti frequently take up the grid motif: their colourful, mosaic-like clusters of fruits and flowers spill out of chequered cornucopia, while the bases on which they stand are ornamented with squares. Once again, individual artistic expression in the play of opposites. Other celebrated pieces from the Wiener Keramic range included its crinoline figurines (p. 135), centrepieces and mountain-sprite figurines.

Michael Powolny: "Autumn" and "Spring" putti, c. 1907, stoneware, modelled white body, white glaze, painted in various colours; made by Wiener Keramik. Michael Powolny's putti, clasping their Klimtesque cascades of fruits and flowers, were a hallmark of Wiener Keramik production.

Gustav Klimt (signed): Putto, c. 1905, stoneware, modelled white body, painted and glazed in various colours

In 1907 the Wiener Werkstätte took over the sale of Wiener Keramik products, a move which marked the start of a welcome increase in turnover: "…We are all the more delighted with the ceramic works by Löffler and Powolny, which are already modestly famous on the international market. Even in Germany, where people are still a little wary of bright colours, they are becoming increasingly popular."[51] (Josef August Lux) A year earlier, in 1906, Hugo Kirsch had founded his own ceramics workshop, which went on to produce figural pieces of widely varying kinds. In 1909 Michael Powolny started up a ceramics class at the School of Arts and Crafts, injecting new stimulus into the field. Julie Sitte, Helena Johnová, Ludwig Schmidt and Robert Obsieger were just some of the pupils in Powolny's class who made a name for themselves as ceramic designers, and who were even able to set themselves up as freelance artists.

In the period before the First World War, the spectrum of Wiener Werkstätte ceramic art ranged from the classicist figures of Richard Luksch and the colourful abundance of the famous putti to the austere black-and-white style which emerged around 1910. Indeed, Wiener Werkstätte ceramic production during these years seemed to illustrate the words spoken by Klimt in his opening speech to the Vienna Kunstschau in 1908, when he declared that "even the most inconspicuous thing can help to increase the beauty of this earth". "We are not a co-operative society, an association, or a union; we have joined forces quite informally with the express purpose of holding this exhibition, united only by the conviction that no area of human life is too insignificant or unimportant to give scope to artistic endeavours.

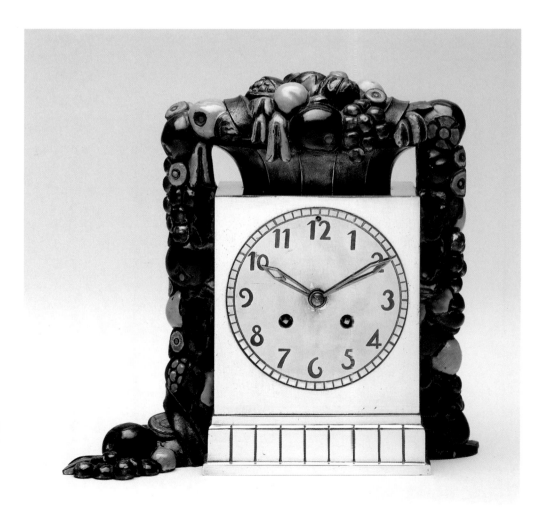

M. Paignant (stamped): Clock, c. 1925, silver-plated bronze, enamelled brass, fruits in multi-coloured enamel glaze. Paignant's clock is an example of Viennese influence upon French Art Déco around 1925: the seeds of the floral designs blossoming in Vienna were also being carried to Paris.

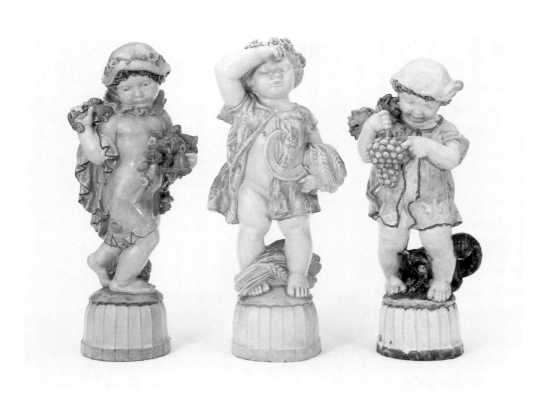

Michael Powolny: "Spring", "Summer" and "Autumn" putti, stoneware, glazed in various colours, c. 1915–1916; made by Wienerberger Ziegelfabriks- und Baugesellschaft, Vienna

Below: *Bertold Löffler:* Interior in the Spring Exhibition at the Austrian Museum for Art and Industry, Vienna, 1912. The glass cabinet contains works by Wiener Keramik.

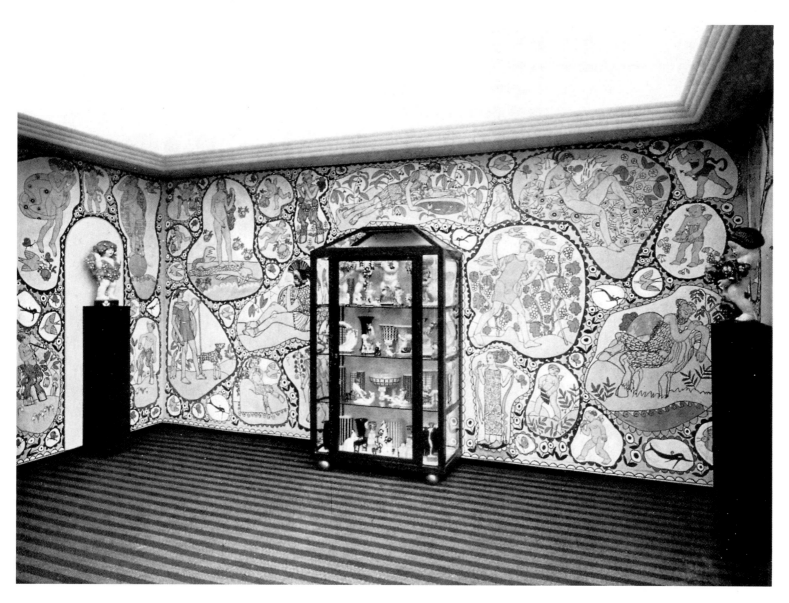

Bertold Löffler: Round lidded jar, c. 1906, glazed stoneware, black-and-white chequerboard pattern; made by Wiener Keramik

As Morris puts it, even the most inconspicuous thing can help to increase the beauty of this earth if it has been made perfectly. Indeed, only by harnessing the artistic spirit in a drive to pervade the whole of life can culture make progress at all."[52]

Josef Hoffmann summarized the situation as follows: "The enamels, chased pieces and the majority of the ceramic works are completed by the artists themselves. All ceramic domestic requisites are entirely produced in our own workshops and kilns, as are the figural pieces, even the life-sized figures... Our age feels and perceives in an entirely fresh and modern way. Our clothes, our cars, our ships, our trains, indeed all our machines have found their contemporary form, and it is only natural that all the other areas of life should also be seeking their new form. We want to work in harmony and unison with everyday life, without feeling afraid when one of our artists or colleagues is suddenly struck by a new idea."[53]

And new ideas were certainly what struck the ceramic artists working within the Wiener Werkstätte.

From 1916–1917 onwards, as the Wiener Werkstätte started to make ceramics in its own studios, members of the various technical classes within the Vienna School

Right: *Josef Hoffmann:* Pot, c. 1905, porcelain, grey body, gold and black underglass painting; made by Jos. Böck, Vienna

Page 143: *Josef Hoffmann:* Design for a coffee pot, c. 1925–1928, pencil and black crayon on squared paper

Page 144: *Josef Hoffmann:* Tea service (detail), c. 1929, glazed porcelain, underglass painting; made by Augarten, Vienna

Page 145: *Josef Hoffmann:* Mocca service, c. 1925, glazed porcelain; made by Augarten, Vienna

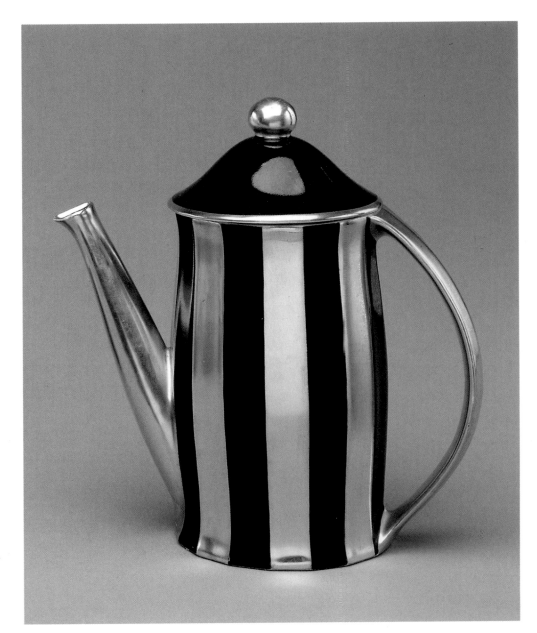

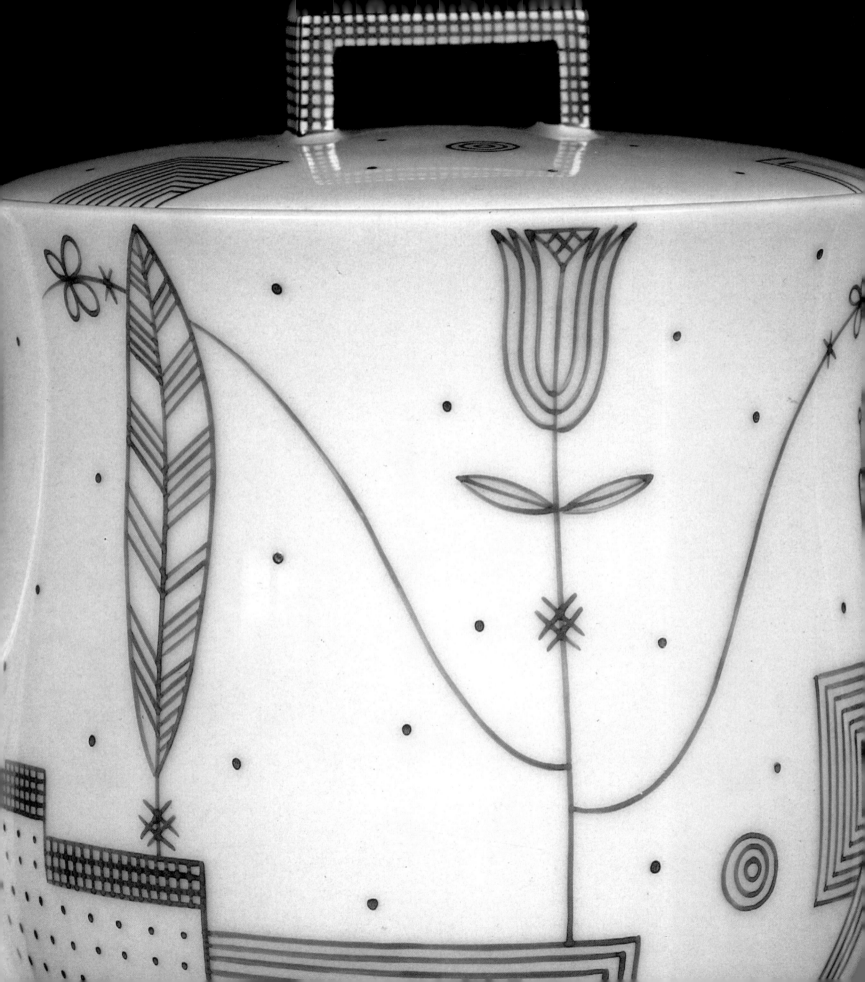

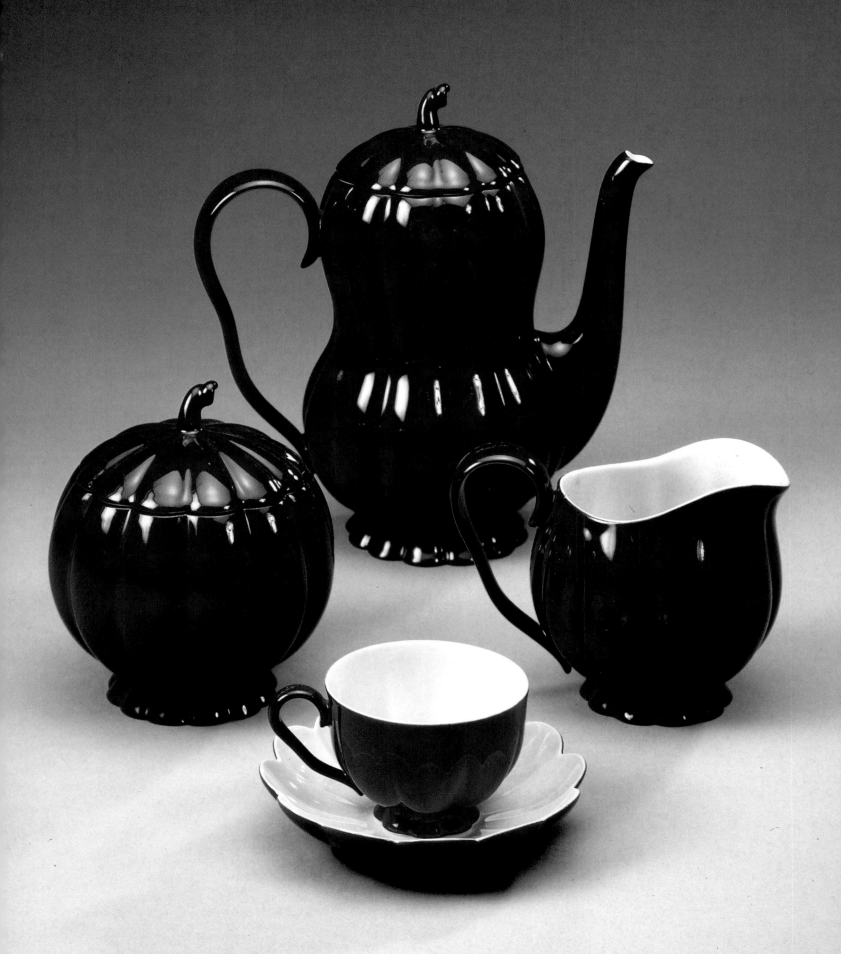

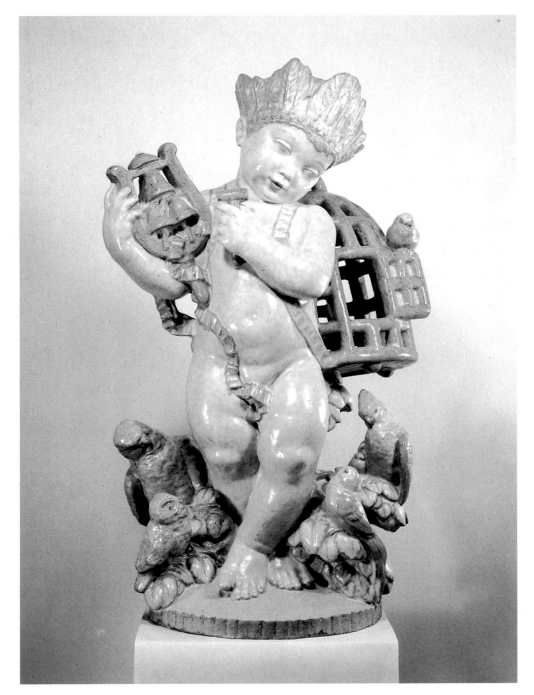

Michael Powolny: Papageno putto, c. 1916–1918, garden statue, glazed ceramic; made by Wienerberger Ziegelfabriks- und Baugesellschaft, Vienna

Friederike Beer holding a putto by Michael Powolny, c. 1913, photograph

of Arts and Crafts began to play a larger role. The works from this era initially still bore the distinctive signature of Dagobert Peche – asymmetrical vessels with "embroidered" patterns. Over the course of the 1920s, these "lacy" rhythms gathered furious momentum in the figures and receptacles designed by the Wiener Werkstätte's women artists: Gudrun Baudisch, Hertha Bucher, Lotte Calm, Mathilde Flögl, Hilda Jesser, Erna Kopřiva, Dina Kuhn, Grete Neuwalder, Kitty Rix, Ena Rottenberg, Susi Singer, Reni Schaschl, Luise Spannring and Vally Wieselthier. The women of the Wiener Werkstätte – maliciously renamed the Wiener Weiberwirtschaft ("Vienna Wenches' Business") or Wiener Weiberkunstgewerbe ("Vienna Vixen's Arts and Crafts") by Julius Klinger – had begun their march to victory. Writing in the periodical *Deutsche Kunst und Dekoration* in 1909, Karl Widmer from Karlsruhe had observed soberly: "The struggle by women to break into new professions is already one of the major social problems of our age. With social condi-

Page 147: *Susi Singer:* Candlestick, c. 1925, glazed earthenware

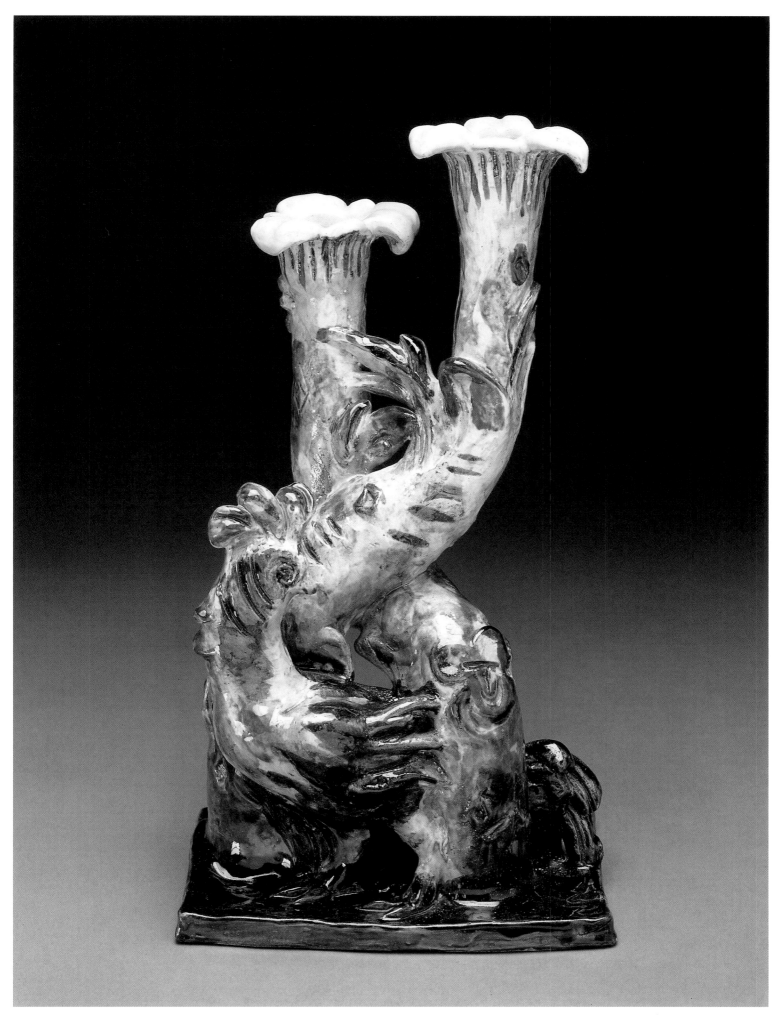

tions in today's civilized world making it increasingly difficult for women to pursue their *natural* careers, this problem can only worsen."[54] Compared with this more or less bald sociological observation, emotions in Vienna ran somewhat higher.

Since there was neither a quota regime nor artistic equality for women within the Wiener Werkstätte, the fact that ten of the Wiener Werkstätte artists exhibiting at the 1925 Exposition des Arts Décoratifs et Industriels Modernes in Paris were women is surely a testament to their outstanding talents. Naturally, this did not make life easier for the men.

A certain degree of male domination over women in the Wiener Werkstätte had been insidious ever since 1913. Although many of the women had completed an academic education, they were disparagingly dismissed as "daughters of senior civil servants and other Fräuleins".[55] The phrase "other Fräuleins" was deliberately aimed below the belt and cast doubt over the suitability of women as artists. There was always something suspicious about a woman who preferred to sit at a potter's wheel rather than stand over the kitchen sink. Something "stilted, exaggerated, affected, titillating, false, counterfeit and above all superfluous" clung to the "frilly Werkstätte style", with its "cloying sweetness".[56] Such acrimony was not confined to the "enemies" of the Wiener Werkstätte, but was also felt within its ranks. Thus Oswald Haerdtl declared in 1925: "...the thing just doesn't suit me – especially this dreadful dolly business".[57] Josef Hoffmann, on the other hand, never had an unkind word to say about them.

Far from being the precious inhabitants of some doll's house, however, the women artists at the centre of this attack rose vigorously to Hoffmann's call for freshness, modernity and inventiveness. Processing international influences in their art, they produced ceramic works that lay fully in line with "the latest trend". It was they who shaped the Austrian version of the roaring twenties, in highly individual designs of outstanding quality. Wiener Werkstätte production in the 1920s continued to be extremely diverse, with the sum of these various stylistic parts making up its overall image. The women in the ceramics workshop occupied an influential position. Their decorative knick-knacks, boxes, ashtrays and figurines of stoneware were the "smash hits" of Art Déco. In the words of an advert by Robj, a Parisian company, their colourfully painted porcelain figurines were a "compliment to every elegant interior".

The ceramic works produced by the Wiener Werkstätte brought together the myriad stylistic influences of the twenties: Cubism, Expressionism, Futurism, the Ballets Russes under Serge Diaghilev, the art of the Mexican Indians, Egyptian art, and the Yachting style, to name but a few. Everything was mixed together without a scruple. Artists in Germany, by contrast, took a stricter more purist view of things. The outstanding achievement of the women ceramic artists of the Wiener Werkstätte was to combine the chic and pep of Paris with the material quality of Asiatic ceramic art. They did not kitschify their figures through mass production, but created for the most part one-off pieces. The tea and coffee services, lamps and vases which they produced in small series are simultaneously decorated with elegance and wit.

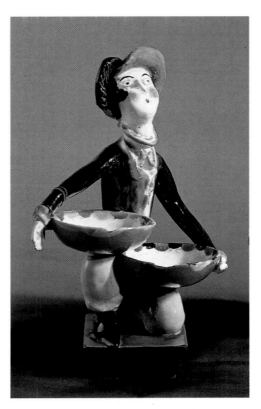

Susi Singer: Male figurine designed to hold salt and pepper, 1926, moulded stoneware, glazed in various colours

Right: *Gudrun Baudisch:* Head of a girl, 1927, stoneware, glazed in various colours

Page 150: *Vally Wieselthier:* Head of a girl, c. 1920, stoneware, glazed in various colours

Page 151: *Lotte Calm:* Terracotta head, c. 1930, glazed in various colours

Vally Wieselthier: Lampstand, 1925, stoneware, glazed in various colours

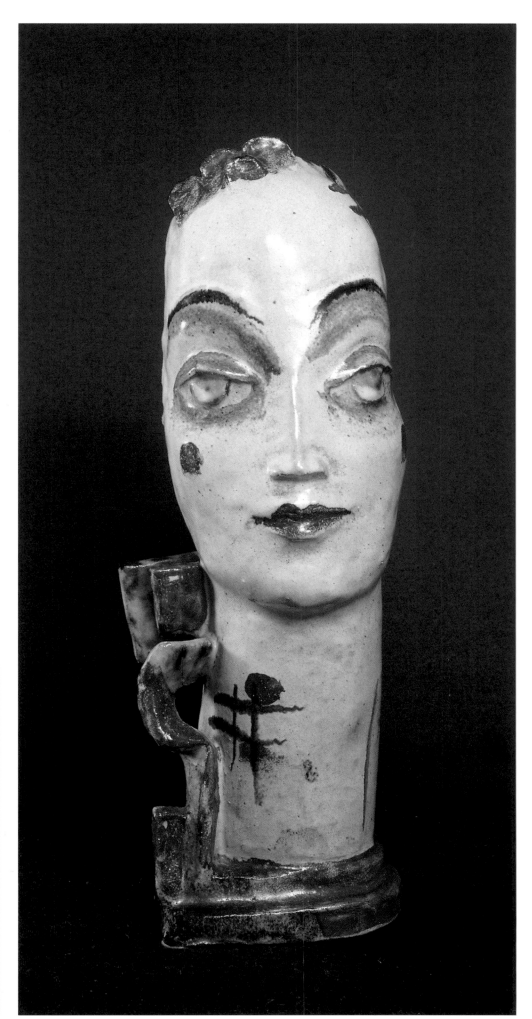

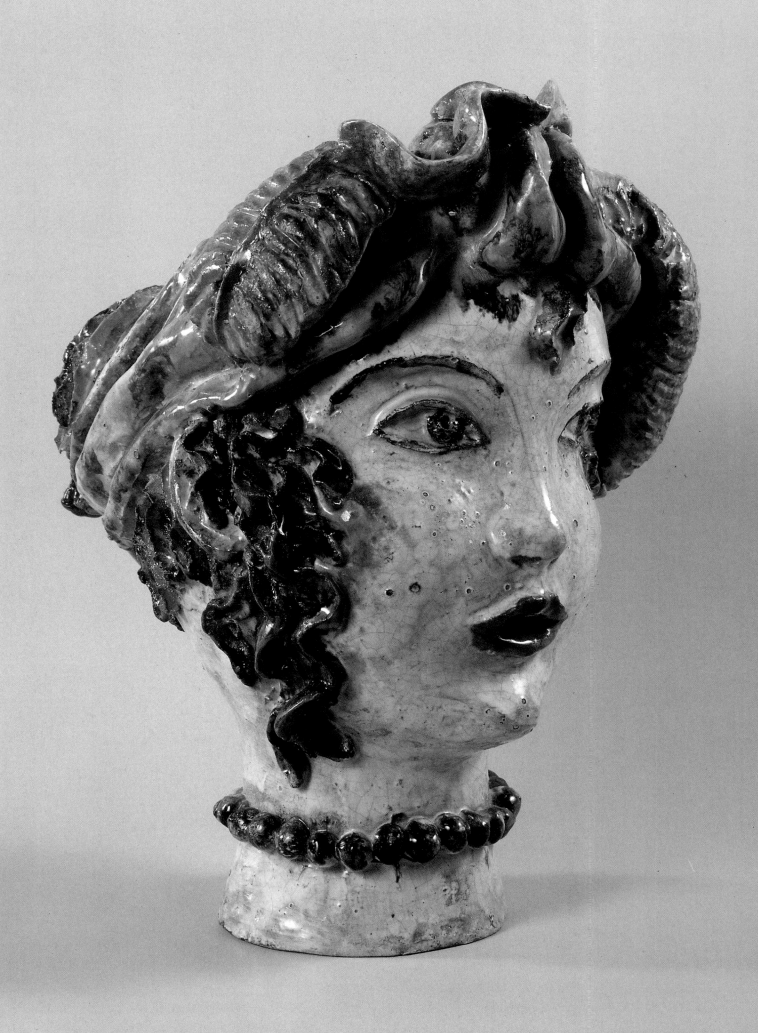

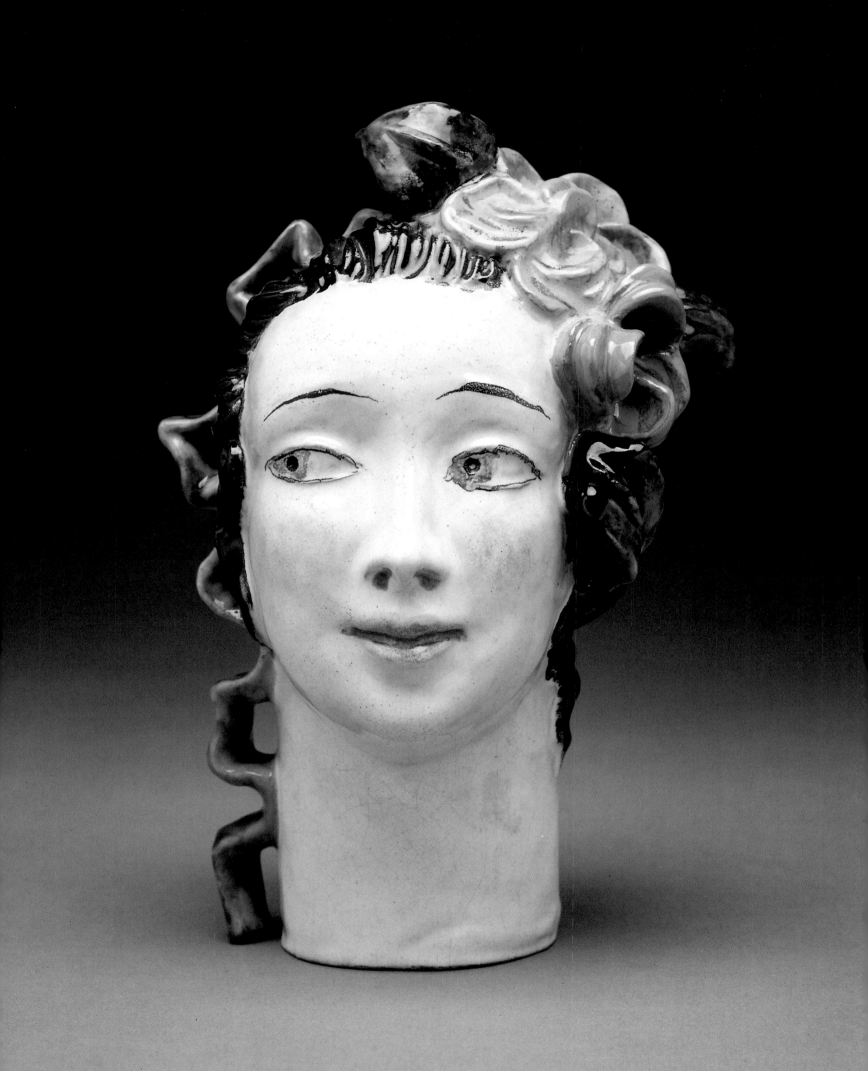

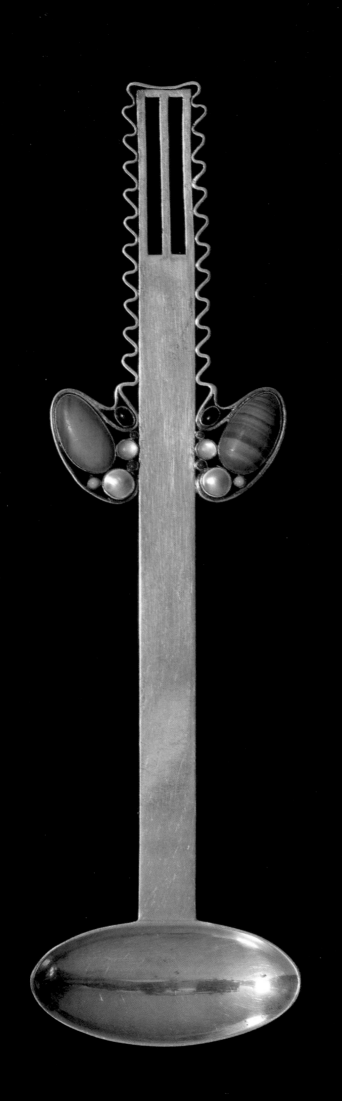

Silver and Metalwork

The Wiener Werkstätte's silver workshop was identified by the colour violet. But it was not simply the resplendence of this "logo" which lent the silver and metal workshop its gleaming reputation; its significance within the Wiener Werkstätte as a whole was enormous. Unlike Wiener Werkstätte ceramics and glassware, which were not produced in-house but were manufactured in other factories to designs by Wiener Werkstätte artists, the works in silver and metal were executed by the artists themselves. It was out of a silver and metal workshop. in fact, that the Wiener Werkstätte originally sprang. Set up in 1902 by three skilled craftsmen, silversmith Karl Kallert and metalworkers Konrad Koch and Konrad Schindel, this first workshop was located at Heumühlgasse 6 in Vienna's 4th district and consisted initially of just the workshop and an office. Even after the Wiener Werkstätte was officially founded six months later, artistic production continued to be dominated by silver and metalwork until the workshop moved to Neustiftgasse in October 1903.

As materials, silver and metal played a leading role not just in Vienna, but in Art Nouveau in general. They were employed in a wide variety of alloys, in items ranging from the simplest utensil to the most sophisticated appliance. The rapid expansion in silverware production in the second half of the nineteenth century was a reflection of the growing prosperity of the countries of western Europe and North America. It was historicism that dominated the field, and this led to the emergence of a heavily overladen style which vaunted itself in racing trophies and honorary gifts, loving cups for societies and centrepieces of the most tasteless kind. The Middle Ages, the Renaissance, Baroque and Louis XV were imitated in mindless combination. Any feeling for the virtues and qualities of the material had for the most part been lost.

It was in defiance of such ostentation and kitsch that the Arts and Crafts movement arose in England in the 1880s. Goldsmith and silversmith were once again to craft practical utensils that would enhance the beauty of everyday life. Metalworkers, too, were to draw upon traditional methods of production. Most of the silverware of the nineteenth century was either mechanically pressed or cast. Art Nouveau saw the "rediscovery" of chasing (the art of ornamenting a metal surface by striking and embossing the cold metal with a hammer), repoussé (a technique whereby the reverse of the metal is hammered to create designs in relief of vertical and spiral ribs), as well as late-Gothic bossing. The unique properties and beauty of the material were thus brought out to the full. Appreciation also grew

Josef Hoffmann: Design for an ornamental spoon, c. 1905, pencil and coloured crayon on squared paper

Josef Hoffmann: Serving spoon, c. 1905, chased silver, mother-of-pearl, moonstone, turquoise, coral, small blue and black stones; made by Anton Pribil

Above right: *Josef Hoffmann:* Two elliptical vases with loop handles, 1906, silver-plated metal (left), metal painted white (right), glass inserts, decorative design of perforated squares

Josef Hoffmann: Candle holder (far left), c. 1904, silver-plated white metal, decorative design of perforated squares, frosted glass insert. Planter (far right), c. 1905, silver, octagonal base on spherical feet, decorative design of perforated squares.
Koloman Moser: Bud vase, 1904, silver, round base with beaded edging, hexagonal stem with decorative design of perforated squares, glass insert. Vinegar and oil cruet stand, c. 1904, silver, basket-like container with central handle, decorative design of perforated squares, glass bottles. Writing set with inkpot, 1903, silver, rectangular tray with round inkpot, both with decorative design of perforated squares, glass insert

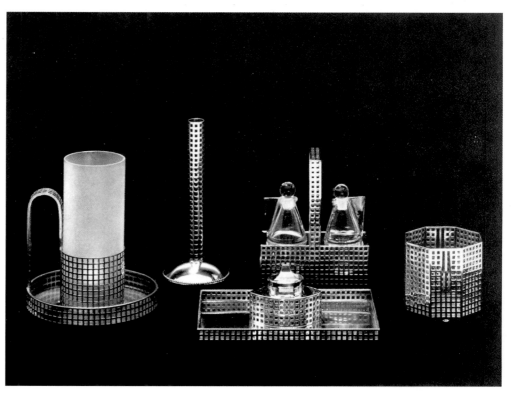

for the colourful and material appeal of copper, brass, bronze, nickel and nickel silver. Even iron and steel made their way into Art Nouveau, both in architecture and art objects.

The stylistic trend towards unadorned, stereometric elementary forms reached its high point in the silver and metalwork of the Wiener Werkstätte's early years. The perforated grid patterns characterizing its utensils and objects in silver and sheet iron built upon the principle of the square as decorative symbol, the hallmark of Wiener Werkstätte design. According to the dictionary, a grid is "a pattern of horizontal and vertical lines forming squares of uniform size".[58] If, for Alfons Mucha, Art Nouveau was "physiognomic harmony in the grids of the intellect", for Josef Hoffmann the grid was the elementary form which intellectualized itself into art. Hoffmann transformed the two-dimensional plane into three dimensions. It might be said that Hoffmann developed everything representational out of the grid and used the same grid pattern to link his forms together. What is significant here is that Hoffmann's construction principle serves not the structure of the object but its decoration.

Hence the objects thus created only fulfil their purpose and reveal their true form when they are in use: "This functional aesthetic is also a theme running through the bowls and fruit baskets of filigree iron by the Wiener Werkstätte. Their latticework walls of perforated squares only attain their full decorative effect when in use. The colours of the apples, pears and grapes inside the fruit bowls are designed to play through the white-enamelled gaps in the sides, as in KPM latticework porcelain from Berlin. The square holes in the dark-patinated napkin rings are destined to be

Josef Hoffmann: Inkstand, c. 1905, silver-plated white metal, decorative design of perforated squares, chased lids; made by Josef Wagner

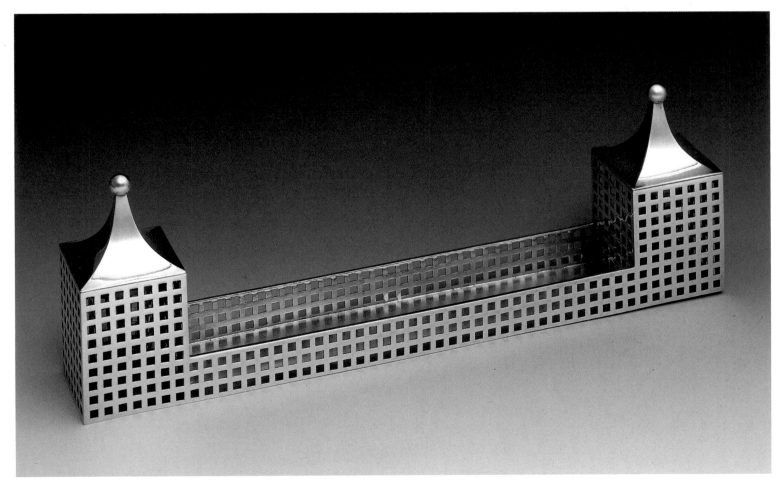

Right: *Josef Hoffmann:* Dish, c. 1910, silver-plated white metal, decorative design of stylized flowers in rectangular fields, baluster feet

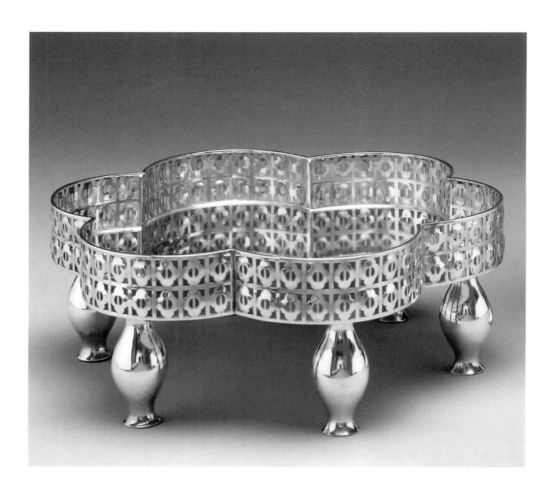

Josef Hoffmann: "Trumpet vase", c. 1905–1907, silver-plated white metal, openwork handle

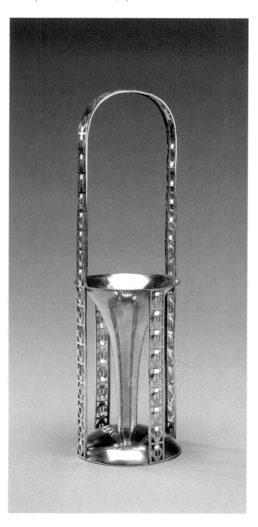

filled in by the white of the damask. A work of particular delicacy is a slender, square-based pillar with curving sides of this latticework type. It is designed for a climbing plant. Attached to it at irregular intervals, and easily rearranged, are little grid boxes resembling miniature balconies, from which sprays of foliage protrude. Here, too, the true charm of the object only emerges in use, when spiralling greenery entwines itself around the white trelliswork and the lofty tower, as graceful as a fountain, cascades with verdant foliage. In the high prices set on such works, which have a low material value and can hardly be said to involve excessive labour, one is paying for artistic inspiration.

A perfect example is the vinegar and oil cruet stand (cf. p. 154 below) from the well-known set of beautiful silver tableware by Koloman Moser. The bottles sit in a silver housing, and this housing features the motif of small perforated squares. This design only fulfils its purpose when the bottles are used, when the liquid inside shimmers colourfully through the squares, like enamel incrustations in the silver surface. This is a decorative effect achieved purely with the characteristics of the object itself, without any additions, created so obviously and naturally by its own means and hence so extraordinarily convincing."[59] (Nikolaus Pevsner)

In the works of the Wiener Werkstätte, the conflicts within Art Nouveau – floral ornament on the one hand vs. line and constructivism on the other – are resolved by dialogue. In architectonic baskets, planters, étagères, vases and pots, flora and geometry combine into a single unity. Absolute extremes of material are drawn harmoniously together; metal and plants form one design.

Objects were not simply re-designed; rather, they were fundamentally re-thought. But if the word "architecture" is frequently mentioned in this respect, this is not to

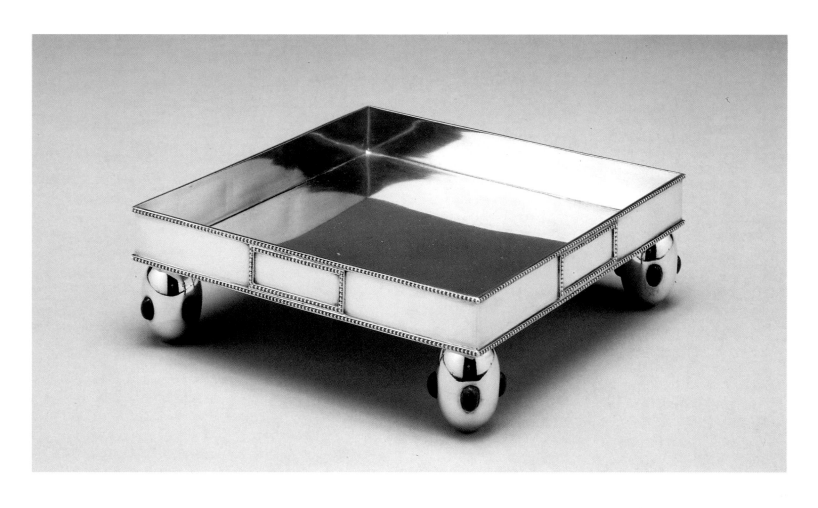

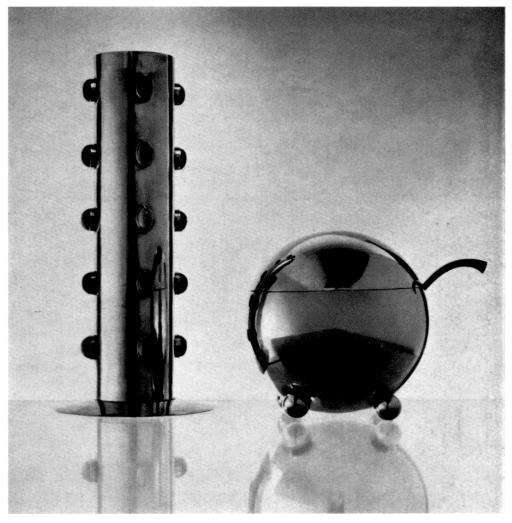

Josef Hoffmann: "Vide-poche", c. 1904, silver, lapis lazuli, decorative beading

Left: *Koloman Moser:* Vase (left), 1905, chased silver with oval amber cabochons; made by Josef Hossfeld. Sugar-bowl with spoon (right), 1905, silver, spherical bowl on four spherical feet; made by Josef Hossfeld

Page 158: *Josef Hoffmann:* Silver pot, c. 1909, silver, gilt interior; made by Alfred Mayer

Page 159: *Josef Hoffmann:* Salad servers, c. 1907–1912, Alpaca (nickel silver alloy)

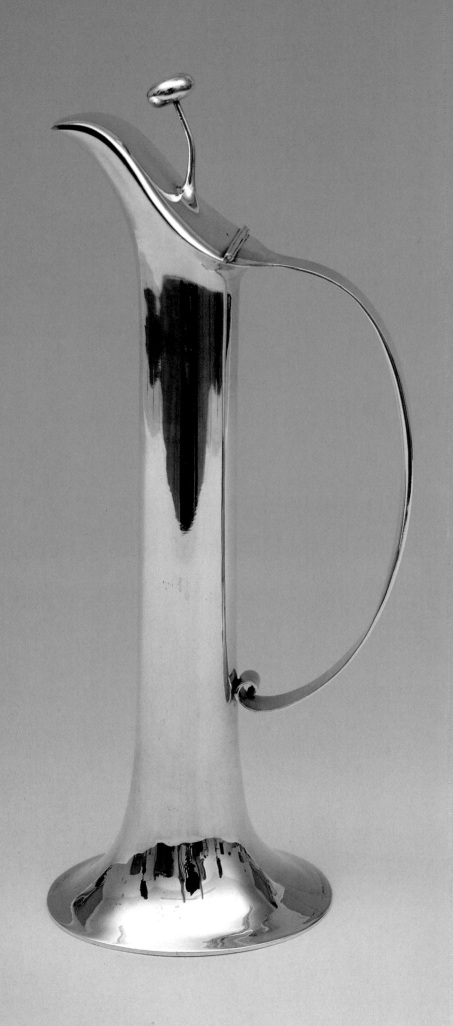

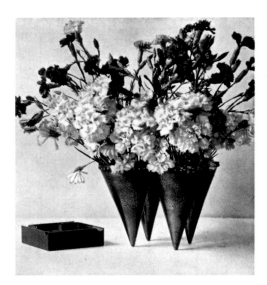

Koloman Moser: Vase, c. 1903–1904, hammered metal

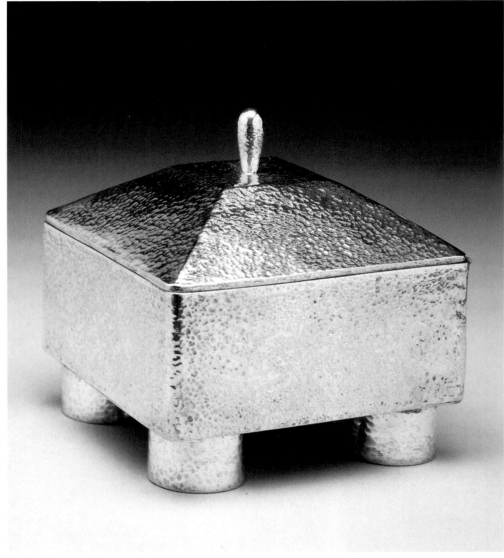

Josef Hoffmann: "Column and Rectangle" lidded box with loop handle, 1904, silver-plated alpaca, chased and hammered; made by Valentin Zeileis

Josef Hoffmann: Tea pot, c. 1903–1904, silver, ebony

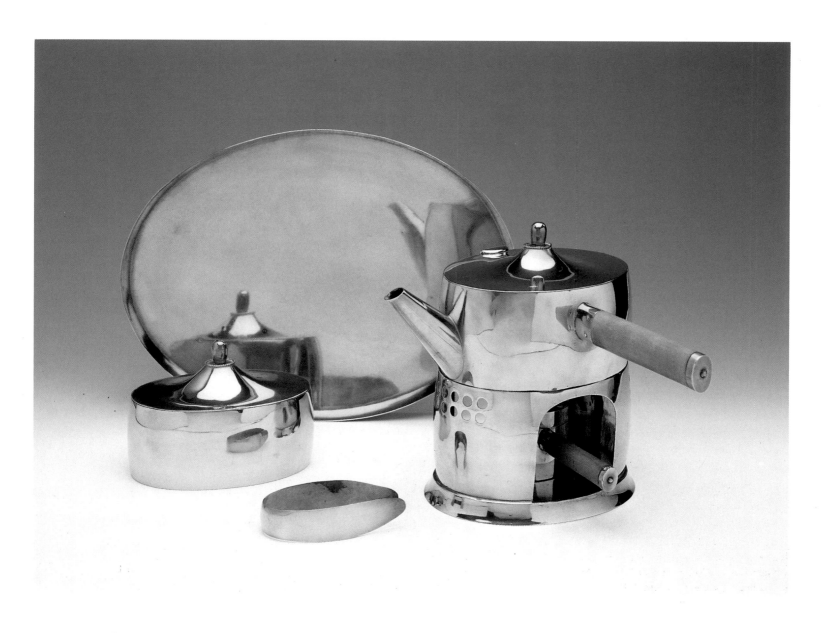

Josef Hoffmann: Tea service with samovar and tray, c. 1910, polished brass, silver-plated interior, wooden handes

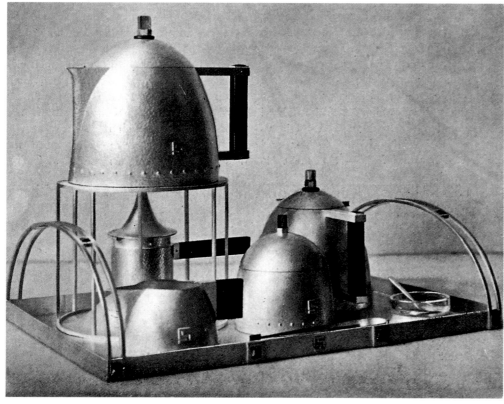

Josef Hoffmann: Tea service, c. 1903–1904, hammered silver; made in 1904 for Adolphe Stoclet.

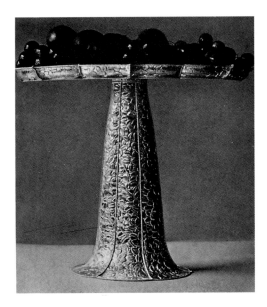

Eduard Josef Wimmer-Wisgrill: Centrepiece, before 1910, silver

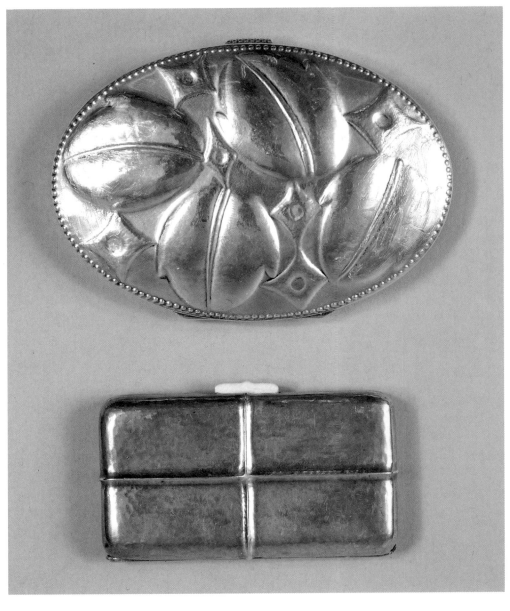

Josef Hoffmann: Snuffbox (above), before 1904, chased silver, gilt interior. Cigarette case (below), c. 1905, chased silver, gilt interior, ivory clasp

Fritz Zeymer: Paintbrush case for Oskar Kokoschka, c. 1907, chased silver, decorative design of stylized leaves and flowers, beading, and "O.K." monogram; made by Josef Husnik

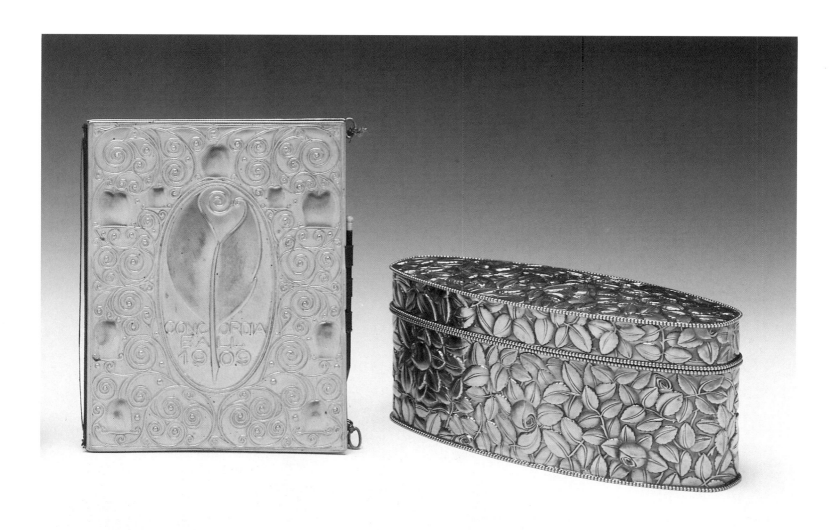

detract from the contribution of the painter Koloman Moser. For Hoffmann, Moser was not simply a like-minded partner, but at the same time a source of inspiration. Hoffmann, who had a vast capacity to absorb new ideas, knew how to translate Moser's ideas and imaginative powers into reality. "[Moser's] talent for decorative art and his inventiveness when it came to the applied arts seemed immense. He knew how to encourage and inspire..., but as soon as he had ignited a spark somewhere, he was impatient to move on to something else."[60] (Berta Zucker-kandl)

Thus the collaboration between Moser and Hoffmann, as in later years between Peche and Hoffmann, seems to represent another apect of the *Gesamtkunstwerk*: the painter and the architect, the "genius of form" and the architect, symbiotically united in the creative act, overstepping the boundaries of their individual fields.

Dualism as the basis of harmony seemed to be a fundamental principle of the Wiener Werkstätte, both in stylistic terms and in the collaboration between its designers. Hoffmann's silverware pieces, their rigorous forms sometimes reminiscent of modern architecture, are generally hammered – a medieval metalworking technique (cf. p. 160 above right). Here, too, the principle of contrast lies at the heart of the decorative design.

Vienna had turned away from the floral caresses of Art Nouveau design to tread a purely ornamental path. Now, at the moment when the rest of Europe – and primar-

Josef Hoffmann: Carnet de bal (left), 1909, gilt white metal, chased and ornamented, bearing the inscription "Concordia Ball 1909", back of red leather.
Eduard Josef Wimmer-Wisgrill: Box (right), 1910, chased brass with decorative design of rosebuds and leaves; made by Josef Husnik

Josef Hoffmann: Incense jar, 1905, silver with semi-precious stones

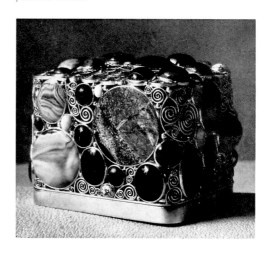

Page 165: *Josef Hoffmann:* "Winged goblet" centrepiece, c. 1924–1925, chased and hammered brass

Right: *Josef Hoffmann:* Silver goblets, c. 1925. "One sees precious metal, refined and discreet silver, sweeping into full, clear tulip shapes, some highly polished, others delicately muted. Leaves and tendrils tenderly intertwine on the stems beneath, tempering the solemnity of the object with their delicate play."[61]

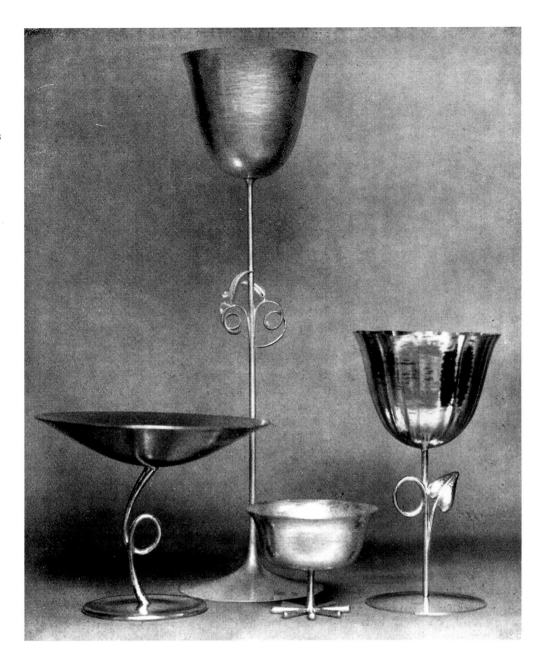

Josef Hoffmann: Vase, c. 1920, silver-plated white metal, fluted baluster shape

ily Paris – was starting to get excited about Cubism, Vienna returned to elegantly ornate forms. "One sees precious metal, refined and discreet silver, sweeping into full, clear tulip shapes, some highly polished, others delicately muted. Leaves and tendrils tenderly intertwine on the stems beneath, tempering the solemnity of the object with their delicate play. One sees a centrepiece, shaped almost as if destined for the altar table, in which silver surfaces and tendrils combine with the colours of precious stones and the shimmer of ivory carving. One sees the elegantly taut contours of the tall, narrow silver vases which reveal their discreet charm only in their harmonious interplay with the colours and foliage of exquisite blooms. Brass presents itself in an even richer display of forms than silver. The brightness of the lighting is amplified by countless movements in its surface, while the powerful contrast between the yellow metal and the green and white of the plants is brought into lively play."[61]

Some of the fluted metalwork which Josef Hoffmann designed in the 1920s (cf. pp. 164, 165) might almost be described as Biedermeier. These works formed the pendant to the ornamental style of Carl Otto Czeschka, with his stylized flower

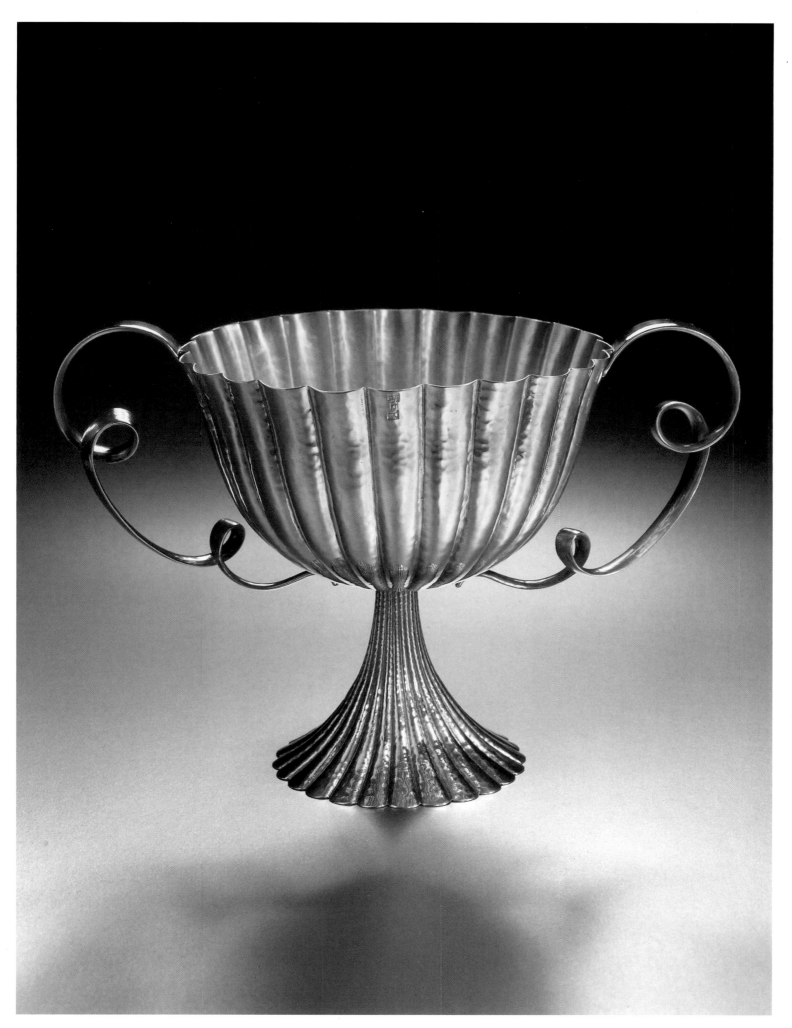

Page 192: *Dagobert Peche:* Jewellery box, 1920–1921, chased and hammered silver, ribbed decorative design with beaded edging, deer with leaf tendrils and grapes on the lid. Ornament had its "revenge" in Dagobert Peche's style, as seen in the chased ribs and curling ribbons of his works in metal, and in his emphasis upon the figural imbued with elegance and imagination.

Dagobert Peche: "Ornamental bird", c. 1920–1923, chased silver, relief decoration

Dagobert Peche: Ornamental object, c. 1920–1921, painted sheet metal

patterns. The vehicle of the "new style", however – the "third style" in Wiener Werkstätte history – was Dagobert Peche. Described all too often as a sort of third rococo, this new style was in fact an ornamental art moving towards the "surreal".

Ornament und Verbrechen (Ornament and Crime), the legendary essay by Adolf Loos, describes Loos' hatred of the ornamental patterns of Art Nouveau. In view of the conflict that had been raging around the question of ornament in Vienna for many years, the almost impudent extravagance of an artist such as Dagobert Peche seemed to be ornament successfully taking its final revenge. Revenge, because Peche could indulge in every mannerism with an absolute confidence in his taste. Since utility was everywhere becoming the order of the day, Peche's attitude may surely be seen as a conscious rejection of the purism of the early Wiener Werkstätte years. He took the sobriety out of New Objectivity not with an alternative artistic doctrine, but with grace and ease. His silverware conceals all reference to function; the object disappears behind its decoration. His vases, caskets and jewellery boxes, made of gold, silver and brass, may at first sight appear overladen, but for all their fanciness, their composition is invariably confident, even rigorous. Rigorous, because nothing is left to chance; instead, every part is perfectly balanced.

Peche's love of animal motifs was something he shared with French Art Déco. The gazelles, deer and birds in his work are not treated in any spirit of exoticism, however, but are transformed into arabesques or veiled by filigree leaves and fruits. Lightness became Peche's principle of design. The firework display of his ideas matched his biography: Peche only lived to 36, a sparkling imagination abruptly extinguished.

Josef Hoffmann waxed lyrical about Peche, his "new source of inspiration", but was

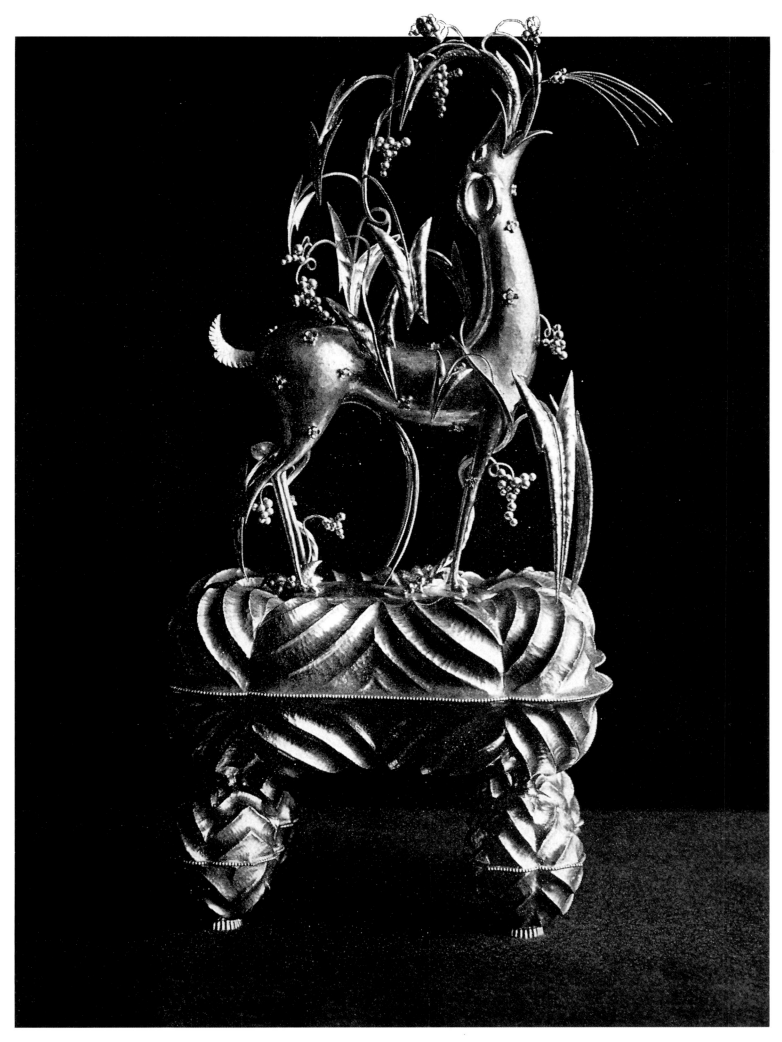

Josef Hoffmann: Design for a lidded jar, c. 1920, pencil and ink on paper. The fluting is related to the façade of the Austrian Pavilion at the Paris 1925 exhibition.

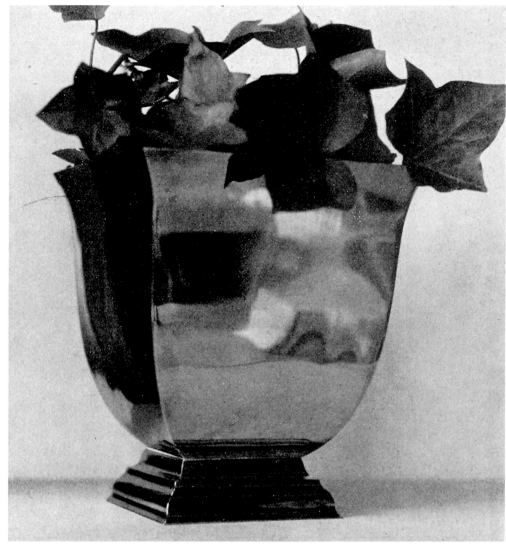

Josef Hoffmann: Vase, 1916–1917, silver

Josef Hoffmann: Bowl with lid, 1927, silver-plated white metal, chased and hammered, ivory knob; made by P. Bruckmann & Söhne, Heilbronn

Page 169: *Dagobert Peche:* Bowl, c. 1915, silver-plated white metal, curving ribbed body, hammered edges

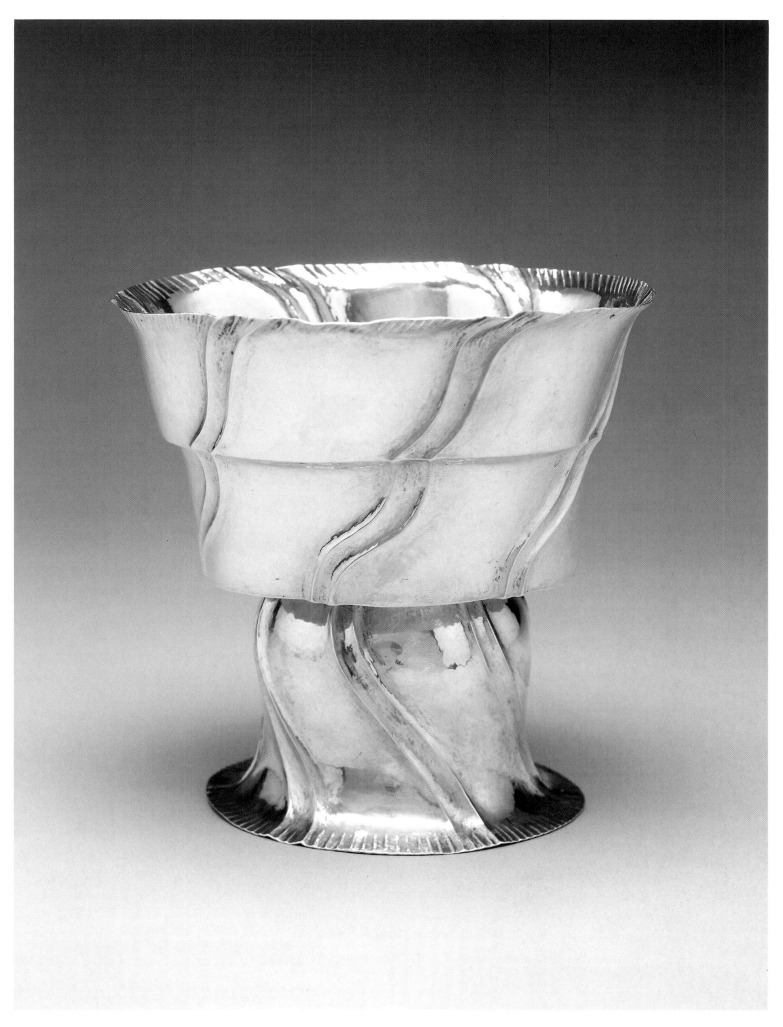

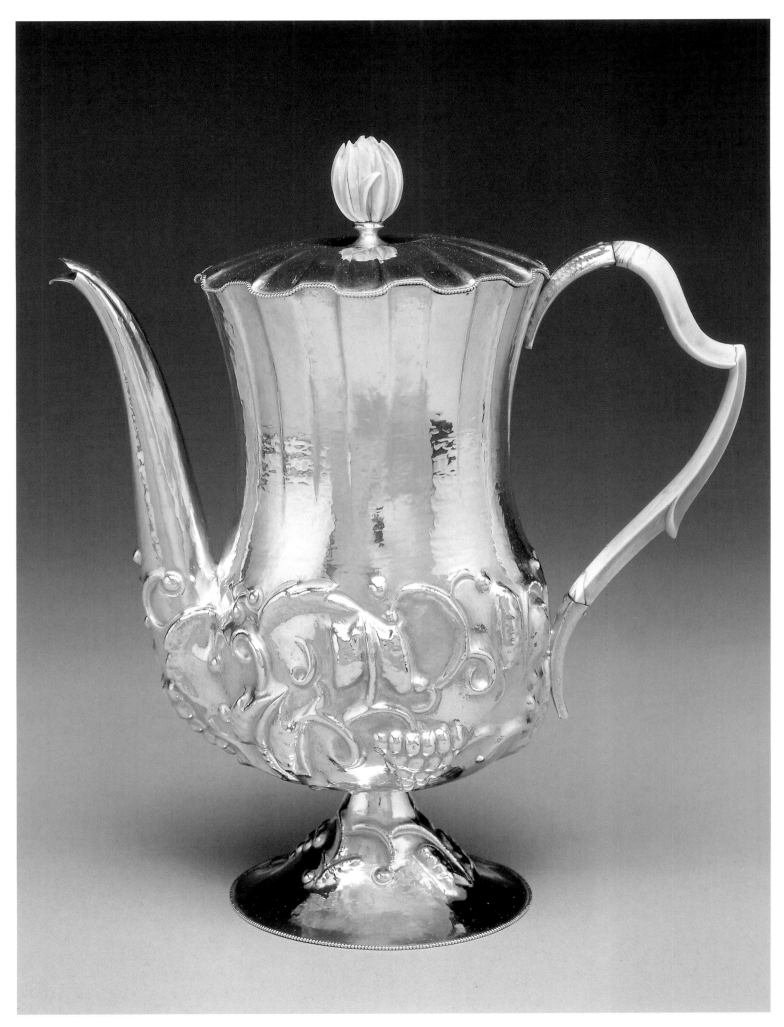

Page 170: *Dagobert Peche:* Coffee pot, 1922, silver-plated white metal, chased relief, ivory knob and handle

Left: *Josef Hoffmann:* Design for a tea and coffee service, c. 1920, pencil, ink and watercolour on paper

Josef Hoffmann: Tea service with tray and sugar-tongs, c. 1920, chased and hammered silver, bulbous ribbed body, ivory knobs and handles, knobs in bud motif

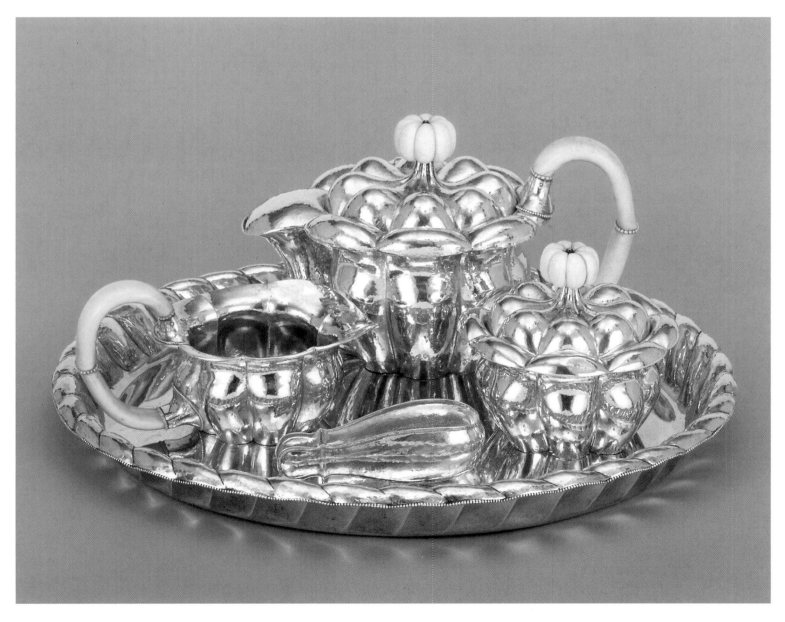

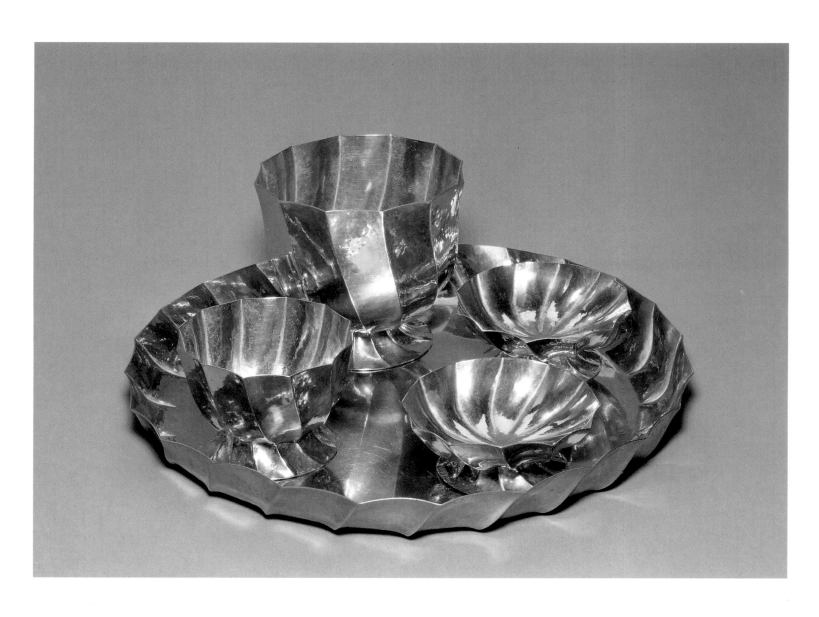

Josef Hoffmann: Smoking set, c. 1920, hammered and creased brass

unable to soar to quite the same artistic heights. Even Hoffmann's tableware grew wings – but remained firmly on the table (p. 165). Hoffmann continued to oppose Peche's asymmetry with his own symmetry. In his late silverware, decoration became abstract, and the object itself became ornament. Hoffmann also demonstrated something of the general trend towards monumentalization in the thirties, although he did not go to the extremes of Scandinavian silversmiths, for example, in their exaltation of the practical utensil. He remained an architect, obligated to scale and grid.

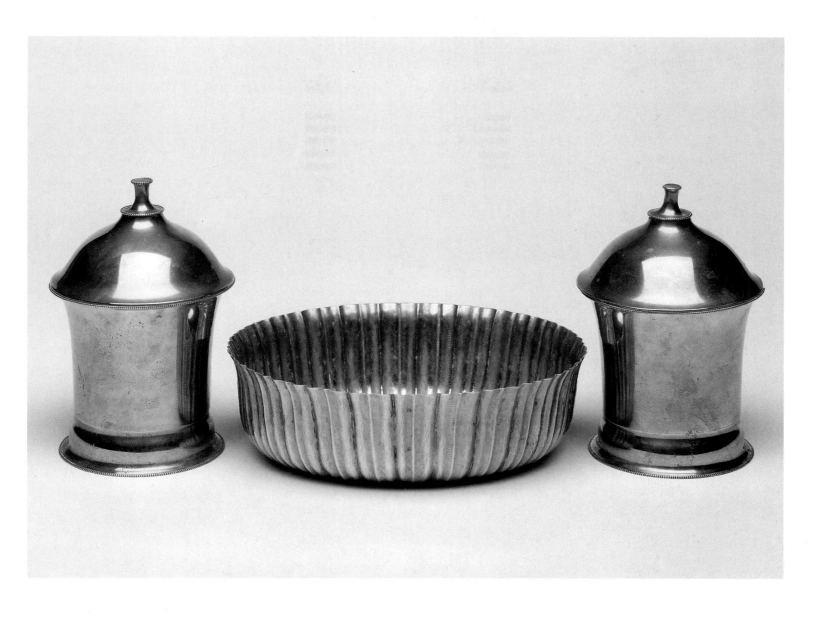

Josef Hoffmann: Two lidded jars, c. 1910, dish, c. 1920, chased and fluted brass

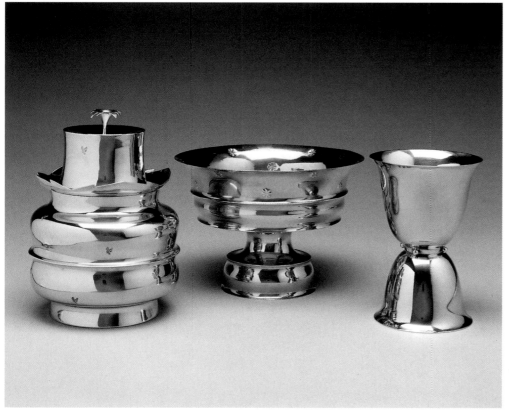

Dagobert Peche: Lidded jar (left) and dish (centre), c. 1915–1920, chased brass, decorative design of stylizec leaves.
Josef Hoffmann: Waisted vase (right), c. 1908–1912, chased brass

Jewellery

"At the Wiener Werkstätte one discovers to one's amazement something which is found in so few jeweller's shops today: goldsmithery and silversmithery as a true art, i.e. a crafting of the material which respects the softness, pliability and other outstanding properties of the precious metal. The works of the Wiener Werkstätte reveal a wealth of beauty which previously lay hidden in the material, a treasure which first has to be brought to light. They also demonstrate how the so-called semiprecious stones – held in low esteem by jewellers up till now – can be exquisite in an artistic setting. In view of the extremely tasteful and varied utilization of these stones, it may surely be assumed that diamond jewellery will soon be seen as banal by comparison. The parvenu judges the value and beauty of a piece of jewellery by the price and size of its stones. Today's connoisseur takes a different view. And the public? If a large enterprise such as the Wiener Werkstätte can survive, there must exist a category of people who wish to furnish their formal lives in the most exquisite manner…"[62] (Josef August Lux)

Dagobert Peche: Brooch, c. 1919–1920, chased gold, baroque pearl

The fact that artistic value did not automatically follow from material value was something made particularly clear in the jewellery of Art Nouveau. Previously, jewellery had chiefly been a question of fashioning the most expensive materials into artistic designs. Towards the end of the nineteenth century, however, the ideas of Art Nouveau began to penetrate the field of goldsmithery, and interest began to shift towards new forms of expression.

The jewellery of Art Nouveau is thus a reaction to the jewellery of the "imperial" age which preceded it, and whose forms, although highly developed, had grown rigid. The "preciousness" of a piece of jewellery was now less important than its decorative function, its symbiosis with the woman wearing it, and its integration within the "total work of art". At the Paris World Fair of 1900, visitors queued to see the wonders created by the French artist René Lalique. Although his highly intellectual and imaginative works were copied in every country, his quality was rarely equalled, leading to a flood of third-class Lalique imitations. Vienna, however, did not catch the Lalique fever.

The Wiener Werkstätte's "architectural jewellery", employing delicate squares, circles, compartments, borders, symmetrical patterns of stylized leaves and standardized flower motifs, was created by architects and designers.

The jewellery workshop was set up immediately following the foundation of the Wiener Werkstätte. From the very start, Josef Hoffmann and Koloman Moser favoured the execution of their designs by skilled gold and silversmiths, of whom the

Josef Hoffmann: Cigarette case, 1912, gold, opal, mother-of-pearl, lapis lazuli, turquoise and semi-precious stones, clasp of clear amber

Right: *Josef Hoffmann:* Brooch, 1904, silver, malachite, lapis lazuli, moonstone cabochons and corals, gold pin. The Wiener Werkstätte's "architectural jewellery", employing delicate squares, circles, compartments, borders, symmetrical patterns of stylized leaves and standardized flower motifs, stemmed from the hands of architects and designers.

Josef Hoffmann: Brooch, c. 1911–1912, silver-plated white metal, malachite, chased bunch of grapes

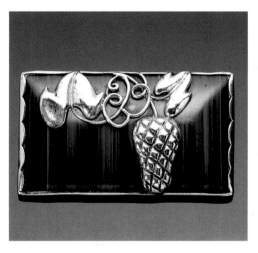

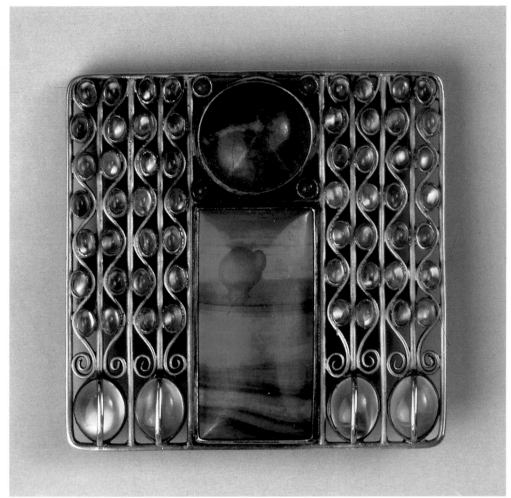

first to join the Wiener Werkstätte were Eugen Pflaumer, Josef Hossfeld and Karl Kallert. Until 1904, production was based exclusively on designs by Hoffmann and Moser. Carl Otto Czeschka arrived at the end of 1905, followed over the next few years by Bertold Löffler, Arnold Nechansky, Otto Prutscher, Eduard Josef Wimmer-Wisgrill, Carl Witzmann and Dagobert Peche.

However different the individual styles of Hoffmann and Moser, their synthesis created a specifically Wiener Werkstätte style. Both overcame the "designer's fear of the material" and, one as painter and the other as architect, brought the common features of their background – Secession, Mackintosh, Japan – into their jewellery designs. Moser held more steadfastly to a floral type, albeit one which could be smoothly integrated within an architectonic division of space. His Lizard pendant (p. 178 left), whose subject recalls English works, is an excellent example of the way in which these different stylistic elements are combined: Moser's characteristic elegance is seen in the "soft motif" of the spiral of the lizard's tail, while Hoffmann's influence is felt in the field of squares. Moser's surviving sketches and studies for pieces of jewellery demonstrate his lively experimentation with creative means in his search for innovation.

In its early phase, Hoffmann's jewellery is dominated by the grid, by linearity and latticework. He combines filigree ornament with colourful cabochons and sets them into geometric shapes. Alongside metal, first amongst his materials were semi-precious stones, which he deployed with consummate skill and a virtuoso mastery

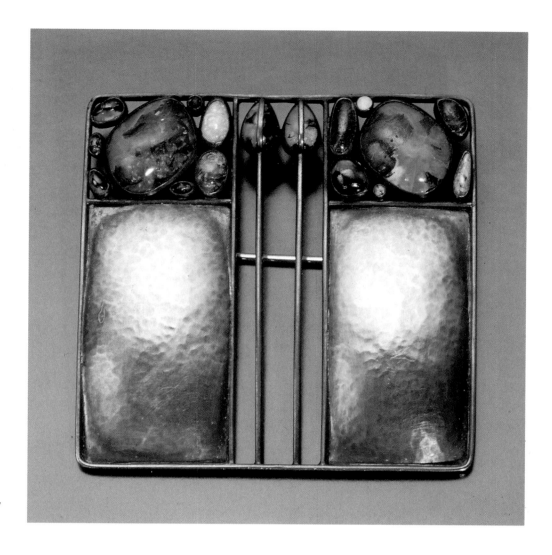

Josef Hoffmann: Brooch, c. 1905, square, with latticework, silver, gold and opal; made by Karl Ponocny for Emilie Flöge

Emilie Flöge wearing the brooch by Josef Hoffmann illustrated above, c. 1905, photograph

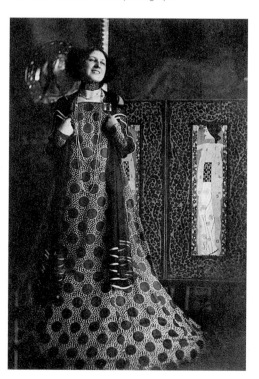

of colour. From around 1908, however, Hoffmann shifted his emphasis away from economy of means towards compositions dominated by flowers and leaves set within block compartments. The reciprocal influence existing between Hoffmann and Moser can be seen in the tiaras and necklaces which Hoffmann designed around 1920, in which he borrows stylistic elements from his artist colleague, who by that time had returned to painting.

At the opposite pole to the jewellery creations of this dominant duo stood the work of Carl Otto Czeschka. Czeschka's creative process was founded upon a sort of building-block principle, according to which individual modules were combined into long necklaces, belt buckles, brooches and bracelets. He oriented himself more closely than Hoffmann and Moser to the rich heritage of folk jewellery and to a symbolic formal vocabulary of flora and fauna.

Jewellery, just like every other area of Wiener Werkstätte activity, also received decisive new stimuli from Dagobert Peche. He fused asymmetry and empty space into pieces of jewellery which frequently incorporate the figures of animals and the lanceolate leaves of which he was so fond. Peche's brooches and necklaces, which were usually worked in mother-of-pearl and ivory combined with gold, resemble delicate pieces of lacework (cf. p. 182 above). Peche also explored the possibilities of ivory in considerable depth; in part this was a response to a certain shortage of materials during the war, but it may also be seen as an anticipation of French Art Déco, and the "chryselephantine statuettes" of the twenties. The

Koloman Moser: Pendant with lizard, 1904, silver, hammered lizard, opal

Josef Hoffmann: Chain with heart-shaped pendant, 1905, silver, mirror, two opals

Josef Hoffmann (attributed): Bracelet, c. 1910, chased and hammered silver, coral, removable clasp in tendril design

Koloman Moser: Necklace for Emilie Flöge, 1905, silver, ivory, cornelian, 48 cm long

Jewellery 179

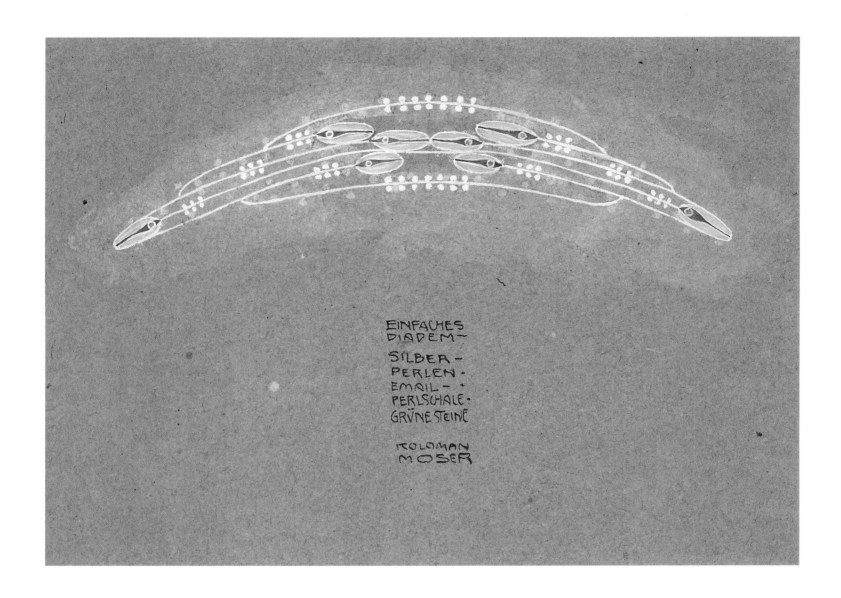

EINFACHES
DIADEM —
SILBER —
PERLEN ·
EMAIL — ·
PERLSCHALE ·
GRÜNE STEINE

KOLOMAN
MOSER

Above: *Koloman Moser:* Design for a tiara, 1902, pencil, opaque white, gouache and ink on russet Ingres paper. The inscription (translated) reads: "Simple tiara – silver – pearl – enamel – mother-of-pearl – green stones Koloman Moser".

Wiener Werkstätte even employed its own ivorycarver, Friedrich Nerold, to execute Peche's designs.

Although Hoffmann's intentions were very similar to those of Peche as far as composition and material were concerned, classicism nevertheless continued to dominate his works from a formal point of view.

The search for cheap materials also prompted the establishment of an enamel workshop (cf. pp. 182 below, 183). A move that was long overdue, it seemed, since enamel had been one of the chief materials of French Art Nouveau jewellery – and was much loved by the Scots. At the Wiener Werkstätte it was employed chiefly in boxes and etuis, however. Such works were executed in translucent enamel and were usually decorated with figural motifs.

Marrying human figures with a typical Wiener Werkstätte grid pattern was a challenge which, if successfully met, produced a particularly striking image. For the Shrovetide carnival celebrations of 1908, graphic artist Josef Diveky and textile designer Franz Karl Delavilla rose to the occasion with their designs for fantastical dominoes, to be worn at the masked balls at the Cabaret Fledermaus (p. 181). Customers could have these costumes made at the Wiener Werkstätte. These figurines display the typical "in-house" Cabaret Fledermaus style of ornament, and the girdle of Diveky's domino reflects Moser's lizard pendant.

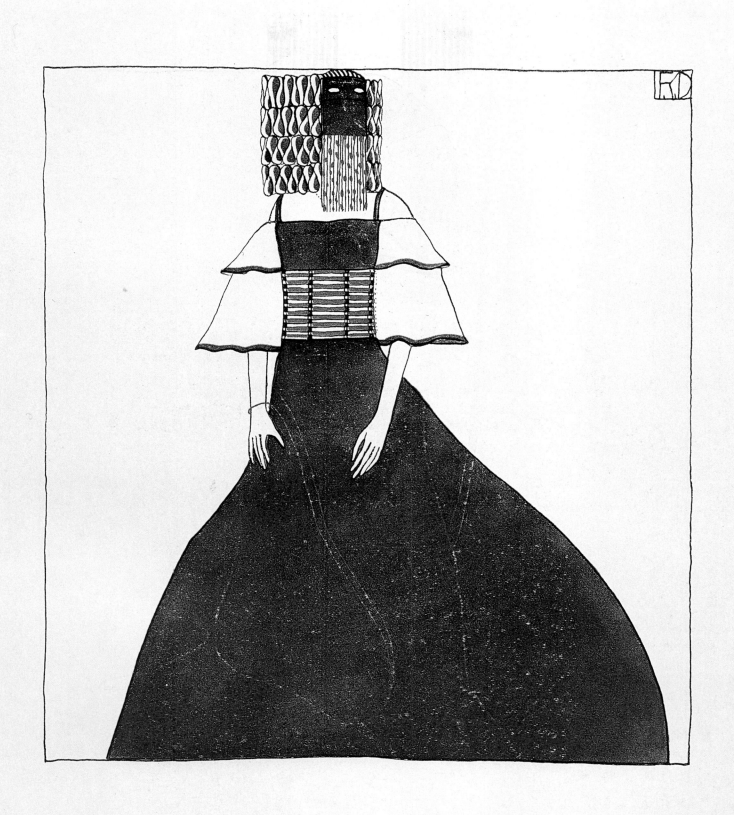

Above: *Franz Karl Delavilla:* Design for a domino,
before 1910

Page 180, below left: *Dagobert Peche:* Tiaras, 1916,
carved ivory

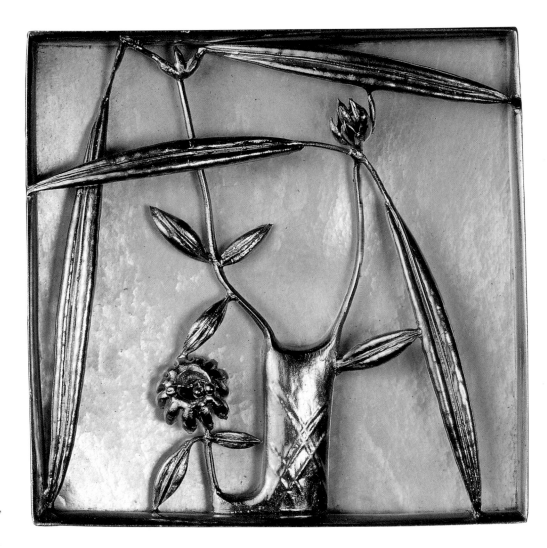

Dagobert Peche: Clasp, 1917–1918, chased gold, decorative motifs in openwork on mother-of-pearl

Max Snischek: Study of three women, c. 1920–1925, coloured ink on metal leaf, enamelled, reverse canvas

Page 183: *Maria Strauss-Likarz:* Head of a girl, c. 1928, enamel on copper

Fashion – Accessories – Small Art Objects – Graphic Design

As the range of products issuing from the Wiener Werkstätte grew even broader with the foundation of the Artists' Workshops in 1913, critics frequently accused the Wiener Werkstätte of degenerating into an impersonally decorative and ornately kitschy style. But the trend towards designing every last aspect of human life was gaining momentum. Alongside the desire to widen the spectrum of Wiener Werkstätte activity, the increasing shortage of materials during the First World War undoubtedly played a major role. Traditional materials such as glass, marble, brass, silver, gold and solid wood were now joined – and partially replaced – by papier mâché, plywood, glass beads, sheet metal, enamel, mother-of-pearl and a wide variety of textiles. Something of a comedown, undoubtedly, from the Olympian heights of artistic taste.

Yet it seemed only logical that, in the ongoing search for a synthesis of the arts and a resolution of the contradiction between life and art, there should be new and original creations in every field. While it may not have been absolutely *necessary* to "design" Christmas and Easter decorations, these nevertheless formed an integral part – albeit just for a few weeks of the year – of the home that was to be reformed. The same was true of wrapping-paper, boxes, toys and playing-cards, tins, pots and caskets – all things that, if tasteless, would mar the home. The collections of trophies choking 19th-century apartments were replaced by small, lovingly designed *objets d'art*. Wallpaper and fabrics had, of course, played an important role in Wiener Werkstätte design from the very start. Photographs of contemporary interiors clearly show a stylistic homogeneity which invariably extends all the way to the ceiling.

The entirely free style of decoration which now established itself caused the Wiener Werkstätte to be accused of a sort of "relapse" and decline after its period of geometric purity. "To Art its Freedom", declared the inscription on the Secession building in Vienna, and the Wiener Werkstätte now exercised its freedom to explore a new style, one which expressed itself first and foremost in that much-maligned category of the small art object. The artists were part of an international movement which had in fact already been prefigured in Vienna; it was here that Art Déco, with its "decorative" lightheartedness, had its beginnings as a seemingly contradictory mixture of classicist elements and so-called Modernism. Richard Strauss' opera *Der Rosenkavalier* (The Rose-Bearer) is an example of this ambivalence: at its première in 1911, it was viewed as an exception to the rule, a hiccup in a cultural development whose course people believed they knew. Instead, the opera was absolutely typical of its time.

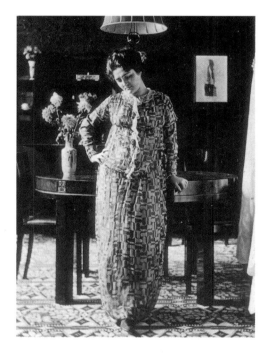

Friederike Beer in a house robe made from the "Stichblatt" fabric designed by Ugo Zovetti, c. 1913, photograph

Ugo Zovetti: "Stichblatt" fabric for a smock for Anton Hanak, c. 1914, pongee silk in white and black. Anton Hanak wore the smock during the years 1914–1921.

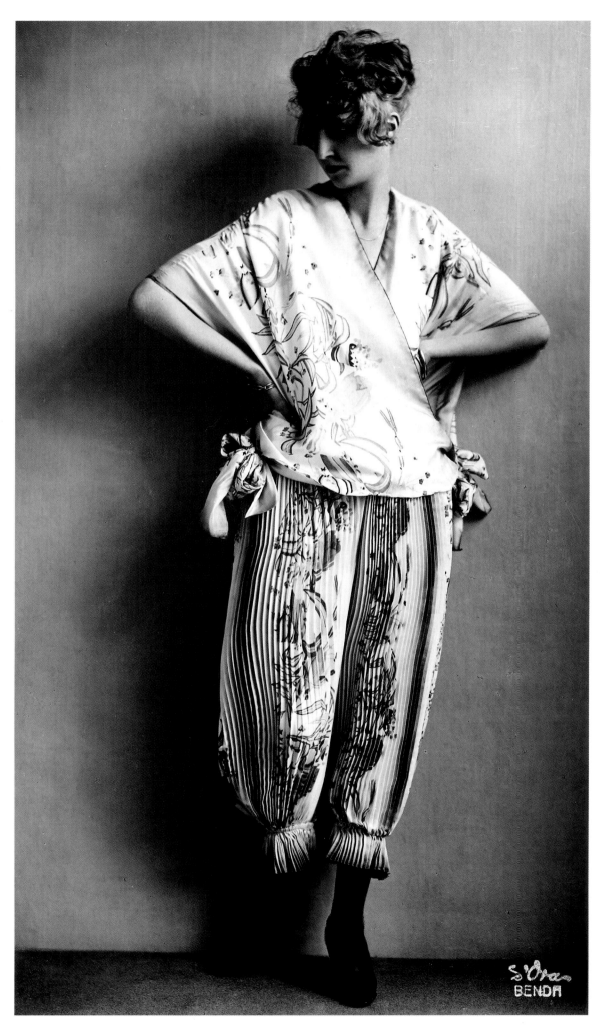

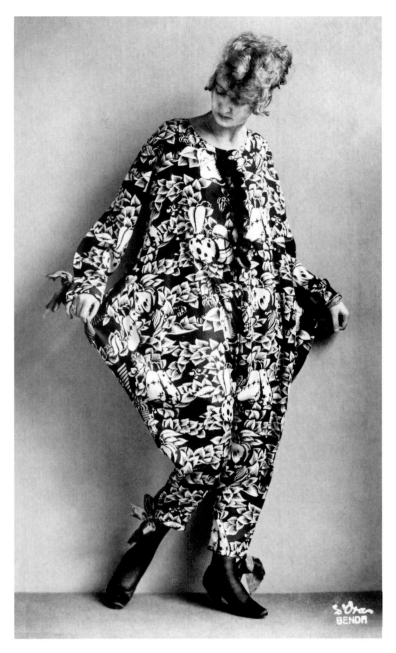

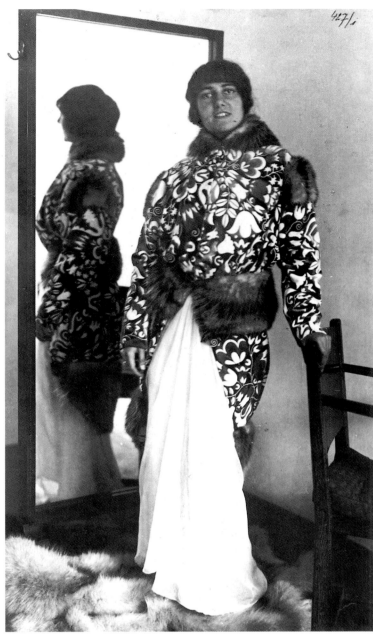

Fashion had already entered the artistic spotlight around 1900. Henry van de Velde, for example, had already paid great care and attention to the clothes worn by the occupants of his interiors. And when it was discovered that Madame Stoclet's Parisian wardrobe failed to match the design of her Brussels Palais, Eduard Josef Wimmer-Wisgrill founded the Wiener Werkstätte fashion department. The striving towards an integral interior décor made such a step imperative. Viennese fashion now proceeded not simply to free itself from the hegemony of Paris, but in turn to exert an enduring influence upon Parisian fashion through the figure of fashion designer Paul Poiret.

In 1917 Otto Lendecke, who had trained under Poiret, founded the fashion magazine *Die Damenwelt* (Ladies' World). Although it only survived for five issues, this short-lived magazine nevertheless provided Viennese fashion with its most beautiful record. Exquisitely designed, the magazine bore front covers by Gustav Klimt, Dagobert Peche and Otto Lendecke himself. On the occasion of the 1916 Vienna Fashion Exhibition, Berta Zuckerkandl commented: "The clothes, many designed

Above left: *Eduard Josef Wimmer-Wisgrill:* Pyjamas, 1920; "Hesperidenfrucht" fabric design by *Dagobert Peche*, 1919, photograph

Above right: *Eduard Josef Wimmer-Wisgrill:* "Cresta" coat, 1913; "Bavaria" fabric design by *Carl Otto Czeschka*, 1910–1911, photograph

Page 186: *Eduard Josef Wimmer-Wisgrill:* Silk house suit; fabric design by *Dagobert Peche*, c. 1920–1921, photograph

Fashion – Accessories – Small Art Objects – Graphic Design **187**

by craftswomen and mostly made of cheap materials, are not intended to serve as models for dressmakers. They are simply there to form the background to a decorative style of ornamental applied art which is still largely alien to the leading fashion houses. It is undoubtedly true, nevertheless, that the craftswomen concerned could benefit from direct contact with professional couturiers and their clients, since this would give them a practical insight into workshop operations and teach them how to translate an idea into a technically valid form. The primary stipulation, however, if Viennese fashion is to achieve a leading position abroad, is that it must be artistic, inventive, and true to its materials – the distinctive characteristics of Austrian style. It should be remembered that Poiret, recognizing four years ago that the stagnation in the applied arts in France was ultimately hindering the progress of fashion, sought to introduce a style in Vienna in which art once again played an active role… What we should be aiming at, therefore, is an international fashion boasting our national quality… only through its inimitable details of finery and ornament, only through its distinctive palette of colours, can Viennese fashion firmly establish itself in Germany, in the Scandinavian countries, in Holland and in America…"[63]

The "male" commentary on fashion, and thus on femininity, had a different tenor, albeit one which the Wiener Werkstätte also took into its calculations. Fashion was

Wiener Werkstätte: A pair of ladies' shoes, c. 1914, coloured silk reps, leather, continental shoe size 39

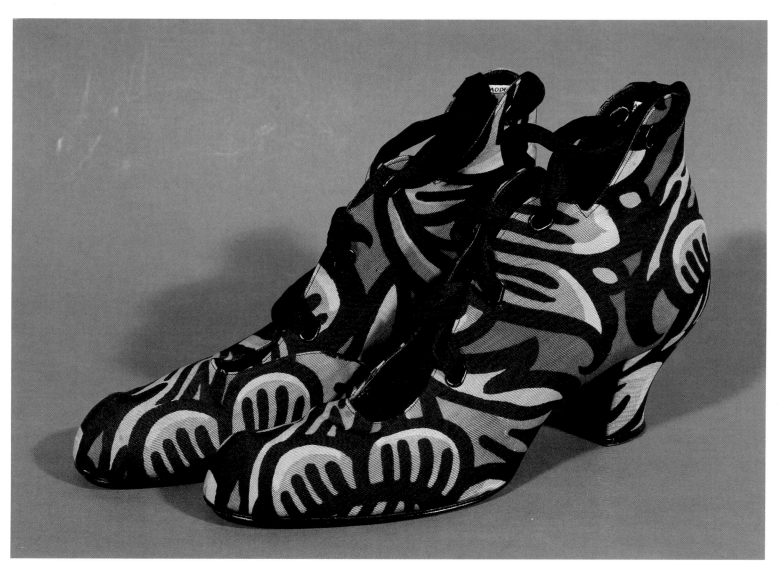

Josef Hoffmann: Umbrella, c. 1910, silk, "Jagdfalke 4 L/2" decorative fabric

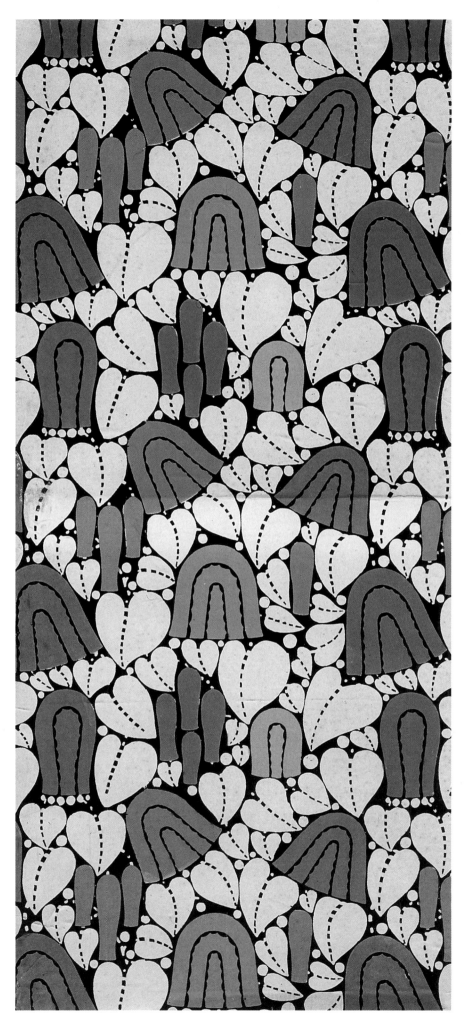

Josef Hoffmann: "Jagdfalke" decorative fabric, c. 1910. This fabric design is typical of the stylized floral patterns of the period after 1910.

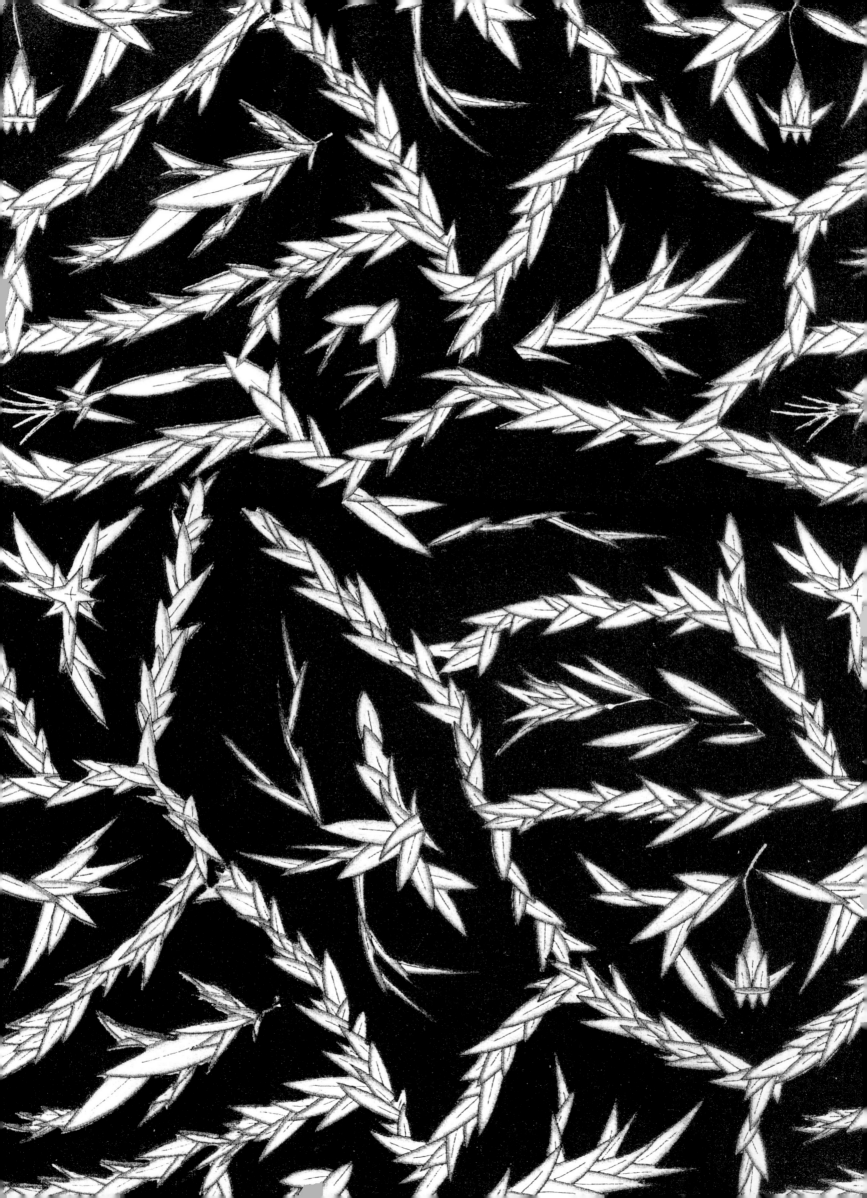

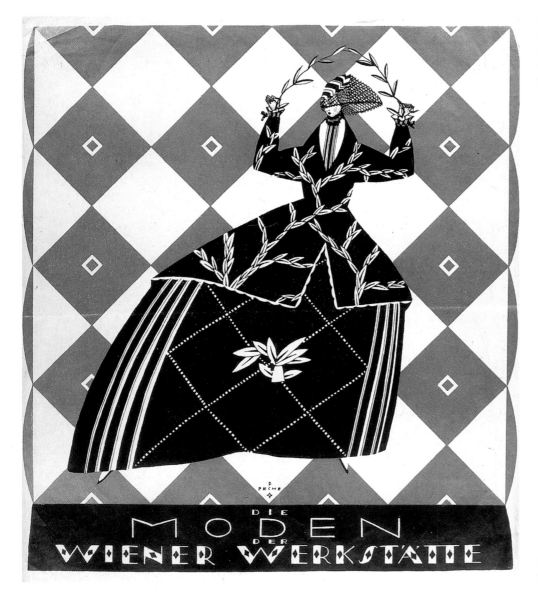

Left: *Dagobert Peche:* Poster advertising Wiener Werkstätte fashions, 1917, lithograph

Dagobert Peche: Lidded jar, 1916, ceramic and gold decoration

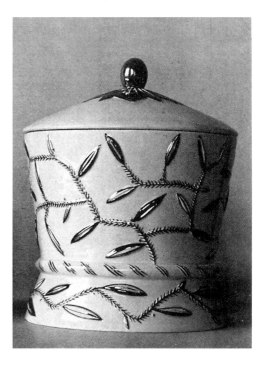

not simply a question of handicraft and healthy design, but was also dominated by "arty drapes of silk" and "bubbling excitement": "Fashion is a homage to women. Silk glistens and gleams and seeks to swathe itself around young hips. All that is colour and light in fabric springs to life like the earth before the rising sun; materials stiffen, fold, billow and rustle… Fur has not yet exhausted its feline art of flattery. Oh, you inconstant beings of wool, silk, brocade, gold and stones, women will never tire of your embraces, your crowns, your masks! But even as you waft around your adored mistresses, arty drapes of silk are already weaving themselves afresh in the workshop; spiralling wires transform themselves into slender filaments shot with bubbling excitement and sweet, fiery passion, ready to join the dance of homage at any moment…"[64] (Anton Jaumann)

At the very heart of the highly individual style of Wiener Werkstätte clothing lay fabric designs of enormous inventiveness. The fabrics themselves were produced in the Wiener Werkstätte workshops, where they were printed and painted by hand, as well as being machine-manufactured by Johann Backhausen & Söhne. More than 80 artists were involved in designing fabrics. A list of the "major suppliers" of ideas would include: Josef Hoffmann, Maria Strauss-Likarz, Mathilde Flögl, Max Snischek, Kitty and Felice Rix, Koloman Moser, Carl Otto Czeschka,

Women artists at the Wiener Werkstätte (clockwise from top left): Maria Strauss-Likarz, Gudrun Baudisch, Mathilde Flögl, Vally Wieselthier, photographs, c. 1918

Bertold Löffler and – with no fewer than a total of 2766 designs to his name – Dagobert Peche.

The "greatness" of Dagobert Peche's work does not lie in the size of the objects he created; his was the domain of the small detail, the charming incidental. His name is synonymous with variety at the Wiener Werkstätte: "Dagobert Peche is one of the most interesting artists of this kind. His characteristic: a singular animation. Peche first drew attention to himself in the 1913 Wallpaper Exhibition at the Austrian Museum with the exaggerated dynamism of his forms. His chairs, tables and sofas might have been termed Expressionist or Futurist. For the young artist refused to step in at the point at which the leading masters of style, already creating their own types, had arrived. He was living through his own *Sturm-und-Drang* period, like the elders of Art Nouveau before him… And it was Hoffmann who, because architect Wimmer-Wisgrill was too busy as the head of the fashion department, now

chose Dagobert Peche as the second decorative force behind the Wiener Werkstätte. He deemed it valuable to set the Baroque note of a passionately animated imagination against his own monumental art, and thereby to establish a polarity whose tensions would permit no coming-to-rest... Dagobert Peche's imagination stamps an intense, animated style upon the textiles and lace in the Wiener Werkstätte's new fabric shop. He is the artist of the unrepeatable flash of inspiration; he is also the marshaller of structure, trained by Josef Hoffmann, who knows how to curb the exuberance of his rhythm."[65] Zuckerkandl's characterization is clearly illustrated by a poster which Peche produced for the fashion department in 1917, in which the figure of a woman stands asymmetrically against a regular geometric background (p. 191 above). Although the woman is rendered in an ornamental, almost rococo fashion, her crinoline nevertheless takes up the geometry of the surround. As discussed earlier in the chapter on ceramics, the Wiener Werkstätte was dominated by "crinolines", or "petticoats", between the wars, much to the annoyance of both its critics and it friends. Women artists such as Gudrun Baudisch, Vally Wieselthier, Maria Strauss-Likarz and Mathilde Flögl nevertheless stood fully in line with Viennese tradition. Art here had started to take on feminine features from around 1900 onwards.

Eduard Josef Wimmer-Wisgrill: Ladies' hats, before 1910

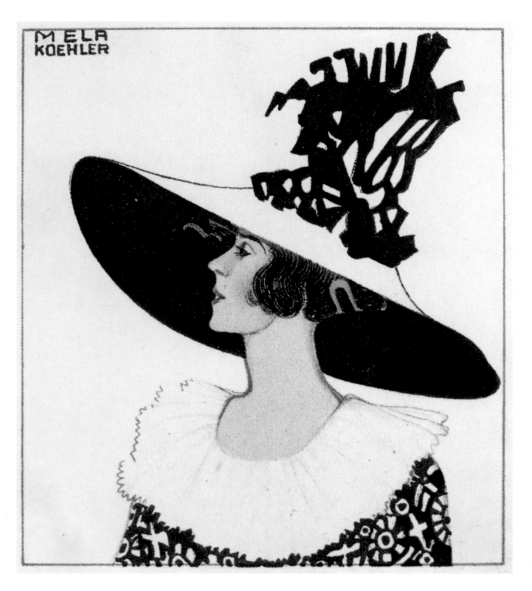

Mela Koehler-Broman: Fashion design, Wiener Werkstätte Postcard No. 312

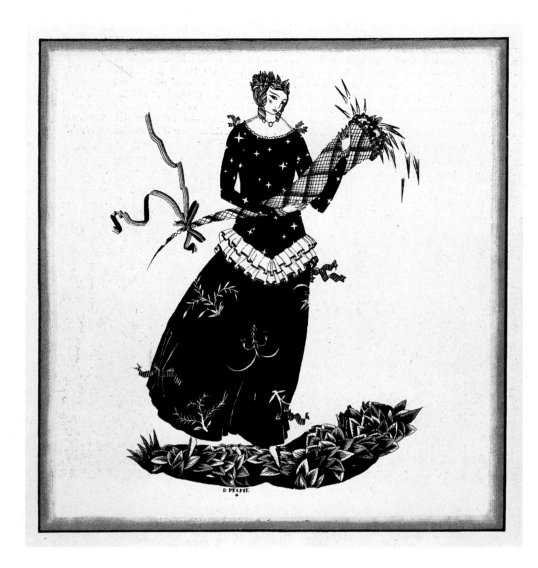

Left: *Dagobert Peche:* Poster for the Wiener Werkstätte fashion department, c. 1918, lithograph

Dagobert Peche: "Das schöne Heim" (The Beautiful Home), 1920, published by Alexander Koch, Darmstadt

Every Sunday, Berta Zuckerkandl received artists and intellectuals in her apartment, which had been designed by Josef Hoffmann. Other women who lent their public support to the "New Art" included Countess Nora Wydenbruck, Ida Conrat, wife of the industrialist Reininghaus, Eugenie Primavesi and Sonja Knips. But the schism remained, and the "coquettishness" of art around this period was blamed on the women, even though its so-called feminine aspects – elegant ornament – derived from Dagobert Peche.

In the special edition of the journal *Deutsche Kunst und Dekoration* published to coincide with the Wiener Werkstätte's 25th anniversary in 1928, photographs of the four above-named women artists, all with bobs, were given equal space alongside those of four men artists (p. 192). Interesting in this regard is Josef Hoffmann's article "Unser Weg zum Menschentum" (Our path to humanity), a title deliberately avoiding all sexist language.

Here he gives a condensed and factual description of the path taken by the Wiener Werkstätte up to that time: "The Wiener Werkstätte, established in 1903, is an enterprise for the active promotion and cultivation of all endeavours in the pursuit of art and quality in modern crafts. The Werkstätte works in its own studios with a host of outstanding craftsmen and creative artists in almost every field of applied art. The things it produces are those universally recognized as handicraft items and demanded as such. Through the fact that the designers are in constant dialogue

Page 195: *Mathilde Flögl:* "Allegro" decorative fabric, c. 1920, printed cambric

Hilda Jesser (left), Lilly Jacobsen (right), Vally Wieselthier (middle), Frizi Löw (below), 1918, photograph

Page 196: *Dagobert Peche:* Interior in the Fashion Exhibition at the Austrian Museum of Art and Industry, Vienna, 1915. "Dagobert Peche's imagination stamps an intense, animated style upon the textiles and lace in the Wiener Werkstätte's new fabric shop. He is the artist of the unrepeatable flash of inspiration; he is also the marshaller of structure, trained by Josef Hoffmann, who knows how to curb the exuberance of his rhythm."[65]

Dagobert Peche: Interior in the Fashion Exhibition at the Austrian Museum of Art and Industry, Vienna, 1915. "In the columned court of the Austrian Museum, Dagobert Peche has created a delightful installation which is intended to symbolize the intimate connection, so to speak, which in moments of creative flights of imagination links fashion with art."[63]

with the workshops, that they assist them at important times, and above all that they execute the models themselves, the objects attain the standard of perfection and quality that is normally only found in works of past classical eras. It is usual for all works to be signed, which also increases their value.

There are workshops for silver, gold and metal, for sheet metal and enamel, for leather and bookbinding, for fashion and knitwear, beadwork, embroidery, fabric painting, and for all types of ceramics. Woven and printed fabrics, carpets, wallpapers and printed silks are produced by distinguished manufacturers linked to the Wiener Werkstätte. Lace, small items of knitwear and special pieces are made with the greatest of care and love by individuals working from home. Although we never deliberately avoid machine production as a rational and flawless method of manufacturing, it is an option we consider only in the case of items where turnover is large. In such instances we produce our own models; we will not be satisfied with an incomplete drawing.

Maria Strauss-Likarz: Fashion design, Wiener Werkstätte Postcard No.775

The enamels, chased pieces and the majority of the ceramic works are completed by the artists themselves. All ceramic domestic requisites are entirely produced in our own workshops and kilns, as are the figural pieces, even the life-sized figures. The fashion department only works from its own models, something rarely found outside Paris. Our goal is, first and foremost, to give objects their most practical and functional shape, and then to render them valuable and individual through the use of harmonious proportions and pleasing forms that are appropriate to the material. Our only language and form of expression are the material, the tool, and in some cases the machine. We do not wish to force anything, but want simply to help and encourage the designer to follow his artistic intuition and develop his creative powers.

When all is said and done, we work in exactly the same way as every other healthy and meaningful epoch in the past. Epochs which live solely from the monotonous copying of long-gone styles never used to exist. This dreadful method has utterly ruined our own age and rendered its products worthless. Billions have been squandered on materials and labour, and no progress has been made. Processing ideas, as in the Empire style, is somewhat different; it is part of a perfectly healthy tradition which employs powerful forces and is constantly giving birth to new forms.

A straight copy, however good it may be, is always worthless and can never replace an original. It will always be in contradiction with the advancing age and will appear a sham.

Our age feels and perceives in an entirely fresh and modern way. Our clothes, our cars, our ships, our trains, indeed all our machines have found their contemporary form, and it is only natural that all the other areas of life should also be seeking their new form. We want to work in harmony and unison with everyday life, without feeling afraid when one of our artists or colleagues is suddenly struck by a new idea. We have deliberately positioned ourselves at the forefront of development and expect sincere understanding and corresponding support from all decent civilized people."[66]

The trimmings and decorative accessories, hats, belts, bags, cloth flowers, embroidery and rope necklaces which rounded off the Wiener Werkstätte fashion collection paint a picture of liveliness and wealth of imagination. The fashion department was

Below left: *Felice Rix:* Rope necklace in glass-bead embroidery, c. 1920–1925, fabric, coloured glass beads, 160 cm long

Below right: *Max Snischek:* Rope necklace in glass-bead embroidery, c. 1920, wood, papier mâché, coloured glass beads. The necklace is made up of twisted strands of small, closely embroidered glass beads of different colours, ending in beaded balls and tassels. These bead necklaces are typical of the fashion jewellery produced by the Wiener Werkstätte in the twenties, as designed by, amongst others, Peche, Strauss-Likarz and Löw.

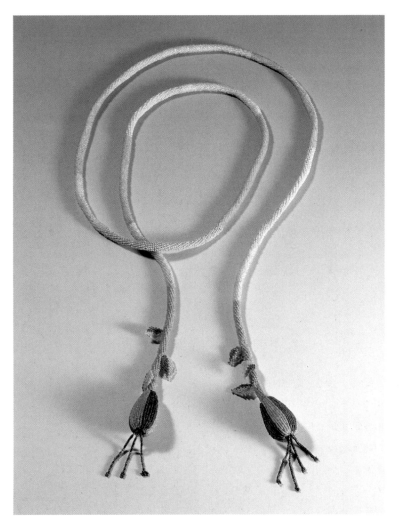

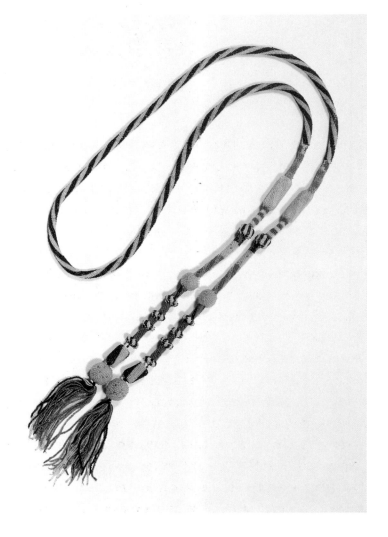

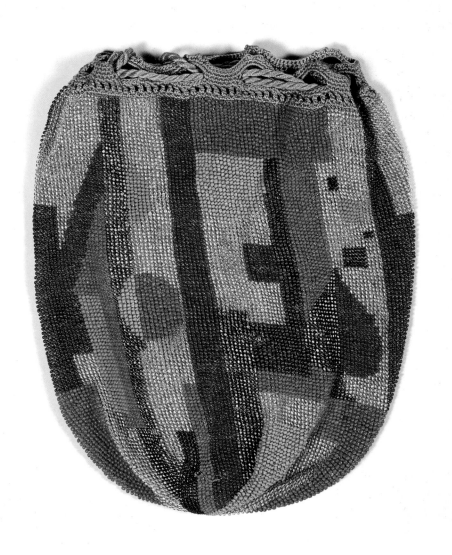

Dagobert Peche: Rope necklace, c. 1916–1917, glass-bead embroidery

Vally Wieselthier (attributed): Beaded purse, c. 1925; embroidered in glass beads of various colours, the surface is divided into abstract fields of luminous colour.

chiefly made up of women, not least due to the war. The men – Eduard Josef Wimmer-Wisgrill, Otto Lendecke, Max Snischek and Dagobert Peche – were responsible for more formal items of clothing. In addition to the women artists in the workshops, the Wiener Werkstätte also employed large numbers of women working from home, in particular for embroidery items, hat decorations and cloth flowers. Soon after the war, the fashion department found itself employing some 70 staff, excluding suppliers: success had arrived. Wiener Werkstätte accessories drew their inspiration from many sources: by combining Empire, Biedermeier and oriental influences with new ideas in a playful rather than eclectic manner, a highly individual style arose.

Old techniques were revived; alongside a comprehensive programme of lace production, designers turned their attention to glass beads (cf. pp. 198, 199). These were employed in a very wide range of accessories, in a glittering display of the attractive possibilities offered by this low-cost material. As in the case of jewellery, it was a question not of costliness but of inventiveness: "Glass beads, with their tremendous versatility, are not yet properly appreciated on all sides. Their lustre, their refractive abilities, and above all the luminosity of their colours, which last unchanged for hundreds of years and which can today be manufactured in almost

Wiener Werkstätte: Handbags, writing cases, brief cases, c. 1925, leatherwork

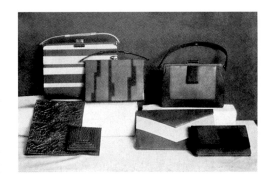

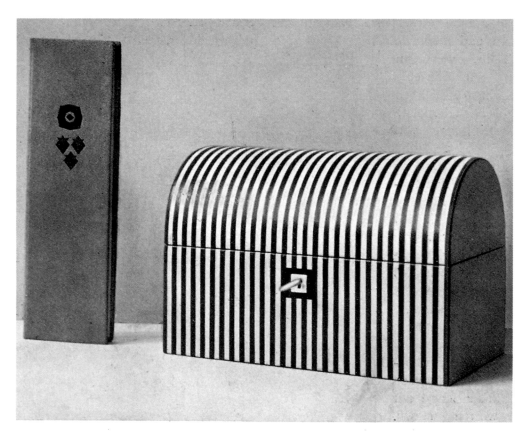

Josef Hoffmann: Casket and book cover, 1904, leather mosaic

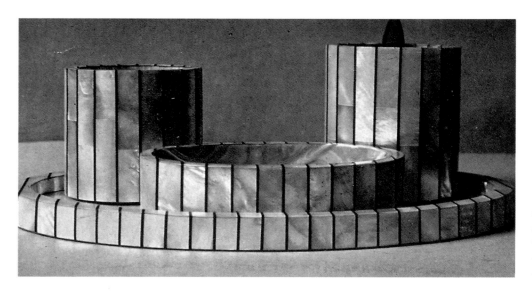

Josef Hoffmann: Smoking set, before 1910, mother-of-pearl. In the Wiener Werkstätte's vision of the total work of art, the collections of trophies choking 19th-century apartments were replaced by small, lovingly designed art objects.

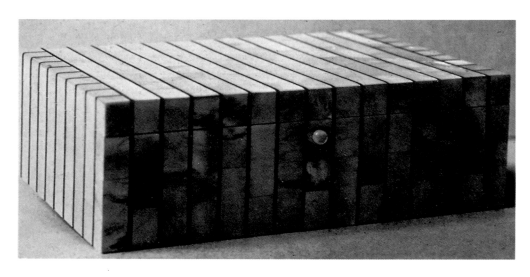

Josef Hoffmann: Box, 1904, mother-of-pearl

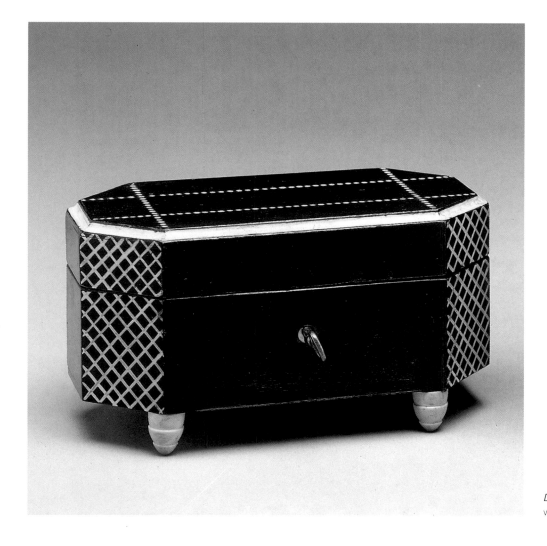

Dagobert Peche: Jewellery box, c. 1920, painted wood, ivory ornament

every hue, together with their extraordinary cheapness, mean that they are bound to find a much broader range of application once they have been accepted by major artists."[67]

The handbags, many of them executed to early designs by Josef Hoffmann (cf. p. 199 below), are very different from the almost old-fashioned beaded bags, and served as a foil for ornamental decoration until well into the twenties.

The Wiener Werkstätte's love of fine materials found its expression in the use of expensive types of leather, which were frequently gold-tooled by hand. The leather workshop practised an artistic type of bookbinding in a style influenced by the English, and had consequently enjoyed special importance right from the start. It was here that skilful craftsmanship and traditional techiques could come into their own, including leather carving, intarsia and braiding in the finest morocco, suede and box calf.

The concept of the "total work of art" naturally also extended to books. Wiener Werkstätte book production concentrated almost exclusively upon limited de luxe editions, bibliophilic gems which fulfilled the aesthetic stipulation of unity of image and word. The fundamental problem in book design is the formal relationship between illustration and text, between graphic and "abstract" form. Illustrations were assigned the function of framing the text in the form of vignettes, borders and tailpieces. At the same time, pictures depicting a scene from the text were allocated a full page. Images and words were thus accorded equal status; artistic unity was

Wiener Werkstätte: Wooden necklace, c. 1920, wooden balls painted with various motifs

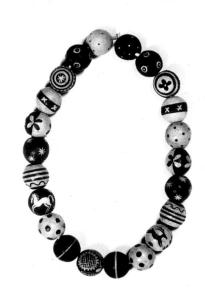

Josef Hoffmann: Book cover, c. 1914, multi-coloured saffian leather with "flower still life" appliqué.

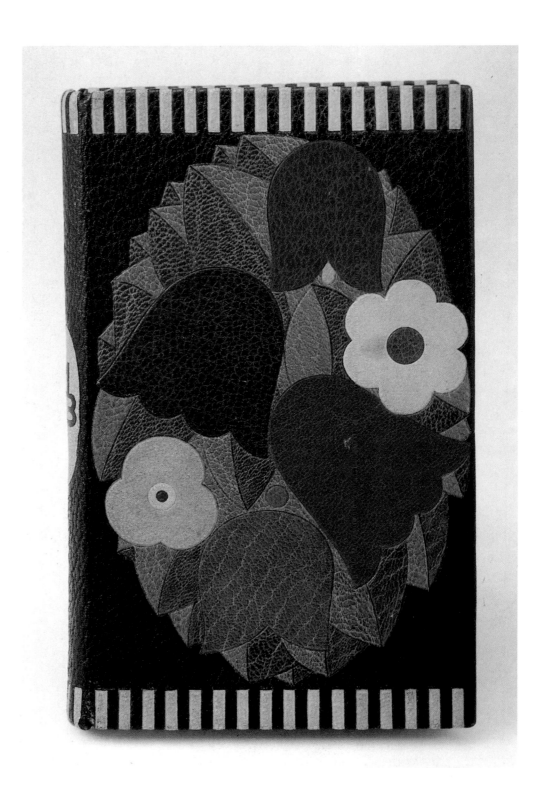

Carl Otto Czeschka: Box, before 1908, leather intarsia

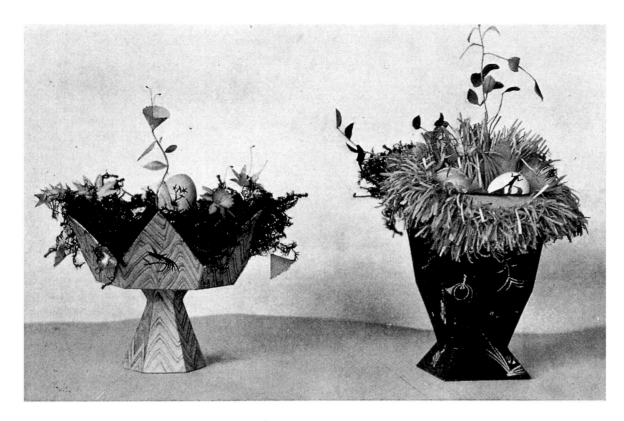

Below: *Bertold Löffler:* Wallpaper
design, before 1920, tempera on
russet paper

Vally Wieselthier and *Gudrun Baudisch:* Cover for the book *Die Wiener Werkstätte 1903–1928, Modernes Kunstgewerbe und sein Weg* (The Wiener Werkstätte 1903–1928, Modern Applied Art and its Path), published to commemorate the Wiener Werkstätte's 25th anniversary; compiled and designed by *Mathilde Flögl*, 1928; front cover by *Vally Wieselthier*, back cover by *Gudrun Baudisch*; papier mâché on card; 143 pages, with each page artistically conceived in different colours; large selection of illustrations relating to the Wiener Werkstätte; published by the Krystall-Verlag, Vienna, 1928

Wiener Werkstätte: Carnival costume, c. 1914, photograph

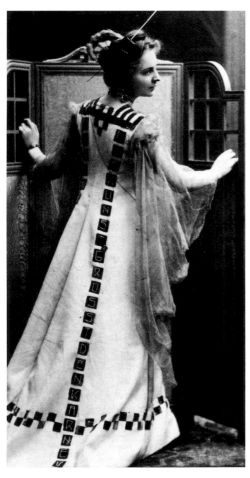

achieved. Particular attention was also paid to the "arch tecture" of the book, i.e. the decorative composition of a page or a binding. Book design was governed by a new, "unwritten law of the plane", one which well suited the emphatically two-dimensional style of the Wiener Werkstätte.

Alongside rhythmic colour combinations of black and white and black and gold, the fruits and flowers of Powolny's putti now increasingly found their way into leatherwork. The Wiener Werkstätte rose, stylized by Josef Hoffmann and Carl Otto Czeschka, reached full bloom, and design, which with its classicist phase had already drawn closer to Mediterranean art, became dominated by the "Rose-Bearer". The flowers that grew out of the grid-patterned planters were now banished to the plane. Wallpaper was also transformed into a colourful garden of blooms. It was inevitable that the purists would react: "Margold came to Darmstadt from Vienna. Vienna is a strange city. It attaches little worth to artistic conscientiousness and skill, but rather to mannerisms and manias. Gravity of any kind is considered too weighty. The Viennese have never liked people or works that are great and important, and no more do they like them today; they prefer to find everything 'cute', and esteem what is nice, coquettish, elegant and flattering. The passion for finery is widespread. People demand and expect compliments, both in manners of speech and in deeds. Vienna is not a proud city, but a vain one… Hence the products of Viennese art often resemble a fancy box of confectionery."[68]

Alexander Koch, editor of *Deutsche Kunst und Dekoration*, was mistaken, although he meant well. He could not know that seeds of the floral designs blossoming in Vienna were also being carried to Paris, the home of Art Déco, and were falling on fertile soil (cf. p. 140 below). As art hovered at the parting of the ways between abstraction and ornament, ornament won once again as the expression of a continuous advance in the direction of quality and imagination. "This art was superfluous, but what a virtue! It bore witness to those mannered, skilful artists whose only mistake was to ignore their age to live solely in the present moment. But the present moment was charming, it seems."[69]

In the theatre, too, life was no longer to be simulated solely at the outward level; instead, the inner meaning of life was now to be revealed in sets and costumes

Ditha Moser: Rummy playing cards, c. 1905. The design of these cards, based on the contrast of black and red, reflects the rigorous, geometric stylization which characterized the early works of the Wiener Werkstätte.

Carl Otto Czeschka: Toy knights (Nibelungen), c. 1910, five knights, turned and carved out of beech, painted and mounted on a circular lead base, each bearing a sword in one hand and a shield in the other, with movable arms. The shields are decorated in typical geometric Wiener Werkstätte fashion.

and expressed through symbols in the language of movement within the designed space of the set. The stage was to be built by "the artist-architect… for the problem of theatre belongs to the domain of interior design."[70] It is not surprising, therefore, that the Wiener Werkstätte also concerned itself with stage design. Apart from the shows it mounted at the Cabaret Fledermaus, however, commissions only started to arrive relatively late. Although Carl Otto Czeschka was asked in 1907 to design a production of Friedrich Hebbel's *Nibelungen* at the Raimundtheater, the project never saw the light of day. Czeschka's designs subsequently appeared in *Die Nibelungen – Dem deutschen Volk wiedererzählt von Franz Keim* (The Nibelungen – retold to the German people by Franz Keim), possibly the most beautiful book to issue from Viennese *Jugendstil*, which was published in 1909 (p. 207).

Following the foundation of the fashion department, the Wiener Werkstätte also began to design an increasing number of costumes for the bigger theatres; the stage thus took on the function of a sort of cat-walk for Wiener Werkstätte fashions. Shortly before his death, Dagobert Peche had started his designs for *Schlagobers*, the ballet by Richard Strauss; had he lived to complete his work, the Wiener Werkstätte's "genius of ornament" would have been seen at the Vienna State Opera.

Carl Otto Czeschka: "Die Nibelungen", 1908. The book *Die Nibelungen – Dem deutschen Volk wiedererzählt von Franz Keim* (The Nibelungen – retold to the German people by Franz Keim) was No. 22 in the Jugendbücherei series published by Gerlach und Wiedling, Vienna and Leipzig, 1909; 68 pages; 36 illustrations, most in colour, with gold printing. Czeschka's drawings were originally intended for a production of Friedrich Hebbel's *Nibelungen* at the Raimundtheater in Vienna. The costumes in Fritz Lang's film *Die Nibelungen* also recall Czeschka's designs.

Alongside stage design, bookbinding and wallpaper, around the turn of the century the expanding graphic design industry broached an entirely new field: advertising. Art Nouveau rapidly replaced the historicizing, visually incoherent posters of the 1870s. The development of commercial art was marked around 1900 by a number of pioneering achievements whose influence is still far from exhausted. It was only natural that the Wiener Werkstätte should also explore this area: on the one hand, it was eager to advertise its own products and propagate new ideas; on the other, graphic art offered a further means of achieving its aim to "design" everything in life. Its impressive range of products included invitations and handbills, programmes, placards, posters, business stationery, book-plates, illustrated books, playing cards, postcards, pictorial broadsheets, fold-out catalogues, calendars, notebooks, adverts and more. Woodcuts and lithographs were produced on the in-house hand press; printing and finishing were carried out by the best printing firms in Vienna. Within the field of advertising, the Wiener Werkstätte artists also concentrated upon typography, the most beautiful result being the "logo" designed by Koloman Moser (p. 215). They also designed signets and monograms for clients.

In this context, one might interpret the concept of the total work of art as nothing other than "CI", corporate identity, that supposedly so modern catchphrase on the lips of every chief executive.

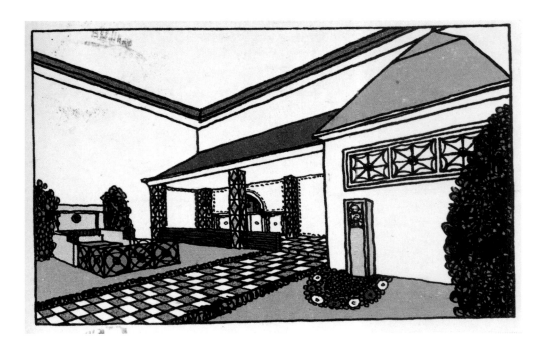

Gustav Klimt: Wiener Werkstätte Postcard No. 3, 1908; addressed to Emilie Flöge; front and back views

The spread of such printed products naturally played an enormous role in educating public taste. They succeeded where interior design had failed: they introduced the new style to a broad public. As a result, the Wiener Werkstätte postcard series became immensely successful and extended to more than 1000 different designs. These postcards, all designed by artists (pp. 208, 209), continue to sell healthily today and provide a complete overview of modern graphic design from the Secessionist style to Expressionism. They also serve as a record of the fashions of the day (pp. 193 below, 197 below). The triumph of these miniature works of art, so cheap to produce, was simultaneously a victory for the revolutionary ideas introduced into artistic thinking around 1900: art for all.

Egon Schiele: Wiener Werkstätte Postcard No. 290, 1910

Fashion – Accessories – Small Art Objects – Graphic Design **209**

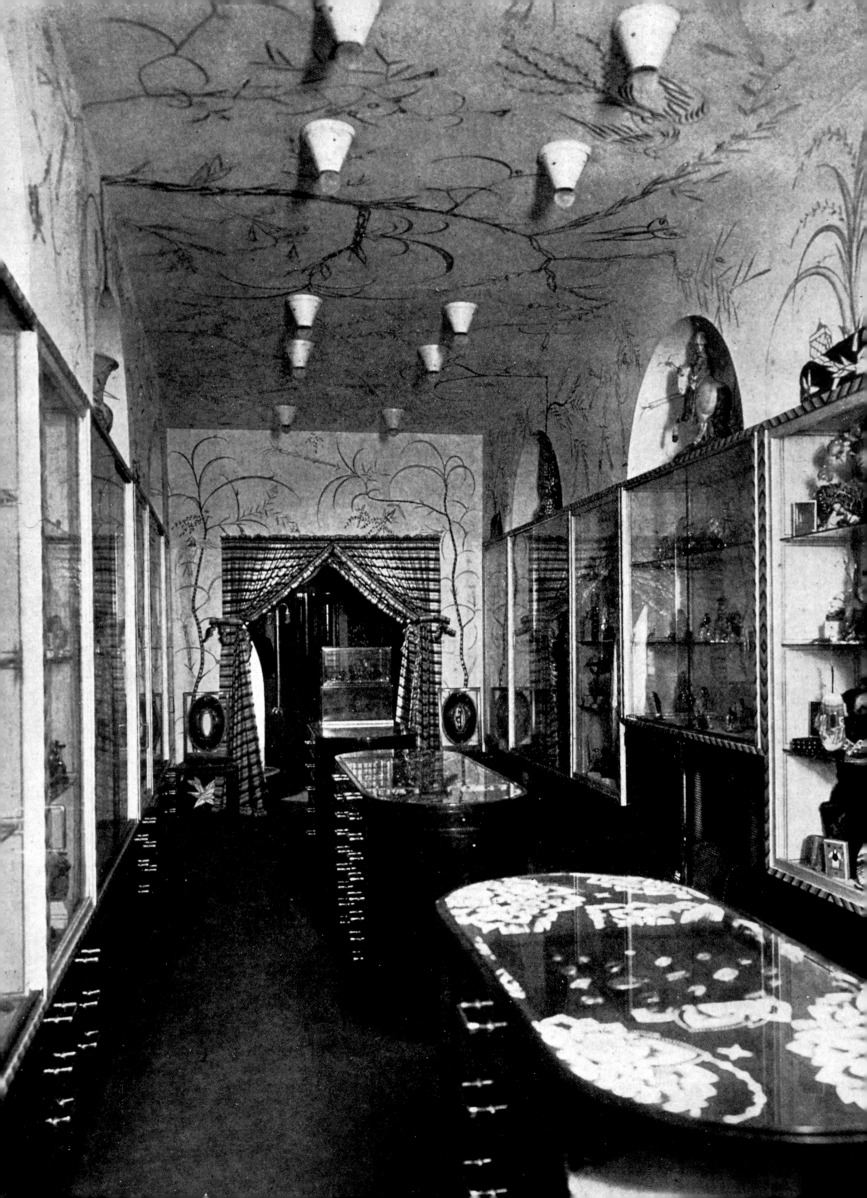

Wiener Werkstätte Branches – Shops

"An arts and crafts enterprise in the grand style has quietly taken shape in Vienna under the direction of its founders Professor Josef Hoffmann, Professor Koloman Moser and Fritz Waerndorfer. This consortium of artist craftsmen has set up shop in a spacious new building in Neustiftgasse; the 'Wiener Werkstätte' is amply housed on three floors, with its own workshops for metalwork, gold and silverwork, bookbinding, leather, cabinetmaking and varnishing, as well as its own machine rooms, architectural offices, design rooms and showroom. Here, in the midst of factory noise, artist craftsmen pursue their quieter, inspired manual labours. For machinery is by no means absent; on the contrary, the 'Wiener Werkstätte' is fully equipped with all the technical innovations facilitating the production process. Here, however, the machine is not a ruler and a tyrant, but a willing servant and assistant. Thus products bear the stamp not of machine manufacture, but of the spirit of their artistic creators and the skill of practised hands. The characteristic principle of the Werkstätte, and one that must be instilled into every craftsman if he is to achieve the most perfect result possible, is that it is better to work for ten days on one item than to produce ten items in one day. Every object thus embodies the maximum of technical and artistic ability, and its artistic worth resides where it is so rarely found and where it should in truth be sought – not in decorative externals or formal trimmings, but in the seriousness and dignity of mental and manual labour. Every object carries the imprint of both: it is not only designed by the artist, but bears the mark of the executant, the craftsman, the worker who alone manufactured it. This is a further aspect of the socio-political insight of the founders, who aim, through these and other measures, is to increase and reinforce their craftsmen's sense of self-worth and the pleasure which they derive from their work. Raising the level of morale in this way has a beneficial effect upon performance. Other educational steps that have been taken include the banning of all bad language on Werkstätte premises, and on one occasion the dismissal of a member of the administrative staff who was foolish enough to utter a thoughtless remark to a worker.

Acting on the assumption that an intelligent worker would arrive with certain expectations as regards his workplace, the rooms have been furnished and equipped accordingly. Factory and workshop are words that usually prompt a slight shudder in civilized people, with their overtones of grime, unhappiness and sad, faceless surroundings in which people work not for the love of it, but under the iron rod of financial necessity. Even though we may be told that the view of an industrial zone holds its own beauty, it remains all too true that the church spires of industry – as

Josef Hoffmann: The Wiener Werkstätte branch in Karlsbad, c. 1909. The shop shared part of the building housing the Auge Gottes Hotel. Interestingly, the inscription on the corner by the door is in English; above it, a typical Wiener Werkstätte latticework flower basket holds ivy.
Fritz Waerndorfer wrote to Czeschka on 8.5.1909: "…in Karlsbad, a shop (WW) unlike any that has been before… The side walls of the display windows [are] white wood, as is ceiling; four carved strips of wood, painted green and black, run along walls and ceiling. Rear wall hung with a whitish-green curtain. – Inside everything completely white… and the lushest green carpet." (quoted according to Eduard F. Sekler, Josef Hoffmann, *Das architektonische Werk*, Salzburg and Vienna, 1982)

Dagobert Peche: Decorative wall painting in the Wiener Werkstätte's showroom, Am Graben 15, Vienna, 1916

Signet of the Wiener Werkstätte's New York branch

the towering stacks are sarcastically called – have never yet touched anyone's heart. With the exception, that is, of Mr. Herz [heart], the industrialist who calculates his profits according to the height of his chimneys. Upon entering the 'Wiener Werkstätte', however, one is pleasantly suprised to discover that the workshops are all optimally furnished from an aesthetic point of view, too, and provide a happy setting for creative activity. Their striking beauty derives from the underlying principle of hygiene, whose case is argued with light, cleanliness and fresh air. Walls and wood are painted white, iron is painted blue or red. Each workshop is dominated by one colour in particular, which is also employed for their respective entry books to avoid any confusion. It is easily conceivable that, for some of those on the long list of employees, the whole thing was so new that they felt quite intimidated to start with; none of them, certainly, had ever worked in such superb conditions. The first step was to accustom them to this sound and healthy working environment – not always an easy task, as in the case of teaching people to use the wash-basins in the hygenic WCs, for example. Social concerns cease to exist in this enterprise; the 'Wiener Werkstätte' today boasts an élite of artist craftsmen who feel a sense of solidarity with the enterprise and are fired by the praiseworthy ambition to do their best in their specialist field. The showroom, which one enters first, offers an overview of the whole. White is the dominant colour. Fitted glass cabinets contain

Josef Hoffmann and *Koloman Moser:* Wiener Werkstätte showroom at Neustiftgasse 32–34, Vienna, 1903. The light, clearly-organized room is "crowned" by a chandelier by Moser. The smooth walls are lined with cupboards and shelves taller than head height, used for storage purposes. In the centre of the room, a large, dark-coloured worktop rests on two cubes, with "grid" waste-paper baskets underneath. The chandelier, on the other hand, is made of pieces of crystal strung together with the lightness and elegance so typical of Moser.

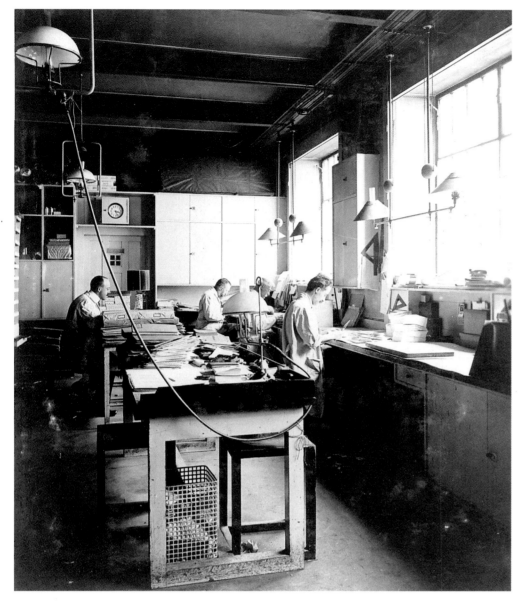

Josef Hoffmann and *Koloman Moser:* Wiener Werk-stätte bookbinding workshop at Neustiftgasse 32–34, Vienna, 1903. The Wiener Werkstätte's work-shops. together with its offices and showrooms, were located in a former factory building in a rear court-yard. Each workshop was designated by a specific colour, which served as its "logo". The colour of the bookbinding workshop was grey.

Josef Hoffmann (attributed): Waste-paper basket (left), c. 1913–1914, sheet iron painted white, dec-orative design of perforated squares.
Josef Hoffmann: Waste-paper basket (right), c. 1905–1906, sheet iron painted white, decorative design of perforated squares

numerous art objects made of precious metal, wood, leather, glass and precious stones, together with jewellery and objects of everyday use, all strictly practical in design and honouring the nature of the materials employed…"[71] (Joseph August Lux)

On 19 May 1903, the "Wiener Werkstätte, Productivgenossenschaft von Kunst-handwerkern in Wien, Genossenschaft mit unbeschränkter Haftung" (Vienna Workshops, manufacturing co-cperative of artist craftsmen in Vienna, co-operative with unlimited liability) was incorporated under reference number Reg. Gen. VIII, 124 in the Vienna Trade Register. Its directors were named as Josef Hoffmann and Koloman Moser, both Imperial Royal Professors at the School of Arts and Crafts in Vienna, and its treasurer as Fritz Waerndorfer, the Viennese manufacturer. The new firm initially operated out of a one-bedroomed apartment at Heumühlgasse 6 in Vienna's 4th district. In October that same year, however, it moved to an abandoned factory site at Neustiftgasse 32–34 in the 7th district (cf. p. 214), where workshops for bookbinding (p. 213 left), leather, cabinetmaking and varnishing were set up alongside the existing gold and silver workshops, together with a new architectural office. In summer 1906 another showroom was added, and one year later the first

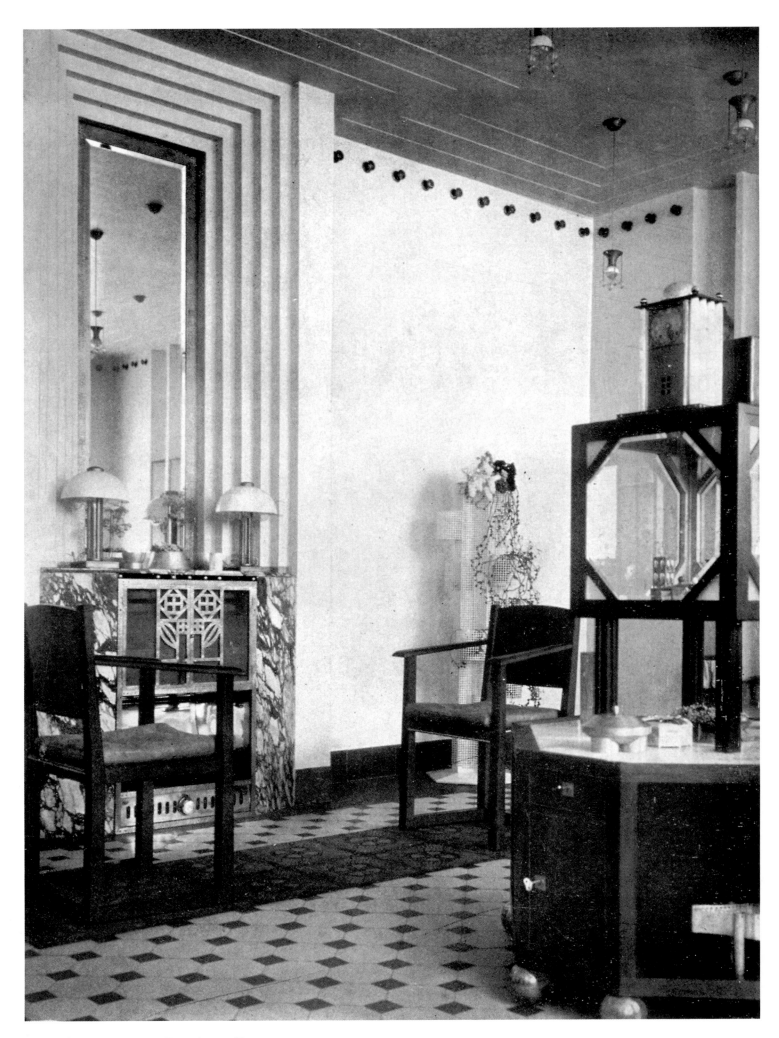

postcards were published. The Wiener Werkstätte's first shop opened its doors to the public in autumn 1907 at Am Graben 15. The introduction of a fashion department under the direction of Eduard Josef Wimmer-Wisgrill in 1910 rounded off the picture of the "total work of art". In 1913 Josef Hoffmann established the Artists' Workshops in a house built by and rented from Otto Wagner at Döblergasse 4. Under the management of the Wiener Werkstätte, these new workshops were to be "open to all artists of quality". In 1915 Otto Primavesi, the Werkstätte's majority shareholder, set up a new head office at Tegetthoffstrasse 7 in Vienna 1. The success of the fashion department led in 1916 to the opening of a new shop at Kärntner Strasse 41, followed in 1917–1918 by new salesrooms for fabrics, lace and lighting fixtures at Kärntner Strasse 32. Branches sprang up at home and abroad: Karlsbad in 1909 (p. 211), Marienbad and Zurich in 1916–1917, New York and Velden in 1922, and Berlin in 1929. Berlin had been home to a branch since 1916.

Exhibitions

The exhibitions mounted by the Wiener Werkstätte, whether on its own premises or within the context of other events, were not simply presentations of its artistic achievements, but manifestos of its programme: the consecration of everyday life on the altar of art.

There is space here for only a limited overview of the Wiener Werkstätte's many exhibitions. The first Wiener Werkstätte exhibition was held in 1904 in the Hohenzollern-Kunstgewerbehaus (Hohenzollern House of Arts and Crafts) in Berlin. In 1905, the Miethke Gallery hosted the first Vienna showing outside the Wiener Werkstätte's own premises; this would be followed by many more shows in the same gallery. Also in 1905, the Wiener Werkstätte was included for the first time

DIE REGISTRIERTE SCHUTZMARKE

DAS MONOGRAMM DER WIENER
■ WERKSTÄTTE ■

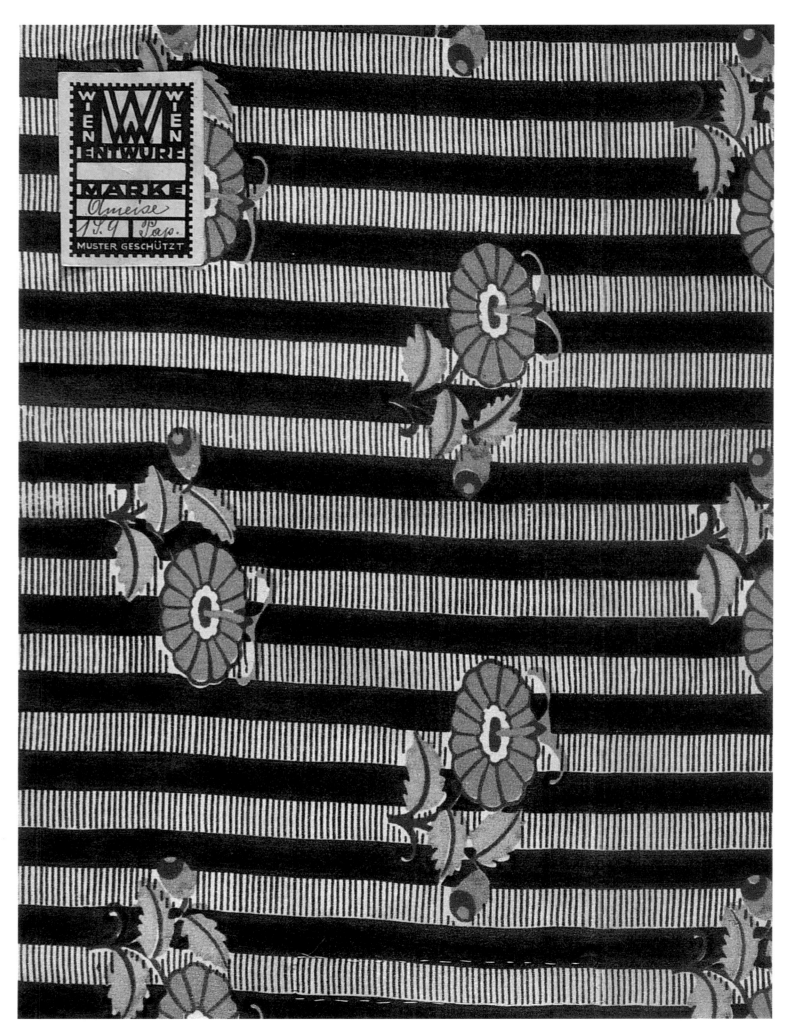

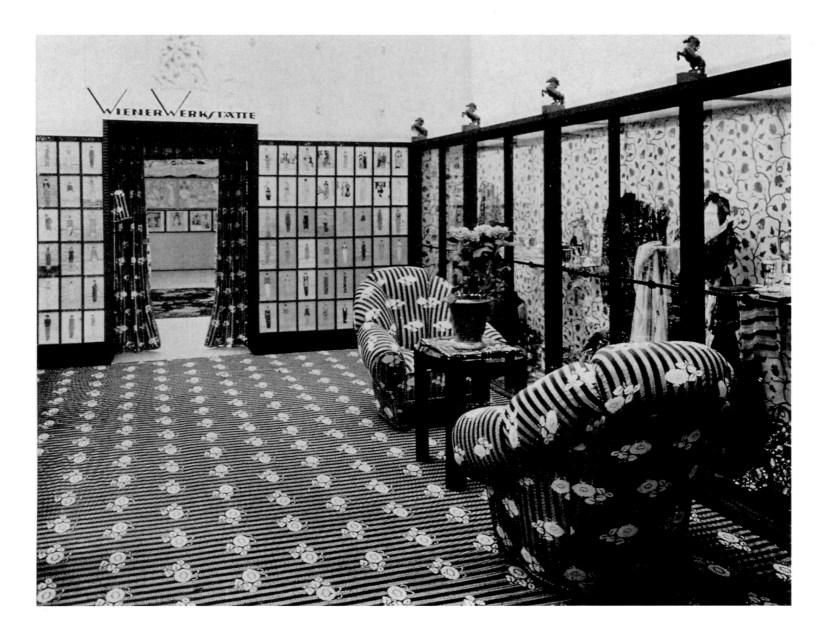

in a museum exhibition, in the Moravian Museum of Applied Art in Brünn. From 1906 onwards the Wiener Werkstätte featured increasingly in international exhibitions. At the Imperial Royal Austria Exhibition in Earl's Court, London, in 1906, it was even given its own room, and was greeted with overwhelming acclaim. This success was repeated in that stronghold of German *Jugendstil*, the Folkwang Museum in Hagen. That same year, it staged "The Laid Table" in its own showrooms, and in 1907 its next programmatic show, "Garden Art" (Die Gartenkunst). The Vienna Kunstschau of 1908 made it clear to even the harshest critics that "this Viennese modern art is perhaps the most homogeneous and perfect that our age has yet brought forth".[72]

At the International Art Exhibition in Rome in 1911, it was the graphic works by the Wiener Werkstätte, alongside works by Gustav Klimt, that attracted the greatest attention. A further high point was the 1914 Werkbund exhibition in Cologne, where the Wiener Werkstätte had its own pavilion (pp. 101 above, 217). This was the "highlight of our exhibition", as Karl Rehorst, mayor of Cologne, so magnanimously put it. With its international reputation now thoroughly established, the Wiener Werkstätte took part in numerous "propaganda exercises" to spread the name of Austrian arts and crafts abroad: in Stockholm and Berlin in 1916 and Zurich in

Eduard Josef Wimmer-Wisgrill: The Wiener Werkstätte room in the Austrian Pavilion at the German Werkbund exhibition, Cologne, 1914. The floral pattern in the armchairs and carpet is repeated in the curtains. The fabric lining the rear of the cabinets and the ceiling features the "Mekka" design by *Arthur Berger* (cf. p.82). The walls on either side of the entrance are hung with fashion designs.

Page 216: *Eduard Josef Wimmer-Wisgrill:* "Ameise" fabric design, c. 1910–1911

Pages 218–219: *Josef Hoffmann:* Austrian Pavilion at the Exposition Internationale des Arts Décoratifs et Industriels Modernes, Paris, view of the large gallery, 1925. The walls, glazed from ceiling to floor, serve as display cabinets; they are supplemented by free-standing display units running down the centre of the room. The wooden elements are painted black with lively white ornament. Both the wall cabinets and the display cases are lined in yellow.

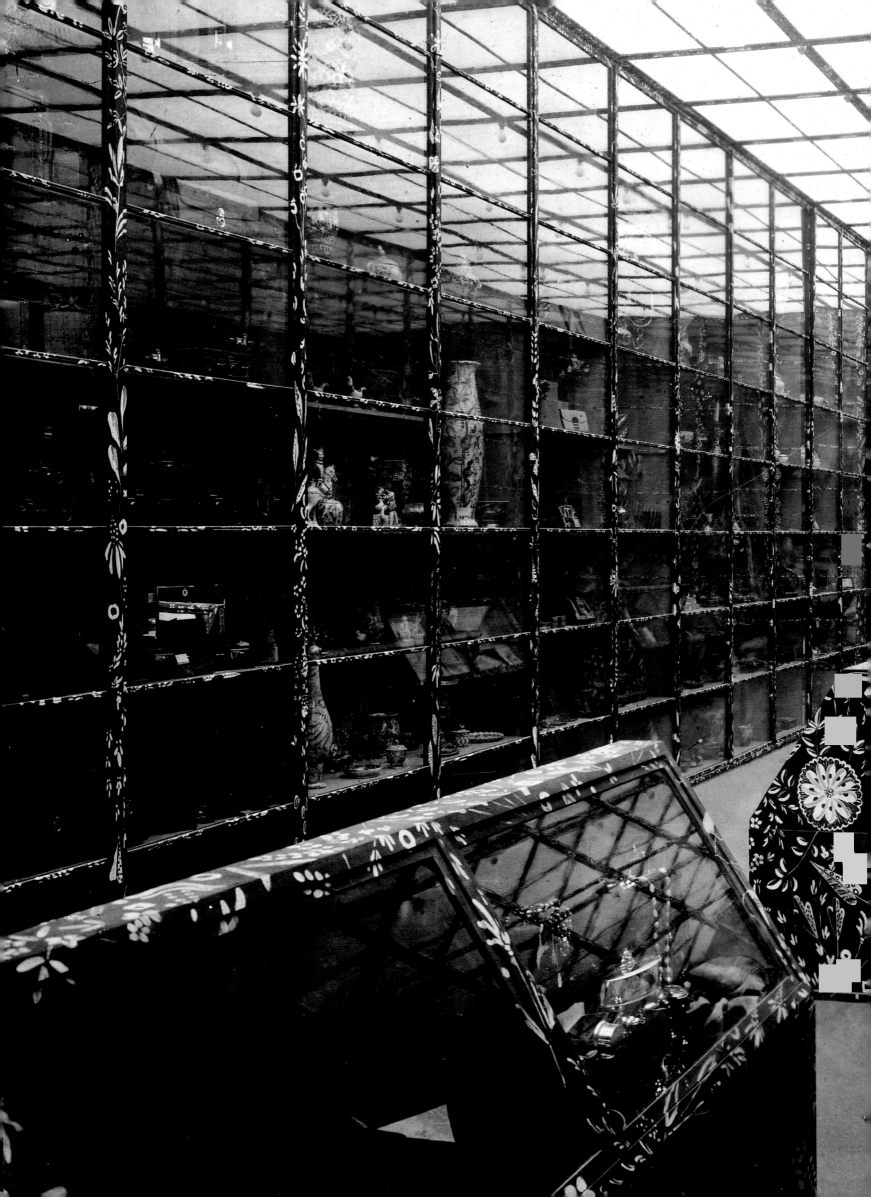

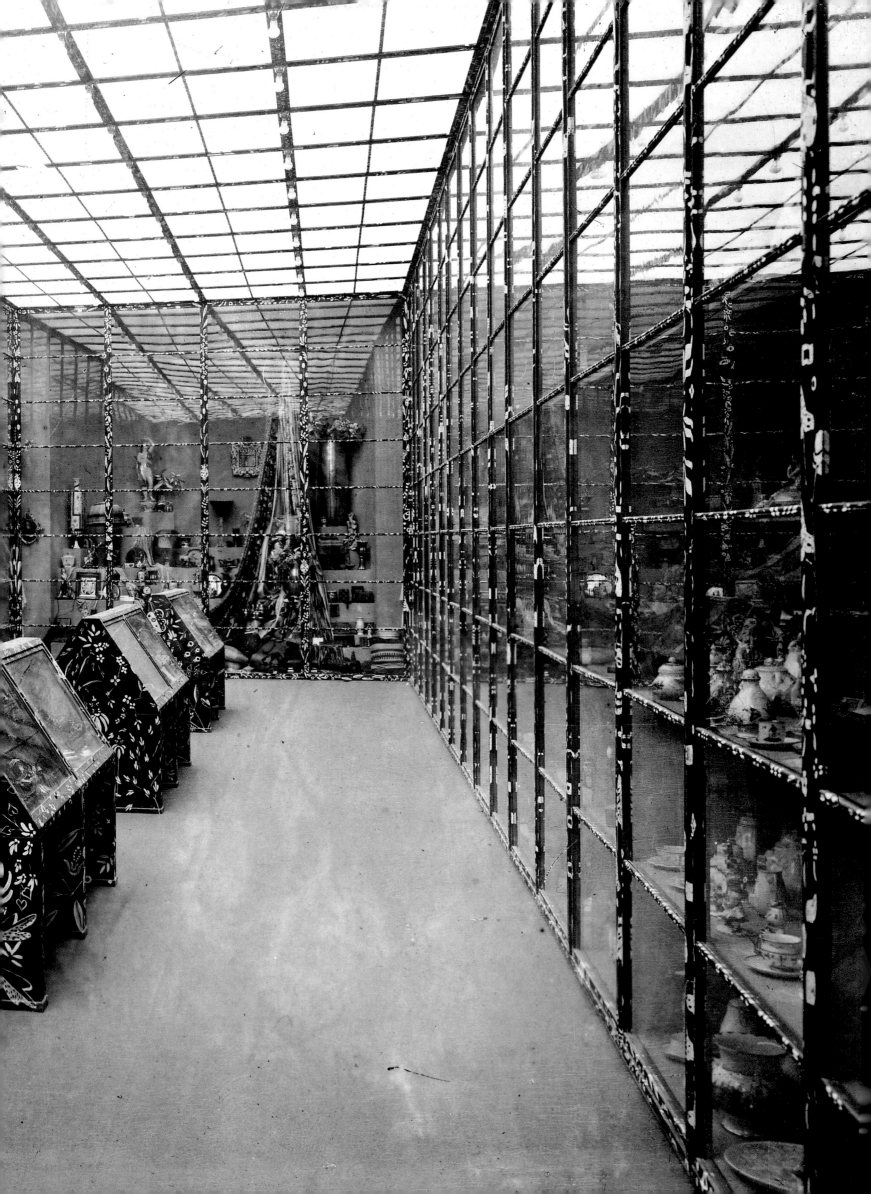

Josef Frank: Project for an extension to the parliament building in Stockholm, after 1940, watercolour. Like Hoffmann, Frank taught at the Vienna School of Arts and Crafts from 1919 to 1925. On the occasion of Josef Hoffmann's 60th birthday, he wrote: "What modern architecture owes to Hoffmann is not just the fact that he turned away from the historical, lifeless forms which had been hindering the new development up till then, but also that he simultaneously reclaimed the lightness and transparency which today appear to us its most important characteristics."[73] As in the above project by Frank, today's architects continue to be influenced by the transparency, linearity and grid patterns of Hoffmann's buildings. Richard Meier is a case in point.

Josef Hoffmann: Letterbox, c. 1904–1906, perforated sheet iron, painted white

1917, for example. Apart from the 1913 Wallpaper Exhibition and 1915 Fashion Exhibition, however, Vienna did not offer the Wiener Werkstätte an opportunity to present its work until the 1920 Kunstschau. A second forum was provided that same year by the Kölner Kunstverein. The Wiener Werkstätte continued to hold exhibitions in its own showrooms even during the war years, such as the Christmas Exhibition of 1917, in which the entire spectrum of its highly imaginative works could be admired. In 1922 it took part in the Deutsche Gewerbeschau (German Exhibition of Applied Art) in Munich, at almost exactly the same time as the New York branch was staging its glittering launch. The Wiener Werkstätte celebrated yet another triumph in 1925, at the enormous Exposition International des Arts Décoratifs et Industriels Modernes in Paris (pp. 218–219). In 1928, just before the Wiener Werkstätte embarked upon its 25th anniversary celebrations, a much-admired Exhibition of Austrian Art was also held in Rotterdam, followed by an exhibition of the same name one year later in Stockholm.

Stockholm also became the second home of architect Josef Frank, who like many of the Wiener Werkstätte artists was a professor at the Vienna School of Arts and Crafts, and who had jointly headed numerous projects with Josef Hoffmann. Both men were members of the Austrian Werkbund; together they had played a major part in ensuring the success of the Paris exhibition in 1925, and they also organized the Austrian Werkbund's "swansong" exhibition of 1930 (p. 113 below). Despite the differences of opinion which sometimes divided these two great architects, a design by Josef Frank dating from 1940 indicates the "survival" of the typical and original Wiener Werkstätte style. Here the thoughts offered by Josef Frank on the occasion of Josef Hoffmann's 60th birthday in 1930: "What modern architecture owes to Hoffmann is not just the fact that he turned away from the historical, lifeless forms which had been hindering the new development up till then, but also that he simultaneously reclaimed the lightness and transparency which today appear to us its most important characteristics. What Austria owes Hoffmann is the fact that he founded this new development on the basis of Austrian tradition as flourishing in still living works; he gave it a new value which has since exercised a determining influence beyond the borders of his country upon the entire world."[73] These words by Josef Frank, an architect who was also a designer of furniture and small art objects, are still true today.

The last "exhibition" was an auction, conducted at the appropriately-named Glückselig – "Happy" – auction house. Between 5 and 10 September 1932, more than 7000 Wiener Werkstätte objects fell under the hammer. The workshops themselves had been disbanded in 1931, and Josef Hoffmann had resigned. What is today the Historische Museum der Stadt Wien was the only Vienna museum to attend the auction. And the rest, suddenly, was history.

Cabinetmakers

Alois Hoppe

Franz Bonek

Vinzenz Soukup

Wenzel Urban

Josef Weber

Beltmakers

Master: Ferdinand Heider

Anton Ders

Franz Fischer

Paul Ruckendorfer

Bookbinders

Master: Karl Beitel

Ludwig Willner

Varnishers

Master: Adolf Roder

Goldsmiths

Master: Eugen Pflaumer

Josef Berger

Karl Ponocny

Anton Pribil

J. Sedlicky

Metalworkers

Master: Konrad Koch

Johann Blaschek

Franz Guggenbichler

Josef Holi

Karl Medl

Theodor Quereser

Konrad Schindel

Stanislaus Teyc

Adolf Wertnik

Valentin Zeileis

Silversmiths

Master: Josef Hossfeld

Master: Karl Kallert

Josef Czech

Adolf Erbrich

Augustin Grotzbach

Josef Husnik

Alfred Mayer

Josef Wagner

Painters

Therese Trethan

Gudrun Baudisch-Wittke, c. 1928

Hans Böhler

Baudisch-Wittke, Gudrun
*17.3.1906 Pöls/Styria †16.10.1982 Hallein
After attending the Austrian School of Architecture
and Arts and Crafts (Österreichische Lehranstalt für
das Baufach und Kunstgewerbe) in Graz, she was a
member of the Wiener Werkstätte from 1926 to
1930. She exerted considerable influence upon the
Wiener Werkstätte ceramics of these years, with her
almost expressive style of ornament and decorative
heads, highly contemporary and superbly hand-
crafted. Further work for the Wiener Werkstätte: tex-
tiles and leather. Close collaboration with Vally Wie-
selthier. From 1930 to 1936 she operated her own
ceramics workshop in Vienna; in 1936 she moved
to Berlin where she carried out work for the Werk-
bund and Burg Giebichenstein. Sculptural work for,
amongst others, the Kemal Pasha palace in Ankara.
Designs for Gmundner Keramik and Hallstätter Ke-
ramik. From 1946 she headed her own workshop in
Hallein.

Berger, Arthur
*27.5.1892 Vienna †11.1.1981 Moscow
Work for the Wiener Werkstätte: textiles and metal-
work.

Böhler, Hans
*11.9.1884 Vienna †17.9.1961 Vienna
Designed postcards for the Wiener Werkstätte.

Bräuer, Carl
*15.12.1881 Vienna †17.3.1972 Grimmenstein
Worked in Hoffmann's architectural office from
1905 to 1920. Supervised the building of the Pri-
mavesi country house in Winkelsdorf, 1913–1914.
Took part in numerous Wiener Werkstätte exhibi-
tions, including the 1908 Kunstschau in Vienna.
Member of the Austrian Werkbund. His work for
the Wiener Werkstätte included supervision of
architectural projects, landscaping, textiles and
jewellery.

Brunner-Frieberger, Maria Vera
*20.4.1885 Neuhäusl/Hungary
†23.3.1965 Vienna
Trained as a concert pianist. As a member of the
Wiener Werkstätte, her work was shown at the
1908 Kunstschau, 1915 Fashion Exhibition (Mode-
ausstellung), and 1920 Kunstschau. Work for the
Wiener Werkstätte: textiles, commercial graphics,
toys, glass painting.

Bucher, Hertha
*14.6.1898 Leverkusen †9.2.1960 Vienna
Studied at the School of Arts and Crafts (Kunst-
gewerbeschule) in Vienna under Strnad, Powolny
and others. Member of the Wiener Werkstätte Ar-
tists' Workshops, the Austrian Werkbund and the
Wiener Frauenkunst (Vienna Women's Art group).
She designed fireplace surrounds and heating
grilles for buildings by Hoffmann. Numerous ce-
ramic works such as figures and containers in
the Wiener Werkstätte style of the 1920s. The ex-
hibitions she participated in include: 1920 Kunst-
schau, 1924 anniversary exhibition of the Wiener
Kunstgewerbe-Verein (Vienna Arts and Crafts As-
sociation), 1925 Exposition Internationale des Arts
Décoratifs et Industriels Modernes (International
Exhibition of Modern Decorative and Industrial
Arts), Paris

Calm-Wierink, Lotte
*1.10.1897 Prague – last living in Holland
Studied at the School of Arts and Crafts in Vienna
under Hoffmann, Powolny, Strnad and others.
Member of the Wiener Werkstätte Artists' Work-
shops, the Austrian Werkbund and the Wiener
Frauenkunst. Chiefly engaged in ceramics, as well
as jewellery, wood and commercial graphics. The
exhibitions she participated in include: 1915
Fashion Exhibition, 1920 Kunstschau, 1925 Paris,
1925 Deutsche Frauenkunst (German Women's
Art).

Gudrun Baudisch-Wittke

Josef Diveky studying one of his works

Czeschka, Carl Otto

*22. 10. 1878 Vienna † 10. 7. 1960 Hamburg
Studied painting at the Academy of Fine Arts
(Akademie der Bildenden Künste) in Vienna. Taught
at the School of Arts and Crafts from 1902 to 1907.
Member of the Wiener Werkstätte from 1905 to
1908, when he took up a teaching post at the Ham-
burg School of Arts and Crafts (Hamburger Kunst-
gewerbeschule). He subsequently continued to
produce designs for the Wiener Werkstätte. His
works were highly influential upon Wiener Werk-
stätte style. At the opposite end of the spectrum to
Hoffmann, his formal language was oriented to-
wards flora and fauna, which he expressed in a
graphic rather than architectonic manner. He
worked in numerous media: jewellery and metal-
work, wooden caskets, wood-carving, lacquer
painting, textiles, fans and toys. His commercial
graphics ranged from postcards, packaging, illustra-
tions and calendars to typefaces. He also designed
stage and interior décors and furniture, private
apartments and commercial interiors. Prominent
role in the interior decoration of the Cabaret Fleder-
maus and the Palais Stoclet. Member of the Aus-
trian Werkbund. Took part in all the major Wiener
Werkstätte exhibitions up to about 1915.

Delavilla, Franz Karl

*6. 12. 1884 Vienna †2. 8. 1967 Frankfurt/Main
After attending the Textile Industry School (Fach-
schule für Textilindustrie), he studied at the School
of Arts and Crafts in Vienna under C. O. Czeschka,
von Larisch, Bertold Löffler and others. Between
1908 and 1950 he taught at the Magdeburg, Ham-
burg, and Frankfurt schools of arts and crafts, the
Städel School in Frankfurt, and elsewhere. Work for
the Wiener Werkstätte primarily in the field of
graphic design: postcards, pictorial broadsheets
and posters. Also active as a stage designer. Promi-
nent role in the interior decoration of the Cabaret
Fledermaus.

Dietl, Fritz

*19. 10. 1880 Vienna
Work for the Wiener Werkstätte: postcards, con-
tributed to the Cabaret Fledermaus.

Diveky, Josef

*28.9.1887 Farmos/Hungary
†1951 Sopron/Hungary
After attending the Academy of Fine Arts, from 1906
he studied at the School of Arts and Crafts in Vienna
under von Larisch, Carl Otto Czeschka, Bertold Löff-
ler and others. Primarily a commercial graphics de-
signer; in Zurich and Brussels from 1910 to 1914; in
Bethlis, Switzerland, from 1919. In 1941 he was ap-
pointed professor at the School of Applied Art in Bu-
dapest. Numerous illustrations for books and con-
tributions to newspapers. For the Wiener Werkstätte,
Diveky worked as an illustrator and designed post-
cards, wine labels and pictures for puzzle games.

Ehrlich, Christine

*12. 3. 1903 Vienna
Studied under Powolny at the School of Arts and
Crafts in Vienna from 1920. She was a junior assis-
tant at the Wiener Werkstätte and trained under
Hoffmann. Designed fabrics and executed ceramic
works for the Wiener Werkstätte. Her stucco works
for the Sonja Knips House in 1924–1925 testify to
her sympathy with Hoffmann's ideas. Took part in
the 1925 Paris exhibition.

Emmel, Bruno

*6. 8. 1877 Kaltenleutgeben
Studied at the School of Arts and Crafts in Vienna.
Professor at the Technical College in Znaim. Ce-
ramics for the Wiener Werkstätte ceramics work-
shop and for factories in Znaim.

Falke, Gisela von

Studied at the School of Arts and Crafts in Vienna
around 1900. Member of the Wiener Kunst im

Mathilde Flögl, c. 1928

C. C. Czeschka

Josef Frank

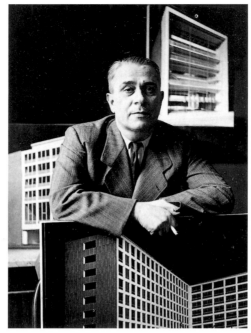

Oswald Haerdtl, Photo: Okamoto

Hause (Viennese Art in the Home) artists' exhibiting society.

Flögl, Mathilde
9.9.1893 Brünn †after 1950 Salzburg
Studied at the School of Arts and Crafts in Vienna from 1909 to 1916 under Hoffmann, Strnad, von Kenner and others. Member of the Artists' Workshops and the Wiener Werkstätte. She decorated apartments designed by Hoffmann with free-hand and stencilled wall paintings, and was active in almost every field of applied art: painted works in wood, ceramics, ivory, leather, enamel, glass painting, textiles, fashion, accessories, wallpapers, free and commercial graphics. Member of the Austrian Werkbund and the Wiener Frauenkunst. She taught and operated her own studio from 1931 to 1935. Took part in almost all the major Wiener Werkstätte exhibitions, including: 1920 Kunstschau, 1925 Paris, 1930 Werkbund exhibition.

Forstner, Leopold
2.11.1878 Leonfelden
†5.11.1936 Stockerau/Lower Austria
After attending the State School of Handicraft (Staatshandwerkschule) in Linz, from 1899 to 1902 he studied at the School of Arts and Crafts in Vienna under Moser and others. Founding member of the Wiener Kunst im Hause. Member of the Austrian Werkbund. From 1906 he specialized in mosaics in marble, ceramics, glass, enamel, stone and metal, e.g. in Wagner's Kirche am Steinhof church, after designs by Moser. His most important works for the Wiener Werkstätte were the dining-room frieze in the Palais Stoclet, executed after designs by Klimt, and his own mosaics. In 1910–1911 he worked on the decoration of the Villa Ast in Vienna.

Frank, Josef
15.7.1885 Baden/Vienna †8.1.1967 Stockholm
After studying at the Technical College (Technische

Hochschule) in Vienna, he gained his doctorate and in 1910 became a free-lance architect. Worked with Strnad. In 1925 he founded the "Haus und Garten" furnishing store in Vienna. In 1934 he emigrated to Stockholm, returning intermittently to Vienna until 1938. Worked for the Wiener Werkstätte as a designer: brass utensils, metal furniture fittings, textiles. Member of the Austrian Werkbund. Exhibitions included: 1913 Wallpaper Exhibition (Tapetenausstellung), 1920 Kunstschau, 1925 Paris, 1930 Werkbund exhibition. In 1960 he was awarded the City of Vienna Prize for Design.

Friedmann-Otten, Mizi
28.11.1884 Vienna †5.5.1955 New York
After studying at the School of Art for Women and Girls (Kunstschule für Frauen und Mädchen) and the School of Arts and Crafts in Vienna, she went on to produce designs for the Wiener Werkstätte in all areas of applied art: jewellery, metalwork, textiles, fashion, enamels, and commercial graphics. From 1920 she also designed large-format enamels. Member of the Neukunstgruppe (New Art Group) and the Austrian Werkbund. Took part in all the major Wiener Werkstätte exhibitions, including: 1908 Kunstschau, 1915 Fashion Exhibition, 1925 Paris, 1925 Deutsche Frauenkunst, 1930 Werkbund exhibition.

Frömmel-Fochler, Lotte
1.5.1884 Vienna – last living in Vienna
After attending the College of Embroidery (Fachschule für Kunststickerei), she studied under Hoffmann at the School of Arts and Crafts in Vienna until 1908. Work for the Wiener Werkstätte: textiles, embroidery, accessories, leather.

Haerdtl, Oswald
17.5.1899 Vienna †9.8.1959 Vienna
Studied at the School of Arts and Crafts in Vienna under Moser, Strnad, Frank and others. After a brief

Mathilde Flögl

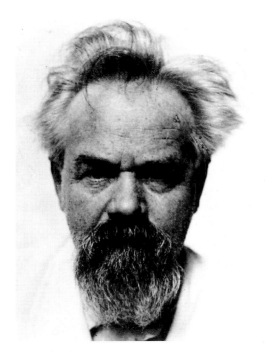

Anton Hanak

Josef Hoffmann

spell as a relief teacher, in 1922 he became Hoff-
mann's assistant, taking over the running of his stu-
dio in 1927. From 1930 to 1939 Hoffmann and
Haerdtl were partners. Professor at the School of
Arts and Crafts from 1925 to 1959. From 1927 on-
wards Haerdtl played a major role in all Wiener
Werkstätte architectural projects and exhibitions.
His precise, non-emotive style proved highly in-
fluential. He also designed furniture, metalwork,
fashion, textiles, and above all glass, first for the Ba-
kalowits company and later for Lobmeyr. His glass
designs are still manufactured today and have
meanwhile become "classics".

Häusler, Philipp
*7.11.1887 Panczowa/Hungary
†18.2.1966 Frankfurt/Main
After attending the Imperial Royal Textile Industry
College (k.k. Lehranstalt für Textilindustrie), he stu-
died at the School of Arts and Crafts in Vienna
under Hoffmann, Metzner and others. After a
period as Hoffmann's assistant from 1911 to 1913,
he taught at the schools of arts and crafts in Offen-
bach/Main and Cologne. In 1920 he became head
of general operations at the Wiener Werkstätte; he
arranged numerous licensing contracts with indus-
try with the aim of improving the Wiener Werk-
stätte's financial position. In 1925 he resigned. In
1923 he organized the memorial exhibition for Da-
gobert Peche. His own work for the Wiener Werk-
stätte ranged from architecture to metalwork, jewel-
lery, leather, textiles, postcards and works on paper.
Took part in numerous exhibitions.

Hanak, Anton
*22.3.1875 Brünn †7.1.1934 Vienna
After an apprenticeship in wood-carving, he stu-
died at the Academy of Fine Arts in Vienna from
1898 to 1904. Taught at the Academy and at the
School of Arts and Crafts. Hanak played an import-
ant role in the history of the Wiener Werkstätte inso-

far as it was through him that Hoffmann was intro-
duced to the Primavesi family. He contributed dec-
orative sculpture to many Wiener Werkstätte archi-
tectural projects, including the Primavesi country
house, Villa Skywa-Primavesi and Villa Ast. His large
sculptural works featured in numerous exhibitions.
He also designed jewellery and the interior of the
Primavesi country house.

Hoffmann, Josef
*15.12.1870 Pirnitz/Moravia †7.5.1956 Vienna
After attending the State School of Arts and Crafts
(Staatsgewerbeschule) in Brünn he became a stu-
dent under Hasenauer and Wagner at the Academy
of Fine Arts, having previously completed an assis-
tantship with the military building authority in Würz-
burg. He subsequently won the Rome Prize and
spent a year in Italy. Upon his return he entered
Wagner's studio. Together with Olbrich and Moser,
in 1895 Hoffmann started the Siebener Club. Found-
ing member of the Vienna Secession in 1897. At the
age of 29, appointed to a teaching post at the
School of Arts and Crafts in Vienna. In 1903 he co-
founded the Wiener Werkstätte, which he headed
until 1931. First buildings: 1902–1903 Henneberg
House, Moll House, Moser House, Spitzer House.
1904–1906 Purkersdorf Sanatorium with the Wiener
Werkstätte; this was followed by numerous major
commissions. As the moving spirit and head of the
Wiener Werkstätte, he directed and took part in all its
exhibitions. Member or corresponding member of
all the major artists' associations of his day. In line
with his ambition to realize the "total work of art", he
produced designs in virtually every branch of ap-
plied art, including furniture, metalwork, jewellery,
leather, glass, textiles, ceramics and floor coverings.
The rigorous black-and-white grid pattern governing
many of his designs earned him the nickname of
"Quadratl-Hoffmann" (Little Square Hoffmann). Hoff-
mann exerted a powerful and enduring influence
upon the development of applied art.

Josef Hoffmann

Carl Leopold Hollitzer, Photo: Fenichel (?), Vienna

Ludwig Heinrich Jungnickel, 1930

Holl·tzer, Carl Leopold
*11.3.1874 Deutsch Altenburg †1.12.1942 Vienna
Studied at the Academy of Fine Arts in Vienna;
stage design. For the Wiener Werkstätte: interior
decoration of the Cabaret Fledermaus.

Hoppe, Emil
*2.4.1876 Vienna †14.8.1957 Salzburg
Student under Wagner at the Academy of Fine Arts
in Vienna from 1898 to 1901, after which he
opened a studio jointly with Otto Schönthal and
Marcel Kammerer. Numerous architectural projects
in Vienna. Took part in the 1908 Kunstschau, which
he documented in large numbers of postcards for
the Wiener Werkstätte. From 1924 to 1930, munici-
pal buildings for the City of Vienna. He designed
postcards for the Wiener Werkstätte.

Jacobsen, Lilly
*25.5.1895 Budapest
Member of Wiener Werkstätte Artists' Workshops
and Austrian Werkbund. For the Wiener Werkstätte:
ceramics, textiles, enamels, wooden jewellery,
wooden boxes, painted chip boxes, jewellery.

Janke, Urban
*12.2.1887 Blottendorf/Bohemia
†1914 killed in action
Studied under Löffler at the School of Arts and
Crafts in Vienna, and subsequently, in 1908, be-
came a teacher at the Magdeburg School of Arts
and Crafts. Took part in the 1908 Kunstschau. Work
for the Wiener Werkstätte: contributed to the Ca-
baret Fledermaus, postcards and pictorial broad-
sheets, broncit decoration for Lobmeyr.

Jesser-Schmid, Hilda
*21.5.1894 Marburg an der Drau
After attending the School of Art for Women and
Girls, she studied at the School of Arts and Crafts
in Vienna until 1917 under Strnad, Hoffmann, Roller

and others. Member of the Wiener Werkstätte Ar-
tists' Workshops from 1916 to 1921. Member of
the Austrian Werkbund and the Wiener Frauen-
kunst. Hilda Jesser exemplifies the multi-talented
"WW craftswoman", working in such wide-ranging
fields as commercial graphics, postcards, textiles,
glass and glass painting, ivory, metalwork, lamps,
toys, wood, wallpapers, wall painting, embroidery,
leather and fashion.

Johnová, Helena
*2.1.1884 Sobieslau/Bohemia †1962 Prague
Studied at the Prague School of Arts and Crafts
from 1899 to 1907, at Bechyn College in 1908,
and at the School of Arts and Crafts in Vienna from
1909 to 1911. In 1911 she founded the Kerami-
sche Werkgenossenschaft (Ceramic Work Co-
operative) together with Rosa Neuwirth and Ida
Lehmann. She designed ceramics for the Wiener
Werkstätte.

Jung, Moriz
*22.10.1885 Nikolsburg/Moravia
†11.3.1915 Carpathians
Studied at the School of Arts and Crafts in Vienna
under Roller, Czeschka, Löffler and others. Con-
tributed to the Cabaret Fledermaus. Joint illustra-
tions with Mela Koehler and Josef Diveky. Took part
in the Wiener Werkstätte exhibitions in the Galerie
Miethke, as well as the 1908 Kunstschau and 1914
"Bugra" (International Exhibition of Book and
Graphic Art) in Leipzig. Primarily commercial
graphics for the Wiener Werkstätte.

Jungnickel, Ludwig Heinrich
22.7.1881 Wunsiedel/Upper Franconia
†1965 Vienna
Studied at the School of Arts and Crafts and the
Academy in Munich, and in Vienna at the Academy
of Fine Arts and the School of Arts and Crafts
under Roller. Trained as an animal painter. Taught at

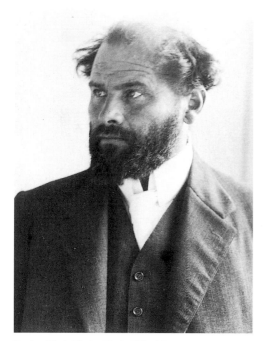

Gustav Klimt, Photo: Moriz Nähr, Vienna

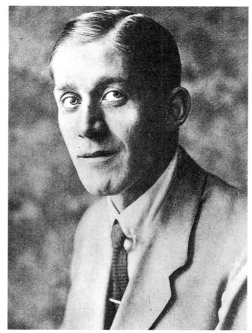

Oskar Kokoschka, collotype postcard published by
the Sturm Verlag, Berlin

the Frankfurt School of Arts and Crafts from 1911.
Took part in almost all the major exhibitions of his
day. Jungnickel was one of the best-known mem-
bers of the Wiener Werkstätte, thanks to his broncit
designs, chiefly of animals, on glasses manufac-
tured by Lobmeyr, and to his animal frieze for the
children's room in the Palais Stoclet. He also de-
signed textiles, wallpapers and postcards for the
Wiener Werkstätte.

Jungwirth, Maria
*17. 8. 1894 Krems an der Donau
†9. 7. 1968 Feldbach
After attending the Vienna Institute of Graphic Art
(Graphische Lehr- und Versuchsanstalt Wien), she
studied at the School of Arts and Crafts in Vienna
under Roller, Hoffmann, Strnad and others. Work
for the Wiener Werkstätte: textiles and enamels.

Klimt, Gustav
*14. 7. 1862 Baumgarten/Vienna
†6. 2. 1918 Vienna
Studied at the School of Arts and Crafts in Vienna
under Laufberger when still only fourteen. In 1883
Klimt opened a studio together with his brother
Ernst and fellow student Franz von Matsch. His first
important commission – the decoration of the stair-
cases of the new Burgtheater – was finished in
1888. He then began to turn away from the aca-
demic style of painting, and his last major official
commission – ceiling paintings for the three secu-
lar Faculties at Vienna University – caused a scan-
dal. With his style based upon the tension between
brittle and supple, hard and soft forms, Klimt rapidly
emerged as a pioneer of Modernism. In 1897 he
became a founder member of the Vienna Se-
cession and its first president. He exered a pro-
found influence over its artistic development up
until his resignation in 1905. Joined the Wiener
Werkstätte, whose artists would remain indebted to
his style for many years. Stylization of natural forms,

"painted mosaics" produced with the aid of a grid
pattern, gold and other reflecting colours. In his
work for the Palais Stoclet, Klimt found himself fully
in tune with Hoffmann's vision, and the mosaics
which he designed for the dining-room represent a
high point in the ornamentalization of the human
figure.

Kling, Anton
*26. 11. 1881 Vienna †21. 9. 1963 Karlsruhe
Studied at the School of Arts and Crafts in Vienna
under Roller, Hoffmann and others. Taught at the
Hamburg School of Arts and Crafts from 1908. Di-
rector of the Pforzheim School of Arts and Crafts
from 1923 to 1927. Work for the Wiener Werkstätte:
contributed to the Cabaret Fledermaus, garden
theatre at the 1908 Kunstschau, jewellery.

Koehler-Broman, Mela
*18. 11. 1885 Vienna †15. 12. 1960 Stockholm
After attending the Hohenberger school of painting,
she studied at the School of Arts and Crafts in
Vienna from 1905 to 1910 under Moser and others.
Her graphic work was published in "The Studio"
and elsewhere while she was still a student. She
also won acclaim at the exhibition by the School of
Arts and Crafts in London in 1908. Member of the
Austrian Werkbund and the Wiener Frauenkunst.
For the Wiener Werkstätte she was principally act-
ive as a graphic designer: postcards of Wiener
Werkstätte fashions, textiles.

Kokoschka, Oskar
*1. 3. 1886 Pöchlarn/Lower Austria
†22. 2. 1980 Montreux
Studied at the School of Arts and Crafts in Vienna
from 1904 to 1909 under Löffler, Czeschka and
others. From 1910, Kokoschka wrote, painted and
drew chiefly for the Berlin magazine "Der Sturm".
His work matured into a highly individual Expressio-
nist style which concurred only briefly with artistic

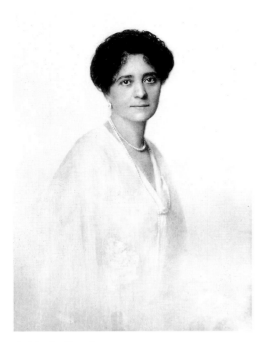

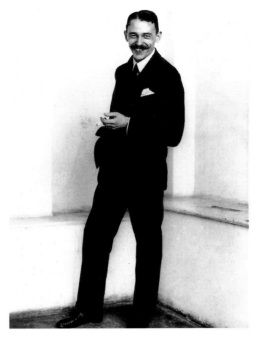

Antoinette Krasnik

Otto Lendecke

developments in Vienna before the First World War. He was a member of the Wiener Werkstätte from 1907 to 1909; his best-known works from this period are the colour lithographs for his book "Die träumenden Knaben" (The Dreaming Boys). He also designed postcards, painted fans and pictorial broadsheets. Illustrations for the 1911 Wiener Werkstätte almanac. Contributed to the interior design of the Cabaret Fledermaus, where he also staged pieces in the nature of Performance Art.

Kopřiva, Erna
*9.11.1894 Vienna – last living in Vienna
After studying at the School of Arts and Crafts in Vienna under Hoffmann, Hanak and others, she became a member of the Wiener Werkstätte Artists' Workshops. Taught at the School of Arts and Crafts from 1928 to 1960; member of the Wiener Frauenkunst. Took part in the 1920 Kunstschau and 1925 Paris exhibition. Particularly renowned for her ceramic works and textile designs.

Krakauer, Leopold
*29.3.1890 Vienna †1954 Jerusalem
Studied at the Academy of Fine Arts in Vienna. Principally active as a painter; enamels for the Wiener Werkstätte. Took part in the Hagenbund exhibitions.

Krasnik, Antoinette
1906 emigrated to Italy
Studied at the School of Arts and Crafts in Vienna under Hoffmann, Moser and others. Produced designs for the Böck porcelain factory in Vienna in close collaboration with the Wiener Werkstätte. Early works for the Bakalowits glass firm. Joint works with her teacher Josef Hoffmann.

Krenek, Carl
*7.9.1880 Vienna †15.12.1948 Vienna
Completed an extensive training in applied art and graphic design, attending the textiles design school attached to the Imperial Royal Textile Industry College, the School of Arts and Crafts in Vienna under Roller, von Larisch, Moser, Czeschka and others, and the Academy of Fine Arts. He produced woodcut illustrations, majolica vases, stained-glass windows and posters for numerous companies. Postcards and textiles for the Wiener Werkstätte. Member of the Austrian Werkbund and the Österreichischer Künstlerbund (Austrian Artists' Union). Took part in numerous exhibitions, including: 1908 Kunstschau, 1912 Secession, 1915 Künstlerbund.

Kuhn, Dina
*26.4.1891
Studied at the School of Arts and Crafts in Vienna from 1912 to 1920 under Moser, Strnad and others. Member of the Wiener Werkstätte Artists' Workshops and the Wiener Frauenkunst. She was one of the most influential ceramic artists at the Wiener Werkstätte in the twenties. She also designed commercial graphics. The exhibitions she took part in included: 1920 Kunstschau, 1925 Paris, 1925 Deutsche Frauenkunst.

Lebisch, Franz
*2.11.1881 Vienna
†23.12.1965 Merkendorf/Styria
After an agricultural education, Lebisch studied at the School of Arts and Crafts in Vienna under Hoffmann and others. Specialized in landscaping. His garden designs were featured in numerous publications. Designed the garden theatre at the 1908 Kunstschau. Took part in the 1907 Wiener Werkstätte Horticultural show (Gartenschau); contributed to the Cabaret Fledermaus. After working as a garden architect in Düsseldorf and Berlin, in 1920 he returned to the School of Arts and Crafts in Vienna under Michael Powolny. Designed postcards, endpapers and textiles for the Wiener Werkstätte in its later years.

Erna Kopriva

Ernst Lichtblau, 1930, Photo: Fayer, Vienna

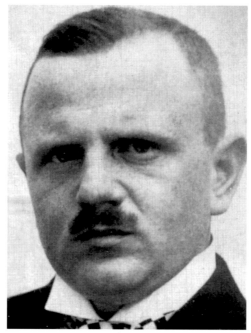

Bertold Löffler, Photo: W. Weis, Vienna Emanuel Josef Margold

Lendecke, Otto
*4.5.1886 Lemberg †17.10.1918 Vienna
After drawing lessons at military college, he was
mainly self-taught. Work for the Atelier Poiret in
Paris. In contact with the Wiener Werkstätte from
1911. Based in Vienna as from 1915; published his
own fashion magazine, "Die Damenwelt" (Ladies'
World). Contributed to numerous fashion and art
journals. Played a prominent role in the 1915
Fashion Exhibition and 1920 Kunstschau. At the
Wiener Werkstätte he worked in all areas of
fashion, as well as designing costumes, stage
décor and commercial graphics.

Lichtblau, Ernst
*24.6.1883 Vienna †8.1.1963 Vienna
Studied under Wagner at the Academy of Fine Arts
in Vienna until 1905. Member of the Austrian Werk-
bund; taught at the State School of Arts and Crafts.
Played a major role in the City of Vienna's munici-
pal building programme; early designs for high-rise
architecture. Much praised for his contribution to
the 1930 Werkbund exhibition. Although primarily
an architect, he also designed textiles for the
Wiener Werkstätte and contributed to the portfolio
"Die Mode" (Fashion) of 1914/15.

Löffler, Bertold
*28.9.1874 Nieder-Rosenthal/Bohemia
†23.3.1960 Vienna
After graduating from the school of drawing at-
tached to the Reichenberg Museum of Arts and
Crafts in 1890, he studied at the School of Arts and
Crafts in Vienna under von Matsch and Czeschka.
Published the satirical "Quer Sacrum". A member
of Koloman Moser's class in 1900. Taught briefly at
the School of Embroidery. Took over the class for
painting and printing, and remained a professor at
the School of Arts and Crafts in Vienna until 1935.
While still a student, he produced numerous works
such as posters, banknotes etc. Experimented with

fresco. In 1906, together with Powolny and the
sculptor Lang, he co-founded the firm Wiener Ke-
ramik (Vienna Ceramics), whose products were
sold via the Wiener Werkstätte as from 1908. Co-
founder of the Kunstschau (Art Show), whose first
exhibition was held in 1908. Over the following
years, he worked on all the Wiener Werkstätte's
major projects, in particular the décor, cloakroom
and bar area of the Cabaret Fledermaus, as well as
costumes and posters, and the interior of the Palais
Stoclet. His work for the Wiener Werkstätte also ex-
tended to postcards, commercial graphics, jewel-
lery, ceramics, costumes and illustrations. Member
of the Austrian Werkbund and the Künstlerhaus
(Artists' House). Took part in all the major exhibi-
tions of his day.

Löw, Jakob
*4.5.1887 Stanislau/Galicia †after 1935
After two years as a wood-carver, attended the Col-
lege of Wood-carving (Fachschule für Holzbildhau-
erei) in Zakopane. Studied at the School of Arts
and Crafts in Vienna from 1910 to 1915 under
Strnad and others. Made ceramics for the Wiener
Werkstätte. Took part in numerous exhibitions, in-
cluding the 1930 Werkbund exhibition and exhibi-
tions by the Secession and the Hagenbund. Mem-
ber of the Austrian Werkbund and the Hagenbund.

Löw-Lazar, Fritzi
*23.10.1891 Vienna †19.9.1975 Vienna
Studied at the School of Art for Women and Girls in
Vienna from 1907 to 1910. Studied at the School of
Arts and Crafts in Vienna from 1910 to 1918 under
Hoffmann, Strnad, Roller, Powolny and others.
Worked as an illustrator for the publishers Anton
Schroll from 1917 to 1923. In 1938 she emigrated
to Brazil, returning to Vienna in 1955. Took part in
numerous exhibitions, including: 1915 Fashion Ex-
hibition, 1920 Kunstschau, 1925 Paris. Member of
the Wiener Frauenkunst. Broad range of work for

Carl Moll, 1909, Photo: D' Ora-Benda

Ditha Moser

the Wiener Werkstätte: postcards, jewellery, toys, painted wooden boxes and chip boxes, glass and glass painting, textiles, accessories, free and commercial graphics, wallpapers, ceramics, fashion and under-glass painting.

Luksch, Richard
*23.1.1872 Vienna †21.4.1936 Hamburg
Studied sculpture at the Academy in Munich and at the School of Arts and Crafts from 1901 to 1902. Taught at the Hamburg School of Arts and Crafts from 1907 to 1937. Worked closely with Wagner, e.g. executing statues for his Kirche am Steinhof. Luksch' work for the Wiener Werkstätte included ceramics and the contributions to the interiors of Wiener Werkstätte shops. His best-known works are his portal figures for the Purkersdorf Sanatorium, figures for the Palais Stoclet and the Hochreith hunting lodge. Member of the Secession and the German Werkbund. Exhibitions included: 1908 Kunstschau, 1914 Werkbund exhibition in Cologne.

Luksch-Makowsky, Elena
*14.11.1878 St. Petersburg
†15.9.1967 Hamburg
Studied at the Academies in Munich and St. Petersburg. Specialized in stoneware reliefs. Designed postcards, chased silverware and fans for the Wiener Werkstätte; contributed with her husband to the Hochreith hunting lodge.

Lurje, Victor
*28.7.1883 Vienna – 1938 emigrated to Shanghai
Graduated from the Technical College in Vienna. Interior designer and furniture designer; his speciality was intarsia. He worked for the Wiener Werkstätte from 1919 to 1921, designing intarsia furniture, metalwork, ceramics, tapestries, jewellery and murals. Exhibitions included: 1908 Kunstschau and 1925 Paris. Wall paintings and stucco for the Vier Jahreszeiten Hotel in Hamburg.

Margold, Emanuel Josef
*4.5.1888 Vienna †2.5.1962 Bratislava
Studied at the Mainz School of Arts and Crafts, the Woodworking College (Fachschule für Holzbearbeitung) in Königsberg an der Eger, and at the School of Arts and Crafts in Vienna under Hoffmann in 1906. There he became Hoffmann's assistant, and later worked in Hoffmann's studio at the Wiener Werkstätte. Primarily active as an interior designer. In 1911 he took up a post at the Darmstadt artists' colony. Architectural projects above all in Berlin, where he settled in 1929. He became particularly well known for his artistic packaging designs for the Bahlsen company. The services he designed for the Böck porcelain factory were sold by the Wiener Werkstätte, for whom he also produced commercial graphics. Member of the Austrian and German Werkbund. Took part in the major exhibitions of his day.

Metzner, Franz
*18.11.1870 Wscherau/Bohemia
†24.3.1919 Berlin
Trained as a stonemason; self-taught sculptor. From 1892 to 1903 he lived in Berlin and produced designs for the porcelain factory there. After 1903 he taught for three years at the School of Arts and Crafts in Vienna. Lived in Berlin until his death. His most important works are the figures on the Battle of the Nations monument in Leipzig. For the Wiener Werkstätte he executed the figures on the tower of the Palais Stoclet.

Moll, Carl
*23.4.1861 Vienna †13.4.1945 Vienna
Pupil of Griepenkerl and Schindler at the Academy of Fine Arts in Vienna. Co-founder of the Secession in 1897, but resigned with the Klimt faction in 1905. Joined the Wiener Werkstätte and organized the first Wiener Werkstätte exhibition in the Galerie Miethke in February 1905, which he had taken over

Koloman Moser

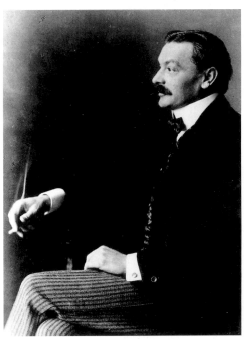

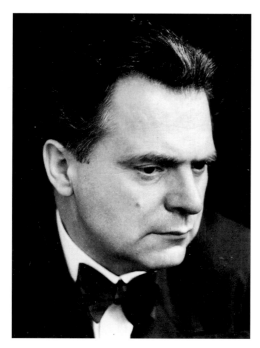

Arnold Nechansky

Robert Obsieger, Pencil drawing by Robert Fuchs,
1941

in 1904. His woodcuts depict the villas of the Hohe
Warte suburb; his own houses were built by Josef
Hoffmann. The Wiener Werkstätte published his
"Beethovenhäuser" (Beethoven Houses) woodcut
series.

Moser, Ditha
*1883 Vienna
Née Mautner-Markhof, she married Koloman
Moser. Her graphic works, calendars and playing
cards were sold in the Wiener Werkstätte shops. In
1906 Fritz Waerndorfer asked Ditha Moser for a
loan to help the Wiener Werkstätte out of its finan-
cial difficulties; this eventually led Koloman Moser
to resign from the Wiener Werkstätte.

Moser, Koloman
*30. 3. 1868 Vienna †18. 10. 1918 Vienna
Studied painting at the Academy of Fine Arts in
Vienna under Griepenkerl and others, and then be-
came a student under von Matsch at the School of
Arts and Crafts in Vienna from 1892 to 1895.
Founder member of the Secession and the Wiener
Werkstätte. Moser exerted a profound influence
upon Wiener Werkstätte style until his resignation in
1908. He subsequently turned to painting. Member
of the Austrian Werkbund. Moser was engaged in
every field of Wiener Werkstätte activity and took
part in all the major exhibitions of his day.
"Of the artists who founded the Vienna Secession,
Kolo Moser was unabashedly the boldest, and one
of those who caused Viennese philistines the most
trouble in the early days of the Secession. Wher-
ever there was something to reform in Viennese
arts and crafts – and where wasn't that needed? –
you could find Kolo Moser working away with per-
severance, intrepidness, taste and astounding tech-
nical skill. In rapid succession, he produced de-
signs for cabinetmakers, glaziers, carpet-weavers,
potters, stucco plasterers, turners and metal
founders, for printed fabrics, jewellery and chased

metalwork, book bindings, enamels, intarsia etc.
Blessed with an extraordinarily fine instinct for the
practical and aesthetic possibilities latent in the ma-
terial, and with an innate understanding of how to
bring them out through technical means, and at the
same time master of what might be called an al-
most hypertrophic imagination as regards the inven-
tiveness of his forms, Kolo Moser crafted dec-
orative and practical utensils which rank amongst
the very best that Modernism has produced in this
field up till now. Alongside and together with his
friend and colleague Hoffmann, Kolo Moser has
devoted himself for many years to the assiduous re-
organization of Viennese applied art, at the same
time producing beautiful and distinguished works
of his own and training a new generation of high-
quality artists…" Arthur Roeßler-Wien, in: Deutsche
Kunst und Dekoration XXXIII, Zu den Bildern von
Koloman Moser, Vienna, Darmstadt 1913/14.

Nechansky, Arnold
*17. 3. 1888 Vienna †25. 3. 1938 Kitzbühel
Studied at the School of Arts and Crafts in Vienna
from 1909 to 1913 under Hoffmann, Strnad and
others. In 1919 he took up a teaching post at the
Charlottenburg School of Arts and Crafts in Berlin,
where he remained until 1933. Also active as an
architect, designing high-rise buildings. Worked for
the Wiener Werkstätte from 1912: postcards, jewel-
lery, wallpapers, textiles, ceramics and silverware. In
1921 he became an authorized signatory of the
Wiener Werkstätte. Played a major role in the 1920
Kunstschau.

Neuwalder-Breuer, Grete
*22. 11. 1898 Berlin – from 1935 in Japan
Studied at the School of Arts and Crafts in Vienna
from 1914 to 1919 under Strnad and others. Exhibi-
tions included: 1920 Kunstschau, 1925 Paris, 1930
Werkbund exhibition. Made ceramics for the
Wiener Werkstätte.

Koloman Moser

Dagobert Peche

Michael Powolny, Photo: Schwab

Obsieger, Robert
*23.9.1884 Lundenburg/Moravia
†27.11.1958 Vienna
Studied at the Clay Industry College (Fachschule für Tonindustrie) in Znaim and at the School of Arts and Crafts in Vienna from 1909 to 1914. Assistant at the School of Arts and Crafts from 1913 to 1918, and professor there from 1919 to 1921, having spent the interim period 1918/19 at the Clay Industry College in Znaim. From 1921 to 1932 he headed the ceramic training workshop at the Wienerberger brickworks and construction company in Vienna. Subsequently head of the ceramics workshop at the School of Arts and Crafts in Vienna, and from 1945 to 1955 principal of the master class for ceramic sculpture and pottery. Ceramic works for the Wiener Werkstätte.

Orlik, Emil
*21.7.1870 Prague †28.9.1932 Berlin
Studied at the Heinrich Knirr school of painting in Munich. Pupil of von Lindenschmidt and others at the Munich Academy of Art from 1891 to 1893. Famed for his graphic works inspired by Japanese prints. Pictorial broadsheets for the Wiener Werkstätte. Member of the Berlin Secession and Vienna Secession.

Peche, Dagobert
*3.4.1887 St. Michael im Lungau/Salzburg
†16.4.1923 Mödling/Vienna
"The greatest genius of ornament that Austria has possessed since the Baroque" (Berta Zuckerkandl) was, alongside Hoffmann, the most influential figure at the Wiener Werkstätte from 1915 onwards. Studied at the Technical College in Vienna until 1910, and at the Academy of Fine Arts in Vienna from 1908 to 1911. He joined the Wiener Werkstätte in 1915 and remained a member until his death in 1923. From 1917 to 1918 he headed the Zurich branch, whose interior he also designed. The first

public showing of his work in 1913, at the Wallpaper Exhibition, was a great success. Ornament played a central role in his highly imaginative and artistic designs. He infused the functional with elegance and took the sobriety out of Neue Sachlichkeit through gracefulness and ease. "His imagination has a thousand hands, a thousand wings, is unbounded in its scope" (Rochowanski). The range of his work for the Wiener Werkstätte was also unbounded: furniture, works in metal, sheet metal and silver, jewellery, enamel, tortoiseshell, ivory, glass, ceramics, paper, book bindings, leather, free and commercial graphics, postcards, textiles, fashion, wallpapers, beadwork, frames, carvings, toys, stage design and costumes. Took part in all the major exhibitions of his day, including: 1911 International Art Exhibition in Rome, 1914 Werkbund exhibition in Cologne, 1920 Kunstschau, 1920 German Exhibition of Applied Art (Deutsche Gewerbeschau) in Munich; posthumously: 1923 Dagobert Peche Memorial Exhibition, 1925 Paris. Member of the Austrian Werkbund.

Powolny, Michael
*18.9.1871 Judenburg/Styria †4.1.1954 Vienna
Powolny's ceramic works have become one of the trademarks of the Wiener Werkstätte. After an apprenticeship as a potter, from 1894 to 1906 he studied at the Znaim Technical College and at the School of Arts and Crafts in Vienna under Metzner and others. In 1906, together with Löffler, he cofounded Wiener Keramik, whose products were sold through the Wiener Werkstätte. Both artists became protagonists of the Wiener Keramik style of "understated elegance". Alongside "latticework" pieces in typical black-and-white Wiener Werkstätte style, Powolny also produced colourful figural pieces. In addition to ceramics, his work for the Wiener Werkstätte included the decorative tiling for the bar and cloakroom of the Cabaret Fledermaus, and contributions to the Palais Stoclet, Villa Skywa-

Dagobert Peche

Otto Prutscher, 1910

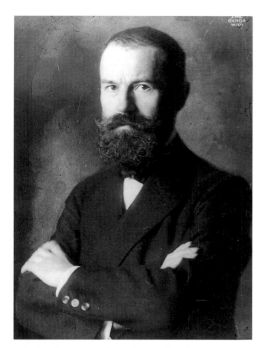

Alfred Roller, 1909, Photo: D' Ora-Benda

Primavesi and Berl House. Took part in all the major Wiener Werkstätte exhibitions. Member of the Austrian and German Werkbund. In 1909 Michael Powolny started up a special course in ceramics at the School of Arts and Crafts, where he continued to teach until 1936.

Prutscher, Otto
*7.4.1880 Vienna †15.2.1949 Vienna
Trained as an architect and applied artist at the Timber Industry College (Fachschule für Holzindustrie) and at the School of Arts and Crafts in Vienna under Hoffmann and others. Taught at the Vienna Institute of Graphic Art, and from 1910 at the School of Arts and Crafts. Subsequently a vocational school inspector in Vienna. As a member of the Wiener Werkstätte, he translated Hoffmann's chequerboard patterns into rigorously geometric glassware for Lobmeyr and Bakalowits. His works in glass are amongst the most beautiful products to issue from the Wiener Werkstätte. He also designed textiles, book bindings, leather, jewellery, clocks, furniture, trophy cups, metalwork and silverwork. Engaged upon the City of Vienna's municipal building programme between the wars. Took part in all the major Wiener Werkstätte exhibitions. Member of the Austrian and German Werkbund, the Künstlerhaus and the Zentralvereinigung der Architekten Österreichs (Central Association of Austrian Architects).

Rix-Ueno, Felice
*1.6.1893 Vienna †15.10.1967 Kyoto
Studied at the School of Arts and Crafts in Vienna from 1913 to 1917 under Hoffmann, Strnad and others. Member of the Wiener Werkstätte Artists' Workshops. Designs for ceramics, textiles, glass painting, glass decoration, painted works in wood, beadwork, enamels, and fashion. Exhibitions included: 1915 Fashion Exhibition, 1920 Kunstschau, 1925 Paris. Frequent trips to Japan, where she eventually settled in 1935. Professor at Kyoto Mu-

nicipal School of Art from 1949 to 1963. Member of the Austrian Werkbund and the Wiener Frauenkunst.

Rix-Tichacek, Kitty
Ceramics and textiles for the Wiener Werkstätte. Exhibitions included: 1925 Paris, 1929/30 Viennese Interior Designers (Wiener Raumkünstler).

Roller, Alfred
*2.10.1864 Brünn †22.6.1935 Vienna
Studied at the Academy of Fine Arts in Vienna. Professor at the School of Arts and Crafts in Vienna from 1899; appointed director in 1909. Head of design at the Vienna State Theatre. Member of the Vienna Secession and the Austrian Werkbund. Work for the Wiener Werkstätte: costumes and stage productions at the Cabaret Fledermaus.

Roller, Paul
*12.4.1875 Brünn
Studied under Wagner at the Academy of Fine Arts in Vienna. Worked in Hoffmann's architectural office at the Wiener Werkstätte. Took part in the 1908 Kunstschau and the 1907 Horticultural show.

Rottenberg, Ena
*9.11.1893 Orawiczabanya/Hungary
†c.1950 Vienna
Work for the Wiener Werkstätte: ceramics, ivory painting, cut and ground glass decoration.

Schaschl-Schuster, Reni
*26.4.1895 Pola/Istria †28.5.1979 Vienna
1912–1916 studied at the School of Arts and Crafts in Vienna under Hoffmann, Strnad and others. Member of the Wiener Werkstätte Artists' Workshops; worked closely with Lendecke. Versatile designer of ceramics, painted chip boxes, Christmas tree decorations, glass, textiles, commercial graphics,

Egon Schiele, 1914, Photo: A. Josef Trcka

Kitty Rix-Tichacek

Otto Prutscher

F.R.

Felice Rix-Ueno

Susi Singer-Schinnerl

ivory. Member of the Austrian Werkbund. Exhibitions: 1915 Fashion exhibition, 1920 Kunstschau, exhibitions by the Wiener Frauenkunst.

Scheibner, Hans
*8. 12. 1897 Krummnußbaum/Lower Austria
Work for the Wiener Werkstätte: ceramics, wood sculpture, intarsia, wooden mirror frames.

Schiele, Egon
*12. 6. 1890 Tulln †31. 10. 1918 Vienna
Studied under Griepenkerl at the Academy of Fine Arts in Vienna from 1906 to 1909. In 1907 he met Klimt, who became his spiritual mentor; first studio of his own. Lived a reclusive existence in great poverty until 1911; subsequently gained increasing international recognition over the following years. An outstanding artist of his era, it is difficult to ascribe Schiele to any one direction in art; he himself wrote on a watercolour: "Art cannot be modern; art is eternal." Member of the Neukunstgruppe, the Sema group, the Bund Österreichischer Künstler (Union of Austrian Artists) and other associations. Took part in numerous exhibitions, including: 1908 Kunstschau, 1912 Sonderbund in Cologne, 1915/16 Berlin and Vienna Secessions, 1917 War show (Kriegsschau) in Vienna.
Schiele's drawings and postcards were sold in the Wiener Werkstätte shops. His designs for the Palais Stoclet, a stained-glass window and an item of chased metalwork, were not executed.

Schmedes, Anna
*20. 7. 1888 Vienna †27. 11. 1967 Innsbruck
Worked in the Wiener Werkstätte fashion department from 1912 to 1928, primarily producing cloth flowers, lace, dress fastenings and knitting patterns. She was an assistant teacher under Hoffmann at the School of Arts and Crafts in Vienna from 1928 to 1932. Exhibitions: 1920 Kunstschau, 1925 Deutsche Frauenkunst.

Schmidt, Ludwig
*3. 12. 1882 Böhmisch-Leipa
Studied at the College of Glass (Glasfachschule) in Haida and at the School of Arts and Crafts in Vienna from 1908 to 1912.

Schröder-Ehrenfest, Anny
*16. 5. 1898 Vienna †11. 4. 1972 Bad Segeberg
For the Wiener Werkstätte: textiles, metalwork, enamel, glass, commercial graphics, jewellery, ceramics, boxes in coloured silk, playing cards.

Schütz, Gertrude
*28. 2. 1890 Vienna †10. 1. 1978 Vienna
Studied at the School of Art for Women and Girls. Worked for the Wiener Werkstätte around 1910. Taught embroidery at the Academy of Fine Arts in Berlin from 1914 to 1945. Took part in the 1908 Kunstschau.

Schwetz-Lehmann, Ida
*26. 4. 1883 Vienna †26. 9. 1971 Vienna
Studied at the School of Arts and Crafts in Vienna from 1904 to 1911 under Metzner, Powolny and others. Made ceramics for the Wiener Werkstätte in the Keramische Werkgenossenschaft which she co-founded in 1911. Member of the Austrian Werkbund. Took part in numerous exhibitions, including: 1911 exhibition by the special ceramics and enamel course (Sonderkurs Keramik/Email), 1925 Paris, 1925 Deutsche Frauenkunst.

Sika, Jutta
*17. 9. 1877 Linz †2. 1. 1964 Vienna
Studied at the Vienna Institute of Graphic Art from 1895 to 1897. Studied under Moser at the School of Arts and Crafts in Vienna from 1897 to 1902. Her teacher's influence is clearly apparent in her ceramic works. She was a co-founder of the Wiener Kunst im Hause, and played a major role in the exhibition "The Laid Table" (Der gedeckte Tisch). Taught at the Vocational College (Gewerbliche Fortbildungsschule) in Vienna from 1911 to 1933. Alongside a wide range of ceramic works for the Wiener Werkstätte, she also designed postcards. Took part in many major exhibitions, including: 1900 World Fair in Paris, 1904 World Exposition in St. Louis, 1908 Kunstschau, 1925 Paris. Member of the Austrian Werkbund, the Wiener Kunst im Hause, and the Vereinigung Bildender Künstlerinnen Österreichs (Austrian Association of Women Fine Artists).

Simandl-Schleiss, Emilie
*27. 1. 1880 Rothenburg/Moravia
†2. 5. 1962 Gmunden
Studied at the School of Arts and Crafts in Vienna under Metzner, Moser and others. For the Wiener Werkstätte, she executed façade sculptures and wooden figures for the Palais Stoclet. Took part in the 1908 Kunstschau.

Singer-Schinnerl, Susi
*27. 10. 1891 Vienna †1965 USA
After attending the School of Art for Women and Girls, she became a member of the Wiener Werkstätte Artists' Workshops. Imaginative "practical ce-

S.S.

Susi Singer-Schinnerl

Maria Strauss-Likarz

Oskar Strnad, Photo: Fleischmann, Vienna

ramic figures" were her speciality. Founded her
own workshop, Grünbacher Keramik, in 1924. Dur-
ing her time with the Wiener Werkstätte she also
designed postcards and textiles. Took part in most
of the major exhibitions, including: 1908 and 1920
Kunstschau, 1925 Paris, 1925 Deutsche Frauen-
kunst, 1930 Werkbund exhibition.

Sitte, Julie
*22. 10. 1881 Langenzersdorf/Lower Austria †1959
Following private tuition, she studied at the School
of Arts and Crafts in Vienna from 1910 under Löff-
ler, Powolny and others. Numerous ceramic works
for the Wiener Werkstätte. Member of the Austrian
Werkbund. Exhibitions included: 1911 exhibition by
the special ceramics and enamel course, 1914
Werkbund exhibition in Cologne.

Skurawy, Friedrich
*6. 8. 1894 Paris †8. 10. 1966 Vienna
Studied at the Ecole des Beaux-Arts in Paris and at
the Vienna Institute of Graphic Art. From 1920 to
1923 he was employed by the Wiener Werkstätte,
for whom he executed designs by Dagobert Peche
in woodcut and linocut.

Snischek, Max
*24. 8. 1891 Dürnkrut
†17. 11. 1968 Hinterbrühl/Lower Austria
Studied at the School of Arts and Crafts in Vienna
from 1912 to 1914. His work for the Wiener Werk-
stätte was primarily concentrated in the field of tex-
tiles, such as fabrics, clothes, and tulle covers, but
also included jewellery, wallpapers and commercial
graphics. After the departure of Wimmer-Wisgrill in
1922, he took over as head of the Wiener Werk-
stätte fashion department. Took up an appointment
at the Munich School of Fashion (Modeschule).
Member of the Austrian Werkbund. Exhibitions in-
cluded: 1915 Fashion Exhibition, 1920 Kunstschau,
1925 Paris.

Spannring, Luise
*5. 7. 1894 Villach – last living in Puch/Salzburg
Attended the College of Wood and Stone-working
(Fachschule für Holz- und Steinbearbeitung) in Hal-
lein. Studied at the School of Arts and Crafts in
Vienna under Powolny, Strnad and others. Own ce-
ramics workshop in Salzburg from 1919. Executed
ceramics for the Wiener Werkstätte, through which
she also sold her own works. Exhibitions included:
1925 Paris, 1925 Deutsche Frauenkunst.

Strauss-Likarz, Maria
*28. 3. 1893 Przemysl †1971
One of the leading women artists at the Wiener
Werkstätte. After attending the School of Art for
Women and Girls, she studied at the School of Arts
and Crafts in Vienna from 1911 to 1915 under Hoff-
mann and others. Doctorate. Taught at the City of
Halle School of Arts and Crafts, Burg Giebichen-
stein, from 1917 to 1920. Paul Thiersch had taken
over the school in 1915 and structured his teaching
programme around the execution of the perfect
one-off piece. After the closure of the Weimar Bau-
haus, Gerhard Marcks also went to Giebichenstein.
Influenced by the school's principles, in 1920 Maria
Likarz returned to the Wiener Werkstätte, where
she had already worked from 1912 to 1914, and re-
mained there until 1931. Initially active primarily as
a graphic designer, from 1920 she moved into
every field of handicraft: ceramics, enamel, bead-
work, textiles, wallpapers, glass, glass decoration,
wood, leather and paper. She also played a major
design role in fashion and accessories. Wall paint-
ings were a further speciality. Maria Strauss-Likarz
was a member of the Austrian Werkbund and the
Wiener Frauenkunst. Took part in all the major
Wiener Werkstätte exhibitions.

Strnad, Oskar
*26. 10. 1879 Vienna †3. 9. 1935 Altausee
Studied architecture at the Technical College in

Maria Strauss-Likarz

Max Snischek

Richard Teschner, 1929, Photo: Hella Katz

Vally Wieselthier, c. 1928

Vienna. Worked in the studios of Ohmann and Fellner & Hellmer. Collaborated with Hoffmann for the first time on the Austrian Pavilion for the 1911 International Art Exhibition in Rome. "You smoothed the way for me" (Strnad to Hoffmann on the occasion of the latter's 60th birthday). Alongside architectural works and exhibition designing for the Wiener Werkstätte, Oskar Strnad also designed ceramics, glass (Lobmeyr) and metalwork. He was involved in the City of Vienna's municipal building programme between the wars; high-rise architecture. From 1909 to 1935 he taught at the School of Arts and Crafts in Vienna, where his pupils included many later members of the Wiener Werkstätte. Member of the Austrian Werkbund. Took part in almost all the major Exhibitions of his day, including: 1913 Wallpaper Exhibition, 1914 Werkbund exhibition in Cologne, 1925 Paris.

Teschner, Richard
*22. 3. 1879 Karlsbad †4. 7. 1948 Vienna
Studied at the Academy in Prague from 1896 to 1899, and in 1900 attended the School of Arts and Crafts in Vienna. His work for the Wiener Werkstätte between 1909 and 1912 included: chased metalwork, trophy cups, sculpture, children's books and postcards. Member of the Austrian Werkbund and the Künstlerhaus. Took part in the 1908 Kunstschau.

Trethan, Therese
*17. 7. 1859 Vienna
Studied at the School of Arts and Crafts in Vienna from 1897 to 1902 under Moser, Linke and others. Active as a painter for the Wiener Werkstätte from 1905 to 1910. Stoneware for the Böck and Wahliss companies. Exhibitions included: 1902–1903 Museum of Art and Industry Winter Exhibition, 1904 World Exposition in St. Louis, 1905 "The Laid Table", Brünn, 1908 Kunstschau, 1925 Paris.

Urban, Josef
*25. 5. 1872 Vienna †10. 7. 1933 New York
Studied under Hasenauer at the Academy in Vienna. Founding member and later, from 1906 to 1908, president of the Hagenbund. In 1911 he went to America, where he worked as a stage designer. Principal designer for the Metropolitan Opera, New York, from 1918 to 1933. Also a film designer from 1920 onwards; close contact with William Randolph Hearst. Built a theatre for Ziegfeld's troupe and designed most of its Broadway shows. Also ran his own "Decorative and Scenic Studio" in New York. After a trip to Vienna, he started an Artists' Fund for the Wiener Werkstätte and initiated the opening of the Wiener Werkstätte's New York branch, of which he became head. He created the interiors of its offices and showroom on Fifth Avenue, partially with furniture he designed himself.

Wieselthier, Vally
*25. 5. 1895 †1. 9. 1945 New York
After attending the School of Art for Women and Girls, she studied at the School of Arts and Crafts in Vienna from 1914 to 1920 under Moser, Hoffmann, Powolny and others. She subsequently became a member of the Wiener Werkstätte Artists' Workshops, while maintaining her own studio in Esterhazygasse. Her ceramic works for the Wiener Werkstätte became a synonym for the "roaring twenties". She was also active in the fields of glass, textiles, wallpapers, toys, book bindings, free and commercial graphics, and painted chip boxes. Collaborated with Gudrun Baudisch-Wittke. Emigrated to USA. Took part in almost all the major Wiener Werkstätte exhibitions, including: 1915 Fashion Exhibition, 1920 Kunstschau, 1925 Paris, 1925 Deutsche Frauenkunst, 1927/28 The Hague.

Wimmer-Wisgrill, Eduard Josef
*2. 4. 1882 Vienna †25. 12. 1961 Vienna
After attending the Commercial College (Handels-

Vally Wieselthier

E. J. Wimmer-Wisgrill

Carl Witzmann, Photo: Schwab

high-rise architecture. Particularly noted as an exhibition designer. "A first-rate artistic director" (Berta Zuckerkandl). In 1911 he "composed" the Austrian Applied Arts exhibition and combined Hoffmann-esque rigour with a fluid ornamental style. From 1910 onwards, he designed almost all the exhibitions for the Austrian Museum of Art and Industry in Vienna. Exhibitions included: 1914 Werkbund exhibition in Cologne, 1920 Kunstschau, 1925 Paris, and, from his earlier days, the 1902 Turin International Exhibition. He also designed jewellery for the Wiener Werkstätte.

Zeymer, Fritz
*7. 12. 1886 Vienna †3. 3. 1940 Vienna
Studied at the School of Arts and Crafts in Vienna from 1902 to 1908 under Roller, Hoffmann, Czeschka, Metzner and others. Member of the Austrian Werkbund, the Künstlerhaus and the Secession. Designed programmes and decorations for the Cabaret Fledermaus, Wiener Werkstätte postcards and pictorial broadsheets, as well as textiles and furniture. He was a participant in numerous exhibitions.

Zimpel, Julius
*30. 8. 1896 Vienna †11. 8. 1925 Vienna
Studied at the School of Arts and Crafts in Vienna from 1911 to 1916 under Moser and others. Taught at the Bookbinders' Vocational College (Fachliche Fortbildungsschule für Buchbinder). Member of the Wiener Werkstätte Artists' Workshops. As Peche's successor, he remained artistic head of the Wiener Werkstätte alongside Josef Hoffmann until his death. Worked with Hoffmann on the Sonja Knips House, for which he designed the carpets. Broad range of work for the Wiener Werkstätte: textiles, book bindings, toys, silverware, ceramics, carpets, glass, ivory, free graphics. Member of the Wassermann artists' association. Took part in numerous exhibitions, including: 1920 Kunstschau, 1925 Paris, 1927/28 The Hague.

Zovetti, Ugo
*5. 9. 1897 Curzola/Dalmatia
Studied at the School of Arts and Crafts in Vienna from 1898 to 1901 under Moser and others. Designed pictorial broadsheets, textiles and accessories for the Wiener Werkstätte. Member of the Austrian Werkbund. Exhibitions included: 1908 Kunstschau, 1913 Werkbund exhibition.

Zülow, Franz von
*15. 3. 1883 Vienna †26. 2. 1963 Vienna
Studied at the Vienna Institute of Graphic Art and at the Academy of Fine Arts under Griepenkerl. Studied at the School of Arts and Crafts in Vienna from 1903 to 1906 under Czeschka and others. Broad range of work for the Wiener Werkstätte: textiles, fans, painting, folding screens and lithographs. Member of the Austrian Werkbund and the Secession. Took part in almost all the major exhibitions of his day, including: 1903 Brünn Museum of Handicraft, 1907 Hagenbund, 1908 and 1909 Kunstschau, 1913 Galerie Miethke, 1913 Wallpaper Exhibition, 1920 Kunstschau, 1925 Paris.

Julius Zimpel

Franz von Zülow, 1933, Photo: Dietrich, Vienna

akademie), he studied at the School of Arts and Crafts in Vienna from 1901 to 1907 under Roller, Hoffmann, Moser and others. Taught there from 1912 to 1953, with a few interruptions. Also taught at the Alsergrund adult education college. Several spells in America between 1923 and 1925, including a teaching post at the Art Institute of Chicago. After a visit to the Palais Stoclet, he founded the Wiener Werkstätte fashion department, which he headed from 1910 to 1922. Under his direction, and with his designs, Wiener Werkstätte fashions were a great – and commercial – success. Influenced by Hoffmann, Czeschka and Moser, Wimmer-Wisgrill developed his own, highly elegant style which lay close to Art Déco. Broad range of work for the Wiener Werkstätte: textiles, silver and metalwork, postcards, jewellery, ivory accessories, leather, book bindings, lamps and costumes. He also contributed to the decoration of the Cabaret Fledermaus. Member of the Austrian and German Werkbund and of the Deutsche Museum Hagen (Hagen German Museum) group. Took part in almost all the major Wiener Werkstätte exhibitions, including: 1908 and 1909 Kunstschau, 1911 International Art Exhibition in Rome, 1913 Wallpaper Exhibition, 1914 Werkbund exhibition in Cologne, 1930 Werkbund exhibition, 1932 Interiors and Fashion (Raum und Mode).

Witzmann, Carl
*26. 9. 1883 Vienna
Apprenticeship as a cabinetmaker and studied at the Cabinetmaking College (Fachschule für Tischlerei) in Vienna. Studied at the School of Arts and Crafts in Vienna from 1901 to 1906 under Hoffmann and others, subsequently becoming a teacher there in 1910 after having previously taught at the Cabinetmaking College. Numerous architectural projects, interior designs for theatres, cinemas, restaurants, and cafés. Engaged upon the City of Vienna's municipal building programme between the wars, including

Chronology

1897 The Vienna Secession is founded on 3 April under the official name of the Vereinigung bildender Künstler Österreichs (Austrian Association of Artists). Its first president is Gustav Klimt; founder members include Josef Hoffmann, Koloman Moser and Joseph Maria Olbrich. It follows the earlier foundation in 1892 of the Verein bildender Künstler Münchens (Munich Association of Artists), the first Secession in the German-speaking world, which would also play a role in setting up the Vereinigte Werkstätten für Kunst im Handwerk (United Workshops for Art in Handicraft) in Munich in 1897–1898.

1898 *Ver Sacrum*, the programmatic journal of the Wiener Secession, is launched in January (ceases publication in 1903). 1st Secession exhibition, 26.3.–15.6.1898, interior décor by Olbrich, Hoffmann and others. 2nd Secession exhibition, 2.12.–28.12.1898, in the new Secession building built by Olbrich; interior décor by Moser and others. In 1899 Josef Hoffmannn and Koloman Moser become professors at the Vienna School of Arts and Crafts.

1900 World Fair in Paris, rooms by Hoffmann for exhibits by the Vienna Secession and the School of Arts and Crafts. 8th Secession exhibition, 3.11.–27.12.1900, interior décor by Moser, Hoffmann and Leopold Bauer. The exhibition focuses upon European applied art and includes contributions from Charles Robert Ashbee and his Guild of Handicraft (founded 1888), Margaret McDonald and Charles Rennie Mackintosh, Frances McDonald and J. Herbert MacNair, Julius Meier-Graefe's Maison Moderne (founded 1898), Henry van de Velde, and members of the Vienna Secession (Otto Wagner, Bauer, Hoffmann, Moser and others).

1901 Gisela von Falke, Emil Holzinger, Jutta Sika and other graduates of the Vienna School of Arts and Crafts, with the support of Hoffmann and Moser, found the Wiener Kunst im Hause (Viennese Art in the Home) artists' exhibiting society. The society takes part in the Vienna Association of Arts and Crafts' Christmas Exhibition and in the 15th Secession exhibition held in 1902.

1902 In December, Hoffmann makes his second trip to Britain, staying with Ashbee in London and with Mackintosh in Glasgow, in connection with his plans – partially inspired by Meier-Graefe – to start a workshop.

1903 The "Wiener Werkstätte, Productivgenossenschaft von Kunsthandwerkern in Wien, Genossenschaft mit unbeschränkter Haftung" (Vienna Workshops, manufacturing co-operative of artist craftsmen in Vienna, co-operative with unlimited liability) is registered on 19 May under the artistic direction of Hoffmann and Moser and the financial management of Fritz Waerndorfer, a Viennese manufacturer. Registrations are made for the trades of precious metalwork, belts and bronzeware, painting and cabinetmaking. An office and a metal workshop are installed at Heumühlgasse 6. In October 1903 the Wiener Werkstätte moves to a disused factory at Neustiftgasse 32–34, where it establishes workshops for precious and other metals, cabinetmaking, varnishing, leather and bookbinding (registered in 1904), as well as a building office, Hoffmann's architectural studio, and showrooms.

1904 First Wiener Werkstätte exhibition in the Hohenzollern-Kunstgewerbehaus in Berlin.

1904–1906 Purkersdorf Sanatorium near Vienna.

1905–1911 Palais Stoclet, Brussels, building and interiors; as a consequence of this commission, the number of permanent Wiener Werkstätte employees grows from autumn 1905 onwards, and the workshops expand.

1905 In February Michael Powolny und Bertold Löffler found Wiener Keramik, whose products are sold through the Wiener Werkstätte from 1907 onwards.

1906 Imperial Royal Austria Exhibition, London.

1907 The Wiener Werkstätte opens a shop at Graben 15, Vienna 1. Koloman Moser resigns from the Wiener Werkstätte at the start of the year.

1907 Cabaret Fledermaus, Vienna.

1908 The Wiener Werkstätte has its own room at the Vienna Kunstschau and exhibits works by Hoffmann, Moser, Otto Prutscher, Carl Witzmann and Oskar Kokoschka. *Die träumenden Knaben* (The Dreaming Boys) is published by the Wiener Werkstätte.

1909 The Wiener Werkstätte opens a branch in Karlsbad.

1909–1911 Villa Ast, Hohe Warte, Vienna.

1910 The fashion department is founded under the direction of Eduard Josef Wimmer-Wisgrill.

1911 International Art Exhibition, Rome.

1913 Wallpaper exhibition, Austrian Museum of Art and Industry, Vienna.

1913 Probably the year in which the Wiener Werkstätte Artists' Workshops (Künstlerwerkstätte) were established at Döblergasse 4, a house built by Otto Wagner. The works produced here were primarily sold via the Wiener Werkstätte.

1913–1914 Primavesi country house, Winkelsdorf.

1913–1915 Villa Skywa-Primavesi, Vienna.

1914 Liquidation of the Wiener Werkstätte; on 27 March, foundation of the "Betriebsgesellschaft m.b.H. der Wiener Werkstätte Productivgenossenschaft für Gegenstände des Kunstgewerbes" (Vienna Workshops manufacturing co-operative for handicraft objects Ltd.). The Primavesi family of industrialists acquires about one third of the shares. At the German Werkbund exhibition in Cologne, the Wiener Werkstätte mounts a comprehensive display of its work.

1914 German Werkbund exhibition, Cologne.

1915 Otto Primavesi becomes managing director. Dagobert Peche joins the Wiener Werkstätte in the spring and assumes a role in its artistic direction. Glass decoration (painting) is begun around this time, and glass cutting is also introduced in 1919.

1915 New head offices at Tegetthoffstrasse 7, Vienna 1.

1916 Concession in Berlin.

1916 Shop opens at Kärntner Strasse 32, Vienna. Branch opens in Marienbad.

1917 Branch opens in Zurich; run by Dagobert Peche until 1919.

From 1917 Own ceramic production.

1917–1918 Installation of new showrooms for fabrics, lace and lighting appliances at Kärntner Strasse 41, Vienna.

1920 Kunstschau in the Austrian Museum of Art and Industry. The Marienbad branch, first established in 1916, is re-opened. The Wiener Werkstätte takes the name of "Wiener Werkstätte Gesellschaft m. b. H." (Vienna Workshops Company Ltd.)

1922 The Wiener Werkstaette of America, Inc. opens in New York. The branch is run by Josef Urban until its closure in 1924. Branch opens in Velden.

1924–1925 Sonja Knips House, Vienna.

1925 International Exhibition of Modern Decorative and Industrial Arts in Paris.

1926 The Wiener Werkstätte AG in Zurich goes bankrupt and closes. The Wiener Werkstätte, Vienna, reaches a successful arrangement with its creditors.

1927 European Arts and Crafts exhibition, Grassi Museum, Leipzig.

1928 25th anniversary celebrations. A comprehensive catalogue and price list of Wiener Werkstätte products is published. Mathilde Flögl compiles the commemorative volume *Die Wiener Werkstätte 1903–1928, Modernes Kunstgewerbe und sein Weg* (The Vienna Workshops 1903–1908, Modern Applied Art and its Path), which is published by Krystall-Verlag, Vienna.

1929 Branch opens in Berlin.

1929 Austria exhibition, Stockholm.

1930 Austrian Werkbund exhibition in Vienna.

1931 At the end of the year, the employees are given notice and the workshops are disbanded.

1932 Beginning of liquidation proceedings. In September the Glückselig Viennese auction house sells off the remaining stock. The Wiener Werkstätte is wound up. It is finally deregistered on 3 February 1939.

Notes

DkuD = Deutsche Kunst und Dekoration

1 Ludwig Hevesi: Acht Jahre Secession, Kritik – Polemik – Chronik, Vienna 1906

2 Otto Wagner: Moderne Architektur, Vienna 1895

3 In: Wien, Munich 1956, Jacqueline and Werner Hofmann (eds.)

4 In: Julius Posener: 59 Arch+, Vorlesung 2, Aachen 1981

5 Dolf Sternberger: Über den Jugendstil und andere Essays, Hamburg 1956

6 Josef August Lux: Der Qualitätsbegriff im Kunstgewerbe, in: Deutsche Kunst und Dekoration, XX (DKuD), Darmstadt 1907

7 Henry van de Velde: Kunstgewerbliche Laienpredigten, Leipzig 1902

8 Frank Lloyd Wright: In the Cause of Architecture, in: Architectural Record, New York 1908

9 Ludwig Hevesi: Altkunst–Neukunst, Vienna 1909

10 Karl Marilaun: Gespräch mit Josef Hoffmann, in: Neues Wiener Journal, vol. 26, Vienna 1918

11 As note 9

12 Armin Friedmann: Secessionistische Tafelfreuden, in: Neues Wiener Tagblatt, vol. 40, Vienna 1906

13 Julian Marchlewski: Secession und Jugendstil, Kritiken um 1900, Dresden 1974

14 Christian F. Nebehay: Gustav Klimt, Sein Leben nach zeitgenössischen Berichten und Quellen, Munich 1976

15 Josef Hoffmann: Einfache Möbel, in: Das Interieur II, 1901

16 As note 7

17 Wolfgang Pehnt: Die Architektur des Expressionismus, Stuttgart 1973

18 Peter Behrens: Feste des Lebens und der Kunst, Jena 1900

19 As note 17

20 G. S. Salles: Adolphe Stoclet Collection, Brussels 1956

21 Hans Ankwicz-Kleehoven: Josef Hoffmann: Das Palais Stoclet in Brüssel, in: Alte und Moderne Kunst, Vienna 1961

22 Berta Zuckerkandl: Erinnerungen an Gustav Klimt, Wiener Tageszeitung, Vienna, February 1934

23 As note 9

24 Hermann Muthesius: The English House, edited by Dennis Sharp and translated by Janet Seligman, Oxford 1979, p. 52

25 Adolf Loos: Sämtliche Schriften, 2 vols., Franz Glück (ed.), Vienna–Munich 1962

26 Josef Hoffmann: unpublished manuscript from his estate

27 Egon Friedell: Jubiläumsband zum 25jährigen Bestehen der WW, Vienna 1928

28 As note 9

29 As note 26

30 Berta Zuckerkandl: Das Cabaret Fledermaus, in: Wiener Allgemeine Zeitung, vol. 28, Vienna 1907

31 Karl Kraus: Eine Kulturtat, in: Die Fackel, vol. 9, Vienna 1907/08

32 Oskar Kokoschka: Brief an Erwin Lang, in: Agathon, Almanach auf das Jahr 48 des 20. Jhs., Leopold Wolfgang Rochowanski (ed.), Vienna 1947

33 Julius Posener: 59 Arch+, Vorlesung 5, Aachen 1981 Erich Mendelsohn: 1887–1953, führender deutscher Architekt des Expressionismus, der Dynamik und Funktion

34 Berta Zuckerkandl, Ein Landhaus in Winkelsdorf bei Mährisch-Schönberg, in: DKuD XXXVIII, Darmstadt 1916

35 Leo Adler: Baukunst, in: DKuD LIX, Darmstadt 1926/27

36 Josef Hoffmann: Die Schule des Architekten, in: Das Kunstblatt, April 1924

37 Berta Zuckerkandl: Erinnerungen an Dagobert Peche, in: Neues Wiener Journal, vol. 31, Vienna 1923

38 Josef Frank, in: L'Amour de l'Art IV, 1923, quoted from: Eduard F. Sekler: Josef Hoffmann, Das architektonische Werk, Salzburg and Vienna 1982

39 Unknown source in: L'Amour de l'Art VI, 1925, quoted from: Eduard F. Sekler: Josef Hoffmann, Das architektonische Werk, Salzburg and Vienna 1982

40 R. Muther: Geschichte der Malerei, vol. III, Berlin 1920

41 Berta Zuckerkandl: Die Möbel-Jubiläums-Ausstellung in Vienna, in: DKuD XXIII, Darmstadt 1908/09

42 A. S. Levetus: Architekt Carl Witzmann-Wien, in: DKuD XXV, Darmstadt 1909/10

43 L. H.: Die Wiener Tapetenausstellung, in: DKuD XXXIII, Darmstadt 1913/14

44 Klaus Jürgen Sembach: Möbel, in: Jugendstil, der Weg ins zwanzigste Jahrhundert, Helmut Seling (ed.), introduction by Kurt Bauch, Heidelberg/Munich 1959

45 Friedrich Ahlers-Hestermann: Stilwende, Berlin 1941

46 Josef Hoffmann: Arbeitsprogramm der Wiener Werkstätte, Vienna 1905; quoted from: Schweiger, W.H.: Wiener Werkstätte, Design in Vienna 1903–1932, London 1984, pp. 42-43 (transl. by Alexander Lieven)

47 Robert Schmidt: 100 Jahre österreichische Glaskunst, Vienna 1925

48 Emile Gallé: Ecrits pour l'Art·1884/89, Paris 1908

49 L. F.: Wiener Werkstätte, in: DKuD LIX, Darmstadt 1926/27

50 As note 49

51 Josef August Lux: Kunstschau-Wien 1908, in: DKuD XXIII, Darmstadt 1908/09

52 Gustav Klimt: Opening Speech at the 1908 Vienna Kunstschau, in: Katalog der Kunstschau, Vienna 1908

53 Josef Hoffmann: 25 Jahre Wiener Werkstätte, Unser Weg zum Menschentum, in: DKuD LXII, Darmstadt 1928/29

54 Karl Widmer: Die gebildete Frau im Kunstgewerbehandel, in: DKuD XXV, Darmstadt 1909/10

55 Open Letter to Adolf Loos, in: Wiener Allgemeine Zeitung, vol. 48, Vienna 1927 Vor dem Richter, Der WW-Vortrag des Architekten Loos, in: Der Tag, vol. 6, Vienna 1927

56 Richard Graul: Leipziger Ausstellung, in: Zeitschrift für Bildende Kunst, September 1927 Julius Klinger: Ein angenehmer Gast, Schmuckkunst Mäda, in: Das Tribunal, May 1927

57 Oswald Haerdtl 1899-1959: Hochschule für angewandte Kunst catalogue, Vienna 1978

58 Reader's Digest Universal Dictionary, London 1987

59 Nikolaus Pevsner: Wegbereiter moderner Formgebung, Hamburg 1957, quoted from: Siegfried Wichmann: Jugendstil Floral Funktional, Herrsching 1984

60 Berta Zuckerkandl: Koloman Moser, Galerie Miethke, exhibition review, in: Wiener Allgemeine Zeitung, vol. 32, Vienna 1911

61 As note 49

62 Josef August Lux: Wiener Werkstätte, Josef Hoffmann und Koloman Moser, in: DKuD XV, Darmstadt 1904/05

63 Berta Zuckerkandl: Die Wiener Mode-Ausstellung, in: DKuD XXXVIII, Darmstadt 1916

64 Anton Jaumann: Kunst und Mode, in: DKuD XXXVII, Darmstadt 1915/16

65 Berta Zuckerkandl: Dagobert Peche – Wien, in: DKuD XXXIX, Darmstadt 1916/17

66 As note 53

67 Gustav E. Pazaurek: Von Glasperlen und Perlenarbeiten, from:…in alter und neuer Zeit, in: DKuD XLI, Darmstadt 1917/18

68 Alexander Koch: Zu neuen Arbeiten von Jos. Margold, in: DKuD XXXIII, Darmstadt 1913/14

69 François Mathey: Les Années 25, exhibition catalogue, Musée des Arts Décoratifs, Paris 1966

70 As note 51

71 Josef August Lux: Wiener Werkstätte, Josef Hoffmann und Koloman Moser, in: DKuD XV, Darmstadt 1904/05

72 As note 51

73 Josef Frank: Josef Hoffmann zum 60. Geburtstag, Österreichischer Werkbund (ed.), Vienna 1930

Selected Bibliography

Ahlers-Hestermann, Friedrich: Stilwende, Aufbruch der Jugend um 1900, Berlin 1941

Ashbee, Charles: A Short History of the Guild and School of Handicraft, London 1890

Bangert, Albrecht: Thonet-Möbel, Munich 1979

Bangert, Albrecht, and Fahr-Becker, Gabriele: Jugendstil, Munich 1992

Bangert, Albrecht, and Fahr-Becker, Gabriele: Art Déco, Munich 1992

Bauch, Kurt, and Seling, Helmut (eds.): Jugendstil, Der Weg ins zwanzigste Jahrhundert, Heidelberg/Munich 1959

Breicha, Otto, and Fritsch, Gerhard (eds.): Finale und Auftakt, Vienna 1898–1914, Salzburg 1964

Behrens, Peter: Feste des Lebens und der Kunst, Jena 1900

Bott, Gerhard (ed.): Von Morris zum Bauhaus, eine Kunst gegründet auf Einfachheit, Hanau 1977

Boullion, Jean-Paul: Art Déco in Wort und Bild 1903–1940, Geneva/Stuttgart 1989

Bröhan, Torsten: Glaskunst der Moderne, Munich 1992

Dry, Graham (ed.): Jacob & Josef Kohn, 1916 sales catalogue, reprint, Munich 1980

Duncan, Alastair: American Art Déco, Kunst und Design der 20er und 30er Jahre in Amerika, London/Munich 1986

Federmann, Reinhard (ed.): Berta Zuckerkandl – Österreich intim, Erinnerungen 1892–1942, Frankfurt/Main, Berlin, Vienna 1970.

Fischer, Wolfgang Georg: Gustav Klimt und Emilie Flöge, Vienna 1987

Fliedl, Gottfried: Gustav Klimt 1862–1918, The World in Female Form, Benedikt Taschen, Cologne 1990

Friedell, Egon: Jubiläumsband zum 25jährigen Bestehen der Wiener Werkstätte, Vienna 1928

Frottier, Elisabeth: Michael Powolny, Keramik und Glas aus Wien 1900–1950, Vienna/Cologne 1990

Gallé, Emile: Ecrits pour l'Art – 1884/89, Paris 1908

Giroud, Françoise: Alma Mahler, Vienna/Darmstadt 1989

Glück, Franz (ed.): Adolf Loos, Sämtliche Schriften, 2 vols, Vienna/Munich 1962

Graul, Richard: Die Krisis im Kunstgewerbe, Leipzig 1901

Gresleri, Giuliano: Josef Hoffmann, Bologna/New York 1985

Günther, Sonja: Josef Hoffmann 1870–1956, Karlsruhe 1972

Haerdtl, Oswald: 1899–1959, Hochschule für angewandte Kunst catalogue, Vienna 1978

Hansen, Traude: Die Postkarten der Wiener Werkstätte, Vienna 1982

Hase, Ulrike von: Schmuck in Deutschland und Österreich 1895–1914, Munich 1977

Hevesi, Ludwig: 8 Jahre Secession, Vienna 1906

Hevesi, Ludwig: Altkunst – Neukunst, Vienna 1909

Hofmann, Jacqueline and Werner (eds.): Wien, Munich 1956

Hofmann, Werner: Von der Nachahmung zur Erfindung der Wirklichkeit, Cologne 1970

Hofstätter, Hans H.: Symbolismus und Kunst der Jahrhundertwende, Cologne 1965

Japonisme, Le, exhibition catalogue, Tokyo/Paris 1988

Jost, Dominik: Literarischer Jugendstil, Stuttgart 1980

Jugendstil und Zwanziger Jahre, Josef Hoffmann–Wien, exhibition catalogue, Zurich 1983

Kurrent, Friedrich: Das Palais Stoclet, Salzburg 1991

Le Arte a Vienna, exhibition catalogue, Milan 1984

Lux, Joseph August: Die moderne Wohnung und ihre Ausstattung, Vienna 1905

MAK (ed.): Wiener Werkstätte, Lederobjekte, catalogue of works, Vienna 1992

Marchlewski, Julian: Secession und Jugendstil, Kritiken um 1900, Dresden 1974

Mathey, François: Les Années 25, exhibition catalogue, Musée des Arts Décoratifs, Paris 1966

Meier-Graefe, Julius: Entwicklungsgeschichte der modernen Kunst, Stuttgart 1904

Metropol, Galerie (ed.): Josef Hoffmann, Architect and Designer 1870–1956, Vienna and New York, undated

Metropol, Galerie (ed.): Sanatorium Purkersdorf, Vienna and New York, undated

Müller, Dorothee: Klassiker des modernen Möbeldesign, Munich 1980

Muthesius, Hermann: The English House, edited by Dennis Sharp and translated by Janet Seligman, Oxford 1979

Nebehay, Christian F.: Gustav Klimt, Sein Leben nach zeitgenössischen Berichten und Quellen, Munich 1976

Neuwirth, Waltraud: Das Glas des Jugendstils, Sammlung des Österreichischen Museums für angewandte Kunst, Vienna 1973

Neuwirth, Waltraud: Österreichische Keramik des Jugendstils, Sammlung des Österreichischen Museums für angewandte Kunst, Vienna and Munich 1974

Neuwirth, Waltraud: Wiener Keramik, Historismus, Jugendstil, Art Déco, Braunschweig 1974

Neuwirth, Waltraud: Wiener Werkstätte, Avantgarde Art Déco Industrial Design, Vienna 1984

Noever, Peter, and Oberhuber, Oswald: Josef Hoffmann, Ornament zwischen Hoffnung und Verbrechen, Vienna 1987

Noever, Peter (ed.): Josef Hoffmann Designs, Munich 1992

Oberhuber, Oswald, and Hummel, Julius (eds.): Koloman Moser 1868–1918, exhibition catalogue, Vienna 1979

Pazaurek, Gustav Edmund: Kunstgläser der Gegenwart, Leipzig 1925

Pehnt, Wolfgang: Die Architektur des Expressionismus, Stuttgart 1973

Pevsner, Nikolaus: Wegbereiter moderner Formgebung, Hamburg 1957

Posener, Julius: Arch+, Aachen 1981

Rochowanski, Leopold Wolfgang: Der Formwille der Zeit in der angewandten Kunst, Vienna 1922

Rochowanski, Leopold Wolfgang: Josef Hoffmann, Vienna 1950

Rykwert, Joseph: Ornament ist kein Verbrechen, Cologne 1983

Salles, G. S.: Adolphe Stoclet Collection, Brussels 1956

Schmidt, Robert: 100 Jahre österreichische Glaskunst, Vienna 1925

Schwarz-Gold Bronzitdekore von J. & L. Lobmeyr Wien, exhibition catalogue, Vienna 1993

Schweiger, Werner J.: Wiener Werkstätte, Design in Vienna 1903–1932, London 1984

Sekler, Eduard F.: Josef Hoffmann, The Architectural Work, Princeton 1985

Sele, Gert: Die Geschichte des Design in Deutschland von 1870 bis heute, Cologne 1978

Sembach, Klaus-Jürgen: Art Nouveau, Benedikt Taschen, Cologne 1991

Spalt, Johannes, and Czech, Hermann (eds.): Josef Frank 1885–1967, Vienna 1981

Sternberger, Dolf: Über den Jugendstil und andere Essays, Hamburg 1956

Sterner, Gabriele: Jugendstil, Cologne 1975

Sterner, Gabriele: Der Jugendstil, Handlexikon, Düsseldorf 1985

Textilien, exhibition catalogue

The Studio, The Art-Revival in Austria, London 1906

Traum und Wirklichkeit, exhibition catalogue, Vienna 1985

Van de Velde, Henry: Kunstgewerbliche Laienpredigten, Leipzig 1902

Varnedoe, Kirk (ed.): Vienna 1900, exhibition catalogue, New York 1986

Vienna Moderne: 1898-1918, exhibition catalogue, New York 1978

Völker, Angela: Die Stoffe der Wiener Werkstätte 1910–1932, Vienna 1990

Wagner, Otto: Moderne Architektur, Vienna 1895

Weiser, A.: Josef Hoffmann, Geneva 1930

Wichmann, Siegfried: Jugendstil Floral Funktional, exhibition catalogue, Munich 1984

Wiener Werkstätte, Modernes Kunsthandwerk von 1903–1932, exhibition catalogue, Vienna 1967

Wright, Frank Lloyd: In the Cause of Architecture, New York 1908

Zacharias, Thomas: Blick der Moderne, Munich and Zurich 1984

Zednicek, Walter: Josef Hoffmann, Vienna 1982

Zetter, Christa, Traum der Kinder – Kinderträume, Wien um 1900, Vienna 1984

Zuckerkandl, Berta: Zeitkunst Vienna 1901–1907, Vienna 1908

Periodicals:

Alte und moderne Kunst, Arch+, Architectural Record, Art et Décoration, Das Interieur, Das Kunstblatt, Deutsche Kunst und Dekoration, Illustrierte Monatshefte für moderne Malerei, Plastik, Architektur, Wohnungs-Kunst und künstlerische Frauenarbeiten, Die Fackel, Die Kunst, Domus, Innen-Dekoration, Kunstchronik, L'architettura, Neues Wiener Journal, Neues Wiener Tagblatt, The Studio, Wasmuths Monatshefte für Baukunst, Wiener Allgemeine Zeitung, Wiener Tagblatt, Wiener Tageszeitung

List of Illustrations

Acknowledgements

My thanks go to all the individuals and institutions who made this book possible. In particular, I would like to thank Diana and Paul Tauchner, Munich, Jutta Osterhoff, Munich, Anne Heidenreich, Munich, Patrick Kovacz, Vienna, and Irene Riedel, Munich, for their selfless support.

For my sons
Gabriele Fahr-Becker, Munich 1994